The Big Book of
NEW Design Ideas
David E. Carter

An imprint of HarperCollins*Publishers*

The original **Big Book of Design Ideas** has become one of the bestselling graphics books of all time. As one example, the book made amazon.com's *Top 1000* books and stayed there for a good while. That territory is usually reserved for novels, cook books, diet books, biographies, and other "general audience" books. Few books with a narrow audience reach those type of sales numbers.

So, when my publisher asked for a **Big Book of NEW Design Ideas**, he said, "Do a book just like the first one, only make it even better."

A "Similar Book, But Better." I think this book accomplishes that goal.

How? For some categories such as brochures, annual reports, and promotions, only a single page or image was shown in the first book.

This time, most brochures and annual reports show the cover as well as a two-page spread. That way, the viewer can see how the inside design relates to the cover.

For promotions, many have been given a full page and several photos. For the designer who uses this book as a springboard for ideas, the value is in the details.

One thing has not changed from the previous book: every piece in this book was selected for its ability to inspire designers and to trigger new ideas that may not even be related to the original piece shown in this book.

So, that pretty well describes what you will find in this book. For all of you designers who use books like this for what I call "solitary brainstorming," I hope this book will be as valuable to you as the first one was.

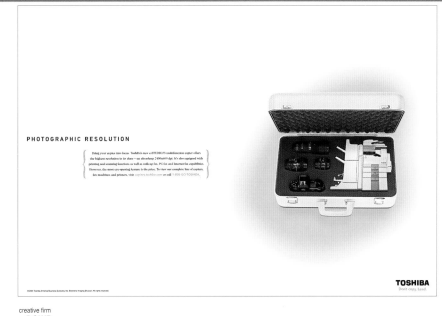

PHOTOGRAPHIC RESOLUTION

TOSHIBA
Don't copy. Lead.

THE JOURNEY TO ENLIGHTENMENT
BEGINS ON A STATIONARY BIKE.

360° PAIN IS BEAUTIFUL.

creative firm
DGWB
Santa Ana, California
creative people
JON GOTHOLD, EDUARDO CORTES,
ENZO CESARIO, DAVE SWARTZ,
MING LAI, DAVE HERMANES,
NEAL BROWN, KARA LAROSA
client
TOSHIBA COPIERS

creative firm
GAUGER + SANTY
San Francisco, California
client
STUDIO 360⁰

creative firm
THE UNGAR GROUP
Chicago, Illinois
creative people
TOM UNGAR, MARK INGRAHAM,
DOUG BENING
client
AMERICAN HARDWARE
MANUFACTURERS ASSN.

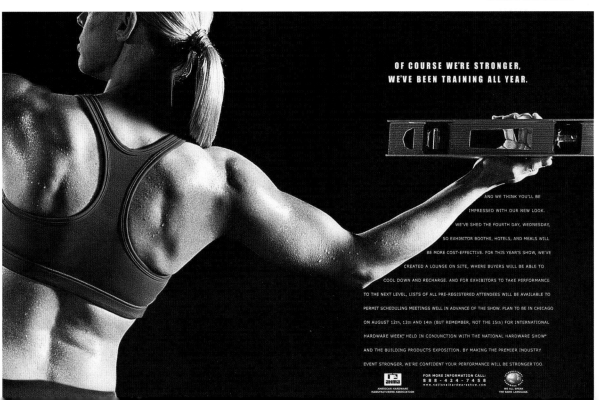

OF COURSE WE'RE STRONGER,
WE'VE BEEN TRAINING ALL YEAR.

AND WE THINK YOU'LL BE
IMPRESSED WITH OUR NEW LOOK.
WE'VE SHED THE FOURTH DAY, WEDNESDAY,
SO EXHIBITOR BOOTHS, HOTELS, AND MEALS WILL
BE MORE COST-EFFECTIVE. FOR THIS YEAR'S SHOW, WE'VE
CREATED A LOUNGE ON SITE, WHERE BUYERS WILL BE ABLE TO
COOL DOWN AND RECHARGE. AND FOR EXHIBITORS TO TAKE PERFORMANCE
TO THE NEXT LEVEL, LISTS OF ALL PRE-REGISTERED ATTENDEES WILL BE AVAILABLE TO
PERMIT SCHEDULING MEETINGS WELL IN ADVANCE OF THE SHOW. PLAN TO BE IN CHICAGO
ON AUGUST 12th, 13th AND 14th (BUT REMEMBER, NOT THE 15th) FOR INTERNATIONAL
HARDWARE WEEK™ HELD IN CONJUNCTION WITH THE NATIONAL HARDWARE SHOW®
AND THE BUILDING PRODUCTS EXPOSITION. BY MAKING THE PREMIER INDUSTRY
EVENT STRONGER, WE'RE CONFIDENT YOUR PERFORMANCE WILL BE STRONGER TOO.

FOR MORE INFORMATION CALL:
888-424-7458
www.nationalhardwareshow.com

AMERICAN HARDWARE
MANUFACTURERS ASSOCIATION

WE ALL SPEAK
THE SAME LANGUAGE.

5

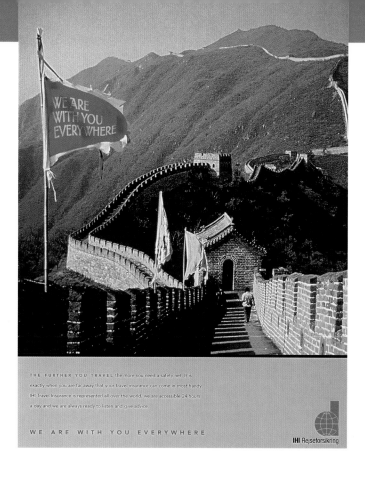

THE FURTHER YOU TRAVEL the more you need a safety net. It is exactly when you are far away that your travel insurance can come in most handy. IHI Travel Insurance is represented all over the world, we are accessible 24 hours a day and we are always ready to listen and give advice.

WE ARE WITH YOU EVERYWHERE

IHI Rejseforsikring

creative firm
HEIMBURGER
Denmark
creative people
ERIN CHAPMAN,
HENRY RASMUSSEN
client
IHI TRAVEL INSURANCE

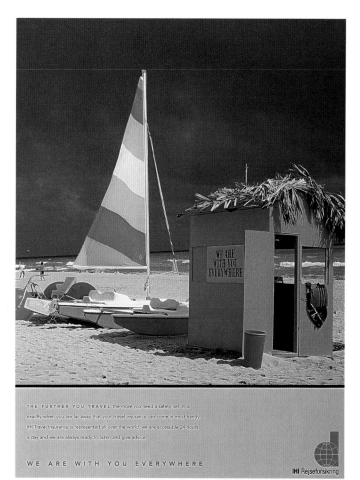

THE FURTHER YOU TRAVEL the more you need a safety net. It is exactly when you are far away that your travel insurance can come in most handy. IHI Travel Insurance is represented all over the world, we are accessible 24 hours a day and we are always ready to listen and give advice.

WE ARE WITH YOU EVERYWHERE

IHI Rejseforsikring

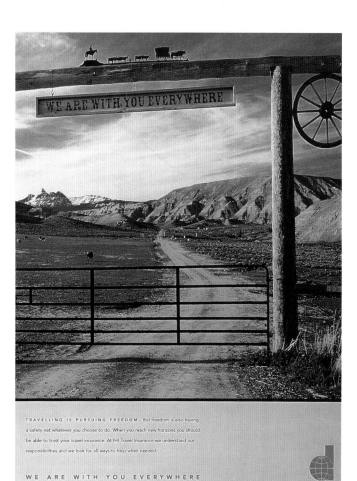

TRAVELLING IS PURSUING FREEDOM. But freedom is also having a safety net whatever you choose to do. When you reach new horizons you should be able to trust your travel insurance. At IHI Travel Insurance we understand our responsibilities and we look for all ways to help when needed.

WE ARE WITH YOU EVERYWHERE

IHI Rejseforsikring

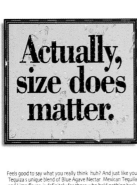

Feels good to say what you really think, huh? And just like you
Tequiza's unique blend of Blue Agave Nectar, Mexican Tequila
and Lime flavor, is definitely for those who hold nothing back.
Speak your mind. Drink your beer.

Beer w/o Borders

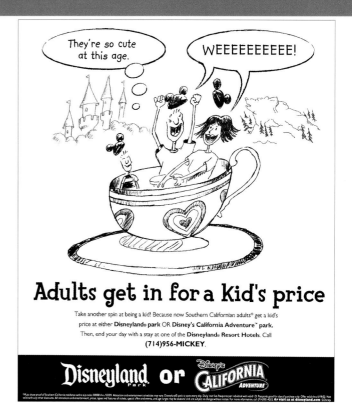

creative firm
DIESTE HARMEL & PARTNERS
Dallas, Texas
creative people
ALDO QUEVEDO, JESSE DÍAZ,
SANTIAGO ALANÍS, JUAN CARLOS HERNÁNDEZ
client
TEQUIZA

creative firm
DISNEYLAND CREATIVE
PRINT SERVICES
Anaheim, California
creative people
DENNIS SNYDER, JACQUELYN L. MOE,
SCOTT STARKEY, JIM ST. AMANT,
JIM DOODY, WES CLARK, LEONA OUNE
client
BRAND MANAGEMENT

creative firm
McCLAIN FINLON ADVERTISING
Denver, Colorado
creative people
TOM LEYDON, MATT LOCKETT,
ANA BOWIE, BILL SIEVERTSEN
client
MUTUAL UFO NETWORK & MUSEUM

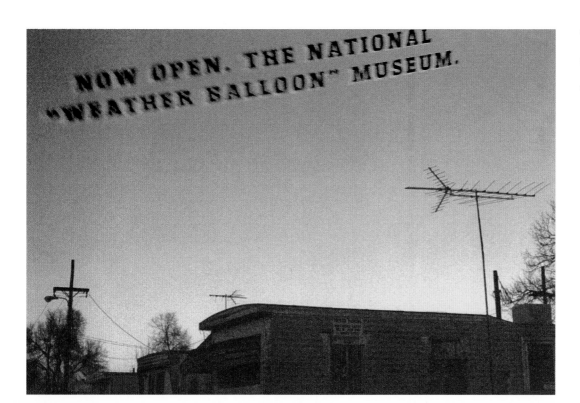

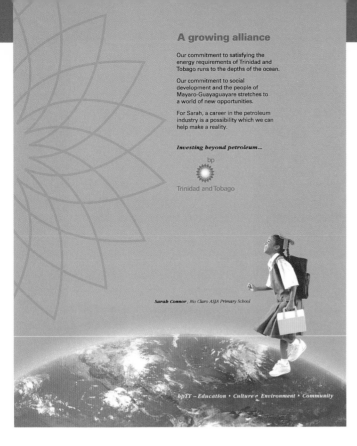

A growing alliance

Our commitment to satisfying the energy requirements of Trinidad and Tobago runs to the depths of the ocean.

Our commitment to social development and the people of Mayaro-Guayaguayare stretches to a world of new opportunities.

For Sarah, a career in the petroleum industry is a possibility which we can help make a reality.

Investing beyond petroleum...

bp

Trinidad and Tobago

Sarah Connor, Rio Claro ASJA Primary School

bpTT – Education • Culture • Environment • Community

creative firm
**ALL MEDIA PROJECTS
LIMITED (AMPLE)**
Port of Spain, Trinidad & Tobago
creative people
*ASTRA DA COSTA, AUSTIN AGHO,
CATHLEEN JONES, GAIL MATTHEW,
GAIL HUGGINS-FULLER,
MARIANELA INGLEFIELD*
client
BP TRINIDAD AND TOBAGO LLC (BPTT)

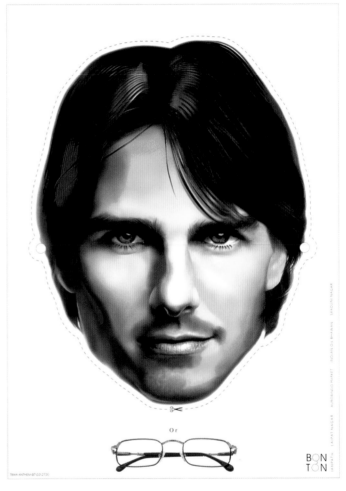

creative firm
TBWA-ANTHEM (INDIA)
New Delhi, India
creative people
*PROBIR DUTT, ARNAB CHATTERJEE,
SANJAY SAHAI*
client
BON-TON OPTICALS

creative firm
LEO BURNETT COMPANY LTD.
Toronto, Canada
creative people
*JUDY JOHN, KELLY ZETTEL,
JOSH RACHLIS, SEAN DAVISON,
ANNE PECK*
client
WOODBINE ENTERTAINMENT GROUP

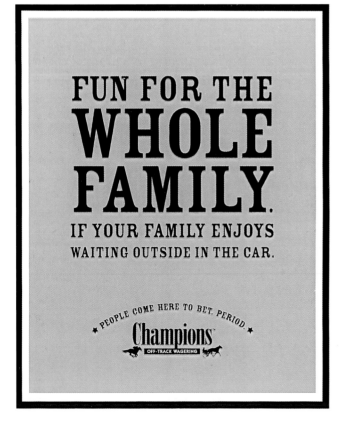

8

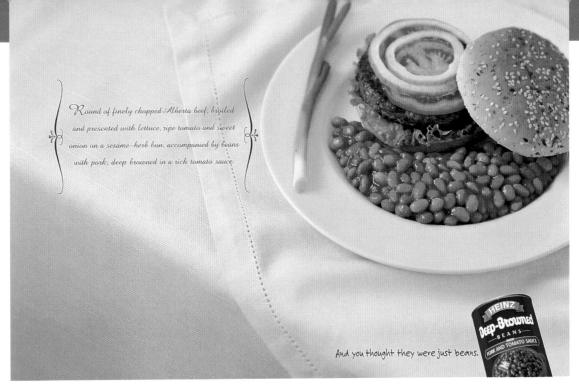

Round of finely chopped Alberta beef, broiled and presented with lettuce, ripe tomato and sweet onion on a sesame-herb bun, accompanied by beans with pork, deep browned in a rich tomato sauce.

And you thought they were just beans.

creative firm
LEO BURNETT COMPANY LTD.
Toronto, Canada
creative people
JUDY JOHN, TONY LEE,
KELLY ZETTEL, ANNE PECK
client
H.J. HEINZ CO. OF CANADA

creative firm
LAWRENCE & PONDER IDEAWORKS
Newport Beach, California
creative people
LYNDA LAWRENCE, MATT MCNELIS,
EVA FINN, GARY FREDERICKSON
client
PLANNED PARENTHOOD

creative firm
LAWRENCE & PONDER IDEAWORKS
Newport Beach, California
creative people
LYNDA LAWRENCE, SIMONE BEAUDOIN,
MATT MCNELIS
client
PICK UP STIX

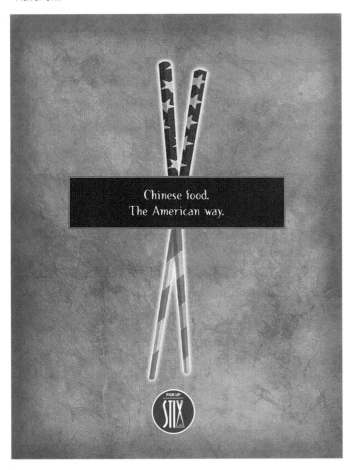

Chinese food.
The American way.

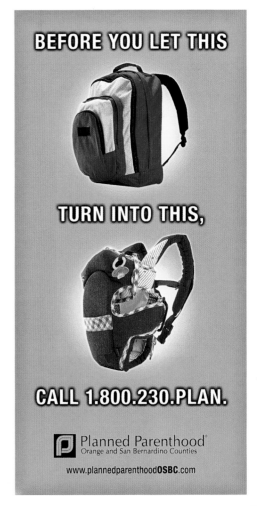

BEFORE YOU LET THIS

TURN INTO THIS,

CALL 1.800.230.PLAN.

Planned Parenthood®
Orange and San Bernardino Counties

www.plannedparenthood**OSBC**.com

9

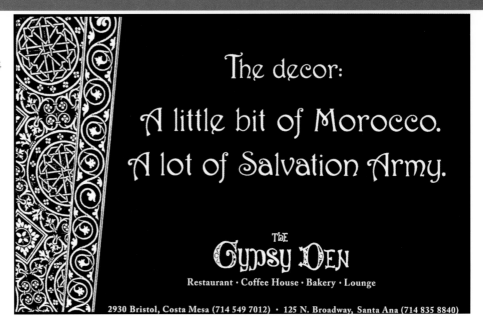

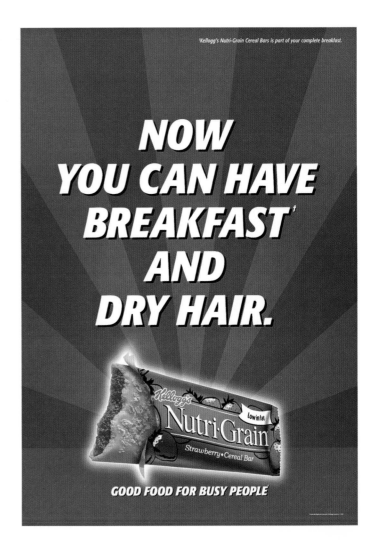

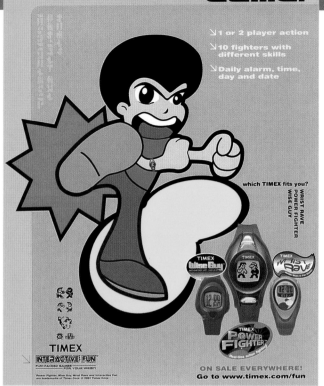

WEAR THE **WATCH** THAT'S ALSO A **GAME.**

↘ 1 or 2 player action

↘ 10 fighters with different skills

↘ Daily alarm, time, day and date

which TIMEX fits you?

WRIST RAVE
POWER FIGHTER
WISE GUY

TIMEX
INTERACTIVE FUN

ON SALE EVERYWHERE!
Go to www.timex.com/fun

creative firm
THE SLOAN GROUP
New York, New York
creative people
SEAN MOSHER-SMITH,
RODDY TASAKA
client
TIMEX

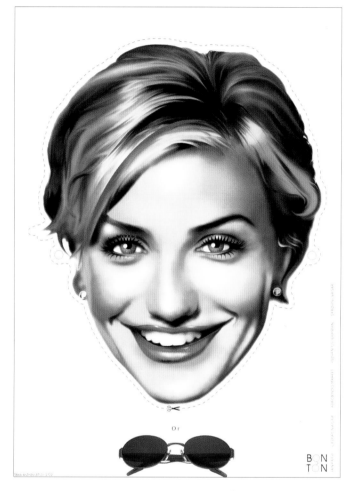

Or

B N
T N

creative firm
TBWA—ANTHEM (INDIA)
New Delhi, India
creative people
PROBIR DUTT,
ARNAB CHATTERJEE,
SANJAY SAHAI
client
BON-TON OPTICALS

"Waiter, I think there's a bug in my soup."

The Business Book & Author Luncheon With Bob Woodward. Monday, October 16, Noon.

 Bob Woodward would like to have lunch with you. Yes, the same Bob Woodward who is Assistant Managing Editor for Investigative News at *The Washington Post.* And the same man best known for his investigative work with Carl Bernstein during the Nixon-Watergate scandal. But not to worry. This affair is completely off the record. The invitation also includes an option for you or your company to sponsor the event. After all, think of the terrific exposure you'll get being connected with the best-selling author of books like *All The President's Men* and *Wired: The Short Life and Fast Times of John Belushi.* Not to mention, the association with The Public Library and this award-winning festival of reading.

If a sponsorship's not possible, you can always buy a table. Your best clients or key employees will be thrilled to attend such an intimate luncheon with this Pulitzer Prize-winning journalist who has had three of his books made into movies. If you're interested in a sponsorship, call 336-4115. For tickets call 336-2020 or visit www.novellofestival.net for more information.

Whatever you decide to do, don't miss this opportunity. It's the type of event where "networking" will reach an all-new level. And who knows, with a national election mounting, Bob might even leak some insider info. But don't count on him to reveal any sources. NOVELLO

Presenting Sponsor: BUSINESS JOURNAL

 Table Sponsors: AT&T, Chick-fil-A, Royal & SunAlliance, Clariant, KaSa, Specialized Media Marketing and Promotions, Pepsi-Cola Bottling Company of Charlotte, TIAA-CREF WFAE 90.7 fm, Centura Bank, Foundation For The Carolinas, WCCB-Fox 18, U.S. Trust of North Carolina, The BookMark, Philip Morris U.S.A.

creative firm
WRAY WARD LASETER ADVERTISING
Charlotte, North Carolina
creative people
JENNIFER APPLEBY, TOM COCKE,
DAVE DICKERSON, ELAINE BOSWELL
client
NOVELLO FESTIVAL OF READING

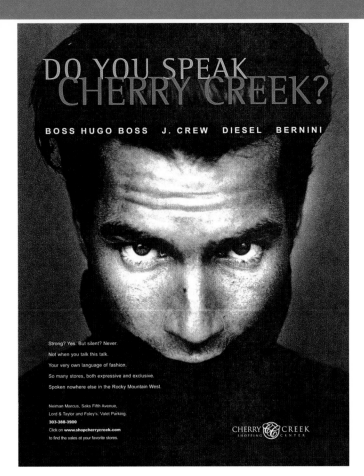

DO YOU SPEAK CHERRY CREEK?

BOSS HUGO BOSS J. CREW DIESEL BERNINI

Strong? Yes. But silent? Never.
Not when you talk this talk.
Your very own language of fashion.
So many stores, both expressive and exclusive.
Spoken nowhere else in the Rocky Mountain West.

Neiman Marcus, Saks Fifth Avenue,
Lord & Taylor and Foley's. Valet Parking.
303-388-3900
Click on www.shopcherrycreek.com
to find the sales at your favorite stores.

CHERRY CREEK
SHOPPING CENTER

DO YOU SPEAK CHERRY CREEK?

DKNY BEBE CARTIER COACH

Want to be heard? Speak up.
We're talking Cherry Creek-speak.
The dialect of design. So many stores,
both expressive and exclusive. Spoken
nowhere else in the Rocky Mountain West.

Neiman Marcus, Saks Fifth Avenue,
Lord & Taylor and Foley's. Valet Parking.
303-388-3900
Click on www.shopcherrycreek.com
to find the sales at your favorite stores.

CHERRY CREEK
SHOPPING CENTER

creative firm
ELLEN BRUSS DESIGN
Denver, Colorado
creative people
ELLEN BRUSS,
CHARLES CARPENTER
client
CHERRY CREEK SHOPPING CENTER

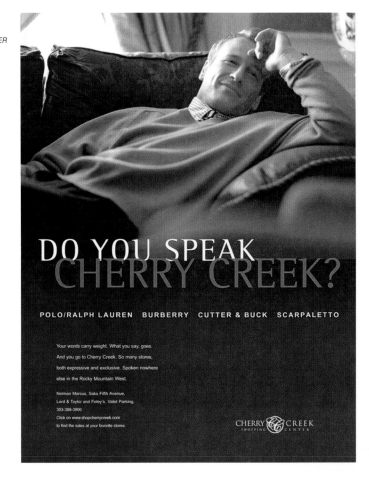

DO YOU SPEAK CHERRY CREEK?

POLO/RALPH LAUREN BURBERRY CUTTER & BUCK SCARPALETTO

Your words carry weight. What you say, goes.
And you go to Cherry Creek. So many stores,
both expressive and exclusive. Spoken nowhere
else in the Rocky Mountain West.

Neiman Marcus, Saks Fifth Avenue,
Lord & Taylor and Foley's. Valet Parking.
303-388-3900
Click on www.shopcherrycreek.com
to find the sales at your favorite stores.

CHERRY CREEK
SHOPPING CENTER

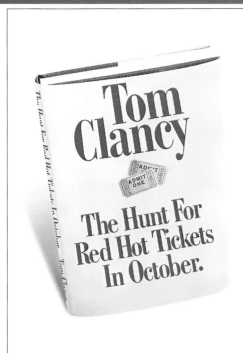

You can be sure that tickets for this rare public appearance by Tom Clancy will go faster than rats off a sinking ship. So reserve your seats now for a presentation, with a question and answer session, from one of the best-selling authors of all time. It's sure to be a high point in this year's Novello Festival of Reading. Don't miss the boat.

An Evening With Tom Clancy

Friday, October 27 at 7:30pm

Ovens Auditorium

Tickets: Orchestra - $15

Balcony and Mezzanine - $10

To order, call Ticketmaster at 522-6500.

For more information,

visit www.novellofestival.net.

NOVELLO

The Charlotte Observer

AT&T

creative firm
WRAY WARD LASETER ADVERTISING
Charlotte, North Carolina
creative people
JENNIFER APPLEBY, TOM COCKE,
DAVE DICKERSON, ELAINE BOSWELL
client
NOVELLO FESTIVAL OF READING

creative firm
SCANAD
Denmark
creative people
KIM MICHAEL, PHILLIP HELBO,
HENRY RASMUSSEN
client
KULTURSELSKABET STILLING

creative firm
DELRIVERO MESSIANU DDB
Coral Gables, Florida
client
VOLKSWAGEN

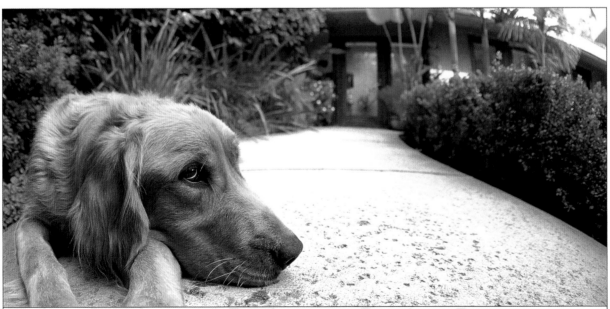

No a todos les gustará que tengas un Volkswagen

Va contigo

13

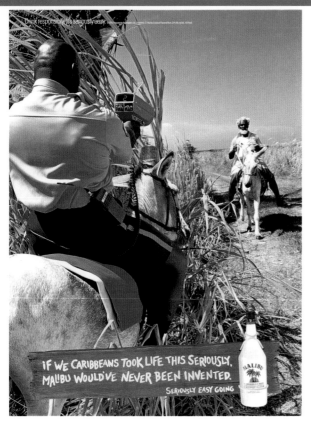

creative firm
J. WALTER THOMPSON
New York, New York
creative people
MIKE CAMPBELL
client
MALIBU

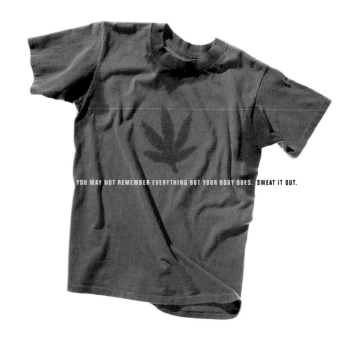

GoodLife

creative firm
LEO BURNETT COMPANY LTD.
Ontario, Canada
creative people
JUDY JOHN, KELLY ZETTEL,
TONY LEE, KIM BURCHIEL
client
GOODLIFE FITNESS CLUBS

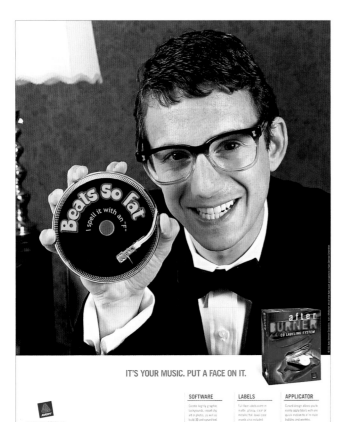

IT'S YOUR MUSIC. PUT A FACE ON IT.

SOFTWARE	LABELS	APPLICATOR

creative firm
DGWB
Santa Ana, California
creative people
JON GOTHOLD, DAVE SWARTZ,
ENZO CESARIO, ANDRE GOMEZ,
ELLIOTT ALLEN, DAVID ALBANESE,
MYKE HALL, DAYLE REIMER
client
AVERY AFTERBURNER

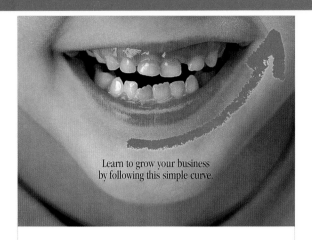

Learn to grow your business
by following this simple curve.

To sharpen your business skills, there's no better place than IAAPA Orlando 2002. With educational seminars and workshops covering everything from fundamental skills to the latest trends and best practices—plus visionary keynote speakers—IAAPA Orlando 2002 will put you at the top of the learning curve. Visit www.iaapaorlando.com today.

IAAPA ORLANDO
the show you never outgrow
Annual Convention and Trade Show
of the International Association of
Amusement Parks and Attractions
CONFERENCE: NOV. 18-23, 2002
EXHIBITION: NOV. 20-23, 2002
Orange County Convention Center
Orlando, Florida USA

For more show information, to register or to exhibit, contact IAAPA:

| ON-LINE: | TELEPHONE: | FAX ON DEMAND: |
| www.iaapaorlando.com | (USA) 703.836.4800 | (USA) 703.836.9678 |

Learn | Buy | Network | Satisfy

creative firm
KIRCHER, INC.
Washington, D.C.
creative people
BRUCE E. MORGAN, RICH GILROY,
TINA WILLIAMS
client
INTERNATIONAL ASSOCIATION OF
AMUSEMENT PARKS AND ATTRACTIONS

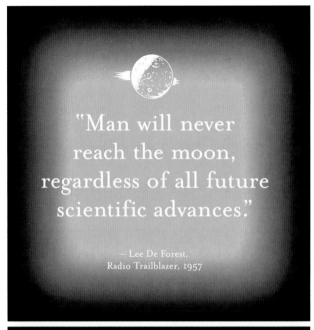

"Man will never
reach the moon,
regardless of all future
scientific advances."

— Lee De Forest,
Radio Trailblazer, 1957

They thought you couldn't reach a reservoir
25,000 feet down in 7,000 feet of water either.

We made it possible.

When Enventure Global Technology developed **Solid Expandable Tubular (SET™)** Technology, amazing possibilities opened up for deepwater wells that before were too costly, or simply out of reach. SET Technology allows you to reach TD with casing large enough to produce the well efficiently, but with a wellbore small enough to minimize rig size. It's an ideal balance that results in less equipment and ultimately hundreds of millions of dollars in savings. Applying SET Technology to your benefit is the only thing we focus on at Enventure. So call 281-492-5000 and ask us for the moon on your next project. We'll show you how to get there.

ENVENTURE
SET. The Standard.™

www.EnventureGT.com/possible

creative firm
SAVAGE DESIGN GROUP
Houston, Texas
creative people
PAULA SAVAGE, ROBIN TOOMS,
BO BOTHE, SCOTT REDEPENNING
client
ENVENTURE GLOBAL TECHNOLOGY

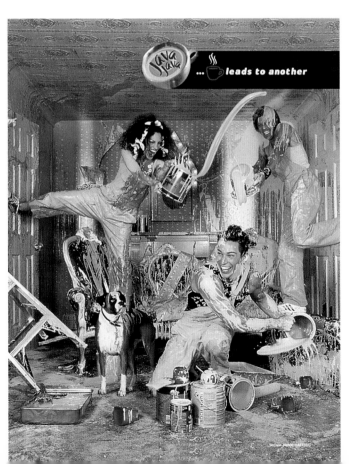

Java Java ...leads to another

creative firm
McCANN-ERICKSON SYDNEY
Sydney, Australia
creative people
JELLY LAND
client
NESTLE

creative firm
GBK, HEYE
Bavaria, Germany
creative people
ALEXANDER BARTEL, MARTIN KIESSLING,
CORINNA FALUSI, THORSTEN MEIER,
KATRIN BUSSON, JAN WILLEM SCHOLTEN
client
ELLE

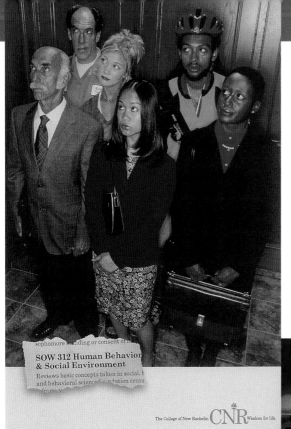

sophomore standing or consent of [...]
**SOW 312 Human Behavior
& Social Environment**
Reviews basic concepts taken in social, [...]
and behavioral science [...] dation cours[...]

The College of New Rochelle. CNR Wisdom for life.

creative firm
McCANN-ERICKSON
New York, New York
creative people
TOM JAKAB, GEORGE DEWEY
client
THE COLLEGE OF NEW ROCHELLE

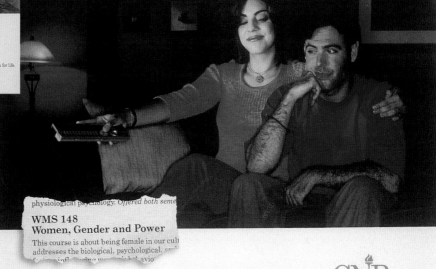

physiological psychology. *Offered both seme[...]*
**WMS 148
Women, Gender and Power**
This course is about being female in our cult[...]
addresses the biological, psychological, [...]
[...] influencing wo[...]ehavio[...]

The College of New Rochelle. CNR Wisdom for life.

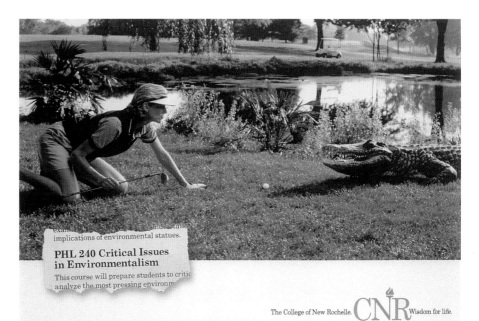

exam[...] implications of environmental statues.
**PHL 240 Critical Issues
in Environmentalism**
This course will prepare students to critic[...]
analyze the most pressing environm[...]

The College of New Rochelle. CNR Wisdom for life.

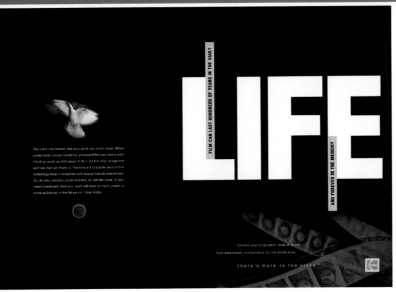

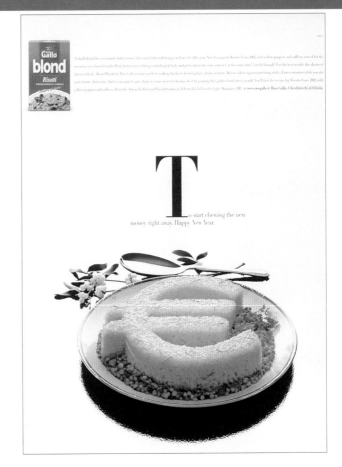

creative firm
BUCK & PULLEYN
Pittsford, New York
creative people
KATE SONNICK, ANNE ESSE,
GEORGE KAMPER
client
KODAK

creative firm
VERBA SRL
Milano, Italy
creative people
GIANFRANCO MARABELLI,
SILVIA ERZEGOVESI,
LORENZA PELLEGRI,
BRUNO DEWE DONNE
client
F&P-RISO GALLO

creative firm
SCANAD
Denmark
creative people
LARS HOLMELUND,
HENRY RASMUSSEN

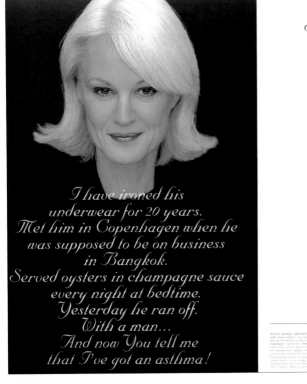

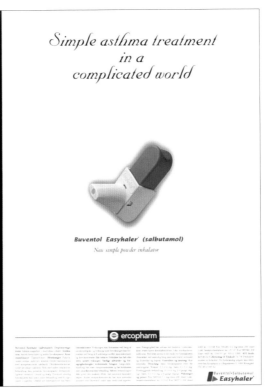

18

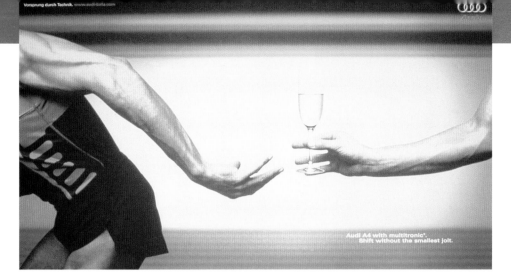

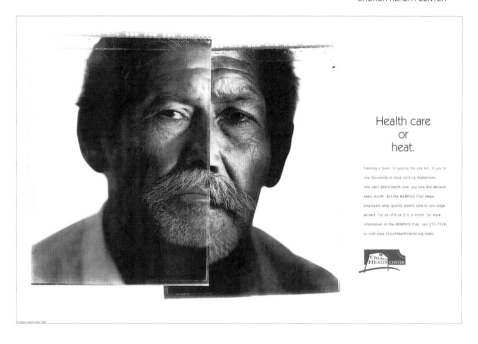

Health care
or
heat.

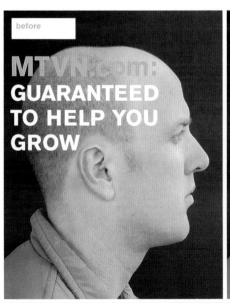

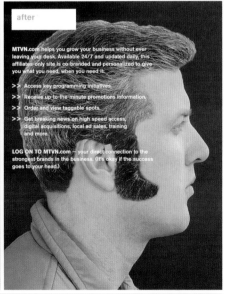

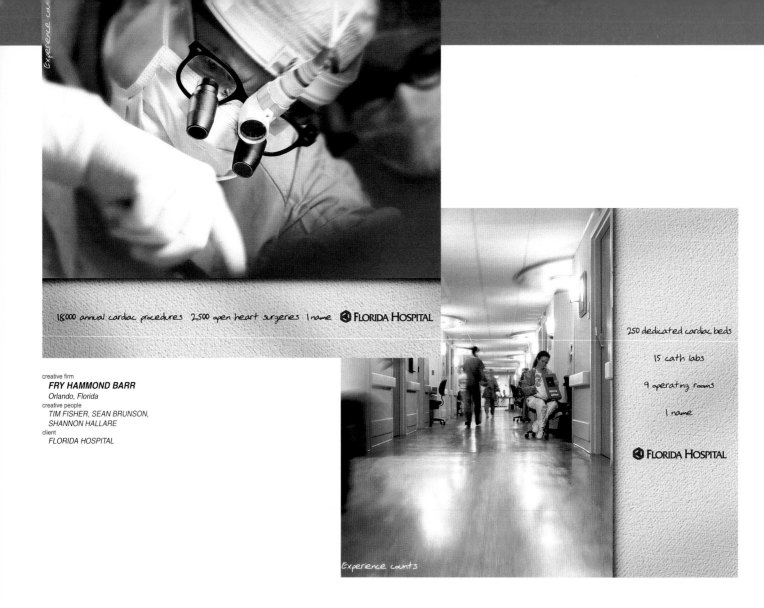

18,000 annual cardiac procedures 2,500 open heart surgeries 1 name ⬥ FLORIDA HOSPITAL

250 dedicated cardiac beds

15 cath labs

9 operating rooms

1 name

⬥ FLORIDA HOSPITAL

Experience counts

creative firm
FRY HAMMOND BARR
Orlando, Florida
creative people
*TIM FISHER, SEAN BRUNSON,
SHANNON HALLARE*
client
FLORIDA HOSPITAL

creative firm
VERBA SRL
Milano, Italy
creative people
*STEFANO LONGONI,
GIULIO BRIENZA,
FRANCESCO VIGORELLI,
FULVIO BONAVIA*
client
AUTOGERMA-AUDI DIVISION

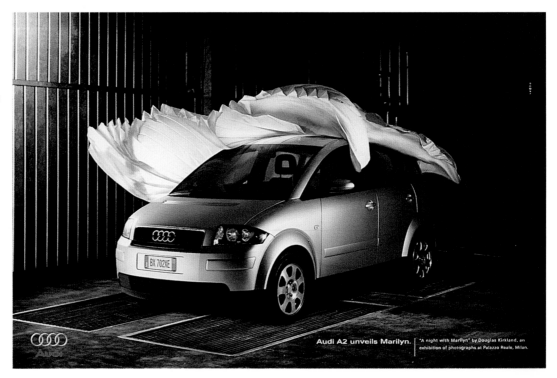

Audi A2 unveils Marilyn. "A night with Marilyn" by Douglas Kirkland, an exhibition of photographs at Palazzo Reale, Milan.

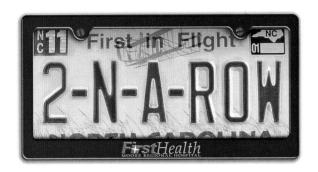

For the second consecutive year, FirstHealth Moore Regional was named a 100 Top Cardiovascular Hospital. We are honored to be the only hospital in the state to receive this award for a second time.

SOLUCIENT
TOP HOSPITALS
Cardiovascular

Hospitals named to the 100 Top Cardiovascular Hospital list constantly outperform their peers, with mortality and complication rates as much as 27 percent lower than other hospitals.

So if you need any type of cardiovascular procedure, we invite you to check us out. Because when you use your head, we don't think you'll let anyone else work on your heart.

FirstHealth
THE HEART+FIRST CENTER
www.firsthealth.org • 800-213-3284

FIRSTHEALTH MOORE REGIONAL: NAMED A TOP 100 CARDIOVASCULAR HOSPITAL TWO YEARS IN A ROW.

creative firm
STERRETT DYMOND STEWART ADVERTISING
Charlotte, North Carolina
creative people
RUSS DYMOND, LEE STEWART, ADAM LINGLE
client
FIRST HEALTH OF THE CAROLINAS

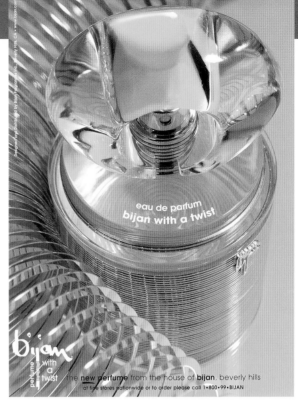

eau de parfum
bijan with a twist

bijan with a twist perfume

the new perfume from the house of **bijan**, beverly hills
at fine stores nationwide or to order please call 1•800•99•BIJAN

creative firm
BIJAN ADVERTISING
Beverly Hills, California
creative people
MR. BIJAN, CYNTHIA MILLER, ANDREA BESSEY
client
BIJAN FRAGRANCES

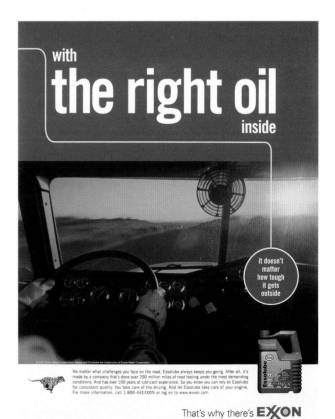

with
the right oil
inside

it doesn't matter how tough it gets outside

No matter what challenges you face on the road, Essolube always keeps you going. After all, it's made by a company that's done over 200 million miles of road testing under the most demanding conditions. And has over 100 years of lubricant experience. So you know you can rely on Essolube for consistent quality. You take care of the driving. And let Essolube take care of your engine. For more information, call 1-800-44EXXON or log on to www.exxon.com

That's why there's **EXXON**

creative firm
McCANN-ERICKSON
New York, New York
creative people
VANESSA LEVIN, JAN REHDER, JERRY CONFINO, SAL DESTEFANO
client
EXXON MOBIL

creative firm
HEIMBURGER
Denmark
creative people
*ERIN CHAPMAN,
HENRY RASMUSSEN*
client
DECATHLON

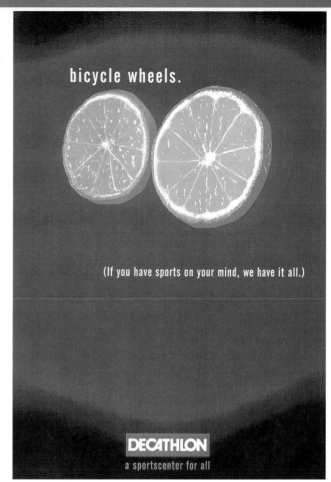

bicycle wheels.

(If you have sports on your mind, we have it all.)

DECATHLON
a sportscenter for all

Entering dialogue

Time is best used for hot leads.

But most sales resources are swallowed by contacts without results. Eliminate them and save a lot. And use your powers were they matter.

It's the art of cutting to the bone. Removing irrelevant information. This is called xformation and that is what TeleEurope produces.

By people and Internet we identify your gold through rational, effective, component market intelligence.

The final product is relevant information. Leads, open doors and positive response. This is the foundation for profitable customer relations.

Start by calling +45 8710 7744.

TeleEurope
XFORMATION

creative firm
SCANAD
Denmark
creative people
*LARS HOLMELUND,
HENRY RASMUSSEN*

?

WHAT IS Art

creative firm
M3AD.COM
Las Vegas, Nevada
creative people
DAN MCELHATTAN III
client
AIGA LAS VEGAS CHAPTER

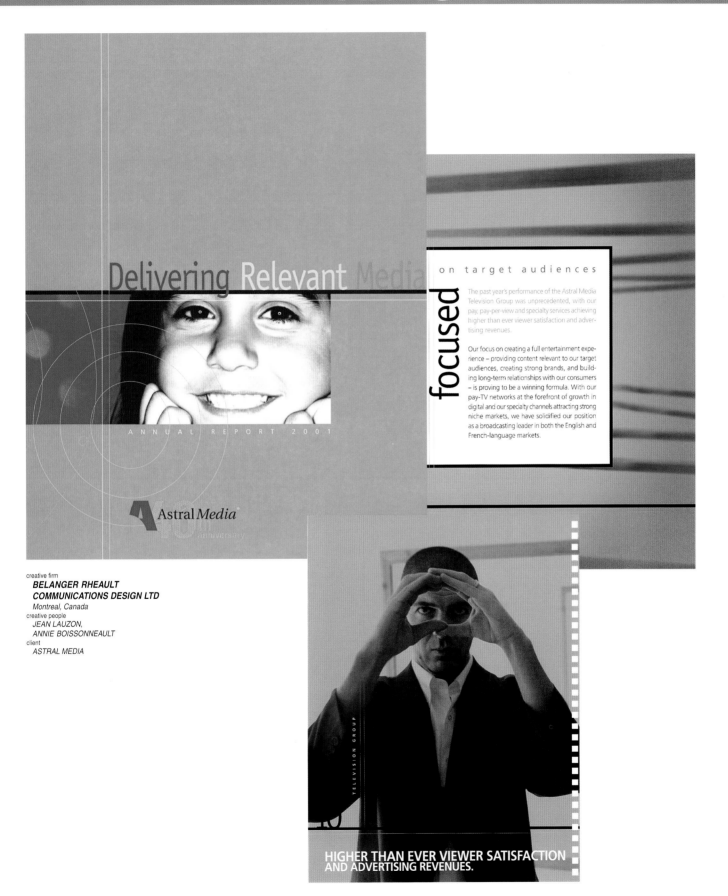

Delivering Relevant Media

ANNUAL REPORT 2001

Astral *Media*

on target audiences

focused

The past year's performance of the Astral Media Television Group was unprecedented, with our pay, pay-per-view and specialty services achieving higher than ever viewer satisfaction and advertising revenues.

Our focus on creating a full entertainment experience – providing content relevant to our target audiences, creating strong brands, and building long-term relationships with our consumers – is proving to be a winning formula. With our pay-TV networks at the forefront of growth in digital and our specialty channels attracting strong niche markets, we have solidified our position as a broadcasting leader in both the English and French-language markets.

TELEVISION GROUP

HIGHER THAN EVER VIEWER SATISFACTION AND ADVERTISING REVENUES.

creative firm
**BELANGER RHEAULT
COMMUNICATIONS DESIGN LTD**
Montreal, Canada
creative people
*JEAN LAUZON,
ANNIE BOISSONNEAULT*
client
ASTRAL MEDIA

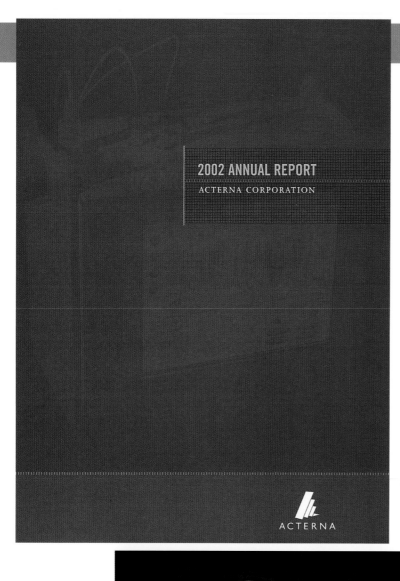

creative firm
GRAFIK
Alexandria, Virginia
creative people
JONATHAN AMER, JUDY KIRPICH,
LYNN UMEMOTO, MELBA BLACK
client
ACTERNA

Our strengths lie in our actions.

- We are streamlining operations and refocusing our resources.

- We are maintaining our presence in the world's largest communications markets.

- We are broadening our already diversified product and service portfolio.

- We are connecting to our customers with an industry-leading sales and support force.

- We are continuing our aggressive commitment to research and development.

1. Refocusing on our core business allows us to reduce costs and increase efficiency.

Certainly, no one could have expected the extent of the industry's prolonged downturn but, in response, we are accelerating our plans to streamline our infrastructure and reduce costs, increase efficiency and introduce new products to the marketplace.

At Acterna, we believe that a strong company is a focused company. That's why we have committed ourselves to focusing on our core business. We are the world's largest provider of test and management solutions for optical transport, access, and cable networks, and the second largest company overall in communications test. Our mission is to advance global communications with innovative test and management solutions intended to drive our customers' business performance to new levels. We realize that, to stay competitive, we must evaluate and rationalize our operations, our product sets, and our workforce.

We will continue to consolidate our order fulfillment and manufacturing facilities. Last year, we consolidated seven North American plants into two plants, a consolidation that accounted for about 20 percent of our workforce reduction. We are turning our attention this year to realizing new synergies in our European operations. By consolidating manufacturing and order fulfillment into fewer sites, we reduce costs and improve our responsiveness to customers.

Our recent decisions to sell Airshow and our wireless handset test business are in concert with our strategy to refocus on our core business.

Perhaps the most difficult of our cost-cutting initiatives has been the streamlining of our infrastructure. In fiscal 2002, we eliminated 1,050 positions, or 17 percent of our workforce. These actions — coupled with aggressive cost management — have reduced our infrastructure costs by approximately $180 million on an annualized basis. We announced the elimination of an additional 800 positions that will be realized in the first half of fiscal 2003, producing an additional $100 million in annualized savings.

2. Our presence in diverse global markets is a true strategic advantage.

We have an established global presence serving customers in more than 80 countries worldwide. When one market experiences turbulence, our presence in other markets helps balance us. We have seen relative stability in Asia as we encounter challenges in the North American market and in Europe.

In order to thrive in an increasingly global marketplace, our customers must extend their global reach. In order to maintain their competitive advantage in a turbulent economic environment, they seek to create efficiencies by turning to a single, proven partner with a substantial global presence and broad product and service offerings. Many of our customers are among the world's top 50 communications services providers and equipment manufacturers, including AT&T, SBC, Verizon, Sprint, Deutsche Telekom, China Telecom, Cisco and Siemens. With extensive global operations and a range of services from local and long-distance to wireless and cable, these customers need a partner that can provide a full range of complementary test and management products and services around the world. With global customer support, development, manufacturing and distribution locations, as well as a diversified product and services set, we believe we are positioned to provide customized support and solutions to our customers wherever they are.

Fact: Acterna reduced its infrastructure costs by $180 million last year on an annualized basis and has announced initiatives to further lower costs by $100 million annually.

ANT-10G Advanced Network Tester
The ANT-10G, an all-in-one SONET / SDH analyzer, is considered best in class for lab test, commissioning and advanced field applications.

DA-3200 Data Network Analyzer
The Acterna DA-3200 Data Network Analyzer enables carriers to better manage existing networks while offering new services such as VoIP, Web hosting, e-mail and IP VPNs.

5.

Anheuser-Busch Employees' Credit Union and its Divisions
Annual Report 2001

Our Members, Our Family, Our Future

creative firm
KIKU OBATA + COMPANY
St. Louis, Missouri
creative people
AMY KNOPF,
CAROLE JEROME
client
ANHEUSER BUSCH EMPLOYEES'
CREDIT UNION

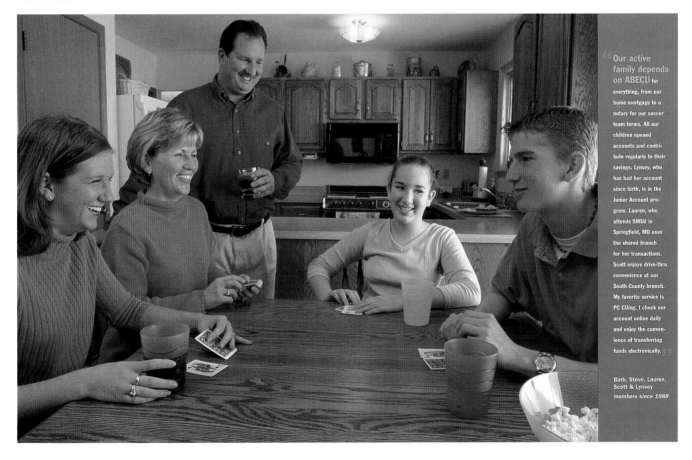

"Our active family depends on ABECU for everything, from our home mortgage to a notary for our soccer team forms. All our children opened accounts and contribute regularly to their savings. Lynsey, who has had her account since birth, is in the Junior Account program. Lauren, who attends SMSU in Springfield, MO uses the shared branch for her transactions. Scott enjoys drive-thru convenience at our South County branch. My favorite service is PC CUing. I check our account online daily and enjoy the convenience of transferring funds electronically."

Barb, Steve, Lauren, Scott & Lynsey
members since 1988

2001 Annual Report and Accou...

creative firm
GRAPHICAT LIMITED
Hong Kong, China
creative people
COLIN TILLYER
client
*ASIA SATELLITE
TELECOMMUNICATIONS HOLDINGS LIMITED*

亞洲衛星控股有限公司

Vantage Point

HO BEE INVESTMENT LTD
Annual Report 2001

Creating Forms
of
Excellence

creative firm
**UKULELE DESIGN
CONSULTANTS PTE LTD**
Singapore
creative people
DAPHNE CHAN
client
HO BEE INVESTMENTS LIMITED

Like the intricate structure of a leaf, Ho Bee's properties are of lasting beauty and value. Through these assets, Ho Bee creates value for her stakeholders, shareholders and investors.

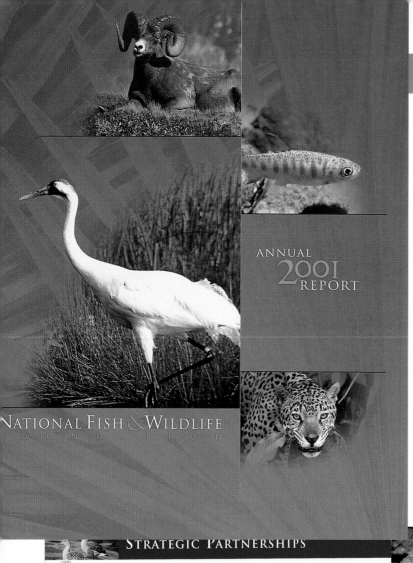

ANNUAL
2001
REPORT

NATIONAL FISH & WILDLIFE
FOUNDATION

creative firm
DEVER DESIGNS
Laurel, Maryland
creative people
BYRON HOLLY,
JEFFREY L. DEVER
client
NATIONAL FISH AND
WILDLIFE FOUNDATION

STRATEGIC PARTNERSHIPS

Budweiser

ANHEUSER-BUSCH

As a longtime partner of the National Fish and Wildlife Foundation, Anheuser-Busch has upheld a tradition of high standards in protecting the environment. The company's leadership in conserving and enhancing natural resources for future generations energizes the many programs that comprise our partnership. Anheuser-Busch has delivered more than $3.7 million to more than 50 outdoor enhancement projects in 41 states.

"Anheuser-Busch's commitment to conserving natural resources has been a priority for the Busch family for generations," said Dan Hoffmann, director of Budweiser marketing, Anheuser-Busch, Inc. "We're proud to be associated with our 'Budweiser Outdoors' partner organizations like the National Fish and Wildlife Foundation, and together, we are ensuring people will be able to enjoy the great outdoors in the future."

One highlight from 2001 was the establishment of the Budweiser Conservation Scholarship Program. Scholarship awards support innovative studies that respond to significant challenges in fish, wildlife, and plant conservation in the United States. Through the program, which drew over 200 applications from more than 90 institutions of higher education in 41 states last year, Anheuser-Busch fosters a new generation of leaders in fish and wildlife conservation.

In 2001, scholarships of $10,000 each were awarded to: Todd Aschenbach, University of Kansas; Patricia Bright, VA-MD Regional College of Veterinary Medicine; Erin Casey, Eastern Illinois University; Tessa Francis, University of Washington; Eric Hecox, Indiana University; Rebecca Jacobs, University of California at Santa Cruz; Susan Nyoka, Humboldt

State University; Susan Parks, Massachusetts Institute of Technology; Jennifer Sevin, North Carolina State University; and Richard Shefferson, University of California at Berkeley.

Additional programs in Anheuser-Busch's conservation portfolio include the "Help Budweiser Help the Outdoors" sales promotion and the "Budweiser Outdoorsman of the Year" Award.

Over the past three years, the Budweiser Outdoors fall promotion has raised more than $1 million for conservation. In the fall, more than 300 participating Anheuser-Busch wholesalers donate a percentage of proceeds from all bottles and cans of Budweiser sold during a select period. The money is divided among several conservation organizations and goes directly to the organizations' on-the-ground conservation projects.

Bruce Lewis, of Natchez, MS, was honored on January 13, 2001, as the sixth annual "Budweiser Outdoorsman of the Year" Award recipient. One of Mr. Lewis' opportunities is to distribute a $50,000 grant from Budweiser and the National Fish and Wildlife Foundation to the wildlife and natural resource conservation groups of his choice.

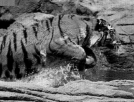

ExxonMobil

FISH AND WILDLIFE
FOUNDATION
THE NATIONAL
SAVE THE TIGER FUND

From "the tiger in your tank" to the tiger in its wild Asian habitat, ExxonMobil and the tiger's future come together with the Foundation in the Save The Tiger Fund (STF). Ed Ahnert, president of the Exxon-Mobil Foundation, reflects on his experience with the partnership: "NFWF offers a forum where business, government, and nonprofits work harmoniously on conservation. By acknowledging that human activity and environmental preservation must coexist, we can operate with shared values on a strong middle ground."

In 1995, when STF began, Asia's wild tigers were in severe decline throughout their range. Human population growth and loss of habitat drove tigers from their homes, while overharvesting of prey species starved the cat, and poaching took its toll. A century before, an estimated 100,000 tigers roamed the continent; by 1995, only five to seven thousand remained.

Responding to the crisis, ExxonMobil and the Foundation resolved to save wild tigers. STF forged partnerships, put conservation dollars on the ground in tiger range, and encouraged collaboration among conservationists and communities around the world. Positioning itself to be an intelligent investor, STF recognized the need to support local people who share their "home range" with wild tigers.

In 2001, the Foundation evaluated the accomplishments of STF's first six years. STF's multi-layered investment strategy, the report concluded, has helped stabilize key tiger populations. "The Fund, through its Council of tiger experts—guided by chairman John Seidensticker—has built leadership, and near unity, in the world of tiger conservation," notes John Robinson, vice president for international conservation at the Wildlife Conservation Society.

STF has invested more than $9.2 million in 158 projects in 12 of the 14 tiger-range countries since 1995. It has drawn unprecedented public participation of more than 19,000 individual donations totaling more than

Tracy Wahner

Michael Cottet/Blackstar

$1.4 million to date. STF's impact has been significant, awarding more than 28 percent of total tiger conservation funds from 1998 to 2001.

The key to STF's success is its willingness to focus on the human side of tiger conservation. Early tiger conservation measures tried to keep people and tigers apart. In today's crowded world, efforts to save tigers must help people if they are to succeed. STF has grasped and acted on this simple truth: saving wild tigers requires engaging the millions of people who live near them. Kathryn Fuller, President of the World Wildlife Fund, notes that, because STF focuses on locally driven conservation, "An Asia-based leadership has emerged—speaking the languages, knowing the customs of stakeholders, in a position to mobilize political will."

In 1995, extinction was predicted for wild tigers. Today, against the odds, tigers still prowl the terai grasslands that edge India and Nepal, the wild borderlands of Cambodia and Vietnam, and the vast boreal forests of the Russian Far East. The Save The Tiger Fund has played a critical role in helping conservationists and local communities achieve this success. STF has created a model for conservation to benefit tigers and people for generations to come.

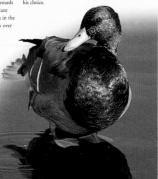

12

NATIONAL FISH & WILDLIFE FOUNDATION 13

creative firm
DAVIDOFF ASSOCIATES
New York, New York
creative people
PATRINA MARINO,
ROGER DAVIDOFF
client
THE PEPSI BOTTLING GROUP INC.

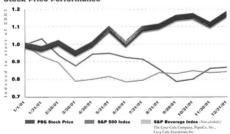

OTTLING GROUP
EPORT 2001

WE SELL SODA

Financial Highlights

$ in millions, except per share data	2001[1]	2000[1]	1999[1]
Net Revenues	$ 8,443	$ 7,982	$ 7,505
Operating Income[2]	$ 676	$ 590	$ 396
EBITDA[3]	$ 1,190	$ 1,061	$ 901
EPS[2][3][4][5][6]	$ 1.03	$ 0.77	$ 0.35
Operating Free Cash Flow[5]	$ 295	$ 273	$ 161

(1) Fiscal years 2001 and 1999 consisted of 52 weeks while fiscal year 2000 consisted of 53 weeks.
(2) Excludes the impact of unusual impairment and other charges and credits.
(3) Fiscal year 1999 reflects the impact of our initial public offering of 100 million shares of common stock on March 31, 1999 as if the shares were outstanding during the entire period presented.
(4) Fiscal year 2000 and 1999 EPS have been restated to reflect our 2001 two-for-one stock split.
(5) Operating Free Cash Flow is defined as net cash provided by operations less net cash used for investments, excluding cash used for acquisitions.
(6) Fiscal year 2001 includes Canada tax law change benefits of $0.08 per share.

Stock Price Performance

PBG Stock Price **S&P 500 Index** **S&P Beverage Index** *(Non-alcoholic)*
The Coca-Cola Company, PepsiCo, Inc.,
Coca-Cola Enterprises Inc.

Return on Invested Capital
Diluted Earnings Per Share

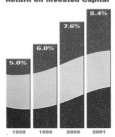
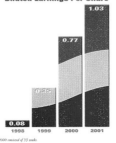

5.0%	6.0%	7.6%	8.4%
1998	1999	2000	2001

0.08	0.35	0.77	1.03
1998	1999	2000	2001

(1) Fiscal years 2001, 1999 and 1998 consisted of 52 weeks while fiscal year 2000 consisted of 53 weeks.
(2) Excludes the impact of unusual impairment and other charges and credits.
(3) Fiscal years 1999 and 1998 reflect our initial public offering of 100 million shares of common stock on March 31, 1999 as if the shares were outstanding during the entire period presented.
(4) Fiscal year 2000, 1999 and 1998 have been adjusted to reflect our 2001 two-for-one stock split.
(5) Fiscal year 2001 includes Canada tax law change benefits of $0.08 per share.

1

américa móvil

ANNUAL REPORT 2001

MAKING THE
WORLD SMALLER...

creative firm
SIGNI DESIGN
Mexico City, Mexico
creative people
DANIEL CASTELAO,
FELIPE SALAS
client
AMERICA MOVIL

RELEVANT FINANCIAL DATA

(millions of Mexican pesos)	2001	2000(2)	Chg%
Total Revenues	41,364	30,095	37%
EBITDA(1)	12,491	5,995	108%
EBITDA Margin(1)	30.2%	19.9%	N.A.
Operating Profit(1)	8,014	2,906	176%
Net Income(1)	2,281	905	152%
EPS (Mexican pesos)(1)	0.17	0.06	168%
EPADR (US dollars)(1)	0.38	0.14	168%
Total Assets	96,271	92,928	4%
Net Debt	9,263	-16,888	155%
Shareholders' Equity	58,684	69,229	-15%

(1) Before exceptional items
(2) Proforma figures

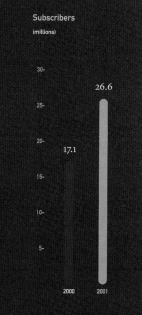

Consolidated Revenues and EBITDA
(millions of Mexican pesos)

- Revenues
- EBITDA

41.4
30.1
12.5
6.0

2000 2001 2000 2001

Subscribers
(millions)

26.6
17.1

2000 2001

EBITDA MARGIN INCREASED FROM **20%** to **30%** IN 2001

4

5

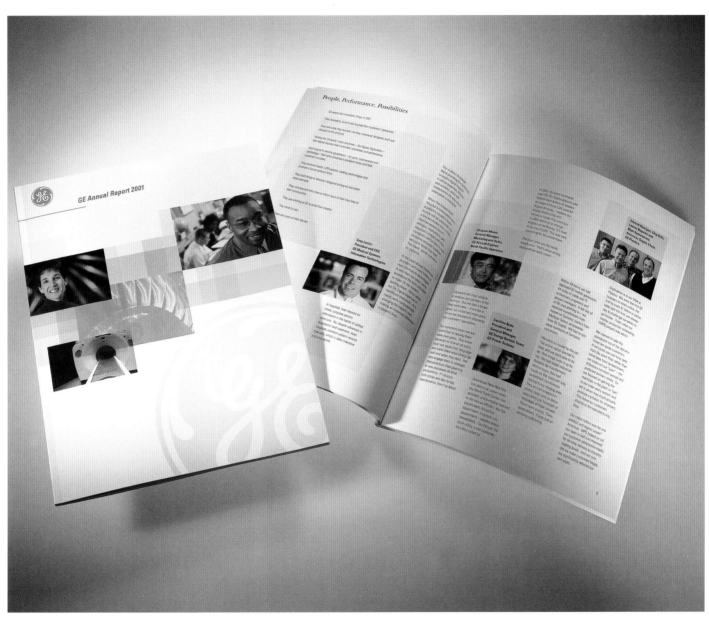

creative firm
FUTUREBRAND
creative people
SVEN SEGER
client
GENERAL ELECTRIC

BOOK JACKETS

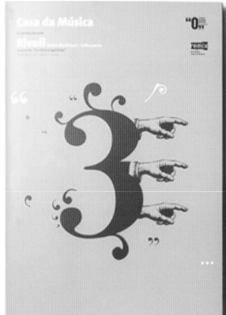

creative firm
LIZÁ RAMALHO
creative people
LIZÁ RAMALHO
client
CASA DA MÚSICA

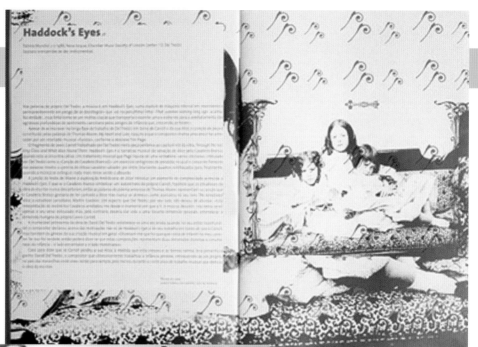

Haddock's Eyes

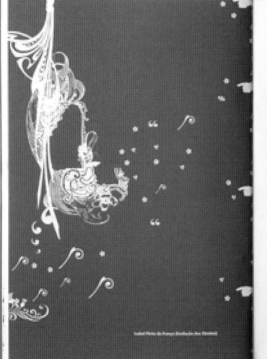

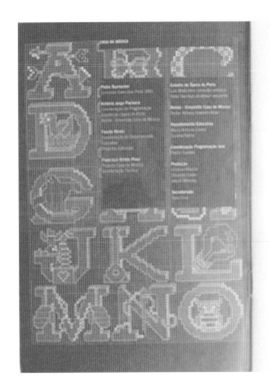

creative firm
LIZÁ RAMALHO
creative people
LIZÁ RAMALHO,
PEDRO MAGALHAES
client
CASA DA MÚSICA/PORTO 2001

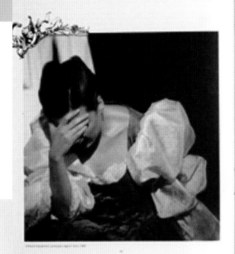

IN BOCCA AL LUPO

REMIX · ENSEMBLE CASA DA MÚSICA

"O rotundo sucesso do Remix-Ensemble"; "O que ouvimos foi música viva, com capacidade para dizer algo a qualquer público.";
"(...) vimos uma sala cheia aplaudir entusiasticamente um concerto de música contemporânea."

"Vejam como soa bem esta música."; "Inúmeras intervenções solísticas de primeiro plano, aliadas a um sólido entrosamento do conjunto, impõem o Remix como um agrupamento com grande futuro na interpretação destes exigentes programas."

"O Remix tem mostrado as suas qualidades desde o final do ano passado; (...) o ensemble acabou por aparecer (esta será uma entre muitas outras coisas boas que o Porto 2001 deixa para o futuro)."

"O Remix-Ensemble demonstrou contar com solistas consumados, capazes de construir em conjunto uma sonoridade caleidoscópica mas coesa."

"A realização musical pelo Remix-Ensemble Casa da Música foi superlativa."

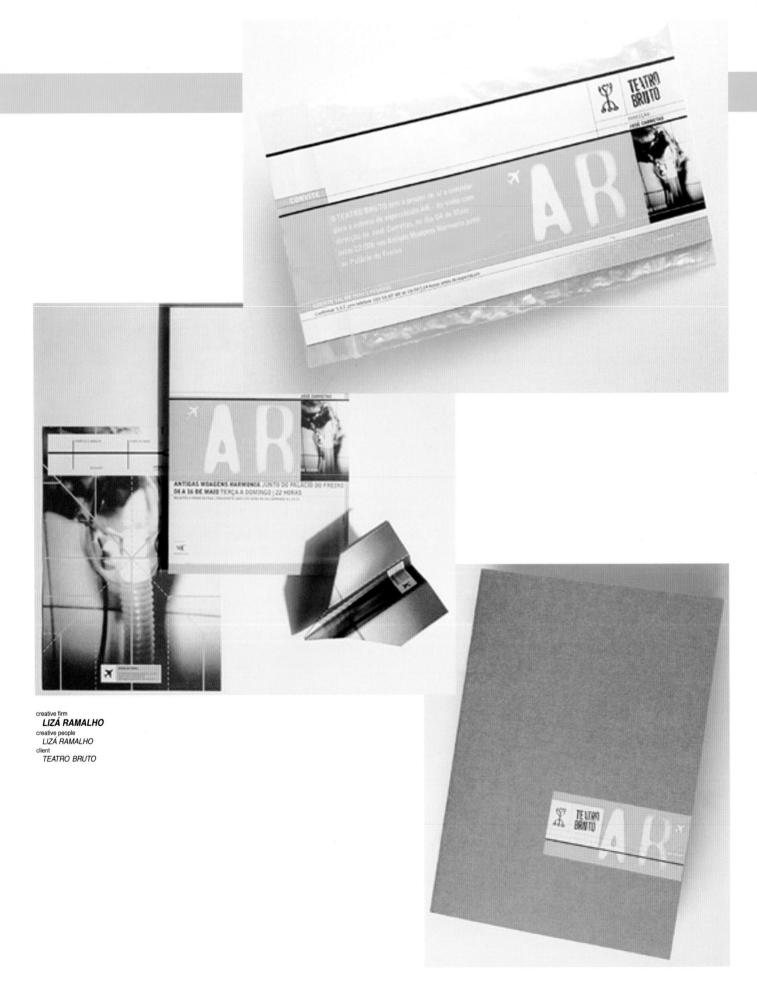

creative firm
LIZÁ RAMALHO
creative people
LIZÁ RAMALHO
client
TEATRO BRUTO

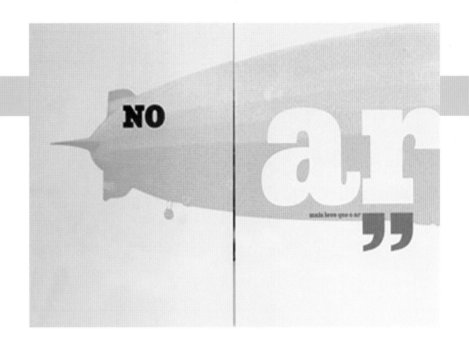

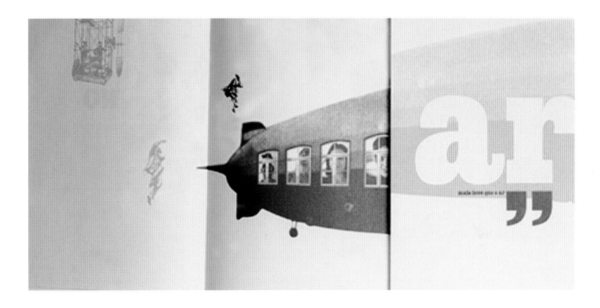

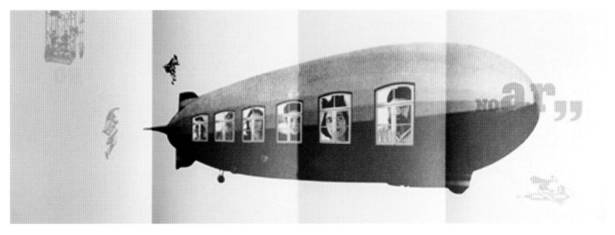

creative firm
LIZÁ RAMALHO
creative people
LIZÁ RAMALHO
client
*CLUBE PORTUGUES
DE ARTES E IDEIAS*

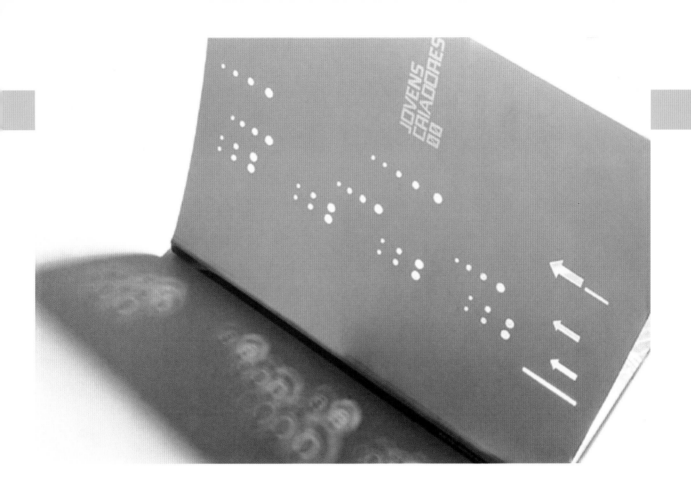

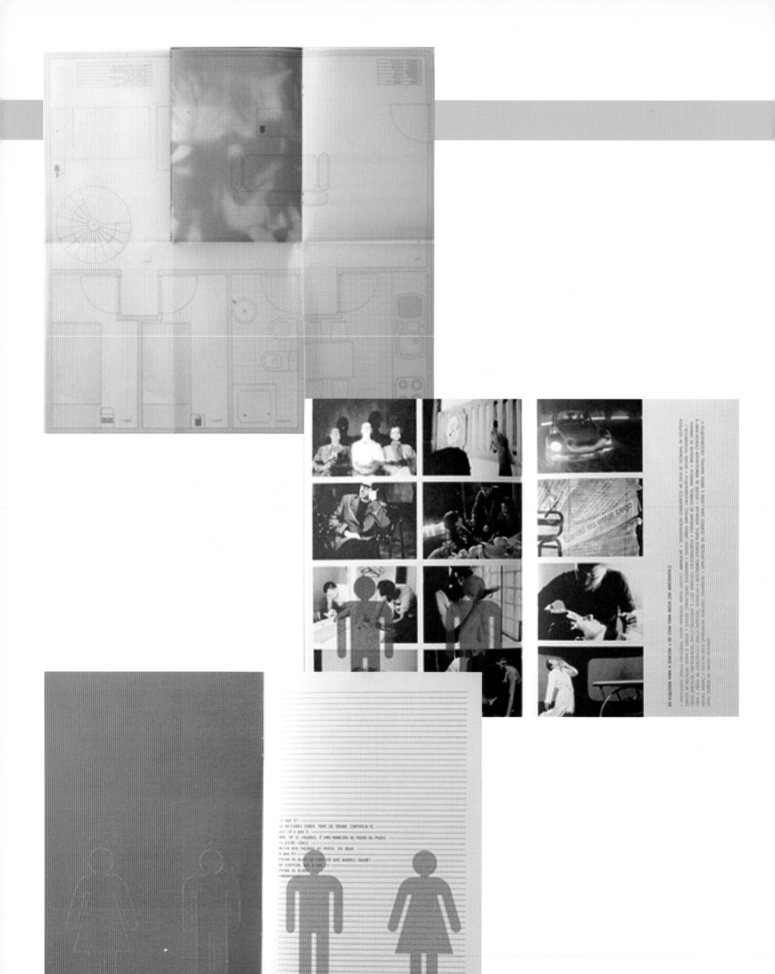

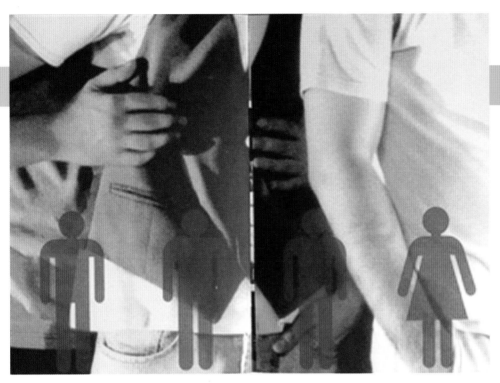

creative firm
LIZÁ RAMALHO
creative people
LIZÁ RAMALHO
client
TEATRO BRUTO

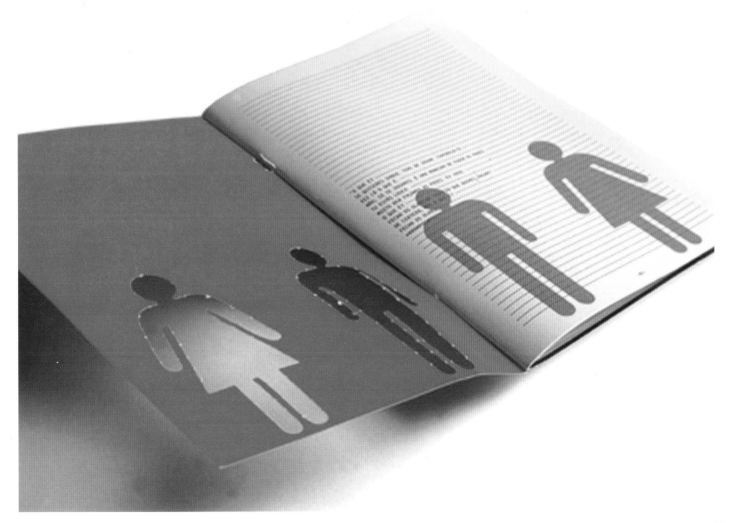

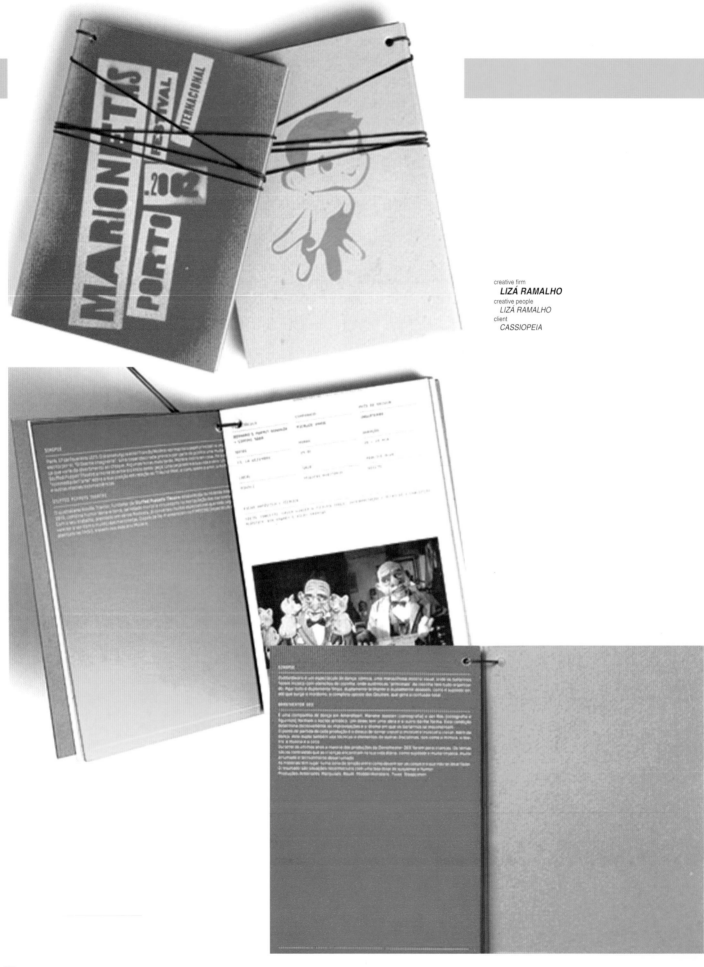

creative firm
LIZÁ RAMALHO
creative people
LIZÁ RAMALHO
client
CASSIOPEIA

QUANDO

1 A 15 DEZEMBRO

CICLOS

MARIONETAS.PORTO.2002
INFÂNCIA E JUVENTUDE / DESCOBERTAS

ONDE

RIVOLI TEATRO MUNICIPAL / TEATRO CAMPO ALEGRE /
TEATRO NACIONAL S.JOÃO / BIBLIOTECA ALMEIDA
GARRETT / MUSEU NACIONAL SOARES DOS REIS

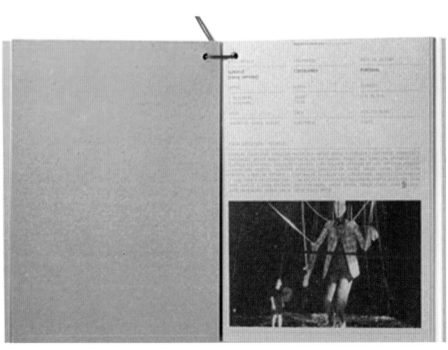

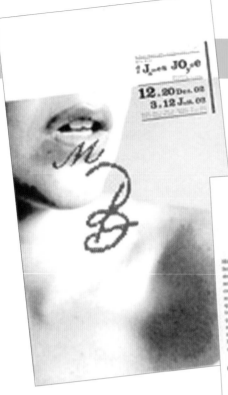

creative firm
LIZÁ RAMALHO
creative people
LIZÁ RAMALHO
client
AS BOAS RAPARIGAS

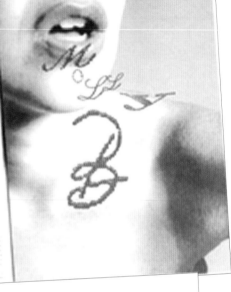

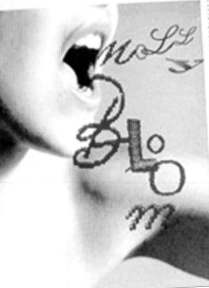

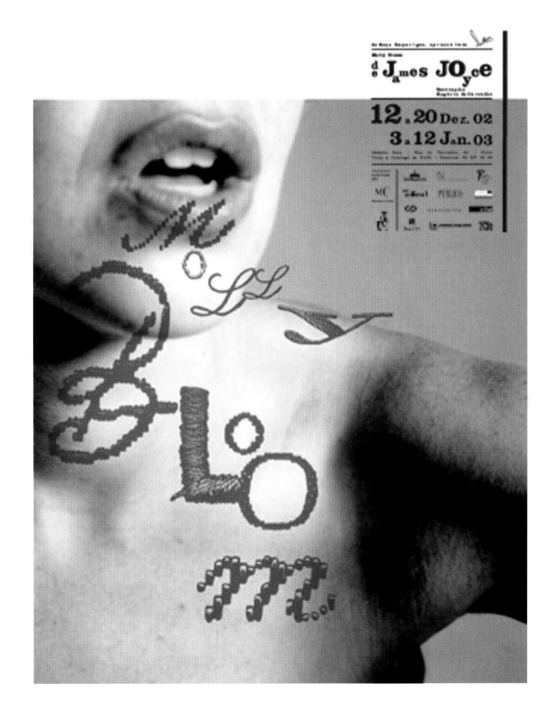

creative firm
LIZÁ RAMALHO
creative people
LIZÁ RAMALHO
client
CASA DA MUSICA/PORTO 2001

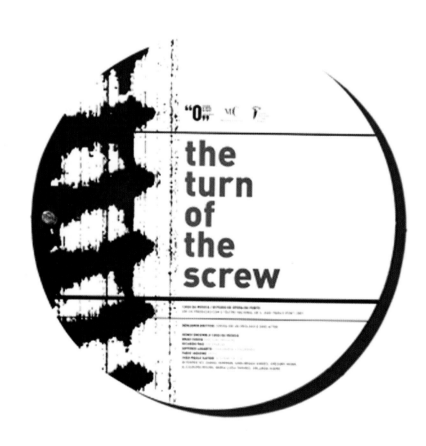

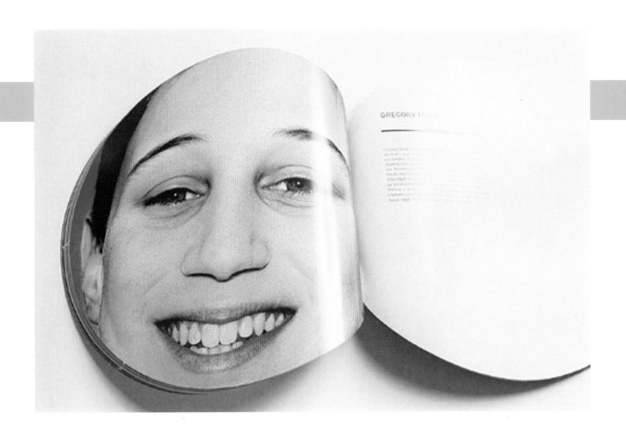

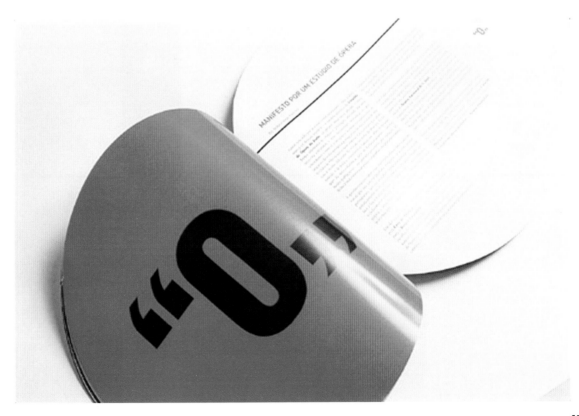

creative firm
VILNIUS ART ACADEMY
creative people
AUSRA LISAUSKIENE
client
KNYGU NAUJIENOS

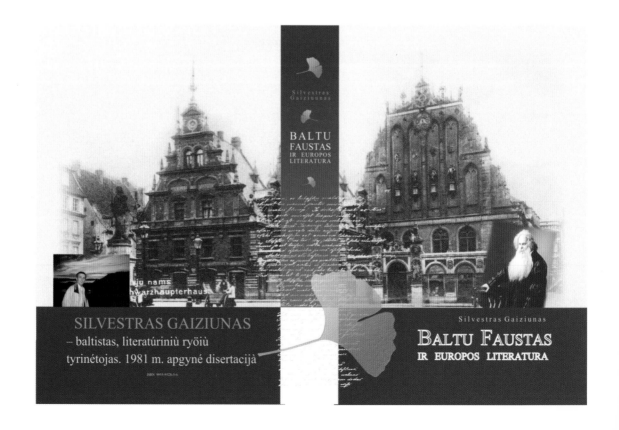

SILVESTRAS GAIZIUNAS
– baltistas, literatūriniù ryöiù
tyrinétojas. 1981 m. apgyné disertacijà

Silvestras Gaiziunas

BALTU FAUSTAS
IR EUROPOS LITERATURA

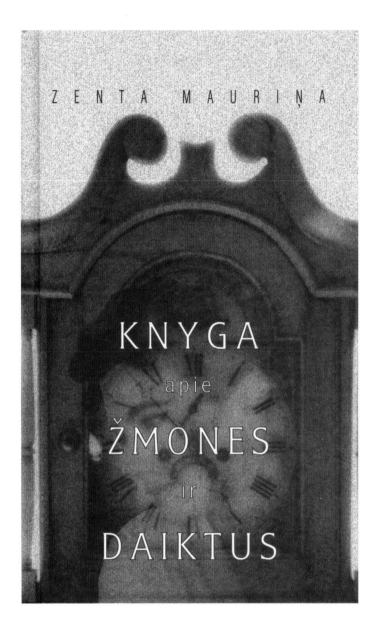

ZENTA MAURIŅA

KNYGA

apie

ŽMONES

ir

DAIKTUS

creative firm
VILNIUS ART ACADEMY
creative people
AUSRA LISAUSKIENE

creative firm
EMERSON, WAJDOWICZ STUDIOS
New York, New York
creative people
JUREK WAJDOWICZ,
LISA LAROCHELLE,
60 MAGNUM PHOTOGRAPHERS
client
DOMTAR

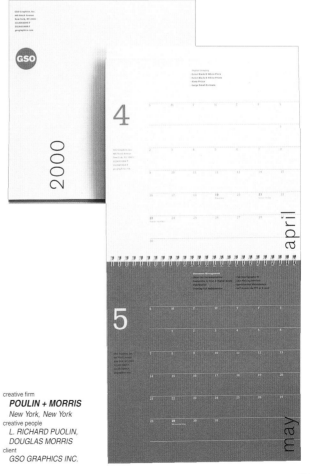

creative firm
POULIN + MORRIS
New York, New York
creative people
L. RICHARD PUOLIN,
DOUGLAS MORRIS
client
GSO GRAPHICS INC.

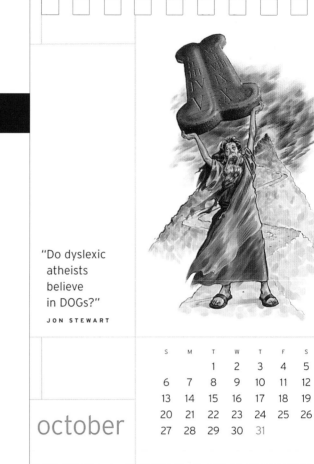

"Do dyslexic
atheists
believe
in DOGs?"
JON STEWART

S	M	T	W	T	F	S
		1	2	3	4	5
6	7	8	9	10	11	12
13	14	15	16	17	18	19
20	21	22	23	24	25	26
27	28	29	30	31		

october

creative firm
BAKER DESIGNED COMMUNICATIONS
Santa Monica, California
creative people
GARY BAKER, MATT COLLINS,
BRIAN KEENAN, BOB BAILEY,
MICHELLE WOLINS, AARON KING
client
BAKER DESIGNED COMMUNICATIONS

july

S	M	T	W	T	F	S
	1	2	3	4	5	6
7	8	9	10	11	12	13
14	15	16	17	18	19	20
21	22	23	24	25	26	27
28	29	30	31			

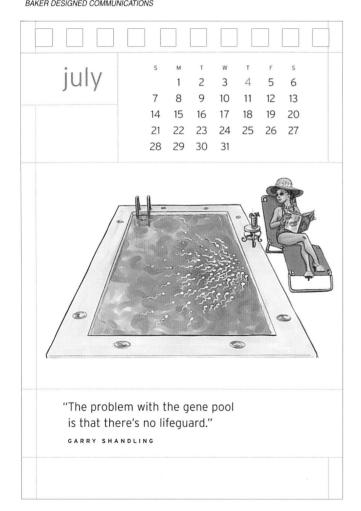

"The problem with the gene pool
is that there's no lifeguard."
GARRY SHANDLING

52

S	M	T	W	T	F	S
					1	2
3	4	5	6	7	8	9
10	11	12	13	14	15	16
17	18	19	20	21	22	23
24	25	26	27	28	29	30

"Karaoke bars combine two of the nation's greatest evils: people who shouldn't drink with people who shouldn't sing."

DENIS LEARY

november

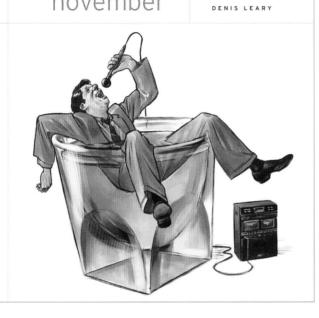

"If life was fair, Elvis would be alive and all the impersonators would be dead."

JOHNNY CARSON

september

S	M	T	W	T	F	S
1	2	3	4	5	6	7
8	9	10	11	12	13	14
15	16	17	18	19	20	21
22	23	24	25	26	27	28
29	30					

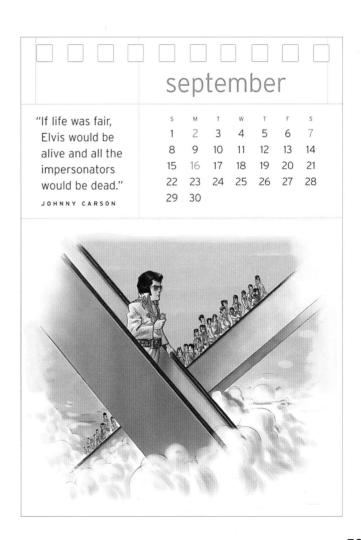

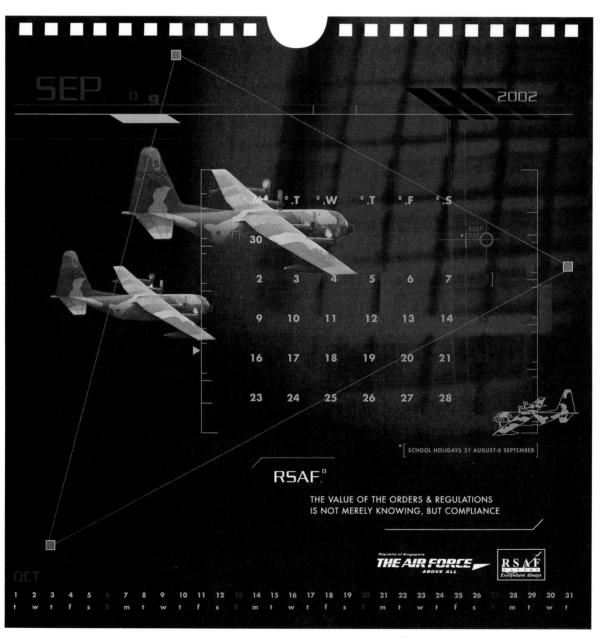

creative firm
UKULELE DESIGN CONSULTANTS PTE LTD
Singapore
creative people
DAPHNE CHAN
client
REPUBLIC OF SINGAPORE AIR FORCE

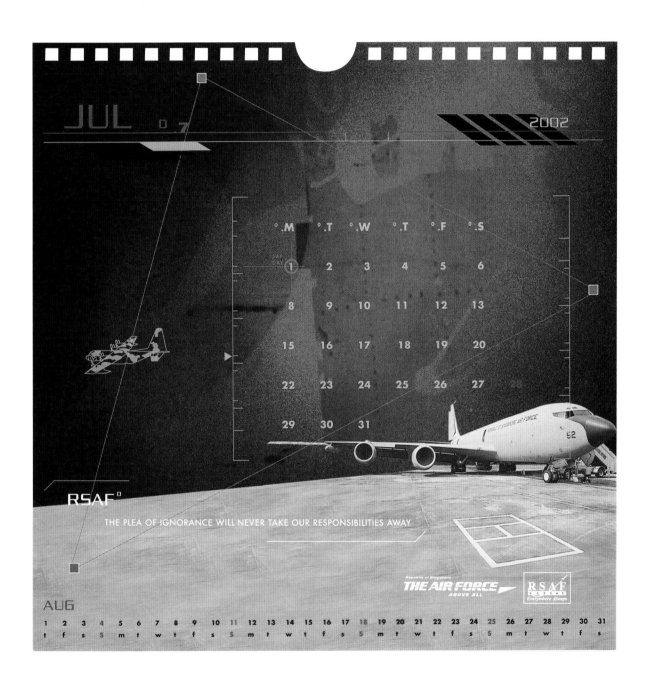

THE PLEA OF IGNORANCE WILL NEVER TAKE OUR RESPONSIBILITIES AWAY

AUGUST 2002

MNdesign Group

Design by: Mitchell Nydish Photography by: Clay Blackmore

MNdesign Group MARCH 2002

creative firm
MN DESIGN GROUP
Rockville, Maryland
creative people
MITCHELL NYDISH
client
MN DESIGN GROUP

56

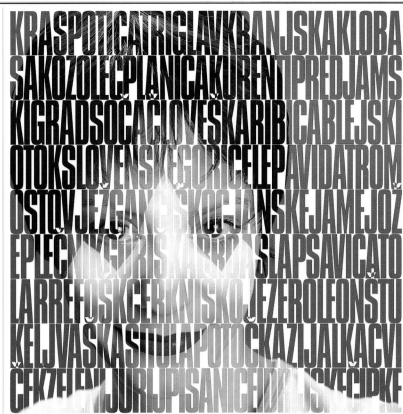

Marec
March

1 Petek *Friday*
2 Sobota *Saturday*
3 Nedelja Sunday
4 Ponedeljek *Monday*
5 Torek *Tuesday*
6 Sreda *Wednesday*
7 Četrtek *Thursday*
8 Petek *Friday*
9 Sobota *Saturday*
10 Nedelja Sunday
11 Ponedeljek *Monday*
12 Torek *Tuesday*
13 Sreda *Wednesday*
14 Četrtek *Thursday*
15 Petek *Friday*
16 Sobota *Saturday*
17 Nedelja Sunday
18 Ponedeljek *Monday*
19 Torek *Tuesday*
20 Sreda *Wednesday*
21 Četrtek *Thursday*
22 Petek *Friday*
23 Sobota *Saturday*
24 Nedelja Sunday
25 Ponedeljek *Monday*
26 Torek *Tuesday*
27 Sreda *Wednesday*
28 Četrtek *Thursday*
29 Petek *Friday*
30 Sobota *Saturday*
31 Nedelja Sunday

April
April

1 Ponedeljek Monday
2 Torek *Tuesday*
3 Sreda *Wednesday*
4 Četrtek *Thursday*
5 Petek *Friday*
6 Sobota *Saturday*
7 Nedelja Sunday
8 Ponedeljek *Monday*
9 Torek *Tuesday*
10 Sreda *Wednesday*
11 Četrtek *Thursday*
12 Petek *Friday*
13 Sobota *Saturday*
14 Nedelja Sunday
15 Ponedeljek *Monday*
16 Torek *Tuesday*
17 Sreda *Wednesday*
18 Četrtek *Thursday*
19 Petek *Friday*
20 Sobota *Saturday*
21 Nedelja Sunday
22 Ponedeljek *Monday*
23 Torek *Tuesday*
24 Sreda *Wednesday*
25 Četrtek *Thursday*
26 Petek *Friday*
27 Sobota Saturday
28 Nedelja Sunday
29 Ponedeljek *Monday*
30 Torek *Tuesday*

creative firm
FUTURA DDB D.O.O.
Ljubljana, Slovenia
creative people
ZARE KERIN
client
DELO DAILY NEWSPAPER

DELO

TorekTuesdaySredaWednesdayČetrtekThursdayPetekFridaySobotaSaturdayNedeljaSundayPonedeljekMondayTorekTuesdaySredaWednesdayČetrtekThursday
PetekFridaySobotaSaturdayNedeljaSundayPonedeljekMondayTorekTuesdaySredaWednesdayČetrtekThursdayPetekFridaySobotaSaturdayNedeljaSunday
PonedeljekMondayTorekTuesdaySredaWednesdayČetrtekThursdayPetekFridaySobotaSaturdayNedeljaSundayPonedeljekMondayTorekTuesdaySredaWednesday
ČetrtekThursdayPetekFridaySobotaSaturdayNedeljaSundayPonedeljekMondayTorekTuesdaySredaWednesdayČetrtekThursdayPetekFridaySobotaSaturday
NedeljaSundayPonedeljekMondayTorekTuesdaySredaWednesdayČetrtekThursdayPetekFridaySobotaSaturdayNedeljaSundayPonedeljekMondayTorekTuesday
SredaWednesdayČetrtekThursdayPetekFridaySobotaSaturdayNedeljaSundayPonedeljekMondayTorekTuesdaySredaWednesdayČetrtekThursdayPetekFriday
SobotaSaturdayNedeljaSundayPonedeljekMondayTorekTuesdaySredaWednesdayČetrtekThursdayPetekFridaySobotaSaturdayNedeljaSundayPonedelje
kMondayTorekTuesdaySredaWednesdayČetrtekThursdayPetekFridaySobotaSaturdayNedeljaSundayPonedeljekMondayTorekTuesdaySredaWednesday
ČetrtekThursdayPetekFridaySobotaSaturdayNedeljaSundayPonedeljekMondayTorekTuesdaySredaWednesdayČetrtekThursdayPetekFridaySobotaSatur
dayNedeljaSundayPonedeljekMondayTorekTuesdaySredaWednesdayČetrtekThursdayPetekFridaySobotaSaturdayNedeljaSundayPonedeljekMondayTo
rekTuesdaySredaWednesdayČetrtekThursdayPetekFridaySobotaSaturdayNedeljaSundayPonedeljekMondayTorekTuesdaySredaWednesdayČetrtekThurs
dayPetekFridaySobotaSaturdayNedeljaSundayPonedeljekMondayTorekTuesdaySredaWednesdayČetrtekThursdayPetekFridaySobotaSaturdayNedeljaS
undayPonedeljekMondayTorekTuesdaySredaWednesdayČetrtekThursdayPetekFridaySobotaSaturdayNedeljaSundayPonedeljekMondayTorekTuesdaySr
edaWednesdayČetrtekThursdayPetekFridaySobotaSaturdayNedeljaSundayPonedeljekMondayTorekTuesdaySredaWednesdayČetrtekThursdayPetekFrid
aySobotaSaturdayNedeljaSundayPonedeljekMondayTorekTuesdaySredaWednesdayČetrtekThursdayPetekFridaySobotaSaturdayNedeljaSundayPonedel
jekMondayTorekTuesdaySredaWednesdayČetrtekThursdayPetekFridaySobotaSaturdayNedeljaSundayPonedeljekMondayTorekTuesdaySredaWednesda
yČetrtekThursdayPetekFridaySobotaSaturdayNedeljaSundayPonedeljekMondayTorekTuesdaySredaWednesdayČetrtekThursdayPetekFridaySobotaSatu
rdayNedeljaSundayPonedeljekMondayTorekTuesdaySredaWednesdayČetrtekThursdayPetekFridaySobotaSaturdayNedeljaSundayPonedeljekMondayT
orekTuesdaySredaWednesdayČetrtekThursdayPetekFridaySobotaSaturdayNedeljaSundayPonedeljekMondayTorekTuesdaySredaWednesdayČetrtekThur
sdayPetekFridaySobotaSaturdayNedeljaSundayPonedeljekMondayTorekTuesdaySredaWednesdayČetrtekThursdayPetekFridaySobotaSaturdayNedelja
SundayPonedeljekMondayTorekTuesdaySredaWednesdayČetrtekThursdayPetekFridaySobotaSaturdayNedeljaSundayPonedeljekMondayTorekTuesday
SredaWednesdayČetrtekThursdayPetekFridaySobotaSaturdayNedeljaSundayPonedeljekMondayTorekTuesdaySredaWednesdayČetrtekThursdayPetekFr
idaySobotaSaturdayNedeljaSundayPonedeljekMondayTorekTuesdaySredaWednesdayČetrtekThursdayPetekFridaySobotaSaturdayNedeljaSundayPone
deljekMondayTorekTuesdaySredaWednesdayČetrtekThursdayPetekFridaySobotaSaturdayNedeljaSundayPonedeljekMondayTorekTuesdaySredaWednes
dayČetrtekThursdayPetekFridaySobotaSaturdayNedeljaSundayPonedeljekMondayTorekTuesdaySredaWednesdayČetrtekThursdayPetekFridaySobotaSa
turdayNedeljaSundayPonedeljekMondayTorekTuesdaySredaWednesdayČetrtekThursdayPetekFridaySobotaSaturdayNedeljaSundayPonedeljekMonday
TorekTuesdaySredaWednesdayČetrtekThursdayPetekFridaySobotaSaturdayNedeljaSundayPonedeljekMondayTorekTuesdaySredaWednesdayČetrtekTh
ursdayPetekFridaySobotaSaturdayNedeljaSundayPonedeljekMondayTorekTuesdaySredaWednesdayČetrtekThursdayPetekFridaySobotaSaturdayNedelj
aSundayPonedeljekMondayTorekTuesdaySredaWednesdayČetrtekThursdayPetekFridaySobotaSaturdayNedeljaSundayPonedeljekMondayTorekTuesda
ySredaWednesdayČetrtekThursdayPetekFridaySobotaSaturdayNedeljaSundayPonedeljekMondayTorekTuesdaySredaWednesdayČetrtekThursdayPetekF
ridaySobotaSaturdayNedeljaSundayPonedeljekMondayTorekTuesdaySredaWednesdayČetrtekThursdayPetekFridaySobotaSaturdayNedeljaSunday
PonedeljekMondayTorekTuesdaySredaWednesdayČetrtekThursdayPetekFridaySobotaSaturdayNedeljaSundayPonedeljekMondayTorekTuesdaySredaW
ednesdayČetrtekThursdayPetekFridaySobotaSaturdayNedeljaSundayPonedeljekMondayTorekTuesdaySredaWednesdayČetrtekThursdayPetekFridaySo
botaSaturdayNedeljaSundayPonedeljekMondayTorekTuesdaySredaWednesdayČetrtekThursdayPetekFridaySobotaSaturdayNedeljaSundayPonedeljek
MondayTorekTuesdaySredaWednesdayČetrtekThursdayPetekFridaySobotaSaturdayNedeljaSundayPonedeljekMondayTorekTuesdaySredaWednesdayČe
trtekThursdayPetekFridaySobotaSaturdayNedeljaSundayPonedeljekMondayTorekTuesdaySredaWednesdayČetrtekThursdayPetekFridaySobotaSaturda
yNedeljaSundayPonedeljekMondayTorekTuesdaySredaWednesdayČetrtekThursdayPetekFridaySobotaSaturdayNedeljaSundayPonedeljekMondayTorek
TuesdaySredaWednesdayČetrtekThursdayPetekFridaySobotaSaturdayNedeljaSundayPonedeljekMondayTorekTuesdaySredaWednesdayČetrtekThursday
PetekFridaySobotaSaturdayNedeljaSundayPonedeljekMondayTorekTuesdaySredaWednesdayČetrtekThursdayPetekFridaySobotaSaturdayNedeljaSunday

dig
it.2002

d

i

g

i

t

2002 calendar

creative firm
AMASINO DESIGN
Boston, Massachusettes
creative people
*CHRISTINE AMISANO,
KAREN LAWSON-CHIPMAN,
MARNE RIZIKA*
client
JOURNEYMAN PRESS

m a r c h

panoramic view, zakim bridge duotone using fluorescent inks

sunday	monday	tuesday	wednesday	thursday	friday	saturday
					1	2
3	4	5	6	7	8	9
10	11	12	13	14	15	16
17	18	19	20	21	22	23
24 Saint Patrick's Day	25	26	27	28 Passover Holy Thursday	29 Good Friday	30
31 Easter Sunday						

Maine Books • Journeyman Press • Amidano Design • Finch Fine

february 2002
S M T W TH F S
1 2
3 4 5 6 7 8 9
10 11 12 13 14 15 16
17 18 19 20 21 22 23
24 25 26 27 28

april 2002
S M T W TH F S
1 2 3 4 5 6
7 8 9 10 11 12 13
14 15 16 17 18 19 20
21 22 23 24 25 26 27
28 29 30

d i g i t

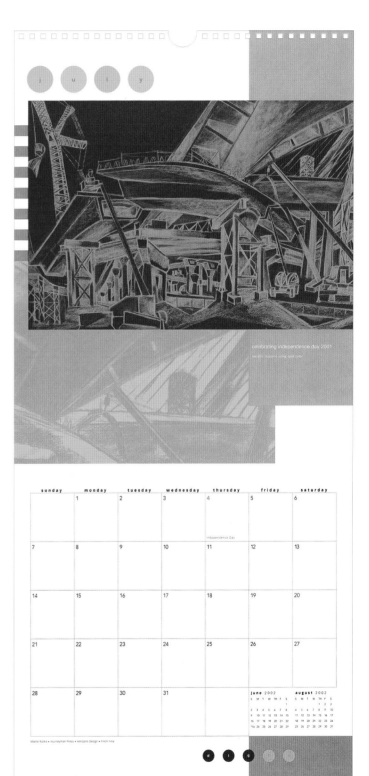

j u l y

celebrating independence day 2001
metallic duotone using spot color

sunday	monday	tuesday	wednesday	thursday	friday	saturday
	1	2	3	4 Independence Day	5	6
7	8	9	10	11	12	13
14	15	16	17	18	19	20
21	22	23	24	25	26	27
28	29	30	31			

Maine Books • Journeyman Press • Amidano Design • Finch Fine

june 2002
S M T W TH F S
1
2 3 4 5 6 7 8
9 10 11 12 13 14 15
16 17 18 19 20 21 22
23 24 25 26 27 28 29
30

august 2002
S M T W TH F S
1 2 3
4 5 6 7 8 9 10
11 12 13 14 15 16 17
18 19 20 21 22 23 24
25 26 27 28 29 30 31

d i g

CATALOGS & BROCHURES

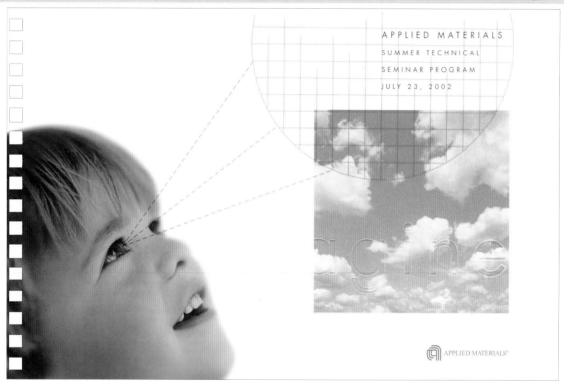

APPLIED MATERIALS

SUMMER TECHNICAL

SEMINAR PROGRAM

JULY 23, 2002

APPLIED MATERIALS®

creative firm
GEE + CHUNG DESIGN
San Francisco, California
creative people
EARL GEE, FANI CHUNG,
KEVIN NG
client
APPLIED MATERIALS

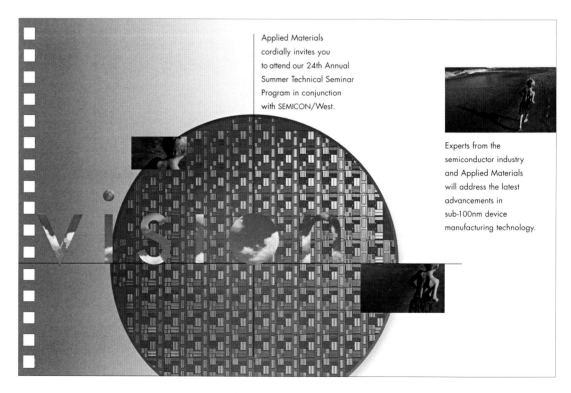

Applied Materials
cordially invites you
to attend our 24th Annual
Summer Technical Seminar
Program in conjunction
with SEMICON/West.

Experts from the
semiconductor industry
and Applied Materials
will address the latest
advancements in
sub-100nm device
manufacturing technology.

creative firm
CHEN DESIGN ASSOCIATES
San Francisco, California
creative people
MAX SPECTOR
client
WESTED

creative firm
DESIGN RESOURCE CENTER
Naperville, Illinois
creative people
JOHN NORMAN, DANA CALLAWAY
client
CP2 DISTRIBUTION, LLC

XYLIFLOSS®
Pocket Dental Flosser

The Xylifloss Pocket Dental Flosser will change the way you floss – forever.

XYLIFLOSS®

FLOSSER
- Over 250 uses – economical and portable
- Mint flavored, shred-resistant, waxed floss
- The only flosser featuring Xylitol-coated floss.

DESIGN
- Developed with oral care specialists
- Unique design allows easy accessibility to hard-to-reach back teeth
- Superior flossing coverage

MECHANISM
- Floss tension is automatically adjusted
- Locking mechanism retains proper tension during use
- Built-in cutter trims off used floss in a snap

FLOSS STORAGE
- When pulling out new floss there are no impurities – therefore, it's extremely hygienic
- Handle with floss storage keeps minty fresh taste on floss
- Features travel cap for portable use.

61

ALGERIA
KYRGYZ REPUBLIC
NIGERIA
BOTSWANA
PANAMA
BURKINA FASO
CHINA
DOMINICA
KAZAKHSTAN
CAMEROON
NICARAGUA
ZIMBABWE
CAMBODIA
BELIZE
HAITI
THAILAND
PAPUA NEW GUINEA
ETHIOPIA

APPROACH

The information technology revolution now sweeping the world has the potential to transform the traditional development paths of countries. In just the past decade, the information and communications technology industry has grown to be a principal driving force behind the world economy, with benefits that are only now being understood. The rapid growth and accelerating expansion of the industry offers enormous potential benefits to countries. At the same time, there are major challenges to be overcome. As with the Industrial Revolution, the timing, positioning, and responsiveness of nations will determine those who will benefit from this Knowledge Revolution, and those that will be left behind.

TSG has been at the forefront in assisting countries, regions, and companies in developing information technology (IT), e-Commerce, and Internet development strategies. We are able to draw upon an impressive roster of leading new economy specialists, e-Government experts, IT educational specialists, and others, to provide cross-disciplinary approaches and solutions.

SERVICES

TSG offers assistance at both the strategic economy-wide, and enterprise level. Our core services include:

IT services sector development and implementation strategies

E-Commerce and Internet development strategies

E-Government strategies and implementation plans

PROJECT EXAMPLES

Preparation of a comprehensive strategy and action plan for the development of export-oriented IT services in Jordan

Development of an e-Government initiative and implementation plan for Jordan

Assistance in IT and e-Government strategies in Subic Bay, Philippines

Formulation of an IT sector development strategy in Armenia

Strategy development to attract investment in export-oriented informatics and offshore services in Mauritius

Hands-on workshops in key "back office" operation development opportunities for informatics firms in Barbados

creative firm
LEVINE & ASSOCIATES
Washington, D.C.
creative people
MAGGIE SOUOHNO,
JENNIE JARIEL
client
THE SERVICE GROUP

creative firm
FORWARD BRANDING & IDENTITY
Webster, New York
client
FORWARD BRANDING & IDENTITY

Come Again

If there's one rule in retail, it's that you can't stand still. Being category leader has its advantages, but it also has its obligations. To help the Sensitive Eyes franchise stay one step ahead of the competition, Forward has twice helped Bausch & Lomb use graphics, colors and messaging to refresh packaging and restage the brand.

Traditional Equities, Advanced Products

With a mix of colors, graphics, and typography, Forward helped Kodak marry the advanced structural cues of its Picture Maker kiosk to its traditional position of trust, quality, and ease of use. The result? A new product consumers weren't afraid to try, and now a category in its own right.

House-branded, Well-brand...

Retailers are rapidly moving to extend their brand... expand their businesses. Forward developed unique... approaches to help retailing innovator Wegmans... improve the image, and the sales, of its pasta offer... also developed a new name, tag line, and color pa... the right associations for Wegmans' expansion i... category with its Trenditions line of "accessories fo...

Got Fresh Milk?

Helping Upstate Farms see that the only relevant, ownable position was based on their location, Forward crafted a relevant identity to express a "Taste Upstate Freshness" position. The visuals enhanced shelf impact and memorability, and gave what was previously a commodity product new access to vital retail accounts.

Maximum Return on Investment

Forward helps Kodak make the most of ongoing brand investments by consolidating the company's many graphic guidelines into a single coherent volume, along with programs to keep the information up-to-date and easy to use.

forward thinking.
forward solutions.

ROCHESTER, NY: Their volleyball team is nicknamed the Brand Bastards. When probed for meaning, Duke Stofer, Senior Designer at Forward, explains. "We have no brandfathers – we're first generation. We didn't come into clients by joining a successful concern. We didn't inherit a reputation. We create it ourselves, every day."

The volleyball team, which regularly pits some of Forward's "elders" against kids half their age, doesn't win much. But on the branding court it's another story. Win they do, on a regular basis. For the past 12 years, Forward has been winning clients, winning awards and winning competitive contracts with some of the world's greatest brands.

How does this small consultancy keep billion-dollar brands happy and healthy? "Simple. We solve problems," says Carlo Jannotti, VP and often-irreverent Senior Brander at Forward. "Most of our relationships begin with referrals from satisfied clients. Many of these referrals have experienced the ways of the big city branding

firms and are seasoned enough to look past the puffery to find real value. They may have been disappointed in studies missing the mark, in the level of service they receive, or in the fees they're expected to pay. They're looking for something better. For passion without pretense. For discipline and consistency. For them, we're a breath of fresh air."

They are not an ad agency, a promotions firm, or a design studio. They are unlike any marketing communications company you've ever dealt with. They are Forward, and they know how to grow brand equity.

FORWARD
branding and identity

it takes more than a logo

Forward does not have their own "style". They do not create fanciful designs just to please the eye or themselves. In their world, design walks in lock step with strategy. They do this through a proven process that turns brand equity theories into actionable objectives. Those are met through a combination of visual and associative elements.

"Once we know what makes your brand special, we've got to make it tangible to your audiences. It's got to have impact and meaning, people need to remember it, and you've got to be able to protect it. That's asking a lot of a logo," explains Jim Forward, President & Creative Director.

"Instead, you should leverage all the tools at your disposal: colors, typefaces, image styles, graphics, symbols, tag lines, even

packaging structures. Unfortunately, many organization... discipline and mechanisms to take full advantage of their...

Too often, companies manage a stable of logos and call it branding. New problem? New logo! Soon they're holding a handful of pebbles, instead of the boulder they need to smash through the competitive clutter. So they alter designs, introduce new symbols, new names and sub-brands, never focusing on the real source of the problem. Never finding a solution.

implementations. "What you can do is manage all the elements of your identity. Make them work together to more effectively communicate what makes your brand different and why that difference is important. Turn them into a great symphony, with meaning, power and longevity. Don't create a logo. Create a brand identity that's impactful, memorable and relevant."

underlying strength℠

TradeFactory℠

creative firm
CULLINANE
New York, New York
creative people
CARMEN LI
client
GOLDMAN SACHS

TradeFactory's flexibility allows for levels of customization not available in competing systems. Three primary user interfaces are currently in use: PortfolioTrader, IndexTrader, and SpreadTrader. For many clients, these proven platforms address key trading and reporting needs pro forma. Others opt to take advantage of TradeFactory's adaptability, addressing unique challenges such as integrating proprietary trading models or interfacing with existing, in-house systems using our standard API or via FIX CTCI.

Streamlined Order Management
TradeFactory offers complete control over the execution process. It provides user-defined views of all trading activity by position and P&L, sector and industry group, trading list, basket or portfolio, and a variety of other criteria. A real-time view of message flow provides details on open, executed, and cancelled orders including terms, execution price, contra information, market center, status messages, and more.

Capacity

The success of your business depends on the speed and reliability of your trading solution. To ensure the highest level of performance, TradeFactory delivers exceptional throughput and incorporates the most robust order management system available today. On peak days, total executed shares have exceeded 20% of the NYSE volume. Additionally, the core infrastructure of TradeFactory has been in use for over 10 years, far longer than any competing product. In that time, its efficiency and reliability have been proven in all market conditions.

Support

The TradeFactory system and user support group is in a class by itself. This unmatched level of service is the result of teaming experienced trading professionals with expert technologists.

Versatile, Independent Professionals
The TradeFactory support group routinely responds to trading/market center inquiries, index and basket definition changes, user interface questions, and other issues as they arise.

Flexibility

Broker-Neutral Routing
TradeFactory gives you access to the liquidity you need. A completely broker-neutral platform, TradeFactory provides access to every major exchange, ECN, market maker, and broker-dealer. In addition to fast, reliable connections to these market centers, the system provides for flexible routing combinations. TradeFactory also offers fully-integrated brokerage services through an NYSE-member broker-dealer. This essential component of the trading solution is simply not available from competing system providers.

complete control over
the execution process.

The development and support groups operate from their own facilities, independent of Goldman Sachs' IT and trading areas. This affords TradeFactory staff complete control over systems and software, and guarantees the confidentiality and propriety that trading professionals expect.

63

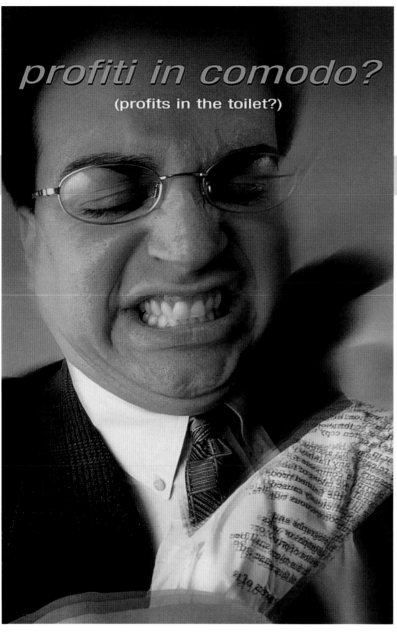

profiti in comodo?
(profits in the toilet?)

creative firm
MUELLER & WISTER, INC.
Plymouth Meeting, Pennsylvania
creative people
*JOE QUINN, ED STEVENS,
BOB EMMOTT*
client
MUELLER & WISTER, INC.

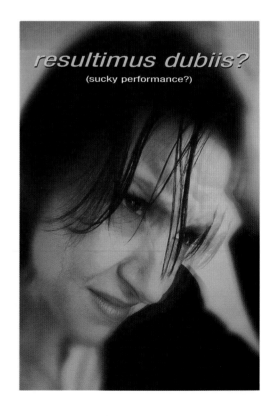

resultimus dubiis?
(sucky performance?)

Choura-Forbes, Incorporated
Architecture and Design
Architecting from the inside out

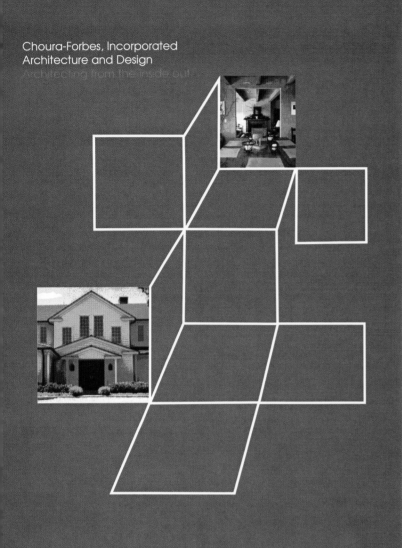

creative firm
DON BLAUWEISS
ADVERTISING & DESIGN
Bronxville, New York
creative people
DON BLAUWEISS
client
CHOURA-FORBES ARCHITECTURE & DESIGN

What is special about Choura-Forbes architecture? A Choura-Forbes house or renovation is an example of an architectural idea that originates with the space within, and flows seamlessly to the outside.

On approach, a Choura-Forbes home is seen sitting comfortably and gracefully among its neighbors and within its surroundings.

The distinctive classically-accented style, with its generosity of space and fluidity of line, imparts a warm and welcoming spirit.

Inside, that look and feel remain constant.

HERE AND ABROAD.

Founder and lead architect, Bana Choura has an international architectural presence. She has accomplished noted work from Monte Carlo to Larchmont, Tunisia to Rhinebeck, the Middle East to Soho.

FEELING AT HOME, AT HOME.

Choura-Forbes homes and renovations are designs for living, achieved through patient and insightful dialogue between Bana Choura and the client family. The result is a warm and welcoming exterior set harmoniously on the site and within its environment.

Inside, each room has its own personality and sense of purpose, yet all are unified in spirit, and in the sense of ease and accommodation one feels moving from room to room.

ARCHITECTING FROM THE INSIDE OUT

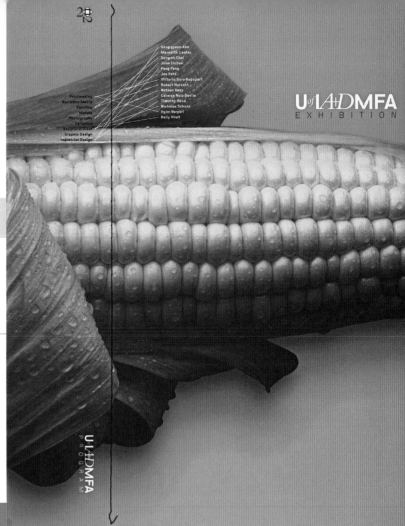

Songgyeun Ahn
Meredith Cantor
Sangoh Choi
John Clohan
Fong Fong
Joe Ford
Victoria Goro-Rapoport
Robert Horvath
Nathan Keay
Carmen Ruiz-Davila
Timothy Read
Nicholas Schonz
Ilgin Veryeri
Holly Wolf

Printmaking
Narrative Media
Painting
Metals
Photography
Ceramics
Sculpture/Glass
Graphic Design
Industrial Design

U of IA+DMFA
EXHIBITION

U IA+DMFA
PROGRAM

Meredith Cantor

BORN December 12, 1975, Oxford, Alabama
DEGREE BFA, Photography/Sculpture, 1999
University of Alaska

GIRL (left) and **LAMP** (right)

oil on panel
4ft × 2ft

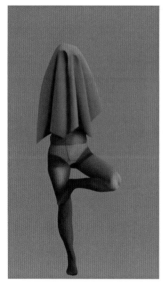

creative firm
FAUST ASSOCIATES, CHICAGO
Chicago, Illinois
creative people
BOB FAUST
client
*UNIVERSITY OF ILLINOIS
AT URBANA/CHAMPAIGN*

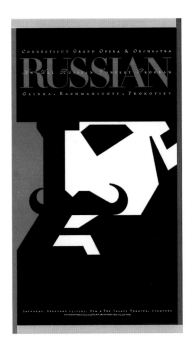

AN ALL RUSSIAN CONCERT
PROGRAM

The Type Director's Club
Certificate of Typographic Excellence (1997)

The Type Director's Club
'Typography 18' (1997)

North Light Books 'The Basics of Visual Communication' (2000)

Connecticut Art Director's 20th Annual Awards Show (1995)
Excellence Award - Public Service
Excellence Award - Posters

Print's 1995 Regional Design Annual

Graphis Poster '96

AIGA/Boston The 1995 BoNE Show (The Best of New England)

Graphic Design: USA's Awards Annual (1995)

creative firm
TOM FOWLER, INC.
Norwalk, Connecticut
creative people
*THOMAS G. FOWLER,
ELIZABETH P. BALL*
client
TOM FOWLER, INC.

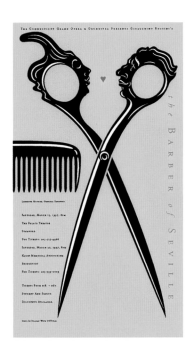

THE BARBER OF SEVILLE

22nd Annual Connecticut Art Director's Club Awards Show (1997)
Gold Award

The Library of Congress
Permanent Design Archives

1999 American Graphic Design Awards - Poster/Pro-Bono

Creativity 27

Print's Sports & Entertainment Show

North Light Books
'The Basics of Visual Communication'

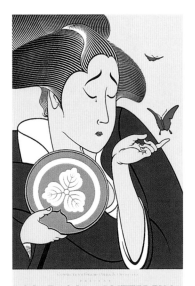

MADAMA BUTTERFLY

Rockport Publishers
'Designer Posters'

Print's 1995 Regional Design Annual

Creativity '95

Connecticut Art Director's 20th Annual Awards Show (1995)
Silver Award - Posters

Graphic Design: USA's Awards Annual (1995)

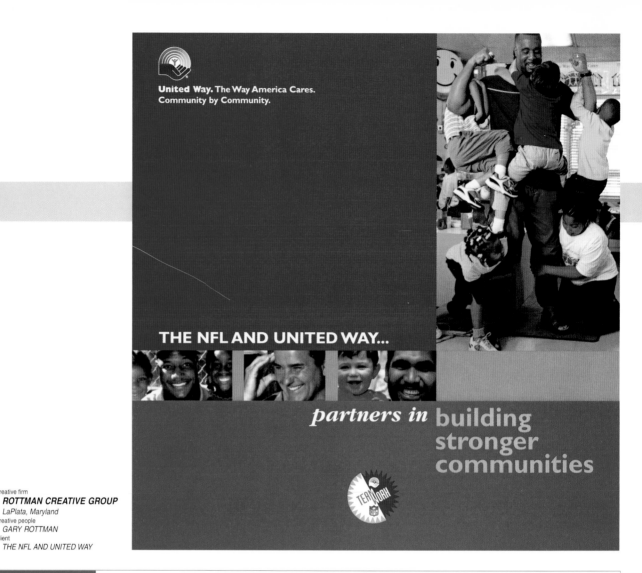

United Way. The Way America Cares.
Community by Community.

THE NFL AND UNITED WAY...

partners in building stronger communities

creative firm
ROTTMAN CREATIVE GROUP
LaPlata, Maryland
creative people
GARY ROTTMAN
client
THE NFL AND UNITED WAY

NEW
TRADITIONS

NFL & UNITED WAY HOMETOWN HUDDLE

On any given Tuesday, NFL players are out in the community—encouraging kids to stay in school, serving meals to the elderly, helping to build homes for low-income families. But once a year, NFL teams join forces with United Way on a single day for the annual Hometown Huddle.

During this national day of community service, NFL heroes from each of the 31 NFL teams put down their shoulder

pads and pick up a paintbrush, box of clothes, or spatula to help lend aide and assistance to members of their communities. Over 300 players, team representatives, and their families interact with an estimated 3,000 United Way agency recipients during the 31 Hometown Huddle events held coast-to-coast.

Hometown Huddle gives the public an opportunity to see how NFL players consistently volunteer their time to improve the communities where they live and play. They are not only impact players on the field, but off the field as well.

THANKSGIVING DAY HALFTIME SHOW

NFL football on Thanksgiving Day is one of the most treasured traditions of the holiday season and United Way's halftime show with the NFL is fast becoming a welcomed addition.

The Thanksgiving Day halftime show celebrates the United Way's longtime partnership with the NFL and serves as a thank you to the millions of

donors and volunteers who help United Way make a visible impact on communities. Graciously hosted by the Detroit Lions, the halftime show is presented to 80,000 football fans in the Pontiac Silverdome and broadcast live to more than 30 million television viewers nationwide.

The past two years have featured live performances by one of the country's hottest bands, Third Eye Blind and the Grammy Award winning group, Boyz II Men. It takes more than 700 people from throughout southeastern Michigan volunteering their time and talents to produce the 9-minute show. In the true spirit of the Thanksgiving season, this joint effort demonstrates the power of working together as a team.

creative firm
ALBERT BOGNER
DESIGN COMMUNICATIONS
Lancaster, Pennsylvania
creative people
KELLY ALBERT,
PATRICK CASEY
client
SAGEWORTH

YOU CAN'T ESCAPE
THE RESPONSIBILITY
OF TOMORROW BY
EVADING IT TODAY.

Abraham Lincoln

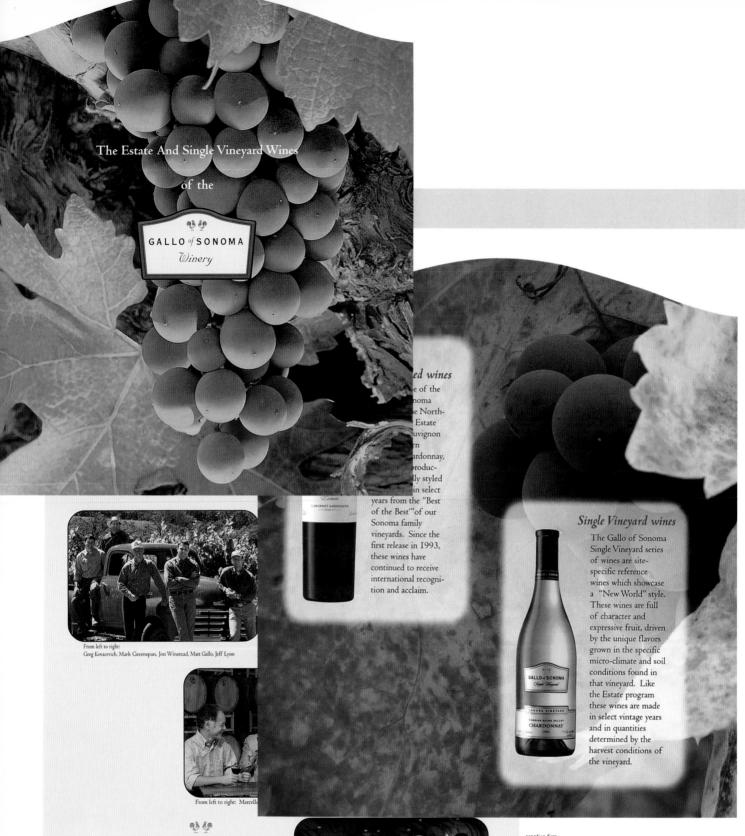

The Estate And Single Vineyard Wines

of the

GALLO *of* **SONOMA**
Winery

...ed wines

...e of the
...onoma
...e North-
...Estate
...uvignon
...rn
...ardonnay,
...produc-
...ly styled
...in select
years from the "Best
of the Best'"of our
Sonoma family
vineyards. Since the
first release in 1993,
these wines have
continued to receive
international recogni-
tion and acclaim.

Single Vineyard wines

The Gallo of Sonoma
Single Vineyard series
of wines are site-
specific reference
wines which showcase
a "New World" style.
These wines are full
of character and
expressive fruit, driven
by the unique flavors
grown in the specific
micro-climate and soil
conditions found in
that vineyard. Like
the Estate program
these wines are made
in select vintage years
and in quantities
determined by the
harvest conditions of
the vineyard.

From left to right:
Greg Kovacevich, Mark Greenspan, Jon Winstead, Matt Gallo, Jeff Lyon

From left to right: Marcello

"*For a winemaker, it doesn't get much better than this. In addition to the best grapes from some of Sonoma's finest vineyards and a state-of-the-art winery, I also get to work with some terrific people.*"

Gina Gallo

From left to right:
Cameron Frey, Scot Covington, Eric Cinnamon, Gina Gallo, Ted
Coleman, Marcello Monticelli, Ralf Holdenried

creative firm
MARCIA HERRMANN DESIGN
Modesto, California
creative people
MARCIA HERRMANN
client
GALLO OF SONOMA

Trefethen Holiday 2002

creative firm
DESIGN SOLUTIONS
Napa, California
creative people
DEBORAH MITCHELL,
RICHARD MITCHELL
client
TREFETHEN VINEYARDS

Our Winter Harvest
Olives harvested from the trees around the winery are used to create this outstanding Trefethen Vineyards Olive Oil. Included are two hand-painted dipping bowls...
(G10) $31. *this gift can be shipped anywhere

The Award Winning Wines of Trefethen Vineyards a la Carte!
(W3) 2001 Estate Dry Riesling...$15.
(W4) 2000 Estate Chardonnay...$22.
(W5) 1997 Library Selection Chardonnay...$30.
(W6) 1995 Library Selection Chardonnay in Magnum...$60.
(W7) 2000 Estate Pinot Noir...$25.
(W8) 1999 Estate Merlot...$26.
(W9) 1999 Estate Cabernet Sauvignon...$40.
(W10) 1998 Estate Cabernet Sauvignon...$35.
(W11) 1996 Estate Cabernet Sauvignon in Magnum...$60.
(W12) 1998 Reserve Cabernet Sauvignon...$70.
(W13) 1996 Reserve Cabernet Sauvignon in Magnum...$120.
*any of the above packed in a wooden box, add ten dollars
*12 bottle case orders will receive a 10% discount

▼ The Vino Hors d'Oeuvre Set
From Napa Valley artist Julia Junkin, this fun set of four occasional plates, 6" square, are perfect for hors d'oeuvres or desserts and packed in a woven box... (G1) $38.50 *this gift can be shipped anywhere

The Vino Linen Collection ➤
Spirited, washable linens designed by Julia Junkin add a bit of whimsy to the table. Placemats, set of 4 (G2)...$36.
Dinner napkins, set of 4 (G3)...$26. Cocktail napkins, set of 4 (G4)...$13. Coasters, set of 4 (G5)...$13.
*this gift can be shipped anywhere

To order call: 1-800-556-4847

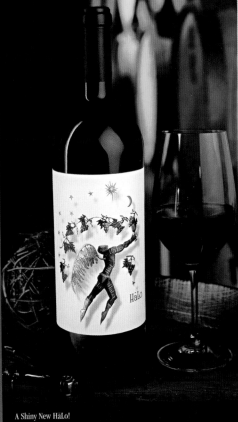

A Shiny New HāLo!
We are proud to release our second vintage of HāLo Cabernet Sauvignon, 1998, named for the future generation of winemakers, Hailey and Loren Trefethen. This limited release 100% Cabernet Sauvignon from our Hillside Vineyard is the best of the best. Aromas of the land; berries, mint and bay are alive in this wine. Elegant, rich, dark cherries and sultry oak on the palate lead to a long, lingering finish...(W1) $125.

creative firm
KROG
Jlubjlana, Slovenia
creative people
EDI BERK, JANEZ PUKSIC,
INES DRAME
client
GIVO, LJUBLJANA

Živimo, kot si želimo – prostore si pr

Vidovo povezujejo s centrom Ljubljane redne avtobusne proge, do vseh ljubljan... je bližja brniškega letališča. Dostop do avtoceste prihrani čas popotnikom h go... kaj dragocenih minut krajša. Izlet na Gorenjsko je lahko lepši, ker je odločite... poldne na Sorškem polju ali ob brzicah Save v Tacnu je le streljaj daleč. Potep na Šmarno goro spremeni trajanje dneva. Na obisk Toškega Cela vabi sonce, ki na Vidovo zaradi usmerjenosti na jugozahod zagotovo posije ... • Življenje v Šentvidu ima mnogo prednosti tako za tistega, ki uživa v zavetju doma, prilago- jenega njegovim željam, kot za tistega, ki prisega na raziskovanje sveta. Življenje v Vidovem je prijazno družinam z otroki, ki potrebujejo dovolj prostora za igro, mladim ljubiteljem družabnosti in popotnikom, ki potrebujejo vsak dan nove izzive, starejšim, ki jih mika posedanje v senci dreves, ljudem s posebnimi potrebami, ki potrebujejo širša vrata v svet. • Vidovo smo zasnovali tako, da je vsakomur prijazno na voljo prav tisto, kar sam razume s kakovostjo življenja.

Oglejmo si Vidovo

S svojo zunanjostjo zbuja zaupanje. Opečna kritina in strešice mansarde mu dajejo vtis domačnosti, terase občutek prostornosti. Približamo se mu mimo Šelanovega trga, z dostopom s Prušnikove ceste. Okoli Vidovega so površine za pešce, pred hišo je otroško igrišče, Celovško cesto zakriva drevored. Kot gostje parkiramo na parkirišču ob dovozni cesti, kot stanovalci se prek pokrite uvozno-izvozne klančine odpravimo do parkirišč v dveh kletnih etažah. Z daljinskim upravljalcem odpremo avtomatska vrata. Prtljago lahko spravimo v kletni shrambi. Po dveh notranjih stopniščih ali z dvigalom se odpravimo do svojega doma v enem od treh nadstropij ali v mansardi.

Če smo prišli peš, lahko vstopimo skozi enega od dveh vhodov, ki ga varujejo dvojna vhodna vrata. Če smo prišli s kolesom, namesto parkirišča uporabimo kolesarnico ob vhodu. Če smo prišli z invalidskim vozičkom, smo avtomobil parkirali na posebnem parkirnem mestu, v hišo pa vstopimo skozi dovolj široka vrata, ne da bi nas pri tem ovirale kakršnekoli stopnice. Skozi dodatna varovalna vrata v hodnik in skozi protivlomna vrata v stanovanje smo prispeli domov – v osončeno bivališče z razgledom na zeleno okolje.

Izberimo svoj prostor in ga prilagodimo svojim željam

Če iščemo dom, lahko izbiramo med stanovanji v velikosti od 30 do 130 m². Večina stanovanj je opremljena z zastekljeno ložo ali balkonom, nekatera imajo tudi razkošno strešno teraso. Vsa stanovanja, tudi mansardna, so dostopna z dvigalom in po enem od dveh notranjih stopnišč.

Če iščemo prostor za mirno poslovno dejavnost, ga najdemo v pritličju Vidovega, z mirno pisarniško dejavnostjo pa se lahko naselimo tudi v prvo nadstropje. Vsi poslovni prostori imajo vse potrebne priključke na napeljave, lasten vhod in možnost dodatnega vhoda za dostavo.

Vidovo je zasnovano tako, da se lahko prilagaja raznovrstnim potrebam. Vsi nepremični in nespremenljivi elementi (konstrukcijske stene in instalacije) so na obodu stanovanj, notranje stene pa so montažne in ponujajo pri notranji razporeditvi domala neomejene možnosti. Prostore v stanovanju lahko prilagodimo vašim željam.

Zasnova Vidovega daje nove razsežnosti tudi poslovnim prostorom. Noben konstrukcijski element ne moti notranje ureditve – vsi so na obodu prostora; tam so tudi instalacijski jaški.

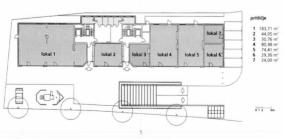

2. nadstropje

1	95,31	m²
2	34,22	m²
3	44,61	m²
4	36,56	m²
5	31,51	m²
6	29,50	m²
7	55,83	m²
8	55,58	m²
9	54,45	m²
10	111,20	m²

pritličje

1	183,71	m²
2	44,05	m²
3	30,76	m²
4	80,98	m²
5	74,41	m²
6	29,30	m²
7	24,00	m²

Poglejmo pod površino

Vidovo je zgrajeno tako, da ustreza vsem zahtevam predpisanih standardov, pravilnikov, predpisov in zakonov glede konstrukcijske trdnosti, požarne varnosti, toplotnih izgub in zvočne zaščite.

Osnovni nosilni konstrukcijski elementi so iz armiranega betona, ločilne stene pa so iz opečnih votlakov. Medetažne plošče so iz masivnega, 24-centimetrskega armiranega betona, kar zagotavlja izjemno zvočno izoliranost. Strešna konstrukcija je lesena, kritina pa je opečna.

Stanovanja in poslovne prostore v objektu Vidovo ogrevajo radiatorji, priključeni na mestno toplovodno omrežje. Vsako stanovanje in vsak poslovni prostor ima lasten števec porabe energije. Tudi ogrevanje sanitarne vode je urejeno s povezavo na toplovod. Vsaka enota ima priključek na vodovodno, električno in telefonsko omrežje ter možnost kabelskega priključka. Objekt ima urejeno meteorno in fekalno kanalizacijo.

Zaupajmo kakovosti

Pri načrtovanju Vidovega smo s posebno pozornostjo izbrali materiale in načine obdelave. Pri zasteklitvah in vratih smo mislili na varnost, pri tlakih na trajnost, pri celotni obdelavi na funkcionalnost, kakovost in privlačen videz.

Vse zasteklitve v pritličju so dvojno toplotnoizolativne in izvedene v aluminijastih okvirjih. Ostale zasteklitve so izvedene v PVC okvirjih in so toplotnoizolativne. Okna so opremljena z žaluzijami.

Vhodna vrata v stanovanja so lesena in v jeklenih vratnih podbojih. Vrata so protipožarna, protihrupna in protivlomna. Notranja vrata so lesena. Oba vhoda v Vidovo sta opremljena z domofoni in zapirali. Vrata v kletnem parkirišču so mreža kovinska in se samodejno odpirajo.

V sanitarijah, kuhinjah in poslovnih prostorih so tla obložena s keramičnimi ploščicami. Sanitarni prostori so do stropa obložени s keramiko, v kuhinjah pa je keramika položena na stene nad kuhinjsko nizozina. V spalnicah in dnevnih sobah je po tleh kakovosten parket.

Notranje stene v stanovanjih so iz lahkih mavčno-kartonskih plošč na konstrukciji iz pocinkanih kovinskih profilov. Obodne stene so ometane oziroma glajene in poslikane z belo poldisperzijsko barvo.

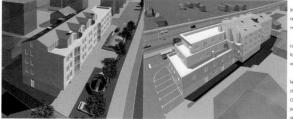

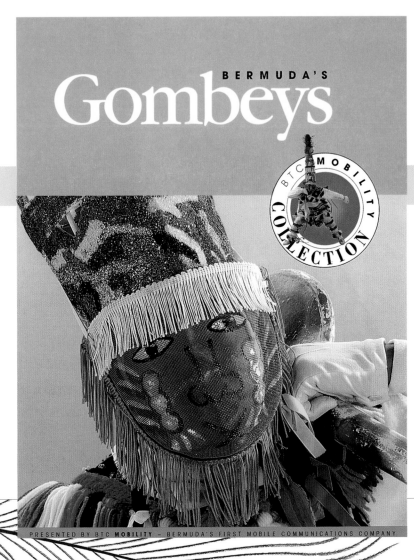

BERMUDA'S
Gombeys

BTC MOBILITY COLLECTION

creative firm
ADVANTAGE LTD.
Hamilton, Bermuda
creative people
*SHEILA SEMOS,
TINA TROUSDELL,
ERIKA KRUPP*
client
BTC MOBILITY

PRESENTED BY BTC **MOBILITY** – BERMUDA'S FIRST MOBILE COMMUNICATIONS COMPANY

BTC MOBILITY

Collect
THE ENTIRE SET OF 5 AUTHENTIC GOMBEY MOBILITY PREPAID CARDS & PASTE THEM IN THE SPACES PROVIDED.

PREPAID WIRELESS $100

ANDRE PLACE - Place's New Generation Gombeys
Native American influence is seen in Gombey folk drama. The long hair and bow and arrow indicate the elder and chief of the group.

COOLRIDGE BELL - Hayward Gombey Group
Acrobatic leaps, jumps and knee-bends are characteristic of the Bermudian Gombeys. The whip indicates the captain of the group.

WAYNE RAYNOR JR. - H&H Gombeys
The Bermuda Gombey is traditionally a group of male dancers and drummers. Gombey is an African word meaning rhythm.

SANCHE GRANT - Place's New Generation Gombeys
The Bermudian Gombey dress is a composite of African-American Indian costumes. The basic origins of dance come from West Africa.

KEVIN KUBLER - K&K Somerset Gombey Tribe
The traditional Gombey "crowd" consisted of men and boys from one family who passed down dance techniques from generation to next.

"If you see a group of people dancing down a Bermuda street to the sound of drums and whistles and if those dancers are wearing... colourful costumes, then you may well be witnessing... The Gombeys". GEORGE RUSHE "YOUR BERMUDA"

Native American influence on the Gombey can be seen in the use of feathers for their headdress, the bow and arrow carried by the Wild Indian, the tomahawk and shield carried by the Chief.

West African influence is demonstrated through the mask and the stilts the Gombey used to dance on.

West Indian flavour is apparent in the dance steps and movements and tall headdress. The majority of Gombey Captains can also trace their families back to the West Indies.

The Military influence is seen in the use of the kettle drum and snare drums as well as the fife and triangle.

The original Bermuda Gombey in St. David's appeared only after sunset. They wore no costume except an illuminated paper hat and tapped out a rhythm on an improvised drum.

It's
PREMIER AMENITIES
for
EXCLUSIVE LIVING

ANCHOR
Club

THE ANCHOR CLUB AT GRAND HARBOR

creative firm
GOUTHIER DESIGN
Fort Lauderdale, Florida
creative people
JONATHAN GOUTHIER,
JO HALLMARK,
APPI
client
THE ANCHOR CLUB

ANCHOR
Club

It's
YOUR LIFE
the
WITHOUT IT
Club
YOUR DREAMS
It's living
WITH IT

The Pickwick Resort area is the premier location in the South for the discriminative person. Whether your enjoyment is found in the autumn, with it's spectacular fall leaves display or the summer filled with sailing, yachting, water skiing or fishing, there is something for the whole family here in this beautiful area. History buffs will enjoy Shiloh National Park and nearby historic Savannah, Tennessee with its homes built in the 1800 century.
Grand harbor at Pickwick offers luxurious condominium living with incredible water views and beautiful surroundings. A full service marina and Yacht Club is also located here.

creative firm
GRAPHIC PERSPECTIVES
Alexandria, Virginia
creative people
SAUNDRA HUTCHISON,
JOSEPH ADDAMS
client
CHILDREN'S ACADEMY OF THEATRE ARTS

creative firm
X DESIGN COMPANY
Denver, Colorado
creative people
ALEX VALDERRAMA,
ANDY SHERMAN
client
FRX SOFTWARE CORPORATION

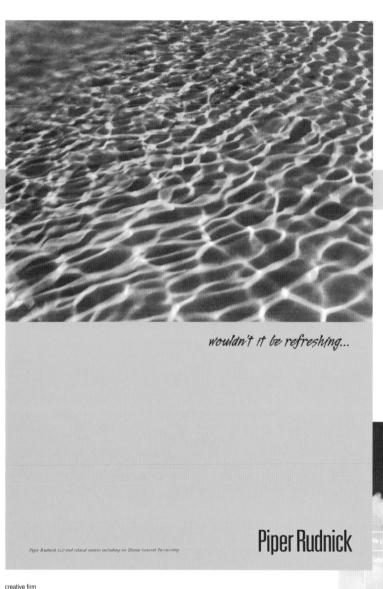

wouldn't it be refreshing...

Piper Rudnick LLP and related entities including an Illinois General Partnership

Piper Rudnick

creative firm
GREENFIELD/BELSER LTD
Washington, D.C.
creative people
BURKEY BELSER,
LISE ANNE SCHWARTZ
client
PIPER RUDNICK LLP

a strong spirit

We proudly contribute time and energy to organizations including:

Baltimore — Boys and Girls Clubs of Central Maryland
Catholic Charities
Cherry Hill and Patapsco Elementary Schools
House of Ruth
Maryland Disability Law Center
Maryland Food Bank
Maryland Volunteer Lawyers Service

Chicago — Asian American Legal Services
Chicago Lawyers Committee for Civil Rights Under Law
Chicago Volunteer Legal Services Foundation
Constitutional Rights Foundation
Greater Chicago Food Depository
South Austin Coalition Community Council
Women Everywhere (Chicago Bar Association
Alliance for Women)

Dallas — Attorneys Serving the Community
Dallas Volunteer Attorney Program (Dallas Bar Association)
Legal Services of North Texas
North Texas Food Bank

Edison — Nanticoke Lenni-Lenape Indians of New Jersey

Los Angeles — Federal Indigent Panel (U.S. District Court for the
Central District of California)

New York — ABA/FEMA September 11 Project
Asian American Legal Defense and Education Fund
Center for Constitutional Rights
New York Lawyers for the Arts
New York Lawyers for the Public Interest

Philadelphia — Christian Advocacy Project
Pennsylvania
Prisoners Assistance by the Indigent Program
Support Center for Child Advocates
World Trade Center Project

Reston — Fairfax Bar Association
Herndon-Reston FISH Program (Friendly Instant
Sympathetic Help)
Reston pro bono

Washington, DC — ABA/FEMA September 11 Project
Appleseed
Coffee House
Children's Law Center
DC Bar Pro Bono Program
DC Bar Pro Bono Program
Rachel's Women's Center
Washington Area Lawyers for the Arts
Washington Lawyers Committee for Civil Rights
and Urban Affairs
Washington Legal Clinic for the Homeless

wouldn't it be refreshing. . .

IF YOUR LAW FIRM HAD A SOUL?

We draw strength from our commitment to good corporate citizenship. More than just an investment, it's part of how we define professionalism. In our communities, it's visible in our *pro bono* work for civic and charitable groups. But it's also found in our long-term relationships with clients, colleagues and adversaries.

99

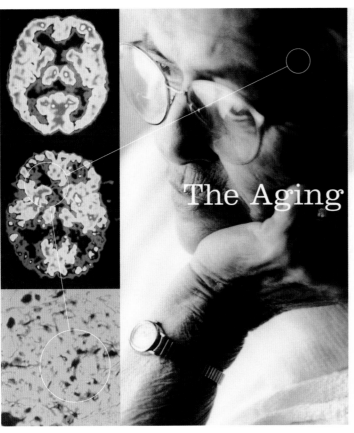
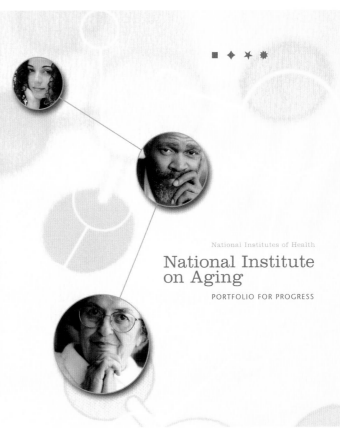

The Aging

National Institutes of Health

National Institute
on Aging

PORTFOLIO FOR PROGRESS

creative firm
LEVINE & ASSOCIATES
Washington, D.C.
creative people
MAGGIE SOUDANO
client
NATIONAL INSTITUTE ON AGING

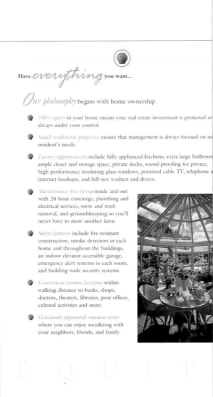

Have *everything* you want...

Our philosophy begins with home ownership.

- *100% equity* in your home means your real estate investment is protected and always under your control.

- *Small residential properties* ensure that management is always focused on individual resident's needs.

- *Luxury appointments* include fully-applianced kitchens, extra large bathrooms, ample closet and storage space, private decks, sound-proofing for privacy, high-performance insulating glass windows, prewired cable TV, telephone and internet hookups, and full-size washers and dryers.

- *Maintenance-free living* inside and out with 24-hour concierge, plumbing and electrical services, snow and trash removal, and groundskeeping so you'll never have to mow another lawn.

- *Safety features* include fire-resistant construction, smoke detectors in each home and throughout the buildings, an indoor elevator-accessible garage, emergency alert systems in each room, and building-wide security systems.

- *Convenient intown locations* within walking distance to banks, shops, doctors, theaters, libraries, post offices, cultural activities and more.

- *Graciously appointed common areas* where you can enjoy socializing with your neighbors, friends, and family.

It's *Wise Living*
Retirement Reinvented

creative firm
DOERR ASSOCIATES
Winchester, Massachusettes
creative people
JOAN WILKING
client
WISE LIVING

creative firm
LEKAS MILLER DESIGN
Walnut Creek, California
creative people
LANA IP
client
STEINHORN CONSULTING

STEINHORN

The Participant Education Program

The availability of effective plan and investment education results in a better understanding of the plan and its investments. And a better understanding of the plan translates into more employees deciding to contribute to the plan, higher contribution rates and more appropriate investment allocation.

Employee meetings, detailed enrollment kits, assistance with asset allocation, ongoing communications, Internet access and printed account statements are all part of The Participant Education Program, a critical component of a successful plan.

The Investment Selection and Review Program

We offer you access to a diversified range of investment options from multiple money managers. Investment options are provided for all major asset classes, covering a broad risk spectrum and representing a wide range of investment styles to meet the individual needs of each participant.

distill it all into a formal plan design that will merge your goals with the regulatory and statutory requirements of qualified retirement plans. Whether you want to establish a new plan or you have an existing plan with administrative or compliance problems, we are the experts you can count on.

When you outsource to Steinhorn Consulting, you reduce the expense and complexity of maintaining an in-house retirement plan department. Instead you will have our team of highly credentialed experts working on every aspect of your plan.

The Plan
Administration System

When you outsource to Steinhorn Consulting, you and your Human Resources staff are freed from the daily burdens of administering and running a qualified retirement plan.

We take care of everything. We interact directly with your payroll system eliminating ongoing data collection. We process all deposits, handle withdrawals, take care of government reporting and form filing, handle all recordkeeping, maintain the voice and Internet access systems and keep the plan in proper compliance.

Leading edge technology is the backbone of The Plan Administration System, facilitating everything from our precision recordkeeping to the most sophisticated back-up and disaster recovery system in the industry.

From this universe of investments a suitable menu can be offered to participants and these selections are reviewed annually to ensure they continue to meet the guidelines established by the plan's Investment Policy Statement.

Employees receive first class service and easy access to accurate information about their retirement plan. Employers receive professional, reliable and cost-effective systems that free Human Resources staff to concentrate on larger issues.

creative firm
OUT OF THE BOX
Fairfield, Connecticut
creative people
RICK SCHNEIDER
client
OUT OF THE BOX

Out of the Box

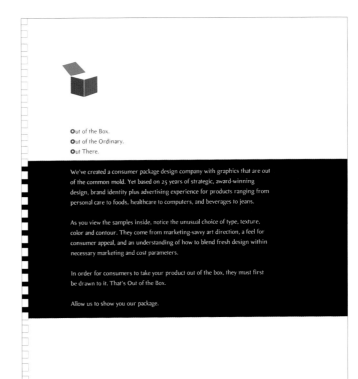

Out of the Box.
Out of the Ordinary.
Out There.

We've created a consumer package design company with graphics that are out of the common mold. Yet based on 25 years of strategic, award-winning design, brand identity plus advertising experience for products ranging from personal care to foods, healthcare to computers, and beverages to jeans.

As you view the samples inside, notice the unusual choice of type, texture, color and contour. They come from marketing-savvy art direction, a feel for consumer appeal, and an understanding of how to blend fresh design within necessary marketing and cost parameters.

In order for consumers to take your product out of the box, they must first be drawn to it. That's Out of the Box.

Allow us to show you our package.

4.

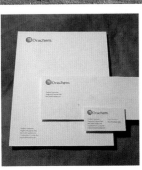

4. Orachem: Chemical research corporation signage and corporate identity
Opposite. HealthSource: Vitamin supplement packaging

YOU WORK HARD.

WHO'S WORKING HARD FOR YOU?

creative firm
DESIGN RESOURCE CENTER
Naperville, Illinois
creative people
JOHN NORMAN,
DANA CALLAWAY
client
ACE HARDWARE CORPORATION

celebrate ARCHITECTURE 2002

creative firm
ID8 STUDIO/RTKL
Dallas, Texas
creative people
DAMON BAKUN
client
AMERICAN INSTITUTE OF ARCHITECTURE

Northeast Perspective

Projects | RTKL Associates Inc.

Jurors felt that this project began with the metaphor of a piece of paper. When developed, it sustains that original idea without becoming diluted. It then extends beyond that container to utilize and benefit from its context on the island. The organizational system is extremely clear and easy for a user to interpret. The structure balances a sophisticated form with a clear way to occupy the building.

15 Questions

Interview questions every law student should ask.

www.pillsburywinthrop.com www.15questions.com

PILLSBURY WINTHROP LLP
For the new business universe

creative firm
GREENFIELD/BELSER
Washington, D.C.
creative people
*BURKEY BELSER, CHARLYNE FABI,
LIZA CORBETT*
client
PILLSBURY WINTHROP LLP

What project are you most proud of?

Why you ask:
You'll not only learn more about the nature of the work associates do, but you'll also learn about the person you're talking to—and create a positive association he or she will remember after you leave.

Whom you ask:
Associates.

Follow up:
What was your most challenging or difficult case? How did you resolve the difficulty? The answer may be, "same as above," but if it's not, you'll learn how the firm handles problems and supports associates.

How effectively does the firm use technology?

Why you ask:
Effective technology will make your job easier; out-of-date or poorly supported technology will make it harder. The firm's interest and investment in technology are also clues to its short-term priorities, long-term strategy and personality (vibrant early adapter or slow-moving follower).

Whom you ask:
Associates—usually the firm's most tech-savvy lawyers.

Follow up:
Long hours and rigorous workloads demand technology you can depend on in the office, at home and on the road. Ask if user support is available remotely 24/7.

How much client contact will I have?

Why you ask:
Client contact and relationships are key to building a successful practice and making partner. Not to mention that seeing the faces and knowing the players makes the work more fun.

Whom you ask:
Junior associates.

Follow up:
Ask how the firm helps associates build practices. Teaching networking strategies, introducing you to clients and supporting business development activities are tangible ways the firm can support you.

Good decisions

are the lifeblood of

your organization.

At Idea Sciences we

offer practical tools

and services that deliver

informed, coordinated

and decisive action.

Our ongoing research

provides clients with the

most effective creative

decision making and problem

solving solutions.

Tools for smarter decisions

ideasciences

creative firm
GRAPHIC PERSPECTIVES
Alexandria, Virginia
creative people
SAUNDRA HUTCHISON,
JOSEPH ADDAMS
client
IDEA SCIENCES

creative firm
BRIDGE CREATIVE
Kennebunk, Maine
creative people
ALEXANDER BRIDGE,
AMANDA HANNAN
client
RAM MANAGEMENT CO., INC.

RiverPlace by Ram
City Living at the Water's Edge

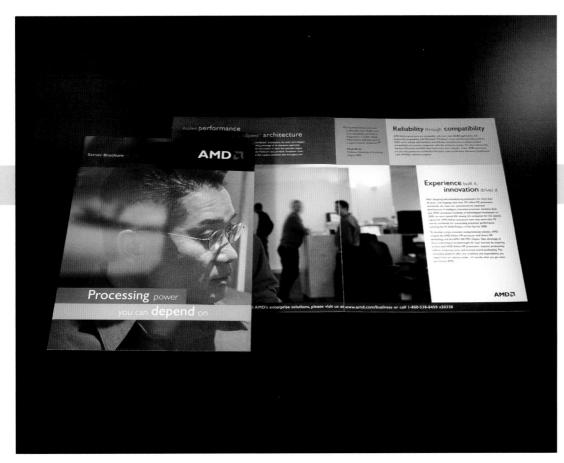

creative firm
FUTUREBRAND
New York, New York
client
AMD

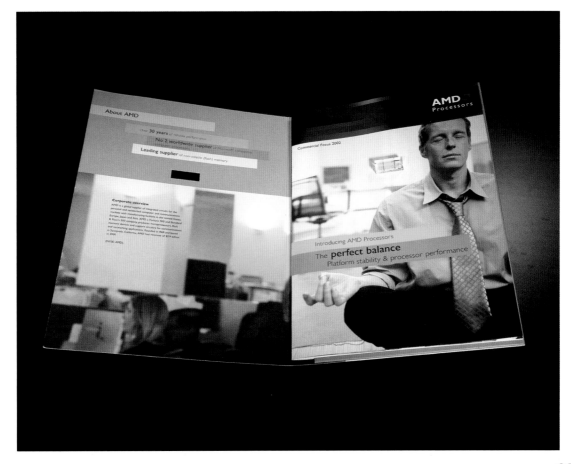

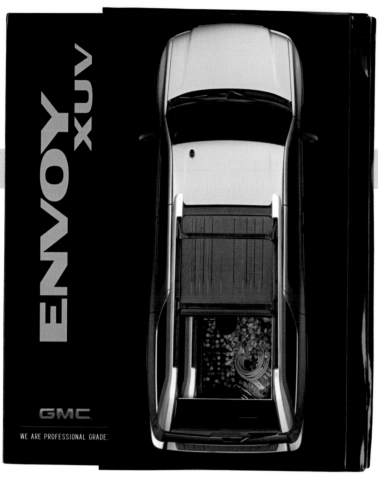

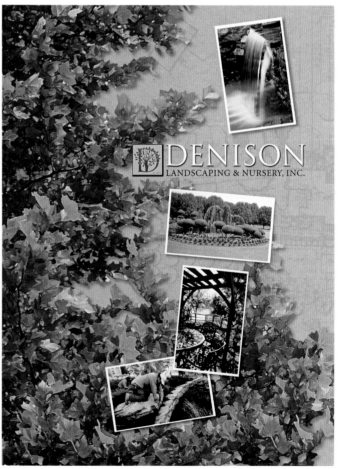

THE MATTEI COMPANIES

creative firm
HANSEN DESIGN COMPANY
Seattle, Washington
creative people
PAT HANSEN,
JACQUELINE SMITH
client
THE MATTEI COMPANIES

creative firm
DEVER DESIGNS
Laurel, Maryland
creative people
JEFFREY L. DEVER,
CHRIS LEDFORD
client
LIBRARY OF CONGRESS

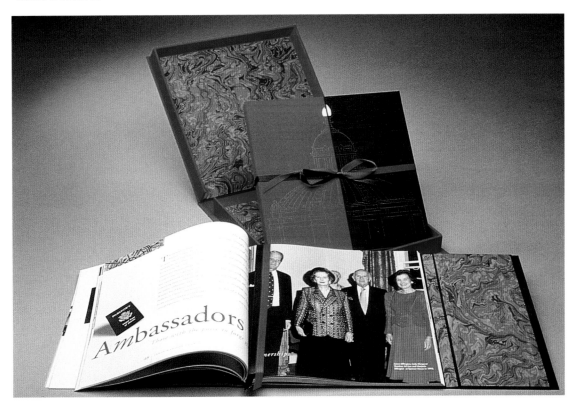

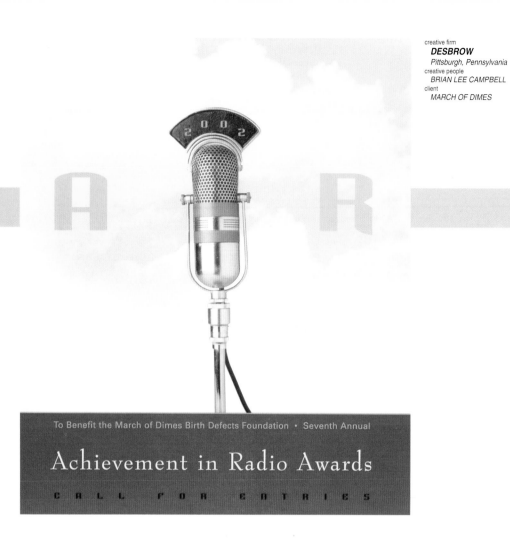

2 0 0 2

To Benefit the March of Dimes Birth Defects Foundation • Seventh Annual

Achievement in Radio Awards

CALL FOR ENTRIES

creative firm
DESBROW
Pittsburgh, Pennsylvania
creative people
BRIAN LEE CAMPBELL
client
MARCH OF DIMES

creative firm
FUTUREBRAND
New York, New York
creative people
MARCO ACEVEDO
client
CARE

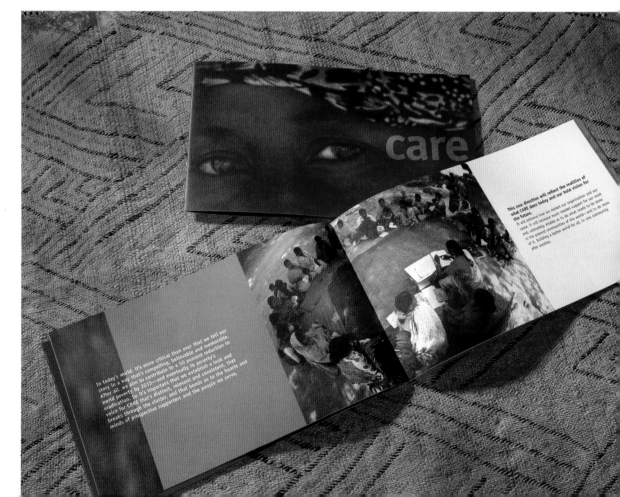

creative firm
LEVINE & ASSOCIATES
Washington, D.C.
creative people
MAGGIE SOUDANO
client
*NATIONAL CENTER ON
EDUCATION AND THE ECONOMY*

NATIONAL CENTER ON Education
AND THE
Economy

America's Choice®
SCHOOL DESIGN

Wherever there are schools using the America's Choice School Design, we carefully track the progress of our students against the state's standards, using their state tests. And students in America's Choice schools are performing very well on them. Results are why the America's Choice School Design is one of the fastest growing comprehensive school design programs in the country.

Inside our design is one of the most highly aligned and most powerful instructional systems anywhere. This potent system is designed to zero in on the key topics in the curriculum, so every student can thoroughly master what is most important, in the least amount of time.

The America's Choice curriculum materials are not only matched to the standards, but they are designed to get students to world class standards *no matter how far behind they are when they start.* Students who begin the program behind, or start to fall behind when they are in it, are identified quickly and given the extra help they need to get back up to speed. A five-layer safety net system is there to catch anyone who stumbles, from students whose understanding of basic math concepts going into middle school is a bit shaky, to students entering high school whose lack of ability to comprehend what they are reading makes it almost certain that they will drop out of school.

America's Choice has been carefully designed to meet the needs of children

from high poverty inner city and rural schools, but it is not set to low standards. To the contrary, there are primary grade students in inner city America's Choice schools writing essays with strong narrative lines that would bear comparison with any suburban school in the United States. Likewise, our math curriculum is designed to get all students ready for high school calculus.

What these words cannot capture is what happens when you visit an America's Choice school and sit down to look at the work of the students. It is work that routinely astonishes their parents and teachers, and becomes the source of pride and confidence in their ability that empowers them to ever greater accomplishments. That is the heart of what it means to be an America's Choice school.

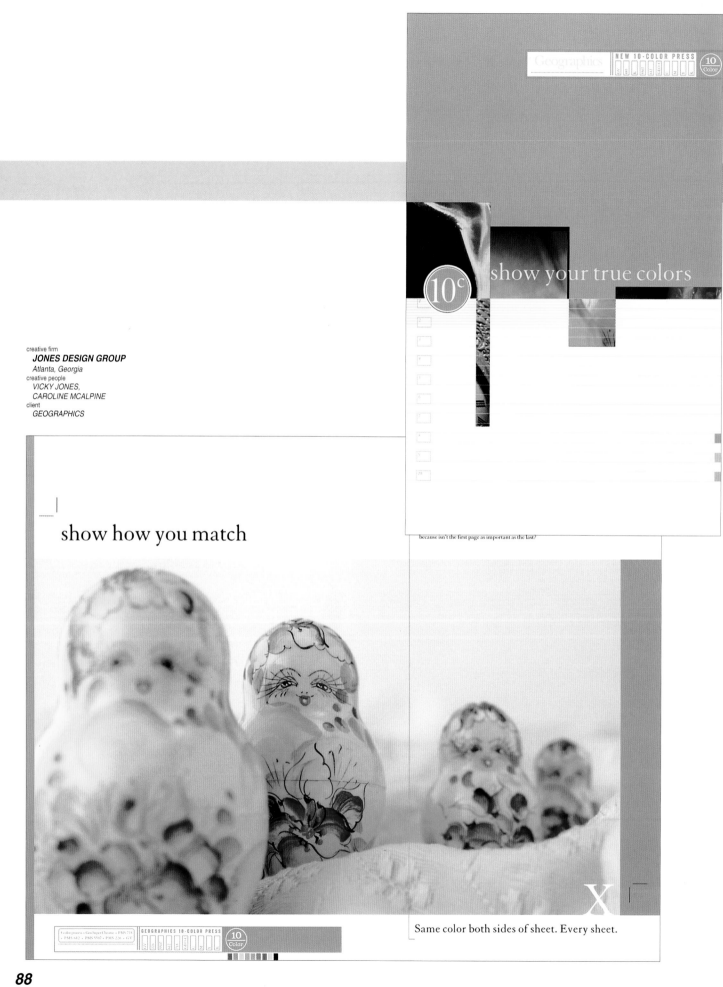

creative firm
JONES DESIGN GROUP
Atlanta, Georgia
creative people
*VICKY JONES,
CAROLINE MCALPINE*
client
GEOGRAPHICS

Geographics | NEW 10-COLOR PRESS | 10 Color

10ᶜ show your true colors

because isn't the first page as important as the last?

show how you match

X

Same color both sides of sheet. Every sheet.

GEOGRAPHICS 10-COLOR PRESS | 10 Color

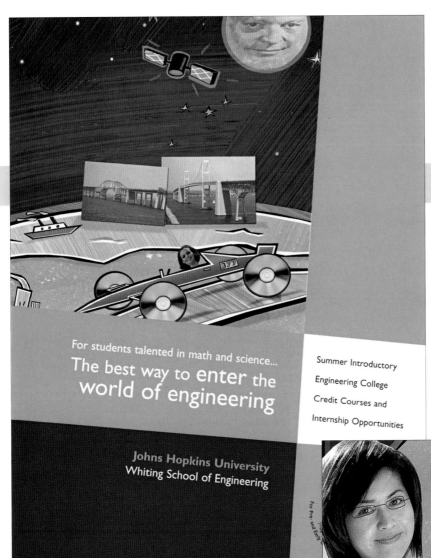

For students talented in math and science...

The best way to enter the world of engineering

Summer Introductory
Engineering College
Credit Courses and
Internship Opportunities

Johns Hopkins University
Whiting School of Engineering

creative firm
**JILL TANENBAUM
GRAPHIC DESIGN & ADVERTISING**
Bethesda, Maryland
creative people
*JILL TANENBAUM,
SUE SPRINKLE*
client
JOHNS HOPKINS UNIVERSITY/PTE

HEADSUP

Johns Hopkins University
Engineering Summer
Program for leading high
school and early college
students

HEADSUP
Hopkins Engineering ADvanced Summer University Program
For Pre- and Early College Students

Providing **entry** to the next generation **of engineers**

HEADSUP is attracting and building tomorrow's top engineers. By partnering with the program, you can connect with these talented students, build your company's image, and energize its operations.

• Offer summer internships to HEADSUP students
• Exhibit at the annual HEADSUP *What Is Engineering?* Fair to reach area students and their families.
• Sponsor HEADSUP scholarships

For details on HEADSUP corporate opportunities, enter...

Johns Hopkins Unversity
Whiting School of Engineering

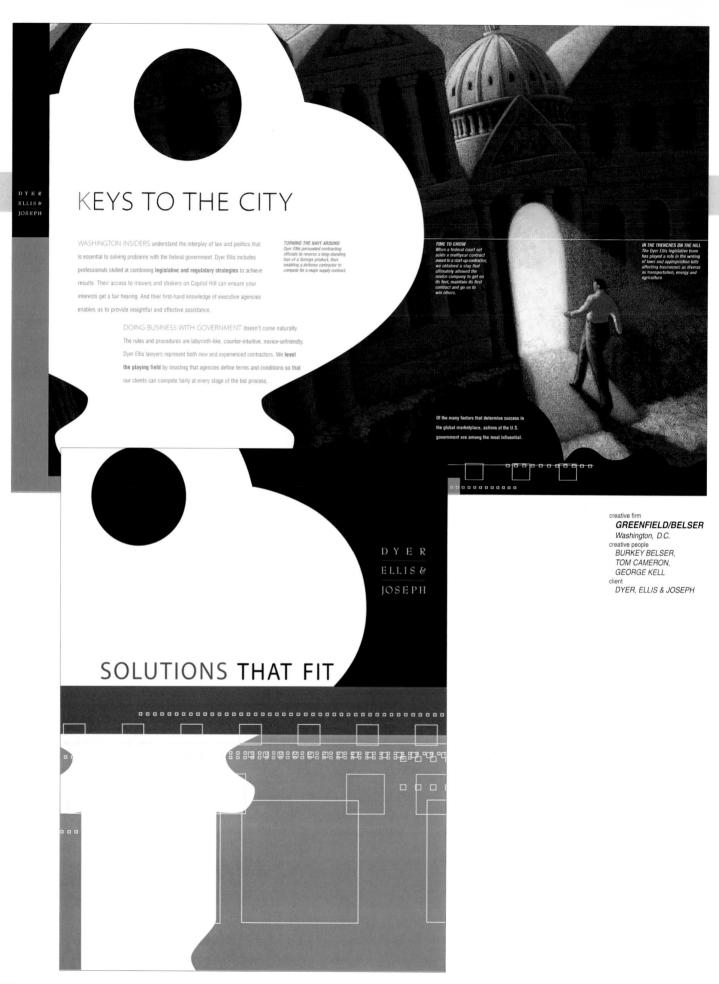

KEYS TO THE CITY

WASHINGTON INSIDERS understand the interplay of law and politics that is essential to solving problems with the federal government. Dyer Ellis includes professionals skilled at combining **legislative and regulatory strategies** to achieve results. Their access to movers and shakers on Capitol Hill can ensure your interests get a fair hearing. And their first-hand knowledge of executive agencies enables us to provide insightful and effective assistance.

DOING BUSINESS WITH GOVERNMENT doesn't come naturally. The rules and procedures are labyrinth-like, counter-intuitive, novice-unfriendly. Dyer Ellis lawyers represent both new and experienced contractors. We **level the playing field** by insisting that agencies define terms and conditions so that our clients can compete fairly at every stage of the bid process.

TURNING THE NAVY AROUND
Dyer Ellis persuaded contracting officials to reverse a long-standing ban of a foreign product, thus enabling a defense contractor to compete for a major supply contract.

TIME TO GROW
When a federal court set aside a multiyear contract award to a start-up contractor, we obtained a stay that ultimately allowed the novice company to get on its feet, maintain its first contract and go on to win others.

IN THE TRENCHES ON THE HILL
The Dyer Ellis legislative team has played a role in the writing of laws and appropriation bills affecting businesses as diverse as transportation, energy and agriculture.

Of the many factors that determine success in the global marketplace, actions of the U.S. government are among the most influential.

DYER
ELLIS &
JOSEPH

SOLUTIONS THAT FIT

creative firm
GREENFIELD/BELSER
Washington, D.C.
creative people
BURKEY BELSER,
TOM CAMERON,
GEORGE KELL
client
DYER, ELLIS & JOSEPH

DYER
ELLIS &
JOSEPH

creative firm
BETH SINGER DESIGN
Washington, D.C.
creative people
CHRIS HOCH
client
B'NAI B'RITH YOUTH ORGANIZATION

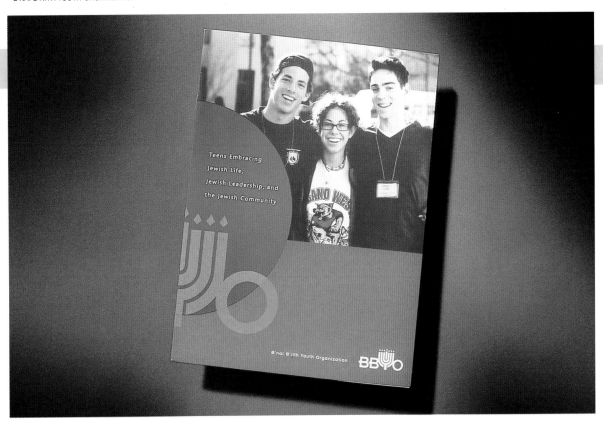

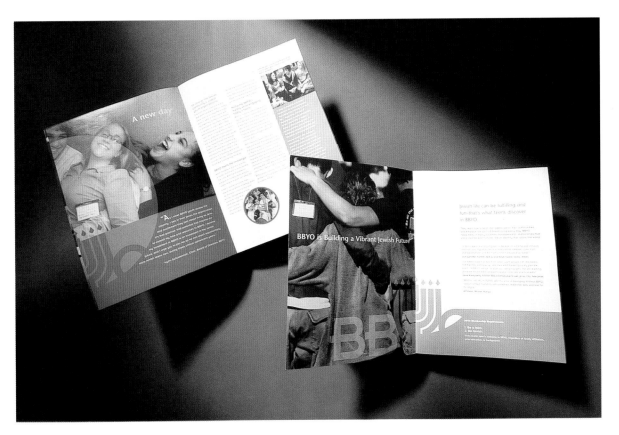

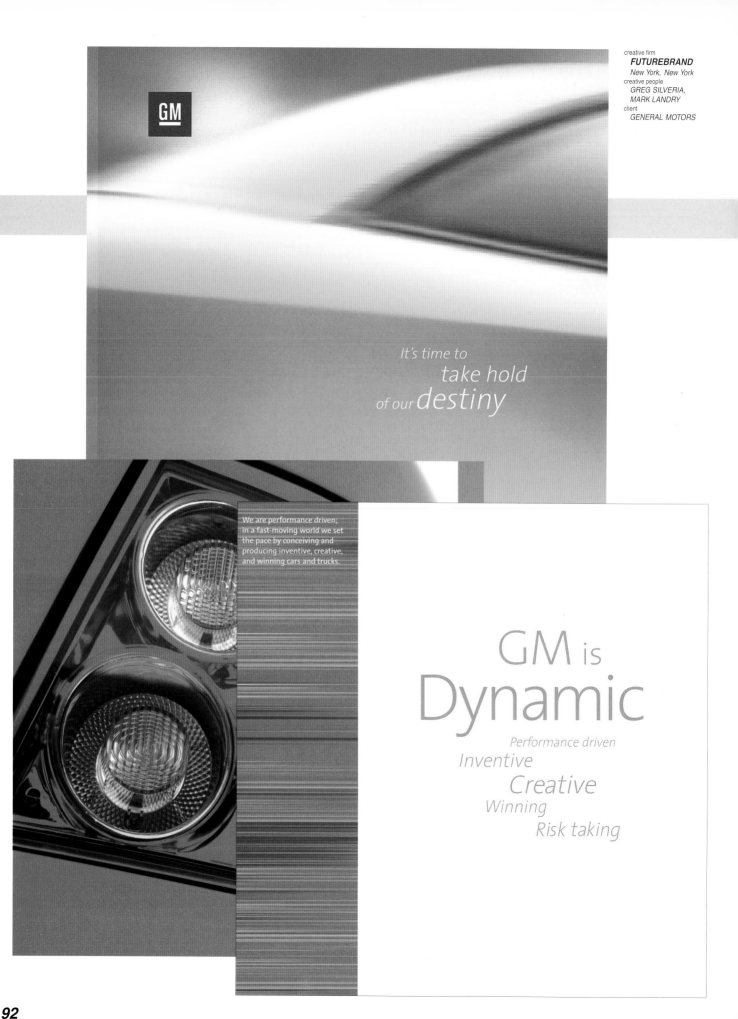

creative firm
FUTUREBRAND
New York, New York
creative people
GREG SILVERIA,
MARK LANDRY
client
GENERAL MOTORS

It's time to
take hold
of our destiny

We are performance driven;
in a fast-moving world we set
the pace by conceiving and
producing inventive, creative,
and winning cars and trucks.

GM is
Dynamic
Performance driven
Inventive
Creative
Winning
Risk taking

Every day, careers are found

24 x 7
365

{ Every hour, every day, all year long }

THE CHRONICLE OF HIGHER EDUCATION'S

careernetwork.com

1,500,000 page views
unique visitors 100,000

Top volume.
If you post it, they will come—more than
2 million career seekers every month.
That's a lot of opportunity to see and be seen.

careernetwork.com

Every week, career seekers get

Exponential impact.
Our employer profiles let you
spotlight your organization and
stand out in a crowded market.

and view

225,000
75
employer
profiles

e-mail job alerts

You've got mail.
Our by-request weekly e-mails push job
announcements out to the top candidates—
even when they're too busy to visit the site!

careernetwork.com

"At **Forsyth**, you have to **work** hard. But what you get in **return** is much **more** than the amount of hard work you **give**. Forsyth shapes its students into **smart**, **caring**, just **GREAT** people. Forsyth is one of the greatest **gifts** your parents could ever **give** you."

— *Class of 2002 alum*

creative firm
BERKELEY DESIGN LLC
St. Louis, Missouri
creative people
LARRY TORNO
client
FORSYTH SCHOOL/PHOEBE RUESS

Spanning a city block, Forsyth's houses face onto both Forsyth and Wydown Boulevards with the backyards forming a secure campus "commons" area that is hidden from street view. Life unfolds here on the playgrounds and playing fields. Older and younger children mingle at lunchtime, recess and after school. Teachers come to know children of all ages in this intimate space. Adults gather in this area to collaborate or simply to chat. In warm weather, you'll find children and adults eating lunch outside. Forsyth's backyards are the neighborhood for the School community. "The campus provides a 'neighborhood' setting that so many kids don't get to enjoy nowadays," reflected a parent. "It instills a sense of ownership in the children."

The children are grouped two grades per house, except for the sixth graders, who share their house with the library. Students — except for the youngest ones in Pre-Kindergarten and Junior-Kindergarten — travel across campus for music, art, physical education, drama, science, library and lunch. Many times a day, they are out in the open, travelling across the "backyard". The physical experience for a Forsyth student is very different than traditional institutional settings provide. In open outdoor space, children can be children. They can move, run, be aware of the environment many times during the day — not just at recess or during physical education. The joy and energy that abounds at Forsyth is due in part to the campus layout. Forsyth feels like something out of a children's book.

The houses themselves were built during the period from 1924 to 1928, and each has its own architectural genre. Although the houses have been remodeled to accommodate their new "families" and a gymnasium and science building have been integrated into the campus, care has been taken to preserve the residential demeanor that defines both the neighborhood and the School. A child in Senior-Kindergarten, for example, might be based in what was formerly a spacious, paneled living room with a baronial stone fireplace mantel and leaded glass windows. The following year, that child would move up the sweeping circular staircase to one of the Grade 1 classrooms — large spacious rooms, with bay windows, smaller breakout rooms and "real" bathrooms.

"The **best** thing about Forsyth is that it **isn't** an **ordinary** school. The houses make it like a **village** or **neighborhood** where everyone knows each other."

— *Class of 2002 alum*

creative firm
GREENFIELD/BELSER
Washington, D.C.
creative people
*BURKEY BELSER, CHARLYNE FABI,
LISE ANNE SCHWARTZ*
client
LEVICK STRATEGIC COMMUNICATIONS

PR is dead.

LEVICK
STRATEGIC COMMUNICATIONS

Targeted messages bypass the gatekeepers and support business development.

Drill down
and tunnel over.

Traditional PR relies on "umbrella" communications
—broad messages targeting general-interest media.
Vertical and horizontal communications are direct
lines to those who control the decision to hire you.

The shortest distance
Vertical communications use
trade publications to establish
you as the "go to" firm for
your prospect's industry.

Horizontal communications reach
decision-makers through target
company publications, in-house
seminars, associations and speak-
ing engagements.

6 LEVICK *Strategic Communications*

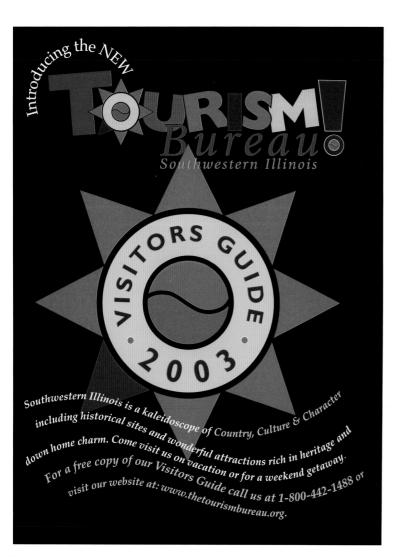

creative firm
AKA DESIGN, INC.
St. Louis, Missouri
creative people
CRAIG SIMON,
J.R. GAIN
client
THE TOURISM BUREAU
SOUTHWESTERN ILLINOIS

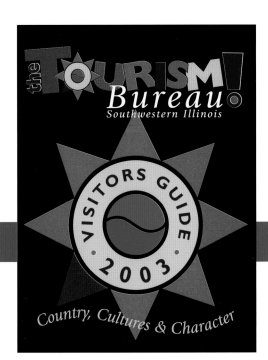

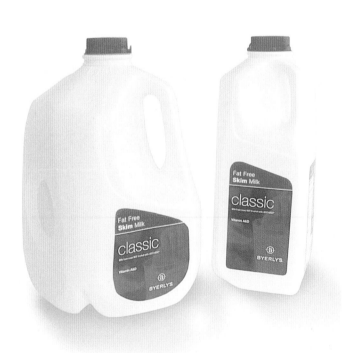

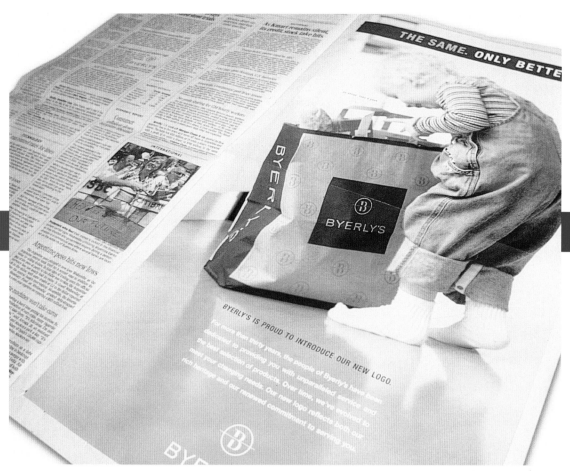

creative firm
CAPSULE
Minneapolis, Minnesota
client
LUND FOOD HOLDINGS

waterpark

creative firm
AKA DESIGN, INC.
St. Louis, Missouri
creative people
CRAIG SIMON,
STACY LANIER
client
SPLASH CITY FAMILY WATERPARK

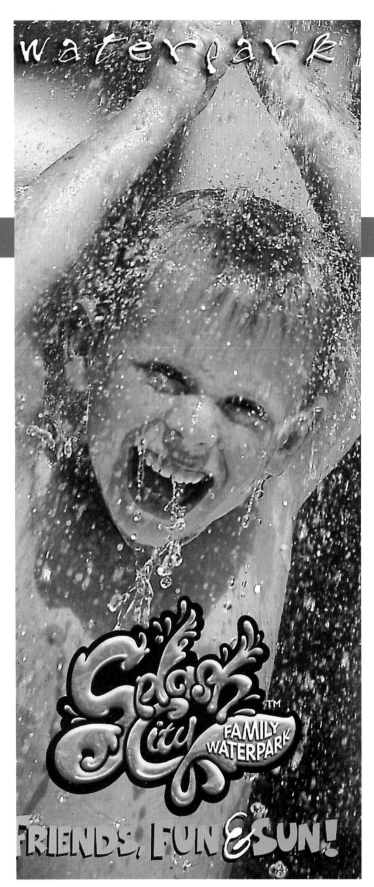

Splash City
FAMILY WATERPARK™

FRIENDS, FUN & SUN!

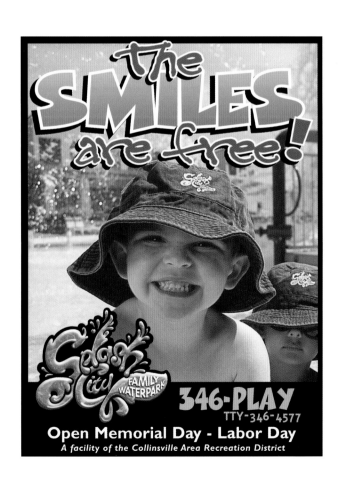

The SMILES are free!

Splash City
FAMILY WATERPARK

346-PLAY
TTY-346-4577

Open Memorial Day - Labor Day
A facility of the Collinsville Area Recreation District

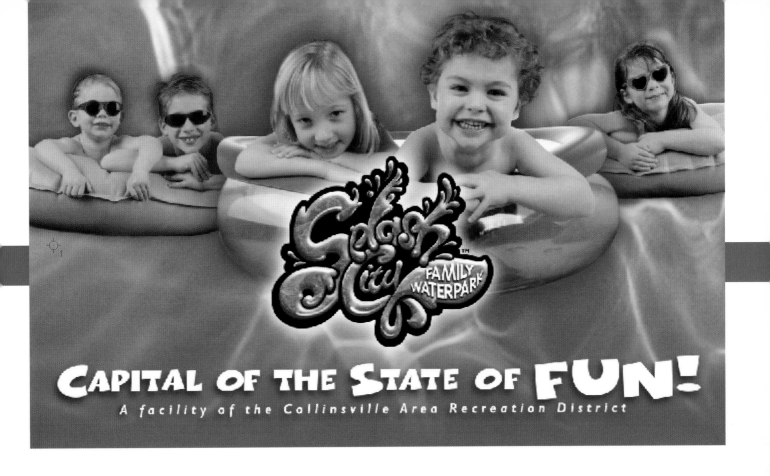

CAPITAL OF THE STATE OF FUN!

A facility of the Collinsville Area Recreation District

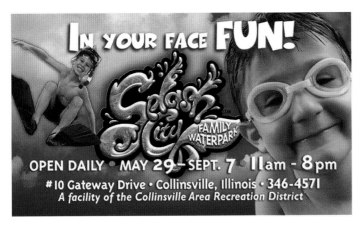

IN YOUR FACE FUN!

OPEN DAILY • MAY 29 – SEPT. 7 • 11am – 8pm
#10 Gateway Drive • Collinsville, Illinois • 346-4571
A facility of the Collinsville Area Recreation District

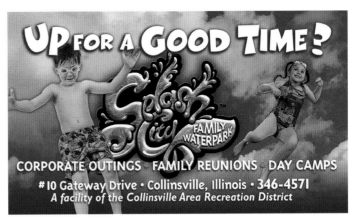

UP FOR A GOOD TIME?

CORPORATE OUTINGS • FAMILY REUNIONS • DAY CAMPS
#10 Gateway Drive • Collinsville, Illinois • 346-4571
A facility of the Collinsville Area Recreation District

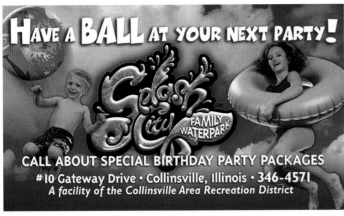

HAVE A BALL AT YOUR NEXT PARTY!

CALL ABOUT SPECIAL BIRTHDAY PARTY PACKAGES
#10 Gateway Drive • Collinsville, Illinois • 346-4571
A facility of the Collinsville Area Recreation District

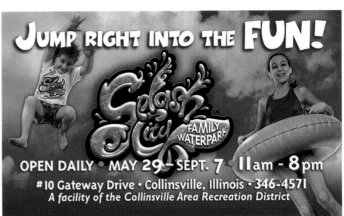

JUMP RIGHT INTO THE FUN!

OPEN DAILY • MAY 29 – SEPT. 7 • 11am – 8pm
#10 Gateway Drive • Collinsville, Illinois • 346-4571
A facility of the Collinsville Area Recreation District

**Inspirational Characters
Promoting the
Creative Development
of Young Minds**

Created & Illustrated by Joe Stites

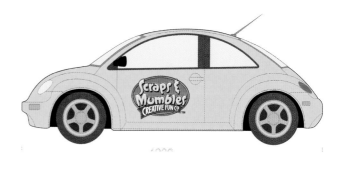

creative firm
THE LEYO GROUP, INC.
Chicago, Illinois
creative people
*JOE STITES, JAYCE SCHMIDT,
BILL LEYO*
client
*SCRAPS & MUMBLES CREATIVE
FUN CO., LLC*

9441 Ensley Lane • Leawood, KS 66206 • Phone & Fax (913) 383-2363

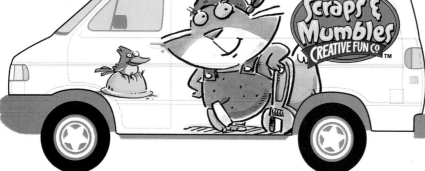

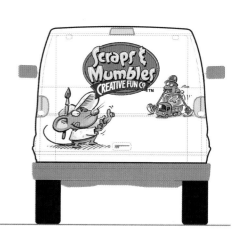

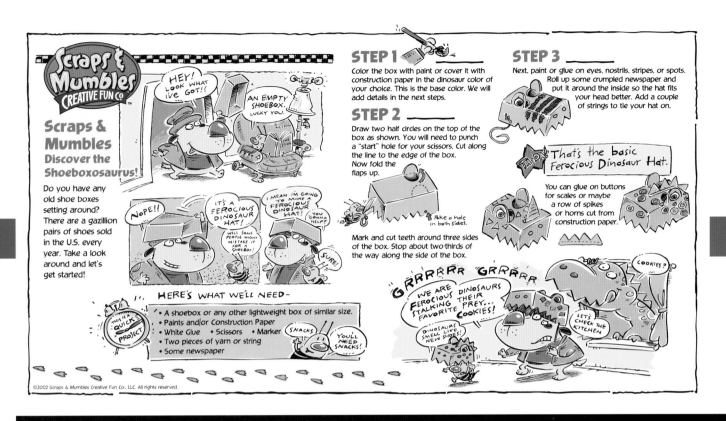

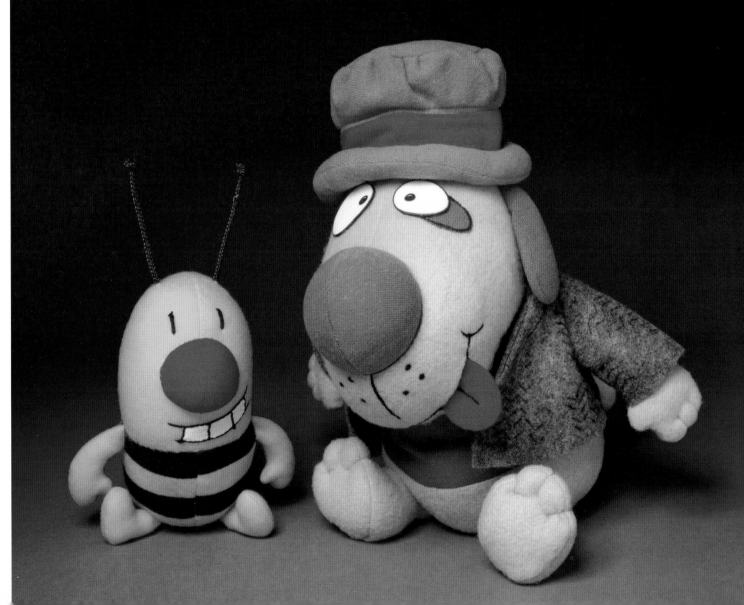

Copenhagen Black

Challenge

Leveraging a 178-year-old brand to introduce a new flavor that would attract a contemporary consumer segment

Solution

A design system including a 4-color process metal lid; Berni's unique brand image communicated an urban, bourbon flavor offering

Result

Trade has embraced and endorsed product; shelf presence commanding; consumer sales phenomenal

Quote

"Berni is a real proactive partner." Rich Fasanelli, Vice President, Marketing

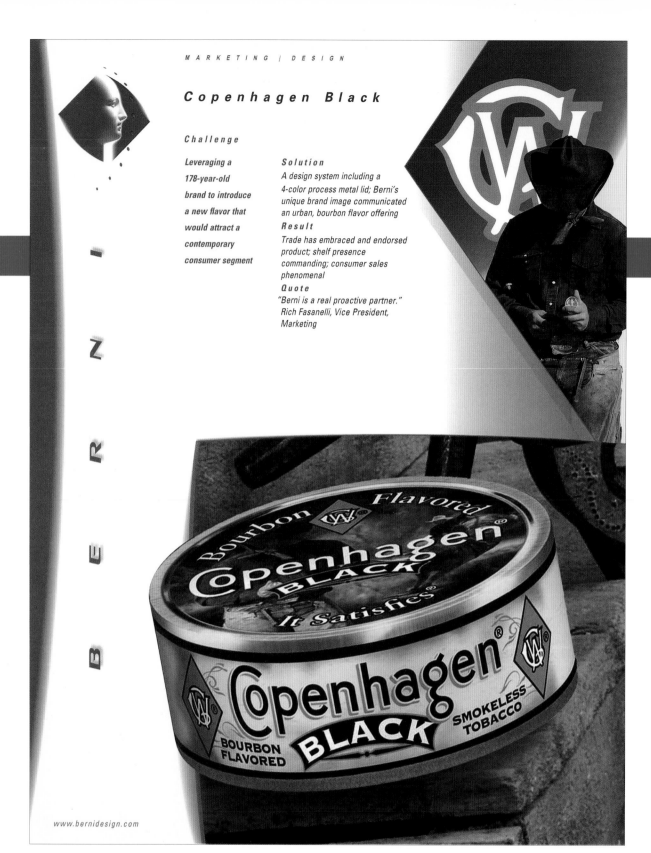

www.bernidesign.com

creative firm
BERNI MARKETING & DESIGN
Greenwich, Connecticut
creative people
STUART M. BERNI,
PELOR ANTIPAS
client
U.S. SMOKELESS TOBACCO

(Berni Marketing uses 8-1/2" x 11" flyers to showcase their work in branding. Since the entire promotional piece is appropriate for this book, several different examples of their work are shown in this format.)

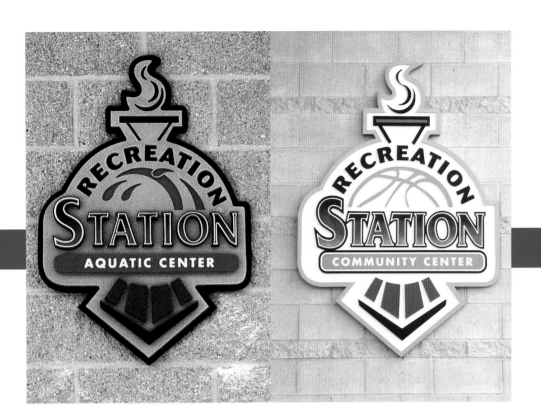

creative firm
AKA DESIGN, INC.
St. Louis, Missouri
creative people
CRAIG SIMON,
STACY LANIER
client
RECREATION STATION

FAMILY CHANGING

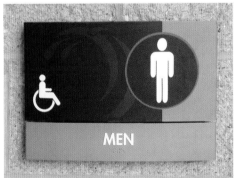

MEN

SWIM/DIVE TEAM

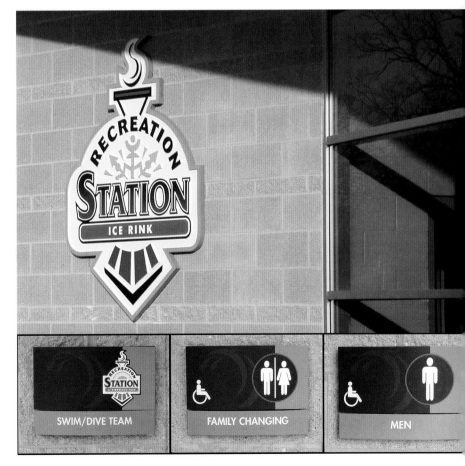

COPERNICUS
FINE JEWELERS

LORD OF THE RINGS

COPERNICUS
FINE JEWELERS

creative firm
AKA DESIGN, INC.
St. Louis, Missouri
creative people
*JOHN AHEARN,
STACY LANIER*
client
COPERNICUS FINE JEWELRY

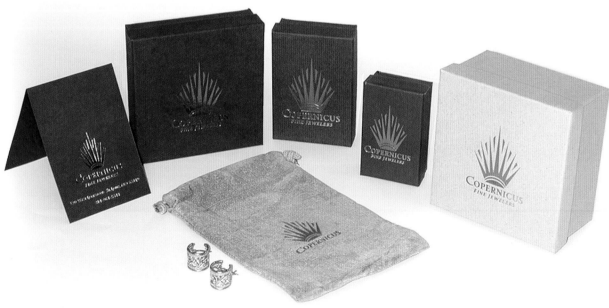

Lady Linda

Challenge

A 70-year-old regional line of bakery sweets needed a fresh new image to expand distribution and compete with national brands.

Solution

Update the brand identity to 35 products using "bakery white" and tempting colors to improve perception of premium quality and tantalize the taste buds. Target the brand to larger supermarkets and support higher price points with new positioning strategy.

Results

Consumer perception of freshness and quality enhanced. New and existing clients reacting positively, with rising sales.

Quote

"The new branding solution reinvigorated our imagery, and created new enthusiasm within our entire company."

Mike Stolarz, Principal

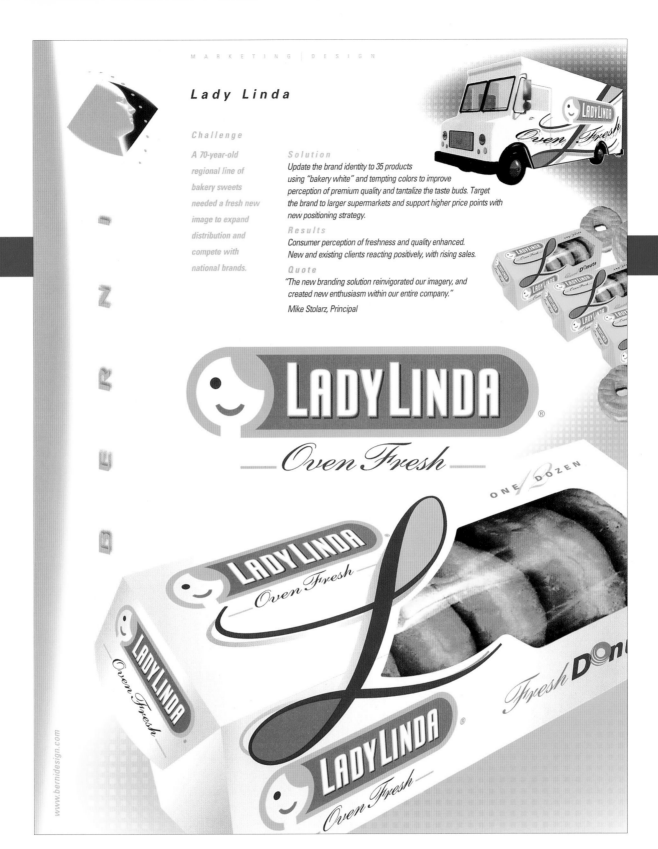

www.bernidesign.com

creative firm
BERNI MARKETING & DESIGN
Greenwich, Connecticut
creative people
CARLOS SEMINAVIC,
STUART M. BERNI
client
LADY LINDA

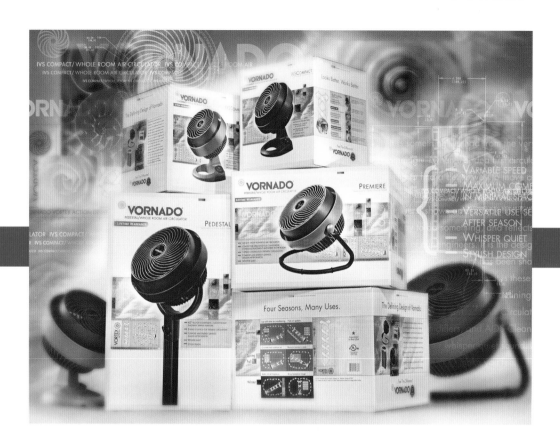

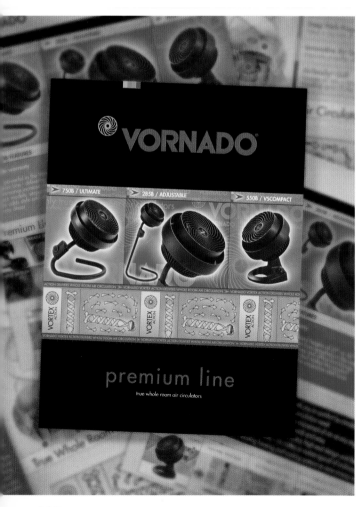

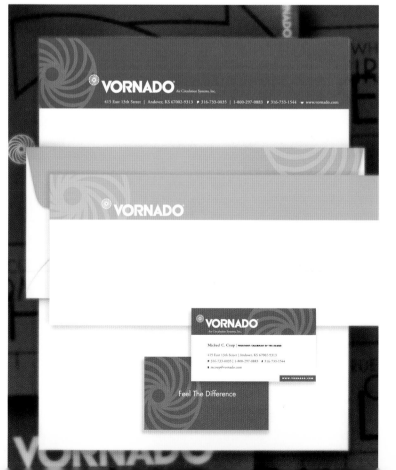

 # VORNADO®

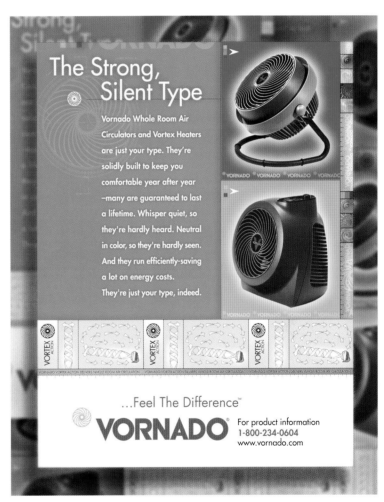

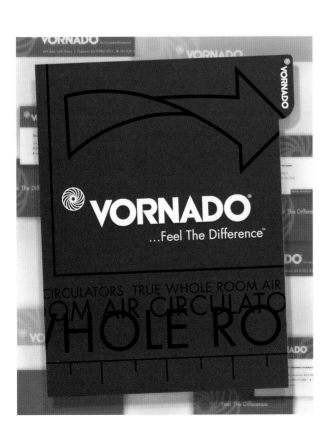

creative firm
INSIGHT DESIGN COMMUNICATIONS
Wichita, Kansas
creative people
*TRACY HOLDEMAN,
LEA CARMICHAEL*

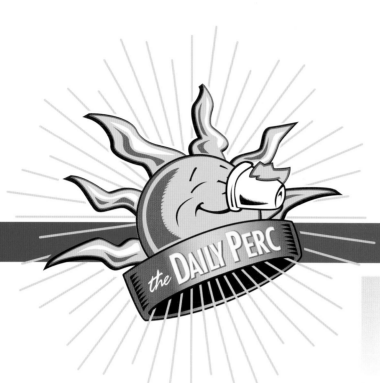

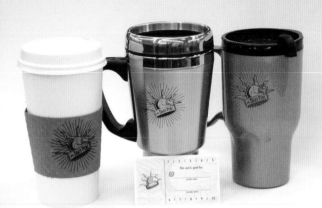

creative firm
AKA DESIGN, INC.
St. Louis, Missouri
creative people
JOHN AHEARN,
J.R. GAIN
client
THE DAILY PERC

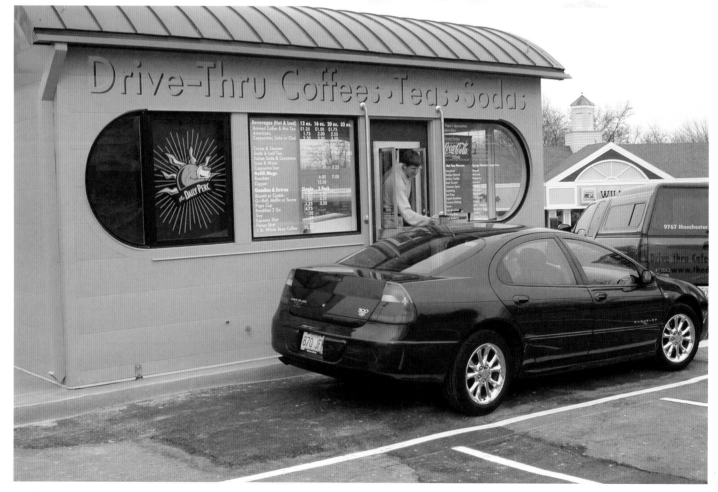

110

Dickinson Brands

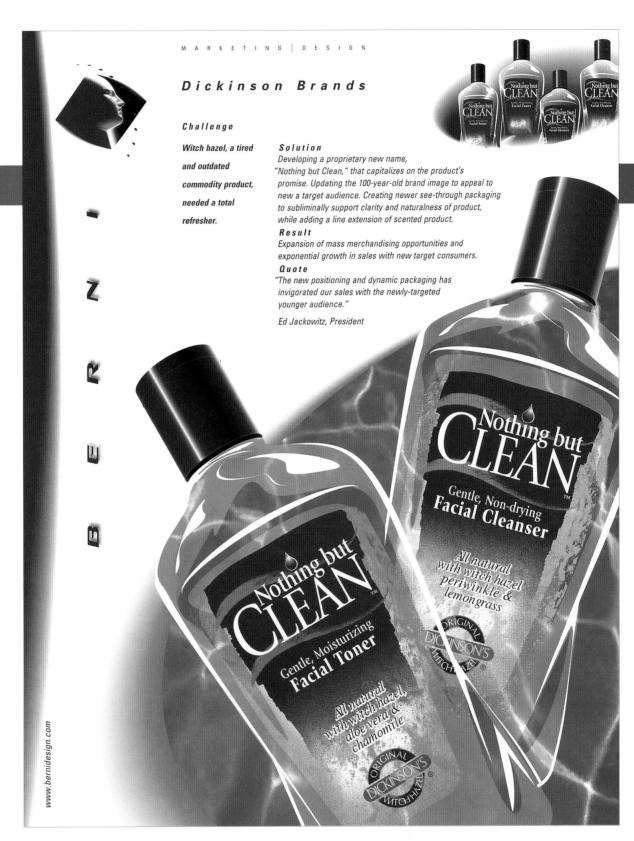

Challenge

Witch hazel, a tired and outdated commodity product, needed a total refresher.

Solution

Developing a proprietary new name, "Nothing but Clean," that capitalizes on the product's promise. Updating the 100-year-old brand image to appeal to new a target audience. Creating newer see-through packaging to subliminally support clarity and naturalness of product, while adding a line extension of scented product.

Result

Expansion of mass merchandising opportunities and exponential growth in sales with new target consumers.

Quote

"The new positioning and dynamic packaging has invigorated our sales with the newly-targeted younger audience."

Ed Jackowitz, President

www.bernidesign.com

creative firm
BERNI MARKETING & DESIGN
Greenwich, Connecticut
creative people
STUART M. BERNI,
CHRISTINE DIKOWSKI
client
DICKINSON BRANDS

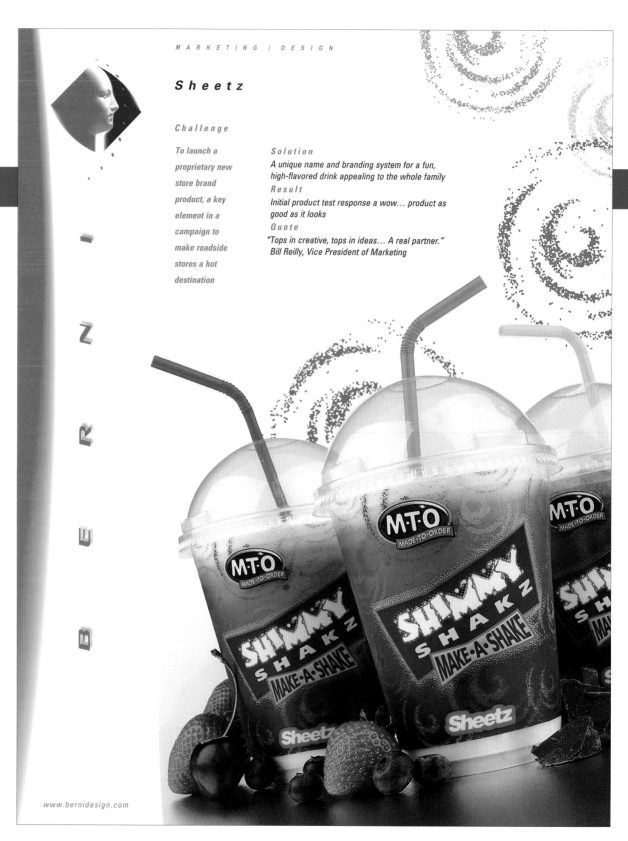

Sheetz

Challenge

To launch a proprietary new store brand product, a key element in a campaign to make roadside stores a hot destination

Solution

A unique name and branding system for a fun, high-flavored drink appealing to the whole family

Result

Initial product test response a wow... product as good as it looks

Quote

"Tops in creative, tops in ideas... A real partner."
Bill Reilly, Vice President of Marketing

www.bernidesign.com

creative firm
BERNI MARKETING & DESIGN
Greenwich, Connecticut
creative people
STUART M. BERNI,
MARK PINTO
client
SHEETZ

112

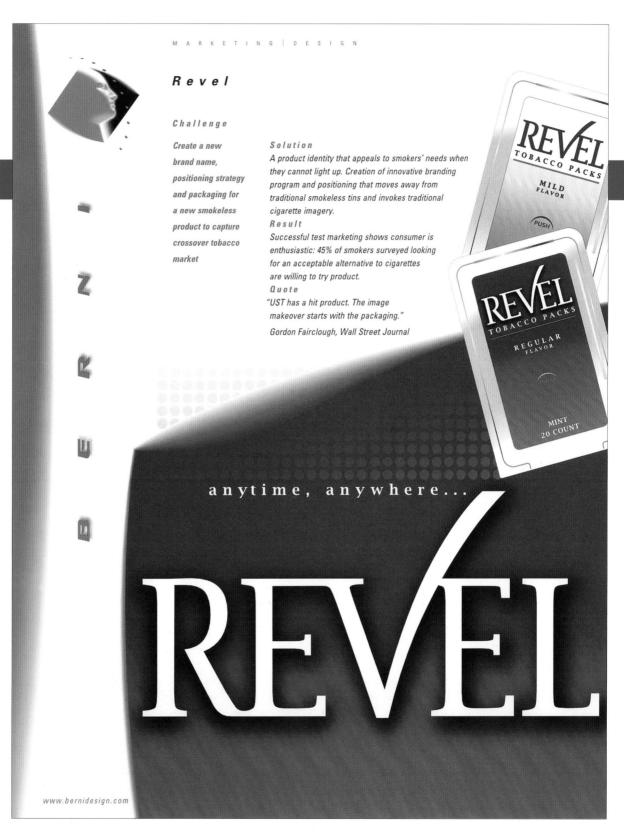

Revel

Challenge

**Create a new
brand name,
positioning strategy
and packaging for
a new smokeless
product to capture
crossover tobacco
market**

Solution

*A product identity that appeals to smokers' needs when
they cannot light up. Creation of innovative branding
program and positioning that moves away from
traditional smokeless tins and invokes traditional
cigarette imagery.*

Result

*Successful test marketing shows consumer is
enthusiastic: 45% of smokers surveyed looking
for an acceptable alternative to cigarettes
are willing to try product.*

Quote

*"UST has a hit product. The image
makeover starts with the packaging."*

Gordon Fairclough, Wall Street Journal

BERNI

www.bernidesign.com

REVEL
TOBACCO PACKS
MILD
FLAVOR
PUSH

REVEL
TOBACCO PACKS
REGULAR
FLAVOR
PUSH
MINT
20 COUNT

anytime, anywhere...

REVEL

creative firm
BERNI MARKETING & DESIGN
Greenwich, Connecticut
creative people
PETER ANTIPAS
client
U.S.S.T.

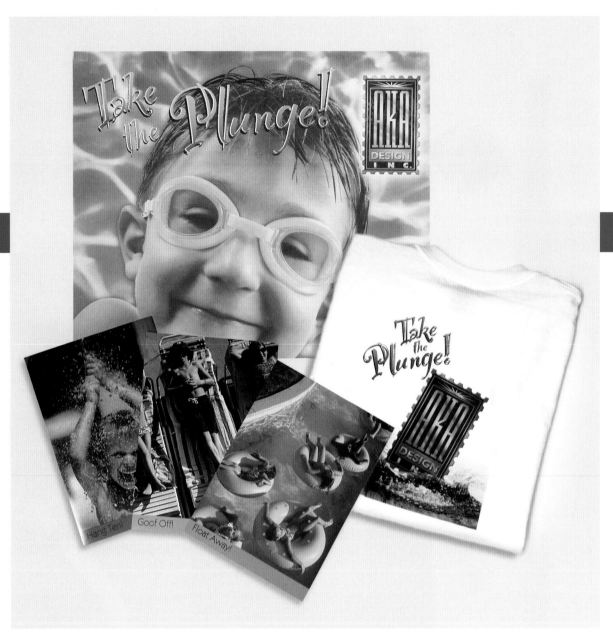

creative firm
AKA DESIGN, INC.
St. Louis, Missouri
creative people
JOHN AHEARN,
RICHIE MURPHY
client
AKA DESIGN, INC.

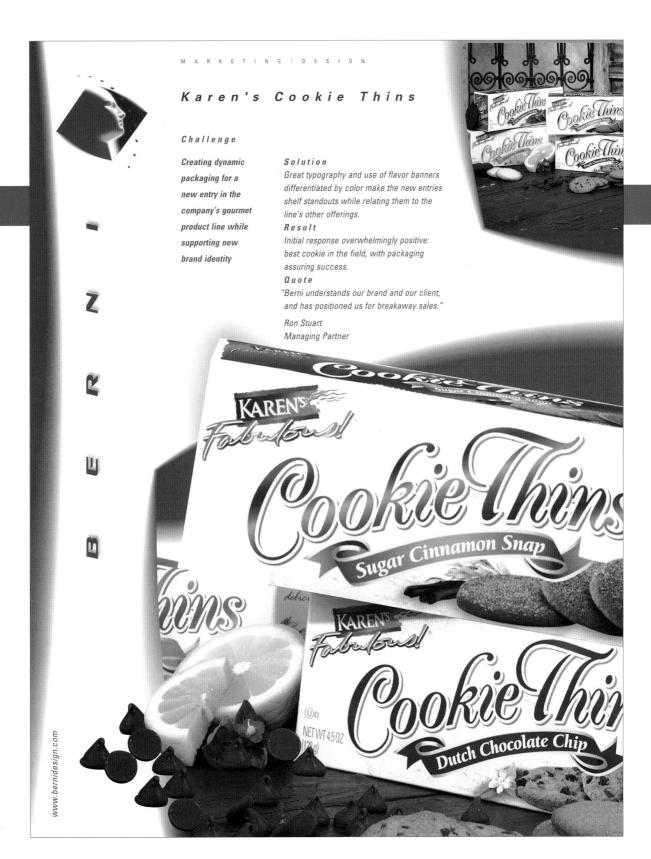

Karen's Cookie Thins

Challenge

Creating dynamic packaging for a new entry in the company's gourmet product line while supporting new brand identity

Solution

Great typography and use of flavor banners differentiated by color make the new entries shelf standouts while relating them to the line's other offerings.

Result

Initial response overwhelmingly positive: best cookie in the field, with packaging assuring success.

Quote

"Berni understands our brand and our client, and has positioned us for breakaway sales."

Ron Stuart
Managing Partner

www.bernidesign.com

creative firm
BERNI MARKETING & DESIGN
Greenwich, Connecticut
creative people
STUART M. BERNI,
PETER ANTIPAS
client
BISCOTTI & CO., INC.

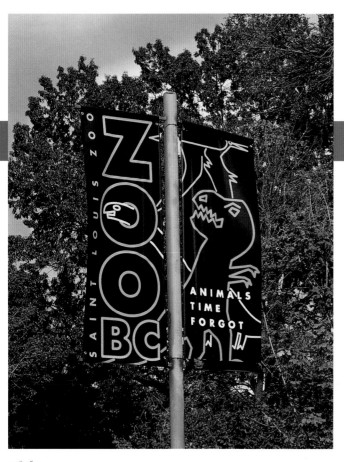

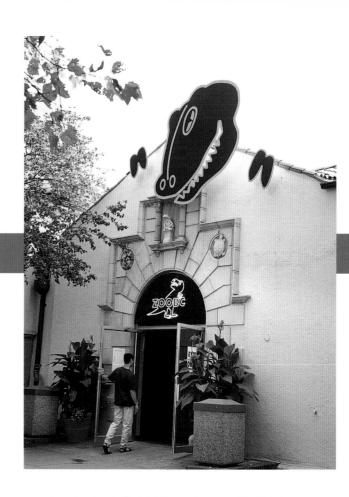

creative firm
CUBE ADVERTISING & DESIGN
St. Louis, Missouri
creative people
DAVID CHIOW
client
SAINT LOUIS ZOO

116

creative firm
FUTUREBRAND
New York, New York
creative people
MICHAEL THIBODEAU,
PAUL GARDNER
client
MICROSOFT

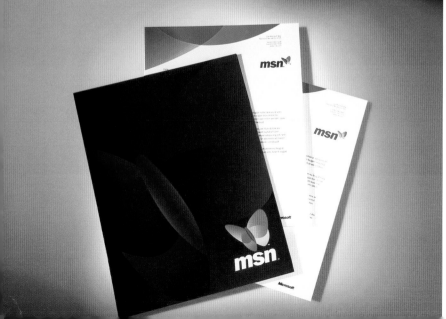

creative firm
DUNN AND RICE DESIGN, INC.
Rochester, New York
creative people
JOHN DUNN, DARLENE KOCHER
client
HASBRO, INC.

LOGOS

creative firm
DESBROW
Pittsburgh, Pennsylvania
creative people
BRIAN LEE CAMPBELL
client
VOCOLLECT

creative firm
DESIGN FORUM
Dayton, Ohio
creative people
AMY DROLL
client
PARIS BAGUETTE

LOUISIANA STATE UNIVERSITY

creative firm
PHOENIX DESIGN WORKS
New York, New York
creative people
JAMES M. SKILES, ROD OLLERENSHAW,
CRAIG MILLER, RICHARD TSAI
client
LOUISIANA STATE UNIVERSITY

creative firm
LEVINE & ASSOCIATES
Washington, D.C.
creative people
RANDI WRIGHT, JOHN VANCE
client
AMERICAN URILOGICAL ASSOCIATION

creative firm
FIXGO ADVERTISING (M) SDN BHD
Selangor, Malaysia
creative people
FGA CREATIVE TEAM
client
TRISILCO MOTOR GROUP

for*someone*special.com

creative firm
KARACTERS DESIGN GROUP
Vancouver, Canada
creative people
MARIA KENNEDY,
NANCY WU
client
FOR SOMEONE SPECIAL

creative firm
PAT TAYLOR INC.
Washington, D.C.
creative people
PAT TAYLOR,
GRAPHICS BY GALLO
client
PALIS GENERAL CONTRACTING

creative firm
FRIDA HOLMFRIDUR VALDIMARSDOTTIR
Reykavik, Iceland
creative people
FRIDA HOLMFRIDUR VALDIMARSDOTTIR
client
THE ICELANDIC ASSOCIATION
OF INTERNAL MEDICINE

FÉLAG
ÍSLENSKRA
LYFLÆKNA

creative firm
KARL KROMER DESIGN
San Jose, California
creative people
KARL KROMER
client
FIRESTARTER

fire*starter*
VENTURE CAPITAL LLC

Medical Systems Inc.

creative firm
IRIDIUM, A DESIGN AGENCY
Ottawa, Canada
creative people
MARIO L'ECUYER
client
VMI MEDICAL SYSTEMS

creative firm
TOOLBOX STUDIOS, INC.
San Antonio, Texas
creative people
PAUL SOUPISET
client
KOEN SUIDGEEST

VISION2HIRE

creative firm
KARACTERS DESIGN GROUP
Vancouver, Canada
creative people
MARIA KENNEDY,
ROY WHITE,
JEFF HARRISON
client
RECRUITEX

creative firm
PHOENIX DESIGN WORKS
New York, New York
creative people
JAMES M. SKILES,
ROD OLLERENSHAW
client
NASCAR

creative firm
THE LEYO GROUP, INC.
Chicago, Illinois
creative people
JAYCE SCHMIDT
client
DIGITAL PRINTING CENTER

creative firm
CONCRETE DESIGN COMMUNICATIONS
Toronto, Canada
creative people
JOHN PYLYPCZAK
client
COMPANY DNA

companydna

creative firm
HAMBLY & WOOLLEY INC.
Toronto, Canada
creative people
PHIL MONDOR
client
PLURIMUS

creative firm
ZGRAPHICS, LTD.
East Dundee, Illinois
creative people
NATE BARON, JOE ZELLER
client
NORTHERN KANE COUNTY CHAMBER OF COMMERCE

CORNERSTONE

creative firm
PORTFOLIO CENTER
Atlanta, Georgia
creative people
ANNA CAZARUS
client
CORNERSTONE CHURCH

creative firm
PHOENIX DESIGN WORKS
New York, New York
creative people
JAMES M. SKILES, ROD OLLERENSHAW, CRAIG MILLER, RICHARD TSAI
client
MLBP INTERNATIONAL

BAUER NIKE HOCKEY

creative firm
NOLIN BRANDING & DESIGN INC.
Montreal, Canada
creative people
GILLES LEGAULT
client
BAUER NIKE HOCKEY

Fundy Cable
We bring you the world…

creative firm
LOGOS IDENTITY BY DESIGN LIMITED
Toronto, Canada
creative people
RENA WELDON,
BRIAN SMITH
client
FUNDY CABLE

creative firm
PETE SMITH DESIGN
TORONTO, CANADA
creative people
PETE SMITH
client
ICC TOOLS

THE 42ND ANNUAL PREMIERS' CONFERENCE

creative firm
TRAPEZE COMMUNICATIONS
Victoria, Canada
creative people
MARK BAWDEN
client
PROTOCOL OFFICE,
PROV. OF BC

creative firm
PHOENIX DESIGN WORKS
New York, New York
creative people
JAMES M. SKILES
client
MLBP

123

Rocky Mountain FOODS

creative firm
MARCIA HERRMANN DESIGN
Modesto, California
creative people
MARCIA HERRMANN
client
ROCKY MOUNTAIN FOODS

KINGSBOROUGH

COMMUNITY COLLEGE

creative firm
MAGICAL MONKEY
New York, New York
creative people
*ROSWITHA RODRIGUES,
RICHARD WILDE*
client
*KINGSBOROUGH
COMMUNITY COLLEGE*

at home
AMERICA®

creative firm
LISKA + ASSOCIATES, INC.
Chicago, Illinois
creative people
LISKA + ASSOCIATES, INC.
client
AT HOME AMERICA

Maritz®

creative firm
KIKU OBATA + COMPANY
St. Louis, Missouri
creative people
*PAUL SCHERFLING, AMY KNOPF,
TERESA NORTON—YOUNG*
client
MARITZ

124

"Here for Good"

Community Foundation for Monterey County

creative firm
THE WECKER GROUP
Monterey, California
creative people
ROBERT WECKER
client
*COMMUNITY FOUNDATION
FOR MONTEREY COUNTY*

NET PERFORMANCE

creative firm
EVENSON DESIGN GROUP
Culver City, California
creative people
*MARK SOJKA,
STAN EVENSON*
client
OVERTURE.COM

creative firm
KIRCHER, INC.
Washington, D.C.
creative people
BRUCE E. MORGAN
client
IAFIS

creative firm
**BARBARA BROWN
MARKETING & DESIGN**
Ventura, California
creative people
*BARBARA BROWN,
JON A. LESLIE*
client
MAVERICKS GYM

NUCLEUS℠
a strategic branding system

creative firm
X DESIGN COMPANY
Denver, Colorado
creative people
ALEX VALDERRAMA
client
X DESIGN COMPANY

SIMTREX

THE SKILLS TO SUCCEED, GUARANTEED.

creative firm
WHISTLE
Atlanta, Georgia
creative people
RYAN GLISSON,
RORY CARLTON
client
SIMTREX CORP.

creative firm
HOLLY DICKENS DESIGN
Chicago, Illinois
creative people
HOLLY DICKENS
client
P&G

Pampers

creative firm
HERIP ASSOCIATES
Peninsula, Ohio
creative people
WALTER M. HERIP,
JOHN R. MENTER
client
CUYAHOGA VALLEY NATIONAL PARK

creative firm
CONFLUX DESIGN
Rockford, Illinois
creative people
GREG FEDOREY
client
ATWOOD MOBILE PRODUCTS

SRBI

Schulman, Ronca & Bucuvalas, Inc.

creative firm
SCHNIDER & YOSHINA LTD.
New York, New York
creative people
LESLEY KUNIKIS
client
SRBI

IMS | SYSTEMS

creative firm
PHOENIX CREATIVE GROUP
Herndon, Virginia
creative people
KATHY BYERS, RANDY POPE
client
IMS SYSTEMS

creative firm
KEEN BRANDING
Charlotte, North Carolina
creative people
MIKE RAVENEY
client
DeMICHO

DeMicho
for the modern life

creative firm
ZGRAPHICS, LTD.
East Dundee, Illinois
creative people
*KRIS MARTINEZ FARRELL,
JOE ZELLER*
client
THE SPICE MERCHANT AND TEA ROOM

creative firm
THE LEYO GROUP
Chicago, Illinois
creative people
JAYCE SCHMIDT
client
WILMINGTON CHILDREN'S MUSEUM

creative firm
OUSLEY CREATIVE
Santa Ana, California
creative people
MIKE OUSLEY
client
CNA TRUST

PlanStat

creative firm
BUTTITTA DESIGN
Healdsburg, California
creative people
*PATTI BUTTITTA,
JEFF REYNOLDS*
client
GREEN MUSIC CENTER

128

GSM Association ✶ Plenary 49

creative firm
FINISHED ART, INC.
Atlanta, Georgia
creative people
MARY JANE HASEK,
LINDA STUART
client
CINGULAR WIRELESS

projectHorizon

creative firm
NORDYKE DESIGN
West Hartford, Connecticut
creative people
JOHN NORDYKE
client
PROJECT HORIZON—COMMUNITY

worldAgriculturalforum

Peace and Security through Agriculture

creative firm
PARADOWSKI GRAPHIC DESIGN
St. Louis, Missouri
creative people
SHAWN CORNELL
client
WORLD AGRICULTURAL FORUM

TATE CAPITAL PARTNERS

creative firm
LARSEN DESIGN + INTERACTIVE
Minneapolis, Minnesota
creative people
JO DAVISON,
BILL PFLIPSEN
client
TATE CAPITAL PARTNERS

creative firm
PORTFOLIO CENTER
Atlanta, Georgia
creative people
PIPER MOORE
client
DOMAIN HOME FURNISHINGS

creative firm
KIRCHER, INC.
Washington, D.C.
creative people
BRUCE E. MORGAN
client
HIRE RETURN, LLC

**BOREALIS
BOOKS**

creative firm
BRAD NORR DESIGN
Minneapolis, Minnesota
creative people
BRAD D. NORR
client
*MINNESOTA HISTORICAL
SOCIETY PRESS*

creative firm
LOGOS IDENTITY BY DESIGN LIMITED
Toronto, Canada
creative people
RENA WELDON, FRANCA DINARDO,
BRIAN SMITH
client
ALPHA STAR TELEVISION NETWORK

creative firm
ART270, INC.
Jenkintown, Pennsylvania
creative people
SUE STROHM
client
DOYLESTOWN SPORTS
MEDICINE CENTER

creative firm
ZD STUDIOS, INC.
Madison, Wisconsin
creative people
MARK SCHMITZ,
TINA REMY
client
GREEN BAY PACKERS

WESTCHESTER

NEIGHBORHOOD
SCHOOL

creative firm
EVENSON DESIGN GROUP
Culver City, California
creative people
KEN LOH, STAN EVENSON
client
WESTCHESTER
NEIGHBORHOOD SCHOOL

creative firm
POOL DESIGN GROUP
Englewood, Colorado
creative people
JEANNA POOL
client
PRUFROCK'S COFFEE

creative firm
PLANIT
Baltimore, Maryland
creative people
JAN KLEMSTINE,
MOLLY STEVENSON
client
NUTRITION 21

creative firm
FUSZION COLLABORATIVE
Alexandria, Virginia
creative people
JOHN FOSTER
client
ART DIRECTORS CLUB
OF METROPOLITAN WASHINGTON

creative firm
PORTFOLIO CENTER
Atlanta, Georgia
creative people
AMANDA MACCAULEY
client
MEXICO CITY

**Real Solutions.
Real Results.**

creative firm
**COMPUTER ASSOCIATES
INTERNATIONAL, INC.**
Islandia, New York
creative people
LOREN MOSS MEYER,
PAUL YOUNG
client
COMPUTER ASSOCIATES

132

PANNAWAY

creative firm
MONDERER DESIGN
Cambridge, Massachusetts
creative people
JASON C.K. MILLER
client
PANNAWAY

creative firm
HARDBALL SPORTS
Jacksonville, Florida
creative people
ANDY GOSENDI
client
GOODRICH & ASSOCIATES

goodrich &
associates

ESOTERA
GROUP

creative firm
CLARK CREATIVE GROUP
San Francisco, California
creative people
ANNE MARIE CLARK, THURLOW WASHAM
client
ESOTERA GROUP, INC.

KenCoat™

creative firm
VIVIDESIGN GROUP
Elizabethtown, Kentucky
creative people
VIVIDESIGN GROUP
client
ARMORCOAT, LLC.

creative firm
PERLMAN COMPANY
Seattle, Washington
creative people
ROBERT PERLMAN
client
GENE'S RISTORANTE

creative firm
LESNIEWICZ ASSOCIATES
Toledo, Ohio
creative people
AMY LESNIEWICZ,
TERRENCE LESNIEWICZ
client
PREVIEW HOME INSPECTION

creative firm
McMILLIAN DESIGN
Brooklyn, New York
creative people
WILLIAM MCMILLIAN
client
ENTERPRISE LOGIC

creative firm
HAMAGAMI/CARROLL
Santa Monica, California
creative people
KRIS TIBOR
client
AMGEN

TRIUMPH
BUILDERS

creative firm
BOELTS/STRATFORD ASSOCIATES
Tucson, Arizonia
creative people
BRETT WEBER, JACKSON BOELTS,
KERRY STRATFORD
client
BOURN/KARIL CONSTRUCTION

creative firm
GAGE DESIGN
Seattle, Washington
creative people
CHRIS ROBERTS
client
IMPINJ, INC.

creative firm
ADDISON WHITNEY
Charlotte, North Carolina
creative people
KIMBERLEE DAVIS,
LISA JOHNSTON,
DAVID HOUK
client
BRINKER INTERNATIONAL

Big Bowl
Asian Kitchen SM

CARRY OUT SM

TAG
THE AMERICAN GROUP
OF CONSTRUCTORS

creative firm
KEYWORD DESIGN
Highland, Indiana
creative people
JUDITH MAYER
client
THE AMERICAN GROUP
OF CONSTRUCTORS, INC.

135

CHRIS**DAVIS**INTERNATIONAL

creative firm
MARYL SIMPSON DESIGN
Tollica Lake, California
creative people
MARYL SIMPSON
client
CHRIS DAVIS

CAL-PACIFIC
CONCRETE, INC.

creative firm
NEVER BORING DESIGN
Modesto, California
creative people
CHERYL CERNIGOJ
client
CAL—PACIFIC CONCRETE, INC.

HEALING
PLACE
MUSIC

creative firm
TOOLBOX STUDIOS, INC.
San Antonio, Texas
creative people
PAUL SOUPISET,
RYAN FOERSTER
client
HEALING PLACE MUSIC

creative firm
THE WECKER GROUP
Monterey, California
creative people
ROBERT WECKER,
HARRY BRIGGS
client
PRODUCE PARADISE

PARC PROVENCE

creative firm
BERKELEY DESIGN LLC
St. Louis, Missouri
creative people
LARRY TORNO
client
PARK PROVENCE/CHARLES DEUTSCH

creative firm
MFDI
Selinsgrove, Pennsylvania
creative people
MARK FERTIG
client
*THE ECCENTRIC
GARDENER PLANT COMPANY*

creative firm
DULA IMAGE GROUP
South Coast Metro, California
creative people
MICHAEL DULA
client
LONNIE DUKA PHOTOGRAPHY

Native Forest
COUNCIL

creative firm
FUNK/LEVIS & ASSOCIATES
Eugene, Oregon
creative people
DAVID FUNK
client
NATIVE FOREST COUNCIL

creative firm
PLATFORM CREATIVE GROUP
Seattle, Washington
creative people
ROBERT DIETZ
client
AHBL

Joie de Charlotte

creative firm
AUE DESIGN STUDIO
Aurora, Ohio
creative people
JENNIFER AUE
client
JOIE DE CHARLOTTE

creative firm
PORTFOLIO CENTER
Atlanta, Georgia
creative people
MARSHAL WOLFE
client
BUNDLES BABY CLOTHES

creative firm
LESNIEWICZ ASSOCIATES
Toledo, Ohio
creative people
AMY LESNIEWICZ
client
ALLIANCE VENTURE MORTGAGE

St. Stephen's

creative firm
SEWICKLEY GRAPHICS & DESIGN, INC.
Sewickley, Pennsylvania
creative people
MICHAEL SEIDL
client
ST. STEPHEN'S

enroute

creative firm
KARL KROMER DESIGN
San Jose, California
creative people
KARL KROMER
client
ENROUTE COURIER SERVICES

Julie Scholz
Certified Clinical Hypnotherapist

creative firm
JIVA CREATIVE
Alameda, California
creative people
JAMES WAGSTAFF
client
JULIE SCHOLZ, CCHT

FORENSIC
Laboratory Technologies

creative firm
PORTFOLIO CENTER
Atlanta, Georgia
creative people
CARMEN BROWN
client
FORENSIC LABS

PEIK

PERFORMANCE

creative firm
EVENSON DESIGN GROUP
Culver City, California
creative people
MARK SOJKA,
STAN EVENSON
client
PEIK PERFORMANCE

MICHAEL TOLLAS
REALTOR®
SM

creative firm
MILESTONE DESIGN, INC.
San Diego, California
creative people
DIANE GIANFAGNA—MEILS
client
MICHAEL TOLLAS

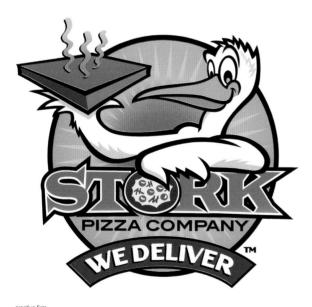

STORK
PIZZA COMPANY
WE DELIVER™

creative firm
DESIGN COUP
Decatur, Georgia
creative people
MICHAEL HIGGINS,
PATRICK FOSTER
client
STORK PIZZA

first coast wine experience

creative firm
HARDBALL SPORTS
Jacksonville, Florida
creative people
ANDY GOSENDI
client
WORLD GOLF FOUNDATION

creative firm
ZD STUDIOS, INC.
Madison, Wisconsin
creative people
MARK SCHMITZ,
TINA REMY
client
GREEN BAY PACKERS

creative firm
MFDI
Selinsgrove, Pennsylvania
creative people
MARK FERTIG
client
BRIDGEHAMPTON MOTORING

creative firm
PHOENIX CREATIVE GROUP
Herndon, Virginia
creative people
KATHY BYERS
client
LAFARGE NORTH AMERICAN,
CORP. COMMUNICATIONS

creative firm
MAGICAL MONKEY
New York, New York
creative people
ROSWITHA RODRIGUES
client
ACADIA CONSULTING GROUP

acadia consulting group, inc.

Appropriate Temporaries

creative firm
THE LEYO GROUP, INC.
Chicago, Illinois
creative people
MIKE KELLY, JASON TURNER,
BILL LEYO
client
APPROPRIATE TEMPORARIES, INC.

creative firm
THE WECKER GROUP
Monterey, California
creative people
ROBERT WECKER,
MATT GNIBUS
client
FIRST CLASS FLYER

creative firm
INGEAR
Buffalo Grove, Illinois
creative people
MATT HASSLER
client
TARGET

a place to grow tm

creative firm
KIKU OBATA + COMPANY
St. Louis, Missouri
creative people
ELEANOR SAFE
client
A PLACE TO GROW

creative firm
GLITSCHKA STUDIOS
Salem, Oregon
creative people
VON R. GLITSCHKA
client
MALLARD CREEK GOLF COURSE

un
Wined

creative firm
MICHAEL NIBLETT DESIGN
Fort Worth, Texas
creative people
MICHAEL NIBLETT
client
UNWINED WINE STORE

COLLEGELABELS.COM

creative firm
MFDI
Selinsgrove, Pennsylvania
creative people
MARK FERTIG,
KEVIN PITTS
client
LABELS-R-US

creative firm
JEFF FISHER LOGOMOTIVES
Portland, Oregon
creative people
JEFF FISHER
client
AIDS RESPONSE—SEACOAST

creative firm
ART270, INC.
Jenkintown, Pennsylvania
creative people
JOHN OPET
client
DRAKE TAVERN

creative firm
BRAD NORR DESIGN
Minneapolis, Minnesota
creative people
BRAD D. NORR
client
BUSINESS INCENTIVES

the
VISIBILITY
company *your world in a whole new light*

creative firm
PARADOWSKI GRAPHIC DESIGN
St. Louis, Missouri
creative people
STEVE COX
client
THE VISIBILITY COMPANY

creative firm
EVENSON DESIGN GROUP
Culver City, California
creative people
MARK SOJKA, STAN EVENSON
client
GALLERY C

GALLERY C

Better Beginnings
Learning Center

creative firm
PORTFOLIO CENTER
Atlanta, Georgia
creative people
DENISE SCHIFER
client
TOULOUSE

creative firm
GRAFIQA
Oneonta, New York
creative people
CHRISTOPHER QUEREAU
client
BETTER BEGINNINGS
LEARNING CENTER

BELL MEMORIALS
& GRANITE WORKS

creative firm
DESIGNFIVE
Fresno, California
creative people
RON NIKKEL
client
BELL MEMORIALS & GRANITE WORK

creative firm
MARCIA HERRMANN DESIGN
Modesto, California
creative people
MARCIA HERRMANN
client
HILLTOP RANCH INC.

CopperFasten

creative firm
BRUCE YELASKA DESIGN
San Francisco, California
creative people
BRUCE YELASKA
client
COPPERFASTEN

NATIVE LANDSCAPES

creative firm
THE LEYO GROUP, INC.
Chicago, Illinois
creative people
JAYCE SCHMIDT
client
NATIVE LANDSCAPES

GO FORTH AND GET FIT

creative firm
WHISTLE
Atlanta, Georgia
creative people
RORY CARLTON
client
*BEAR BODIES
FITNESS STUDIO*

creative firm
SCHNIDER & YOSHINA LTD.
New York, New York
creative people
LESLEY KUNIKIS
client
SWEET RHYTHM

sweet rhythm

fitwest

ascentives

corporate speciality solutions

creative firm
BARBARA BROWN MARKETING & DESIGN
Ventura, California
creative people
BARBARA BROWN,
JON A. LESLIE,
CAROLE BROOKS
client
FITWEST, INC.

creative firm
RULE29
Elgin, Illinois
creative people
JUSTIN AHRENS, JIM BOBORCI,
JON MCGRATH
client
ASCENTIVES

THE GALLERY AT FULTON STREET

creative firm
KOLANO DESIGN
Pittsburgh, Pennsylvania
creative people
CATE SIDES
client
THOR EQUITIES

Retirement Consultants, Ltd.

creative firm
GCG ADVERTISING
Fort Worth, Texas
creative people
PAULA LECK
client
RETIREMENT CONSULTANTS, LTD.

BLACKSTOCK

creative firm
HAMBLY & WOOLEY INC.
Toronto, Canada
creative people
JAYSON ZALESKI,
KATINA CONSTANTINOU
client
BLACKSTOCK LEATHER

TIMOTHY PAUL
C A R P E T S + T E X T I L E S

creative firm
DESIGN NUT
Washington, D.C.
creative people
BRENT M. ALMOND
client
TIMOTHY PAUL
CARPETS & TEXTILES

creative firm
ZD STUDIOS, INC.
Madison, Wisconsin
creative people
MARK SCHMITZ,
TINA REMY
client
GREEN BAY PACKERS

**PEREGRINE
TECHNOLOGY**
SENDIRIAN BERHAD

creative firm
FIXGO ADVERTISING SDN BHD
Selangor, Malaysia
creative people
FGA CREATIVE TEAM
client
PEREGRINE TECHNOLOGY SDN BHD

148

creative firm
HERIP ASSOCIATES
Peninsula, Ohio
creative people
WALTER M. HERIP, JOHN R. MENTER
client
CUYAHOGA VALLEY NATIONAL PARK

Interlocking Media

creative firm
KIRCHER, INC.
Washington, D.C.
creative people
BRUCE E. MORGAN
client
INTERLOCKING MEDIA

c a n o p y

creative firm
PORTFOLIO CENTER
Atlanta, Georgia
creative people
MARSHALL WOLFE
client
CANOPY RESTAURANT

lexicomm

creative firm
ART270, INC.
Jenkintown, Pennsylvania
creative people
SEAN FLANAGAN,
NICOLE GANZ
client
LEXICOMM

globeandmail.com

OLIVES & LEMONS
CATERING

Sunna
GARÐYRKJUSTÖÐ

TELVIS
SOLUTIONS • PRODUCT • SERVICE

LEADINGBRANDS™

creative firm
KARACTERS DESIGN GROUP
Vancouver, Canada
creative people
MARIA KENNEDY,
NANCY WU
client
LEADING BRANDS

creative firm
DESBROW & ASSOCIATES
Pittsburgh, Pennsylvania
creative people
BRIAN LEE CAMPBELL
client
VOCOLLECT

RIVER VALLEY RIDERS
THERAPEUTIC RIDING PROGRAM

creative firm
CAPSULE
Minneapolis, Minnesota
creative people
ANCHALEE CHAMBUNDABONGSE
client
RIVER VALLEY RIDERS

creative firm
KARACTERS DESIGN GROUP
Vancouver, Canada
creative people
MATTHEW CLARK
client
SPIKE BRAND

151

creative firm
PHOENIX DESIGN WORKS
New York, New York
creative people
JAMES M. SKILES, ROD OLLERENSHAW,
CRAIG MILLER, RICHARD TSAI
client
MLBP INTERNATIONAL

creative firm
PORTFOLIO CENTER
Atlanta, Georgia
creative people
DAVID ZORNE
client
COLEMAN OUTDOOR ESSENTIALS

YARDBIRDS
FREE RANGE CHICKENS

creative firm
THE WECKER GROUP
Monterey, California
creative people
ROBERT WECKER
client
SAGE METERING, INC.

creative firm
PORTFOLIO CENTER
Atlanta, Georgia
creative people
DENISE SCHISER
client
YARDBIRDS ORGANIC CHICKEN

SAGE
METERING, INC.

creative firm
OUT OF THE BOX
Fairfield, Connecticut
creative people
RICK SCHNEIDER
client
ANASYS

anasys

creative firm
FINISHED ART, INC.
Atlanta, Georgia
creative people
DOUG CARTER,
DONNA JOHNSTON
client
THE COCA-COLA COMPANY

creative firm
KARACTERS DESIGN GROUP
Vancouver, Canada
creative people
MARIA KENNEDY,
MATTHEW CLARK
client
QUICK

creative firm
LESNIEWICZ ASSOCIATES
Toledo, Ohio
creative people
LES ADAMS
client
SCHMAKEL DENTISTRY

creative firm
MATT TRAVAILLE
GRAPHIC DESIGN
Ocheyedan, Iowa
creative people
MATT TRAVAILLE
client
JDS STABLES

UTILITY SAFETY
CONFERENCE & EXPO

creative firm
PRACTICAL COMMUNICATIONS, INC.
Palatine, Illinois
creative people
BRIAN DANAHER
client
UTILITY SAFETY CONFERENCE & EXPO

R E A D Y

Raising Expectations And Discovering our Youth

creative firm
IM-AJ COMMUNICATIONS & DESIGN, INC.
West Kingston, Rhode Island
creative people
JAMI OUELLETTE,
TYLER HALL,
MARK BEVINGTON
client
PROVIDENCE SCHOOL DEPARTMENT
& THE RI CHILDREN'S CRUSADE

YoungAudiences
of Indiana **arts powering education**

creative firm
STAHL PARTNERS INC.
Indianapolis, Indiana
creative people
DAVID STAHL,
BRIAN GRAY
client
YOUNG AUDIENCES OF INDIANA

webdoctor

creative firm
GLITSCHKA STUDIOS
Salem, Oregon
creative people
VON R. GLITSCHKA
client
WEBDOCTOR

barware

creative firm
MICHAEL ORR + ASSOCIATES, INC.
Corning, New York
creative people
MICHAEL R. ORR,
THOMAS FREELAND
client
ROBINSON KNIFE COMPANY

creative firm
TOOLBOX STUDIOS, INC.
San Antonio, Texas
creative people
PAUL SOUPISET
client
TRINITY BAPTIST CHURCH

creative firm
BARBARA BROWN MARKETING & DESIGN
Ventura, California
creative people
BARBARA BROWN,
JON A. LESLIE
client
RONALD REAGAN
PRESIDENTIAL LIBRARY FOUNDATION

creative firm
ZD STUDIOS, INC.
Madison, Wisconsin
creative people
MARK SCHMITZ,
TINA REMY
client
GREEN BAY PACKERS

Ladle of Love

creative firm
HOLLY DICKENS DESIGN
Chicago, Illinois
creative people
HOLLY DICKENS
client
LADLE OF LOVE

creative firm
FUTUREBRAND
creative people
MICHAEL THIBODEAU,
KEVIN SZELL,
ADAM STRINGER
client
McGRAW-HILL

The McGraw·Hill Companies

creative firm
GCG ADVERTISING
Fort Worth, Texas
creative people
BRIAN WILBURN
client
STRATA CORE

creative firm
LEINICKE DESIGN
Manchester, Missouri
creative people
BOB GAUEN,
TONYA HUGHES
client
OPTITEK, INC.

creative firm
TOOLBOX STUDIOS, INC.
San Antonio, Texas
creative people
STAN MCELRATH,
RAQUEL SAVAGE
client
HOME FIELD SERVICES INC.

creative firm
KARACTERS DESIGN GROUP
Vancouver, Canada
creative people
JEFF HARRISON
client
DESTINA

157

creative firm
PHOENIX DESIGN WORKS
New York, New York
creative people
JAMES M. SKILES, ROD OLLERENSHAW
client
COCA-COLA COMPANIES

MaxMining&Resources

creative firm
THE IMAGINATION COMPANY
Bethel, Vermont
creative people
MICHAEL CRONIN
client
MAX MINING AND RESOURCES

creative firm
DULA IMAGE GROUP
South Coast Metro, California
creative people
MICHAEL DULA
client
MUNIFINANCIAL

creative firm
TOM FOWLER, INC.
Norwalk, Connecticut
creative people
THOMAS G. FOWLER
client
GIDEON CARDOZO

NORTHWESTERN NASAL + SINUS

creative firm
LISKA + ASSOCIATES, INC.
Chicago, Illinois
creative people
HANS KREBS
client
NORTHWESTERN NASAL + SINUS

PINPOINT
TECHNICAL SERVICES

creative firm
McMILLIAN DESIGN
Brooklyn, New York
creative people
WILLIAM MCMILLIAN
client
PINPOINT TECH SERVICES

creative firm
THE LEYO GROUP, INC.
Chicago, Illinois
creative people
HORST MICKLER
client
PLUM GROVE PRINTERS

FINELINE
LITHO

creative firm
NESNADNY + SCHWARTZ
Cleveland, Ohio
creative people
TERESA SNOW
client
FINE LINE LITHO

creative firm
TOP DESIGN STUDIO
Toluia, California
creative people
REBEKAH BEATON,
PELEG TOP
client
RENDEZVOUS ENTERTAINMENT

creative firm
PHOENIX DESIGN WORKS
New York, New York
creative people
JAMES M. SKILES
client
NASCAR

creative firm
PHOENIX DESIGN WORKS
New York, New York
creative people
JAMES M. SKILES, ROD OLLERENSHAW,
CRAIG MILLER, RICHARD TSAI
client
INDIANAPOLIS 500

Westborough
OFFICE PARK

creative firm
DOERR ASSOCIATES
Winchester, Massachusettes
creative people
JOAN WILKING,
LINDA BLACKSMITH
client
ARCHON GROUP

LANTANA

creative firm
ID8 STUDIO/RTKL
Dallas, Texas
creative people
DAMON ROBINSON
client
PUBLIC PROPERTY GROUP

Dream House
for medically fragile children

A home. A family. A future.

creative firm
WHISTLE
Atlanta, Georgia
creative people
RORY CARLTON
client
THE DREAMHOUSE FOR
MEDICALLY FRAGILE CHILDREN

EPS Settlements Group

creative firm
X DESIGN COMPANY
Denver, Colorado
creative people
ALEX VALDERRAMA,
ANDY SHERMAN
client
EPS SETTLEMENTS GROUP

MANHATTAN · BRONX · SARAH NEUMAN CENTER/WESTCHESTER · LIFECARE SERVICES

creative firm
BAILEY DESIGN GROUP
Plymouth Meeting, Pennsylvania
creative people
CHRISTIAN WILLIAMSON,
WENDY SLAVISH,
STEVE PERRY, DAVE FIEDLER
client
THE JEWISH HOME &
HOSPITAL OF NEW YORK

creative firm
AQUEA DESIGN
Las Vegas, Nevada
creative people
ALEX FRAZIER,
RAYMOND PEREZ
client
WALTERS GOLF

creative firm
PHOENIX DESIGN WORKS
New York, New York
creative people
JAMES M. SKILES, ROD OLLERENSHAW
client
WALT DISNEY COMPANIES

creative firm
KOLANO DESIGN
Pittsburgh, Pennsylvania
creative people
TIM CARRERA,
ADRIENNE CIUPRINSKAS
client
PHARMACHEM LABORATORIES, INC.

creative firm
PHOENIX DESIGN WORKS
New York, New York
creative people
*JAMES M. SKILES, ROD OLLERENSHAW,
CRAIG MILLER, RICHARD TSAI*
client
SAINT JOSEPH'S UNIVERSITY

creative firm
POOL DESIGN GROUP
Englewood, Colorado
creative people
JEANNA POOL
client
PHIL'S NATURAL FOOD GROCERY

creative firm
OUSLEY CREATIVE
Santa Ana, California
creative people
MIKE OUSLEY
client
OUTDOORS CLUB

creative firm
MFDI
Selinsgrove, Pennsylvania
creative people
*MARK FERTIG,
RICHARD HILLIARD*
client
BIRDPLAY

PINNACLE
Environmental

creative firm
GCG ADVERTISING
Fort Worth, Texas
creative people
BILL BUCK
client
PINNACLE ENVIRONMENTAL

162

How to get yourself out of the dumps and onto a positive path

By Robert McGarvey and Babs S. Harrison
Illustrations by Lisa Manning

No sales rep manages to avoid a slump forever. In a tough economy it may seem as if nothing is going right. So it's natural to ask yourself: "Why bother?" Well, the reality is that deals sometimes fall through, the economy may not be able to take off, a rep may suffer rejection after rejection, and the best customers in the world may have to cut back on their orders. You can't do much about all that. It's simply a part of sales. So what do you do about it – drown in self-pity, throw a temper tantrum, look for another career? While these reactions may seem like a good idea at the time, the real key is to keep pumped up until the situation changes. Even little things can work wonders to improve any salesperson's outlook. Consider the following tips – they'll help you to not only ride out the rough patches but also come out with the right attitude to boost sales.

Next!

How do you stomach rejection after rejection and stay upbeat? Mark Victor Hansen, co-creator of *Chicken Soup for the Soul* (Heath Communications, 1993), swears by the N-E-X-T formula. As he points out, "Everybody gets rejected. Count on it. And you have to know how to deal with it." A prime prospect will say, "No thanks;" key customers will shift their business elsewhere and, well, those things happen. At that point, if you don't have a plan for meeting rejection head-on, you'll lose important momentum and begin to falter.

To avoid that, "Use this formula: N-E-X-T," Hansen explains. "If a prospect says no, go to the next one on your list. If an idea doesn't work, immediately go to the next one. 'Next' is the most important word I know. Whenever something doesn't work for me, I just tell myself, 'Next!' It works." Remember what N-E-X-T can do. It helped transform Hansen into a multimillionaire. Perhaps it will work for you.

Make a Journal

According to speaker and author Jim Reilly, "I keep a journal which I refer to as my idea book. I throw in motivating stories clipped from newspapers, such as stories on Tiger Woods. Read these and you are reminded how other people struggled and persevered."

Reilly also advises keeping in the book a list of everything you are really proud of, from accomplishments to things your kids have done, and reviewing it when you're down. The next time you feel you cannot do anything worthwhile, flip your book open and – right there in front of you – you'll see that not only have others done amazing things, so, too, have you.

SELLING POWER NOVEMBER/DECEMBER 2001 **69**

creative firm
SELLING POWER
Fredericksburg, Virginia
creative people
MICHAEL AUBRECHT,
LISA MANNING
client
SELLING POWER MAGAZINE

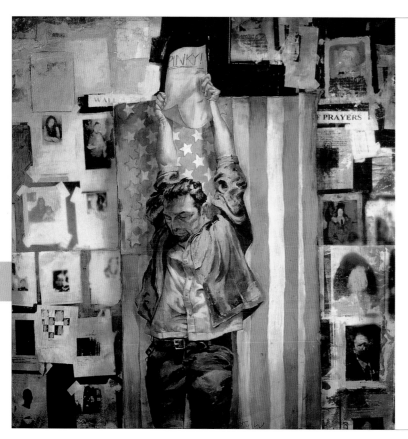

a last call from

the burning tower

PINKY

sent abel on a

desperate quest

fiction By Walter Mosley

I was stuck at Norfolk International Airport for seven hours on September 11. I had flown down there the night before to give a Tuesday-morning talk to an important group of educators about the reading habits of teenagers in the inner city. I had been working as a researcher, studying adolescent school behavior and doing postdoc work at NYU for the past six years, but this was the first time I had been called upon to discuss my findings.

The conference was canceled, of course. Thousands dead and the world on the brink of war; no one seemed to care about much other than the television news reports.

Everybody was talking about the World Trade Center and the number of bodies, about terrorists and the Middle East, as if the Middle East had never existed before that day. Pictures of men and women in traditional Arabic and Islamic dress appeared now and then on the airport TV screens. The president spoke and everyone listened closely, and afterward they discussed his innuendos and the possible ramifications.

But mostly they talked about the dead and expressed shock that terrorists could be so cunning and evil. People cried and held on to one another. I saw the towers fall dozens of times on CNN.

"Terrible, terrible," a woman sitting next to me said over and over. I finally had to move away from her.

I've lived in New York for 13 years, but I couldn't think of anyone I knew who worked in the towers, or even near them. The spectacle was terrifying—the jet almost languidly gliding until it exploded

71

PAINTING BY KENT WILLIAMS

creative firm
**PLAYBOY ENTERPRISES
INTERNATIONAL, INC.**
Chicago, Illinois
creative people
*TOM STAEBLER, KENT WILLIAMS,
KERIG POPE*
client
PLAYBOY MAGAZINE

creative firm
SELLING POWER
Fredericksburg, Virginia
creative people
TARVER HARRIS
client
SELLING POWER MAGAZINE

How a good job description is an indispensable asset for hiring smarter and closing more sales

The Whole Picture

By William F. Kendy
Illustrations by Anders Wenngren

"IT'S NOT PART OF MY JOB." How many times have you heard your salespeople say these words? Maybe they were just trying to get out of doing a part of their job that they dislike. Or more likely they have a less-than-adequate job description and don't really know what's expected of them.

Ask sales managers and they'll be the first to admit that creating job descriptions is not the most glamorous aspect of their job – and certainly not the easiest. Nevertheless, identifying the tasks that salespeople are responsible for is vital to an organization's sales success.

Where is the best place to start? "The first thing a sales manager should do when creating a job description is determine what the ultimate goal is for that specific job function," says Sharon Collins, sales manager for AutoTrader in Charlotte, NC. "A job description is basically a road map for your sales reps, with starting and stopping points and a clear goal."

Good advice. However, as anyone who uses a map knows, sometimes the most fruitful journeys include a detour now and then.

Making A Mark

Even with the German economy in a slump, American law firms cannot afford to stay away.

By Tom Blass

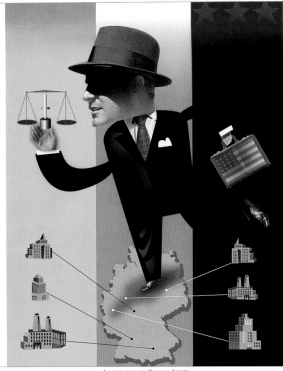

THE OPENING OF A German office by New York's Shearman & Sterling in 1991 seemed like a pretty modest move. Based in Düsseldorf with four lawyers, Shearman's practice appeared Lilliputian in comparison to those of the resident Gullivers. But when the firm's roster soon grew to include a number of name-brand German clients such as Hoechst AG and Thyssen AG, the locals were none too pleased. Sentiment against the interloper reached such a pitch that in 1992 the natives went to court. "The Düsseldorf bar attempted to sue us, arguing that as neither Mr. Shearman or Mr. Sterling had ever practiced law in Germany, the firm had no right to use the name," says Shearman partner Hans Jürgen Meyer-Lindemann.

By the time Shearman won the suit five years later, the firm was regarded as a leading corporate player that could stand its ground with the best of the locals. One deal in particular solidified the firm's standing—and drove home the message that the out-of-towners could not be easily dismissed. "It was when Shearman represented Daimler in its acquisition of Chrysler that we realized we'd have to take notice of foreign competition," says a partner at Stuttgart's Gleiss Lutz Hootz Hirsch.

Germany's economy may be in the doldrums, but it remains a magnet for U.S. firms. Pioneers like Shearman now have plenty of competition—from domestic firms, foreign firms, and their own compatriots. Three U.K. leaders—Freshfields, Clifford Chance, and Linklaters—went after the market in the late 1990s and established themselves through mergers with top domestic firms. Those global giants certainly command attention and attract enviable assignments. But size isn't everything. The U.S. firms, which mostly entered on a smaller scale, have nevertheless mounted their own land rush. At least 17 U.S. firms show up in the Martindale-Hubbell listings for Frankfurt, the favored destination so far. But other cities, Munich in particular, have become popular [see "Market of the Moment," page 139]. Client opportunities in Germany—Europe's largest national economy—are varied. German companies have wanderlust—and manifold international interests and legal needs. Banks and other financial institutions have also been the source of much business.

In a crowded market, where most everyone is clamoring to bring German talent on board, the U.S. firms have a trump card: financial clout. "We haven't found hiring too difficult," says the managing partner of the Frankfurt office of a New York firm. "We pay at the top end of the [Frankfurt] salary scale—and then some." The going rate for first-year associates at leading Frankfurt firms is around 80,000 euros a year.

But money is not all that the Americans have to offer. Many local lawyers who fear losing their independence at one of the U.K. giants are attracted to U.S. firms, which allow their German attorneys more freedom. "Yes, the U.S. firms are offering financial incentives," says one German partner at a U.S. firm in Hamburg. "But there's also the advantage of better access to U.S. clients and the fact that [U.S. firms] seem to be happier with more autonomy in their German offices than are their U.K. counterparts."

Even as some firms put the brakes on their expansion plans in the wake of the global slowdown, others insist that Germany is simply too important a market to ignore—even if there's no imminent payoff. "Apart from anything, we are having to open for defensive reasons," says one managing partner of the Frankfurt office of a U.S. firm. "If we're not in Germany, we'll lose a lot of work."

The first U.S. firms arrived in Germany in 1991, around the same time as Shearman, shortly after the German government relaxed the rules that had long barred foreign lawyers from practicing. They were drawn largely by U.S. investment bank clients that had set up Frankfurt subsidiaries in the 1980s—and by the opportunities created by reunification, which had generated huge volumes of new foreign and domestic investment as the industries of the former East Germany were privatized. Most handled that business from Frankfurt, the banking center.

One of the first arrivals, New York's Cleary, Gottlieb, Steen & Hamilton, already had a well-established practice advising U.S. investment clients on their German interests from the firm's offices in London and Paris. "With reunification, we saw an enormous demand for legal services," says Christof von Dryander, managing partner of Cleary's Frankfurt office. An early Cleary client was that effervescent vanguard of capitalism, The Coca-Cola Company, one of the largest investors in the former East Germany. Cleary's office remains modest in size, despite its relative longevity. Its eight partners and 27 associates all work out of Frankfurt. Cleary's portfolio of U.S. investment bank clients, which includes The Goldman Sachs Group, Inc.; Lehman Brothers Holdings Inc.; Morgan Stanley Dean Witter & Co.; and UBS Warburg, remains an important part of the firm's practice. But major German institutions, including Commerzbank AG; Deutsche Bank AG; Deutsche Börse AG; and Deutsche Telekom AG now provide a significant amount of corporate and finance-related work, says von Dryander.

continued on page 143

ILLUSTRATION BY WILLIAM RIESER

creative firm
THE AMERICAN LAWYER
New York, New York
creative people
DARLENE SIMIDIAN,
WILLIAM RIESER
client
THE AMERICAN LAWYER

creative firm
THE AMERICAN LAWYER
New York, New York
creative people
JOAN FERRELL,
NICHOLAS WILTON
client
THE AMERICAN LAWYER

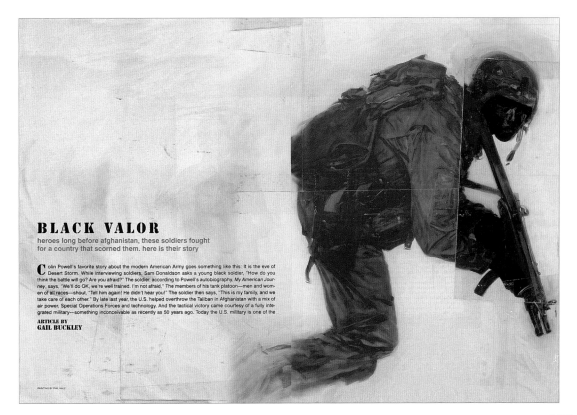

BLACK VALOR

heroes long before afghanistan, these soldiers fought for a country that scorned them. here is their story

Colin Powell's favorite story about the modern American Army goes something like this: It is the eve of Desert Storm. While interviewing soldiers, Sam Donaldson asks a young black soldier, "How do you think the battle will go? Are you afraid?" The soldier, according to Powell's autobiography, *My American Journey*, says, "We'll do OK, we're well trained. I'm not afraid." The members of his tank platoon—men and women of all races—shout, "Tell him again! He didn't hear you!" The soldier then says, "This is my family, and we take care of each other." By late last year, the U.S. helped overthrow the Taliban in Afghanistan with a mix of air power, Special Operations Forces and technology. And the tactical victory came courtesy of a fully integrated military—something inconceivable as recently as 50 years ago. Today the U.S. military is one of the

ARTICLE BY
GAIL BUCKLEY

PAINTING BY PHIL HALE

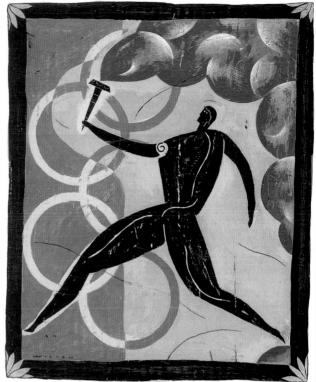

ILLUSTRATION BY NICHOLAS WILTON

THE STRAIGHT

DOPE

A probe led by Skadden's Bob Bennett levels withering criticism at the U.S. track federation for its handling of athlete drug charges.

By Susan Beck

I N THE SUMMER OF 1999 AN AMERICAN TRACK AND FIELD ATHLETE TESTED POSITIVE for a banned steroid during a competition. A urine sample showed the presence of nandrolone, which builds muscle mass. A USA Track & Field hearing panel ruled that the athlete was guilty of doping and imposed a suspension. Then, two months before the start of last year's summer Olympics in Sydney, a USATF appeals panel overturned the decision. The athlete, whose name has never been publicly revealed, competed in Sydney.

Was justice done? Did the system work by giving a clean athlete the chance to clear his or her name? Or did a dirty athlete flex enough legal muscle to get into and possibly medal in the Olympics?

That's one of the questions left hanging in the wake of a nine-month investigation by a commission of four international sports experts, assisted by New York's Skadden, Arps, Slate, Meagher & Flom. USATF appointed the commission a year ago, in the wake of charges during the Sydney Olympics that the U.S. track federation was concealing information about athlete doping. The commission was asked to examine whether anyone at USATF had covered up positive drug tests, and review the organization's overall doping adjudication program during the 20 months before the Olympics.

The Skadden team, led by Washington, D.C., partner Robert Bennett, pursued these issues with all the investigative zeal expected from the man who defended President Bill Clinton in the Paula Jones case. They interviewed more than 60 witnesses in North America and Europe and pored over doping case files. The commission itself included two recognized experts in the field of doping adjudication. Chairman Richard McLaren of the University of Western Ontario is a veteran sports arbitrator, and New Zealand barrister David Howman heads the World Anti-Doping Agency's legal committee.

When the commission released its 104-page report this summer, it cleared the organization of the cover-up charges. But the result was hardly a victory for USATF. The report criticized its day-to-day handling of doping cases, rebuking it for its adversarial approach, its failure to follow its own rules, and a

creative firm
PLAYBOY ENTERPRISES INTERNATIONAL, INC
Chicago, Illinois
creative people
TOM STAEBLER, PHIL HALE, ROB WILSON
client
PLAYBOY MAGAZINE

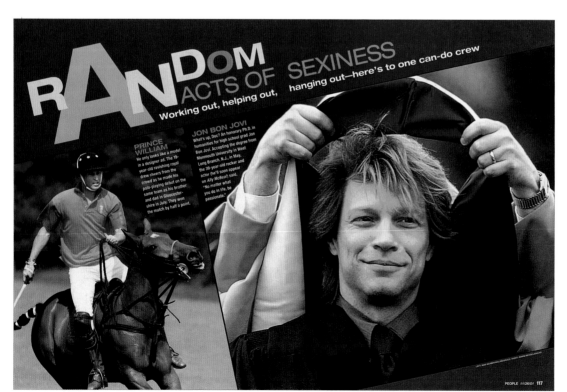

rANDom ACTS OF SEXINESS

Working out, helping out, hanging out—here's to one can-do crew

PRINCE WILLIAM
He only looks like a model in a designer ad. The 19-year-old ravishing royal drew cheers from the crowd as he made his polo-playing debut on the same team as his brother and dad in Gloucestershire in July. They won the match by half a point.

JON BON JOVI
What's up, Doc? An honorary Ph.D. in humanities for high school grad Jon Bon Jovi. Accepting the degree from Monmouth University in West Long Branch, N.J., in May, the 39-year-old rocker and actor (he'll soon appear on Ally McBeal) said, "No matter what you do in life, be passionate."

PEOPLE 11/26/01 **117**

creative firm
PEOPLE SPECIAL ISSUES
New York, New York
creative people
GREGORY MONFRIES, JANICE HOGAN
client
PEOPLE MAGAZINE

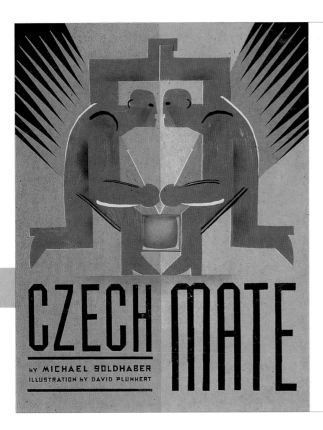

creative firm
THE AMERICAN LAWYER
New York, New York
creative people
JOAN FERRELL,
DAVID PLUNKERT
client
THE AMERICAN LAWYER

creative firm
THE AMERICAN LAWYER
New York, New York
creative people
JOAN FERRELL,
JUD GUITTEAU
client
THE AMERICAN LAWYER

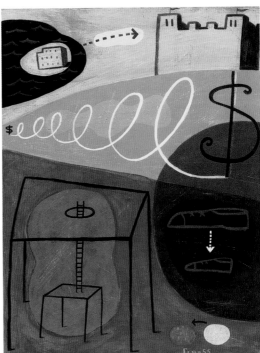

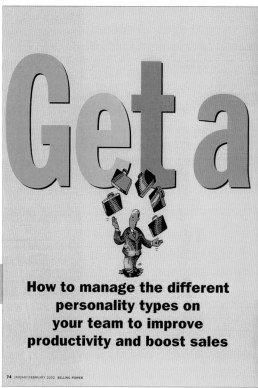

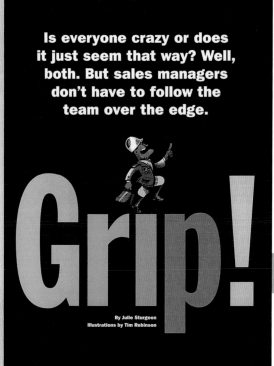

Get a Grip!

Is everyone crazy or does it just seem that way? Well, both. But sales managers don't have to follow the team over the edge.

How to manage the different personality types on your team to improve productivity and boost sales

By Julie Sturgeon
Illustrations by Tim Robinson

creative firm
SELLING POWER
Fredericksburg, Virginia
creative people
*COLLEEN MCCUDDEN,
TIM ROBINSON*
client
SELLING POWER MAGAZINE

creative firm
THOMSON MEDICAL ECONOMICS
Montvale, New Jersey
creative people
*BARRY BLACKMAN, DONNA MORRIS,
ROGER DOWD*
client
MEDICAL ECONOMICS FOR OBGYNS

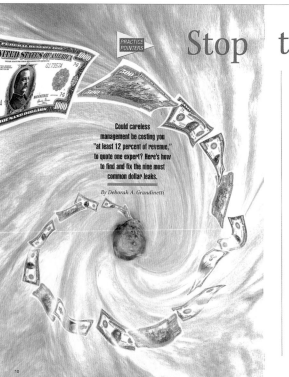

Medical Economics
OCTOBER 2001

PRACTICE POINTERS

Stop the money drain!

Could careless management be costing you "at least 12 percent of revenue," to quote one expert? Here's how to find and fix the nine most common dollar leaks.

By Deborah A. Grandinetti

You may not be able to stop reimbursements from declining, but some things that affect practice income *are* within your control. If you look closely enough, you may find a number of areas where you can pocket dollars that are now being lost needlessly. Indianapolis practice management consultant Michael D. Brown says that physicians "easily lose at least 12 percent" of their revenue through carelessness.

Here are nine key areas to explore. The practice management experts we consulted say these are the most common money-losing mistakes primary care physicians make.

Mistake 1
Coding too conservatively
It's natural to want to reduce your risk of an audit. But needless downcoding was the top problem each of our experts cited when asked about the typical ways primary care physicians lose money.

Every time a northern New Jersey physician uses a 99212 when he can legitimately claim a 99213, for instance, he's out $15. If he does that routinely over the course of a year, the potential for lost income is enormous.

Practice management consultant David C. Scroggins has done coding checkups for many of his clients. "It's amazing how often doctors downcode on evaluation and management services," says the Cincinnati expert, who's with Clayton L. Scroggins Associates. "I've found that one doctor out of every three or four is really in trouble. That doctor could be losing $20,000 a year. Other doctors may have one category of visits coded properly, but several others are way off."

Fix the problem, and "the money goes straight into your pocket," says Scroggins.

The author is a former Senior Editor of Medical Economics.

How do you do that? Read up on coding and attend a coding seminar once or twice a year. "In primary care, you make your money from approximately 15 codes—for new and established office and hospital visits," says Scroggins. "Family physicians may use the same four codes for established patient visits 4,000 to 5,000 times a year. These represent about $250,000 of their income. To get paid, you've got to know what the rules are."

Smart computer software—including programs that can be used with a pocket-size personal digital assistant—also knows the rules and will compute the codes for you. But use it as an aid, not as a substitute for your own efforts.

If you're too rushed to do the necessary documentation to be paid in full, invest in a system that uses voice recognition technology so you don't have to chart manually, suggests Ted Byer, a practice management consultant with Mintz Rosenfeld in Fairfield, NJ. Some systems allow you to dictate your notes into a digital recorder small enough to carry from exam room to exam room.

At the end of the day, you or your assistant can download the audio file into the office computer. The next morning, your chart notes will be in the printer, ready for you to proofread.

Mistake 2
Accruing too much staff overtime
"Many physicians are unaware of how much overtime they're paying employees," says Sherry Migliore, a director of consulting for PMSCO, a subsidiary of the Pennsylvania Medical Society. But time-and-a-half pay can add up quickly, especially if employees are asked to work overtime regularly. If that's the case, you need to find more-creative ways to staff your office.

Let's say that staff members arrive at the office on time, but you're always late—and that you ask key people to stay until you fin-

10

11

168

creative firm
NASSAR DESIGN
Brookline, Massachussettes
creative people
NELIDA NASSAR,
MARGARITA ENCONIENDA
client
THE AMERICAN LAWYER

ENVIRONMENTAL GRAPHICS

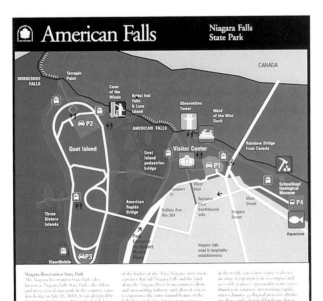

creative firm
KRAHAM & SMITH
Chatham, New York
creative people
RICH KRAHAM
client
NYS DEP'T PARKS &
RECREATION

creative firm
CORBIN
Traverse City, Michigan
creative people
JEFF CORBIN, ROBERT BRENGMAN,
HEATH GNEPPER
client
FERRIS STATE UNIVERSITY

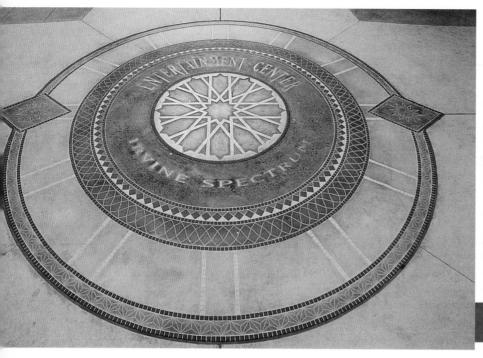

creative firm
ID8 STUDIO/RTKL
Los Angeles, California
creative people
PAUL F. JACOB III,
KATHERINE J. SPRAGUE,
KEVIN HORN, DAVE SCHMITZ
client
IRVINE COMPANY

creative firm
LORENC + YOO DESIGN
Roswell, Georgia
creative people
JAN LORENC, CHUNG YOO, DAVID PARK,
MARK MALAER, SAKCHAI RANGSIYAKORN,
SUSIE NORRIS, KEN BOYD,
STEVE MCCALL, GARY FLESHER
client
WYCLIFFE

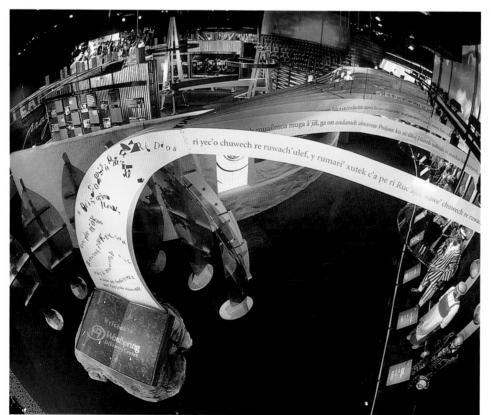

creative firm
HORNALL ANDERSON DESIGN WORKS, INC.
Seattle, Washington
creative people
*JACK ANDERSON, LISA CERVENY,
SONJA MAX, JAMES TEE,
ANDREW SMITH, MICHAEL BRUGMAN*
client
JAMBA JUICE

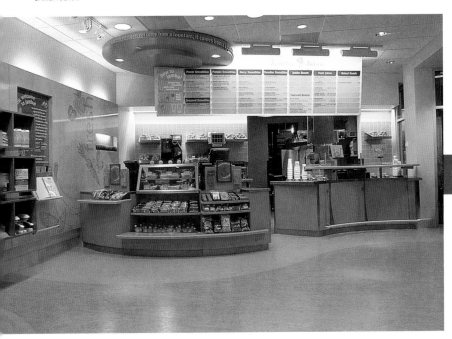

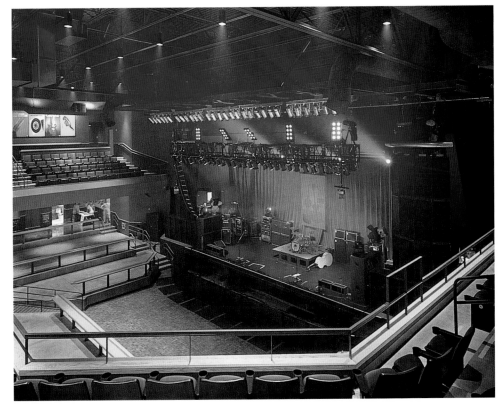

creative firm
KIKU OBATA + COMPANY
St. Louis, Missouri
creative people
*KIKU OBATA, KEVIN FLYNN,AIA,
DENNIS HYLAND, AIA, LAURA MCCANNA,
RICH NELSON, TOM KOWALSKI,
JEF EBERS, JON MILLER*
client
THE PAGEANT

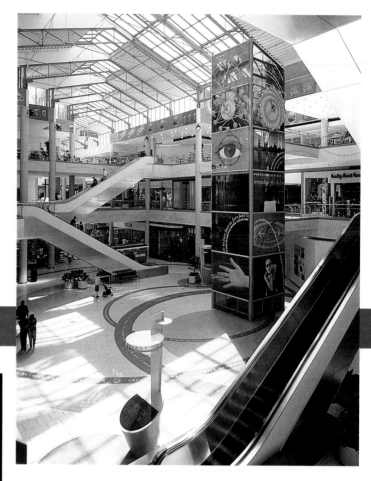

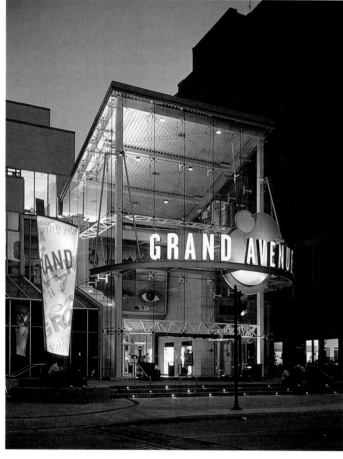

creative firm
KIKU OBATA + COMPANY
St. Louis, Missouri
creative people
*KIKU OBATA, TODD MAYBERRY,
RICH NELSON, TROY GUZMAN,
AMBER ELLI, DENISE FUEHNE,
CAROLE JEROME*
client
PALISADES REALTY

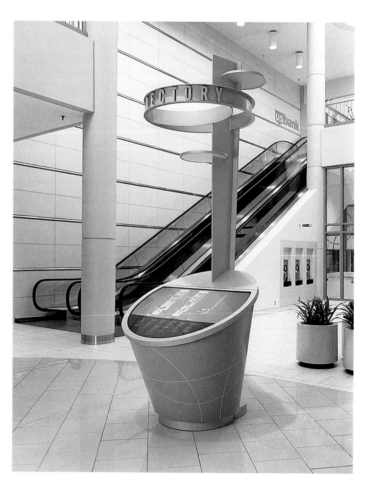

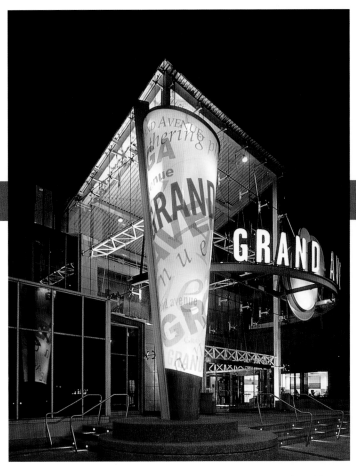

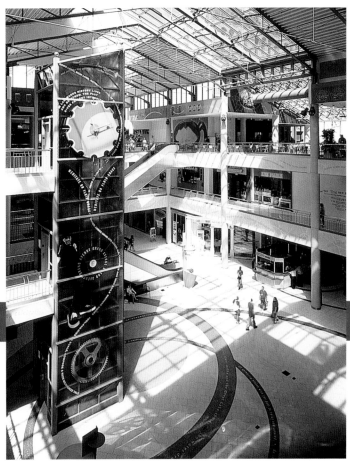

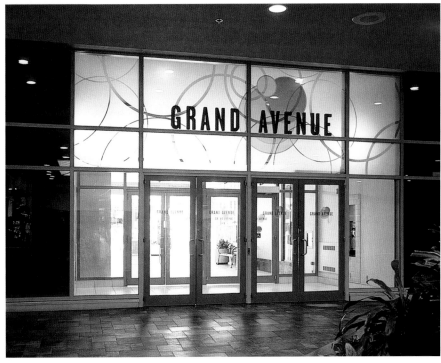

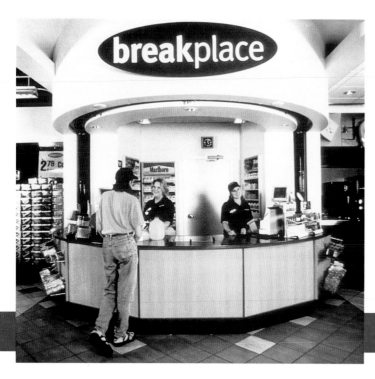

creative firm
LIPPINCOTT & MARGULIES
New York, New York
creative people
CONSTANCE BIRDSALL
client
CONOCO "BREAKPLACE"

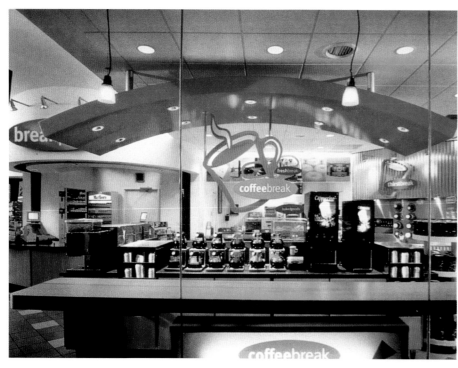

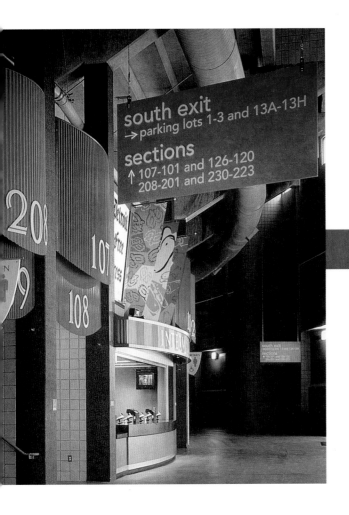

south exit
→ parking lots 1-3 and 13A-13H

sections
↑ 107-101 and 126-120
208-201 and 230-223

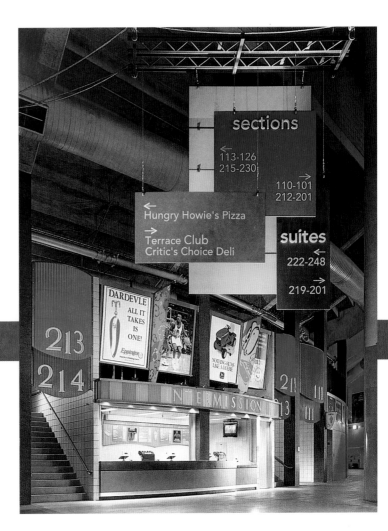

sections
← 113-126
 215-230
→ 110-101
 212-201

← Hungry Howie's Pizza
→ Terrace Club
 Critic's Choice Deli

suites
← 222-248
← 219-201

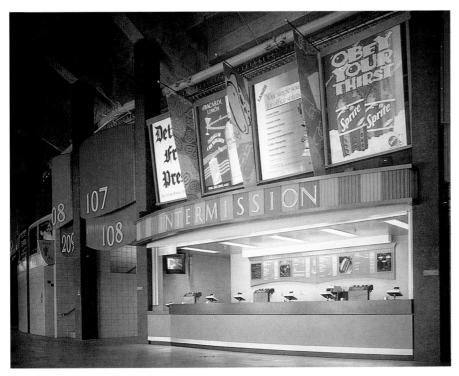

creative firm
KIKU OBATA + COMPANY
St. Louis, Missouri
creative people
*KIKU OBATA, RUSSELL BUCHANAN JR.,
JOHN SCHEFFEL, ANSELMO TESTA, AIA,
KAY PANGRAZE, LIZ SULLIVAN, JEANNA STOLL,
HEATHER TESTA, AIA, AL SACUI*
client
PALACE OF AUBURN HILLS

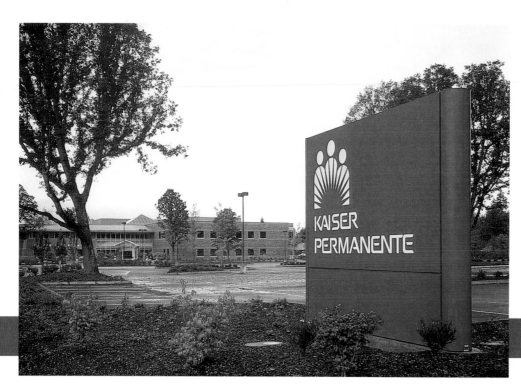

creative firm
ODIUM, INC.
Portland, Oregon
creative people
RICHARD A. GOTTFRIED,
MIKE KIBBEE
client
KAISER PERMANENTE NORTHWEST

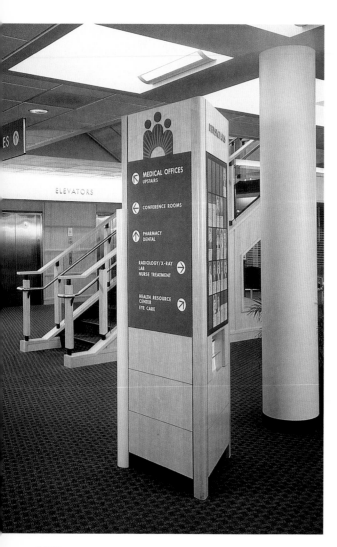

creative firm
ODIUM, INC.
Portland, Oregon
creative people
*RICHARD A. GOTTFRIED,
MIKE KIBBEE*
client
S & G PROPERTIES, NW LLC

creative firm
IMS
Chicago, Illinois
creative people
JAMIE ANDERSON
client
NAVY PIER

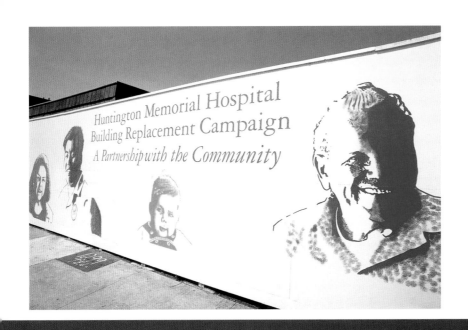

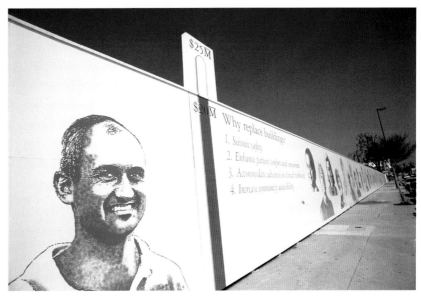

creative firm
DENNIS S. JUETT & ASSOCIATES INC.
Pasadena, California
creative people
DENNIS S. JUETT
client
HUNTINGTON MEMORIAL HOSPITAL

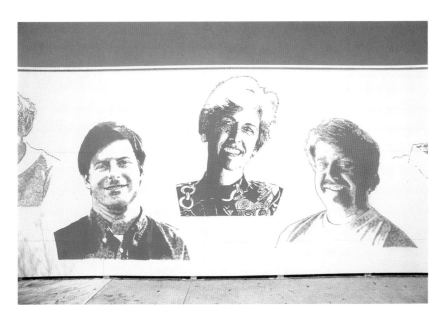

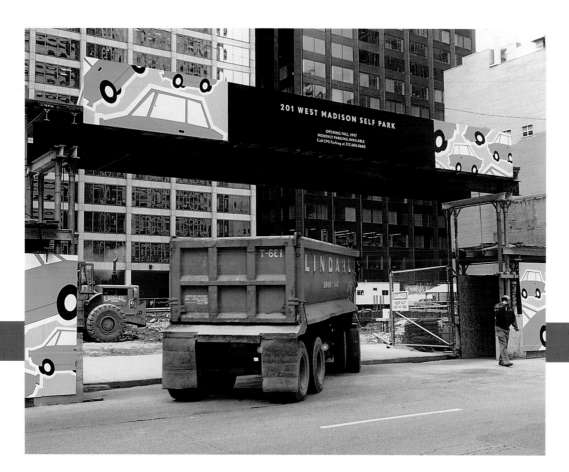

creative firm
IMS
 Chicago, Illinois
creative people
 JAMIE ANDERSON
client
 FIFIELD DEVELOPMENT COMPANY

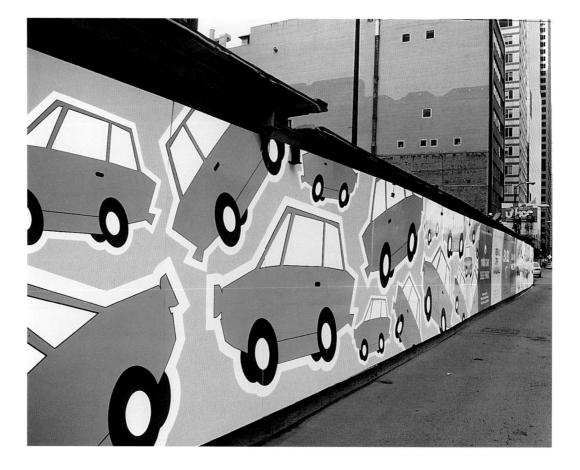

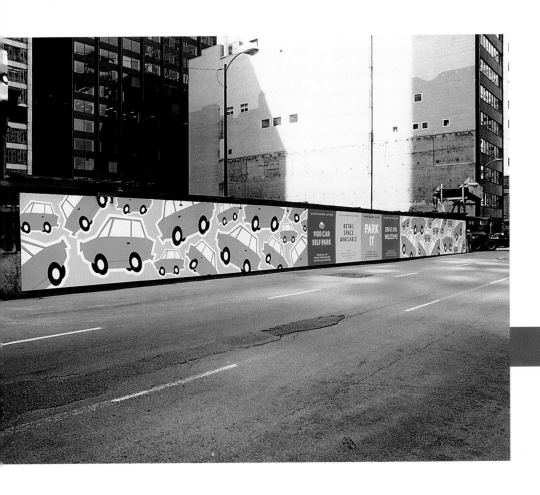

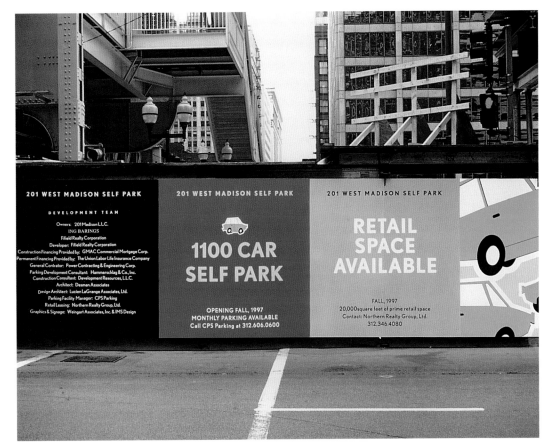

creative firm
TWO TWELVE ASSOCIATES
New York, New York
creative people
ANDY SIMONS,
CESAR SANCHEZ
client
CHICAGO PARK DISTRICT

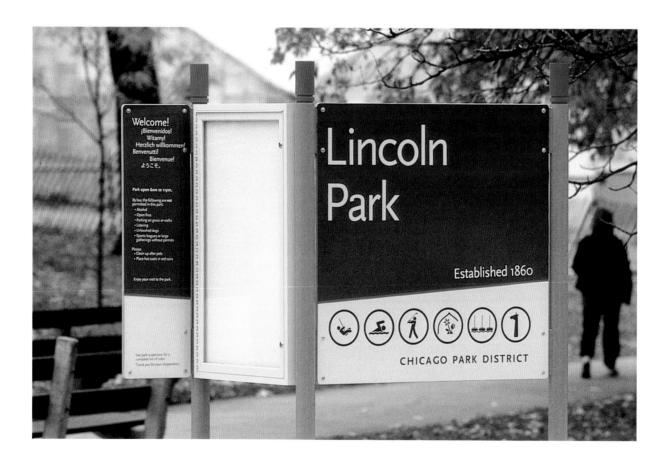

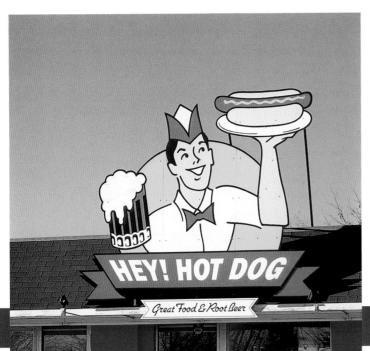

creative firm
BULLET COMMUNICATIONS, INC.
Joliet, Illinois
creative people
TIM SCOTT
client
HEY! HOT DOG RESTAURANT

creative firm
CORBIN DESIGN
Traverse City, Michigan
creative people
ROBERT BRENGMAN
client
OAKLAND UNIVERSITY
ROCHESTER, MICHIGAN

creative firm
ADDISON DESIGN CONSULTANTS PTE LTD
Singapore, China
client
CHINA REBAR CO., LTD.

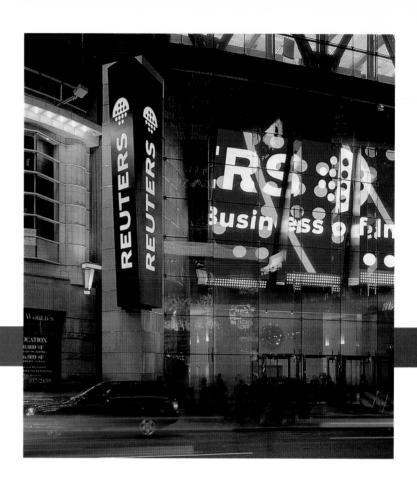

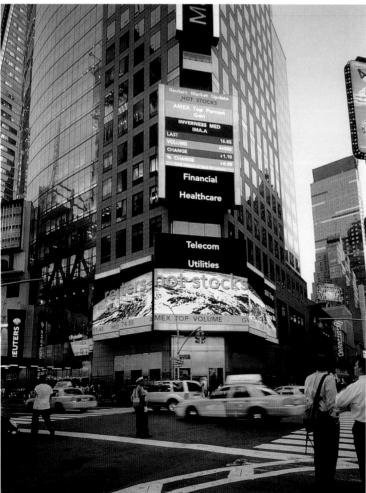

creative firm
ESI DESIGN
New York, New York
creative people
*EDWIN SCHLOSSBERG,
JOE MAYER,
STACEY LISHERON,
MARTHA GARVEY,
MATTHEW MOORE,
GIDEON D'ARCANGELO,
ANGELA GREENE,
JOHN ZAIA,
MARK CORRAL,
DEAN MARKOSIAN,
NAOMI MIRSKY,
RON MCBAIN*
client
REUTERS NORTH AMERICA AND INSTINET CORP

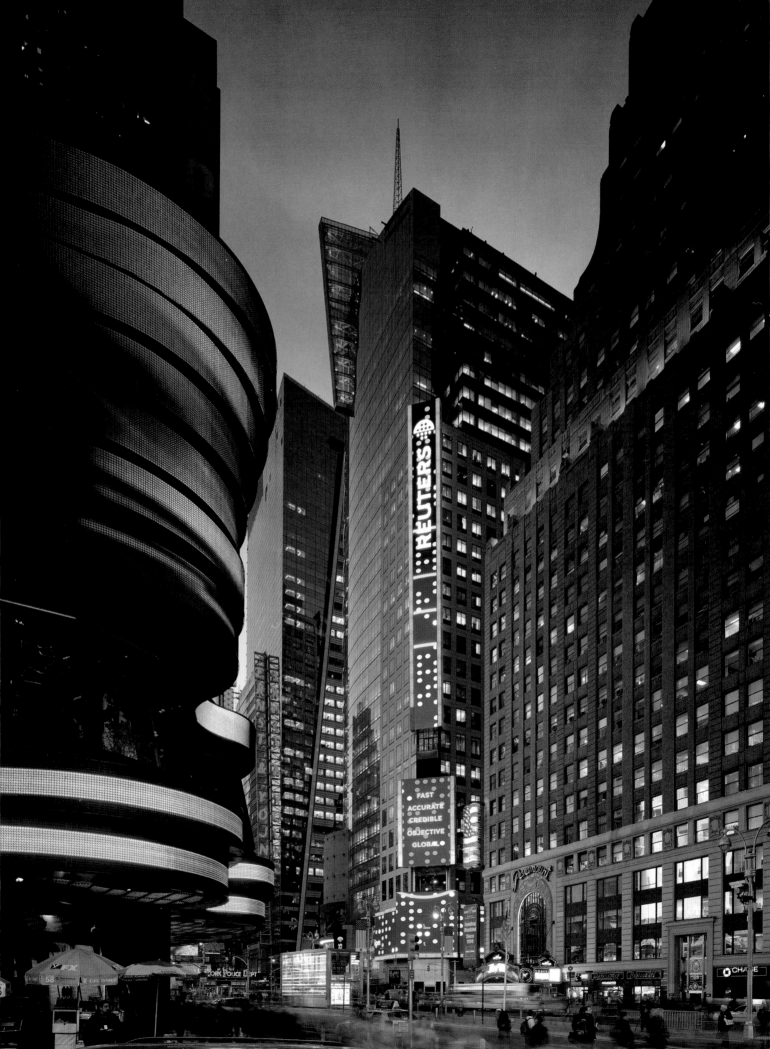

creative firm
CORBIN DESIGN
Traverse City, Michigan
creative people
ROBERT BRENGMAN,
JIM HARPER
client
CLARIAN HEALTH
INDIANAPOLIS, IN

creative firm
NOBLE ERICKSON INC.
Denver, Colorado
creative people
STEVEN ERICKSON, ROBIN H. RIDLEY,
NOAH DEMPEWOLF
client
ENGLE HOMES/THE JAMES COMPANY

creative firm
SMITH DESIGN ASSOCIATES
Charleston, Indiana
creative people
CHERYL SMITH
client
CITY OF JEFFERSONVILLE, INDIANA

creative firm
LORENC + YOO DESIGN
Roswell, Georgia
creative people
*JAN LORENC, CHUNG YOO,
DAVID PARK, MARK MALAER,
SAKCHAI RANGSIYAKORN,
SUSIE NORRIS, KEN BOYD,
STEVE MCCALL*
client
SONY ERICSSON

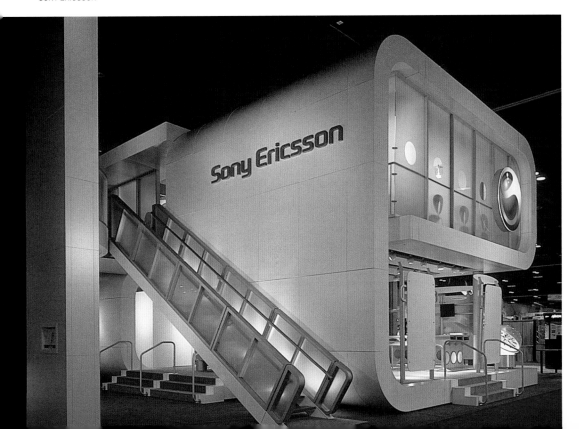

189

creative firm
KINGGRAPHIC
Hong Kong, China
creative people
HON BING-WAH
client
FAR EAST ORGANIZATION

creative firm
JONES WORLEY DESIGN INC.
Atlanta, Georgia
creative people
NELSON HAGOOD,
BARRY WORLEY
client
GEORGIA WORLD CONGRESS CENTER

creative firm
FUNK/LEVIS & ASSOCIATES
Eugene, Oregon
creative people
CHRISTOPHER BERNER
client
CAFE YUMM!

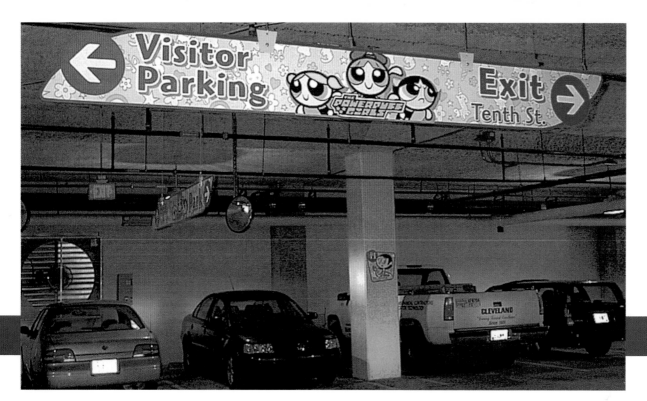

creative firm
JONES WORLEY DESIGN INC.
Atlanta, Georgia
creative people
BARRY NATION,
BARRY WORLEY
client
TURNER PROPERTIES

creative firm
YUGUCHI & KROGSTAD, INC.
Los Angeles, California
creative people
CLIFFORD YUGUCHI,
KOJI TAKEI
client
WELLS FARGO BANK

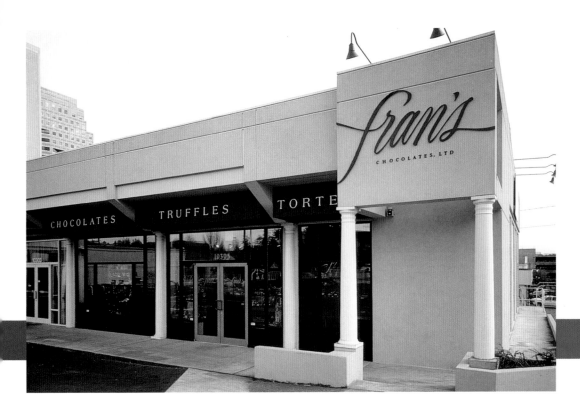

creative firm
WALSH & ASSOCIATES, INC.
Seattle, Washington
creative people
MIRIAM LISCO
client
FRAN'S CHOCOLATES LTD.

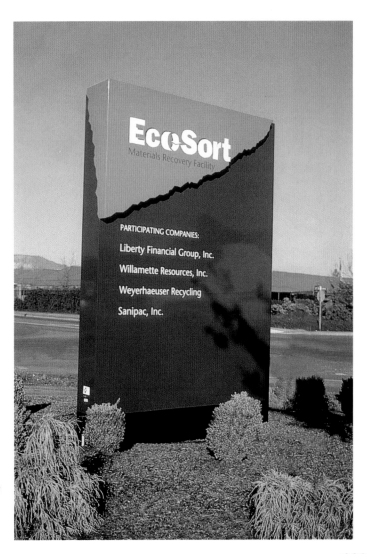

creative firm
FUNK & ASSOCIATES
Eugene, Oregon
creative people
JOAN GILBERT MADSEN
client
ECOSORT

creative firm
KINGGRAPHIC
Hong Kong, China
creative people
HON BING-WAH
client
FAR EAST ORGANIZATION

creative firm
LIPSON•ALPORT•GLASS & ASSOCIATES
Northbrook, Illinois
creative people
KEITH SHUPE
client
ALLEGIANCE

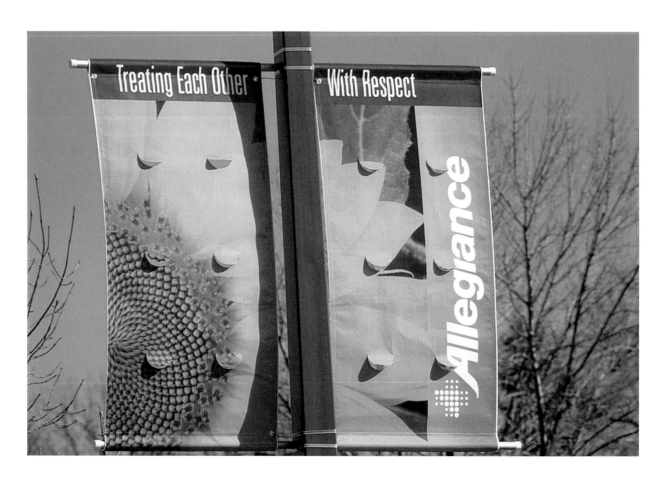

creative firm
LORENC + YOO DESIGN
Roswell, Georgia
creative people
*JAN LORENC, CHUNG YOO,
DAVID PARK, SUSIE NORRIS,
KEN BOYD, STEVE MCCALL*
client
MEMPHIS SHELBY COUNTY

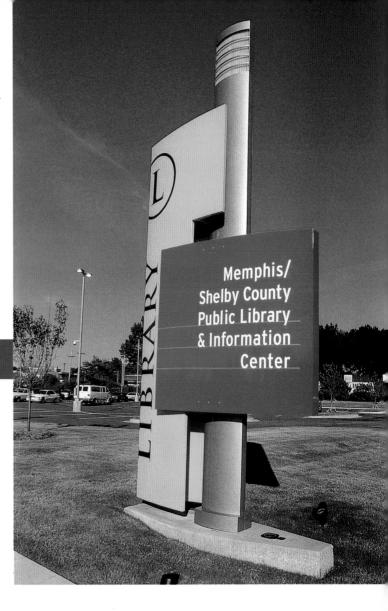

creative firm
ADDISON SEEFELD AND BRE
New York, New York
creative people
*KRAIG KESSEL, MOE SUELIMAN,
JONATHAN CRESON, DAVID TAKEUCHI*
client
DOMINO'S PIZZA

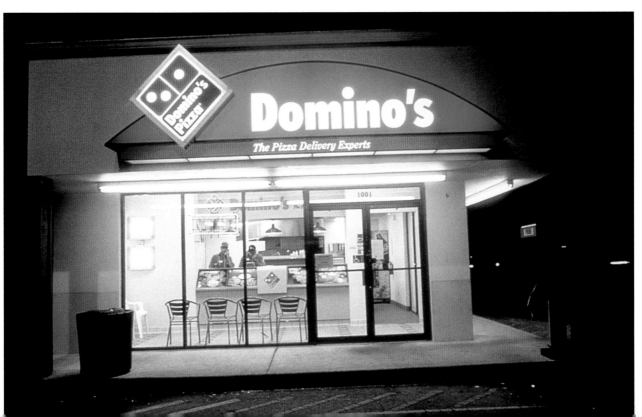

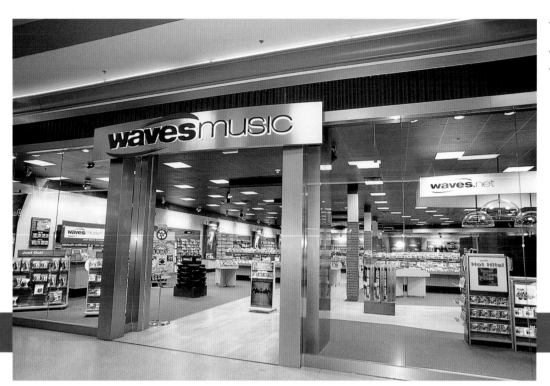

creative firm
LOUIS & PARTNERS
Bath, Ohio
creative people
LOUIS & PARTNERS
client
WAVES MUSIC STORE

creative firm
WALSH DESIGN
Seattle, Washington
creative people
LIN GARRETSON
client
SEATTLE CHILDREN'S HOME

198

EXHIBITS & TRADE SHOWS

creative firm
GEE + CHUNG DESIGN
San Francisco, California
creative people
EARL GEE,
FANI CHUNG
client
APPLIED MATERIALS

199

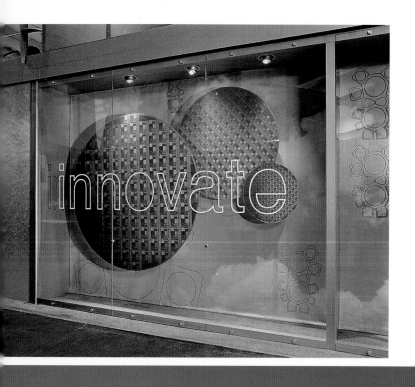

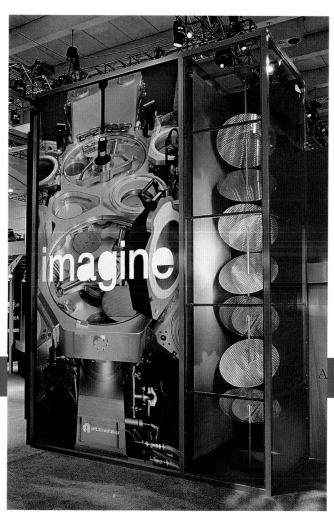

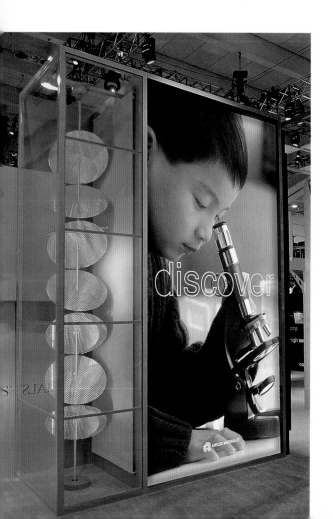

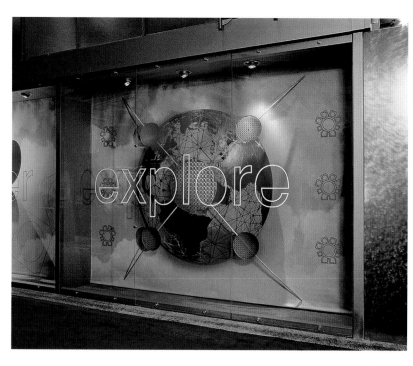

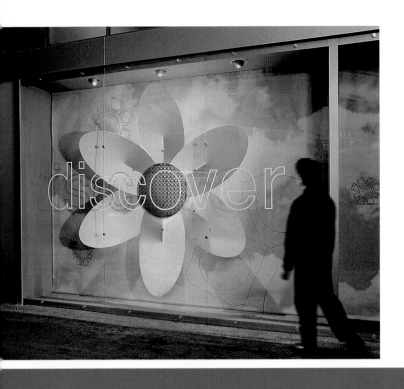

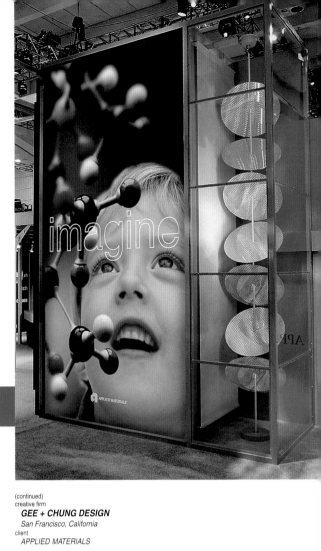

(continued)
creative firm
GEE + CHUNG DESIGN
San Francisco, California
client
APPLIED MATERIALS

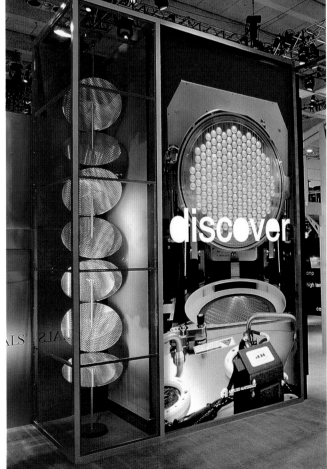

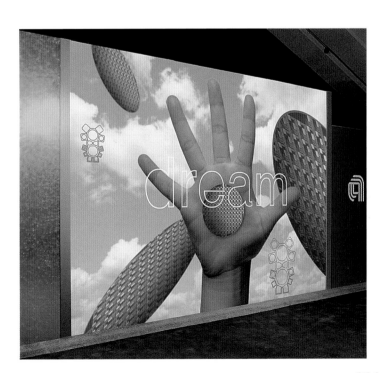

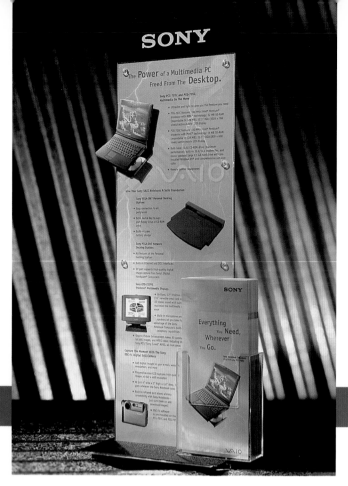

creative firm
PROFILE DESIGN
San Francisco, California
creative people
KENICHI NISHIWAKI,
ANTHONY LUK,
BRIAN JACOBSON
client
SONY ELECTRONICS

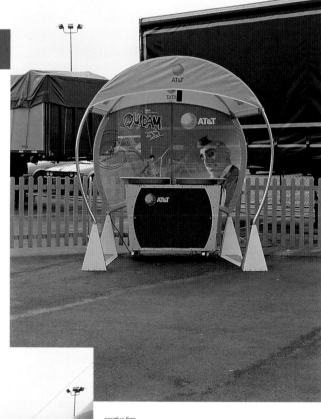

creative firm
BLUMLEIN ASSOCIATES, INC.
Greenvale, New York
creative people
WILLIAM ARBIZU,
SURIN KIM
client
AT&T/ACURA/CIRQUE DUSOLEIL

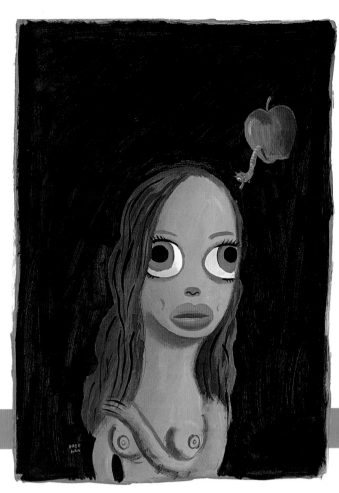

creative firm
RED CANOE
Deer Lodge, Tennessee
creative people
DEB KOCH, CAROLINE KAVANAGH,
JAN COLLIER, GARY BASEMAN
client
JAN COLLIER REPRESENTS

ILLUSTRATION

creative firm
RED CANOE
Deer Lodge, Tennessee
creative people
DEB KOCH, CAROLINE KAVANAGH,
JAN COLLIER, RICHARD BORGE
client
JAN COLLIER REPRESENTS

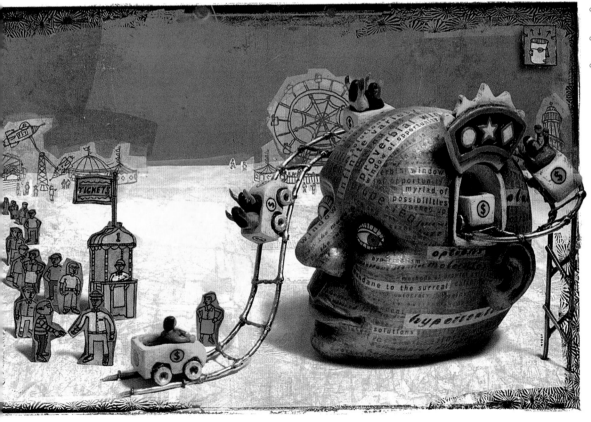

creative firm
RED CANOE
Deer Lodge, Tennessee
creative people
*DEB KOCH, CAROLINE KAVANAGH,
JAN COLLIER, NICHOLAS WILTON*
client
JAN COLLIER REPRESENTS

creative firm
RED CANOE
Deer Lodge, Tennessee
creative people
*DEB KOCH, CAROLINE KAVANAGH,
JAN COLLIER, GERALD BUSTAMANTE*
client
JAN COLLIER REPRESENTS

creative firm
RED CANOE
Deer Lodge, Tennessee
creative people
*DEB KOCH, CAROLINE KAVANAGH,
JAN COLLIER, MARTI SOMERS*
client
JAN COLLIER REPRESENTS

creative firm
RED CANOE
Deer Lodge, Tennessee
creative people
*DEB KOCH, CAROLINE KAVANAGH,
JAN COLLIER, PETER SYLVADA*
client
JAN COLLIER REPRESENTS

205

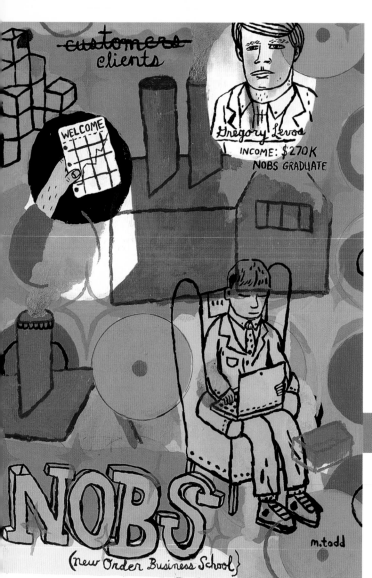

creative firm
RED CANOE
Deer Lodge, Tennessee
creative people
*DEB KOCH, CAROLINE KAVANAGH,
JAN COLLIER, MARK TODD*
client
JAN COLLIER REPRESENTS

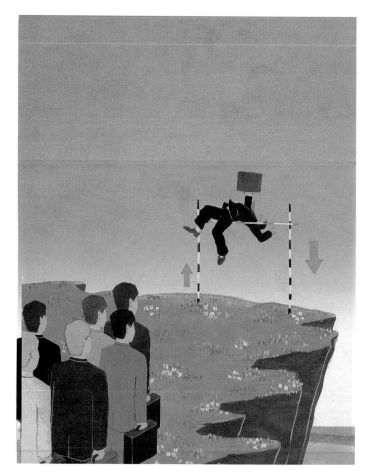

creative firm
RED CANOE
Deer Lodge, Tennessee
creative people
*DEB KOCH, CAROLINE KAVANAGH,
JAN COLLIER, ELLIOTT GOLDEN*
client
JAN COLLIER REPRESENTS

creative firm
RED CANOE
Deer Lodge, Tennessee
creative people
DEB KOCH, CAROLINE KAVANAGH,
JAN COLLIER, DAVID LESH
client
JAN COLLIER REPRESENTS

creative firm
RED CANOE
Deer Lodge, Tennessee
creative people
DEB KOCH, CAROLINE KAVANAGH,
JAN COLLIER, RICHARD BORGE
client
JAN COLLIER REPRESENTS

207

creative firm
RED CANOE
Deer Lodge, Tennessee
creative people
DEB KOCH, CAROLINE KAVANAGH,
JAN COLLIER, JENNIE OPPENHEIMER
client
JAN COLLIER REPRESENTS

creative firm
RED CANOE
Deer Lodge, Tennessee
creative people
DEB KOCH, CAROLINE KAVANAGH,
JAN COLLIER, RAE ECKLUND
client
JAN COLLIER REPRESENTS

creative firm
RED CANOE
Deer Lodge, Tennessee
creative people
DEB KOCH, CAROLINE KAVANAGH,
JAN COLLIER, GREG MABLY
client
JAN COLLIER REPRESENTS

creative firm
RED CANOE
Deer Lodge, Tennessee
creative people
DEB KOCH, CAROLINE KAVANAGH,
JAN COLLIER, RAE ECKLUND
client
JAN COLLIER REPRESENTS

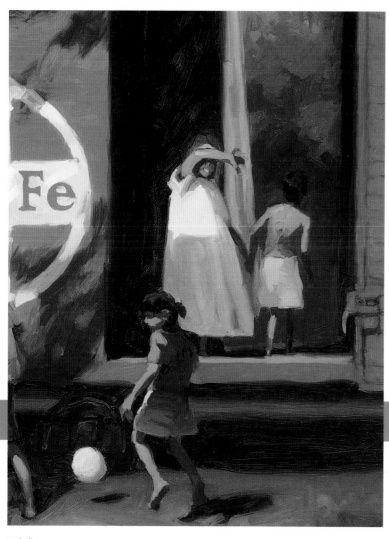

creative firm
RED CANOE
Deer Lodge, Tennessee
creative people
*DEB KOCH, CAROLINE KAVANAGH,
JAN COLLIER, TRAVIS FOSTER*
client
JAN COLLIER REPRESENTS

creative firm
RED CANOE
Deer Lodge, Tennessee
creative people
*DEB KOCH, CAROLINE KAVANAGH,
JAN COLLIER, GARY BASEMAN*
client
JAN COLLIER REPRESENTS

creative firm
RED CANOE
Deer Lodge, Tennessee
creative people
*DEB KOCH, CAROLINE KAVANAGH,
JAN COLLIER, TYSON FULLER*
client
JAN COLLIER REPRESENTS

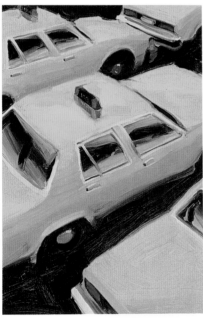

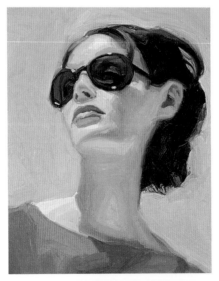

creative firm
RED CANOE
Deer Lodge, Tennessee
creative people
*DEB KOCH, CAROLINE KAVANAGH,
JAN COLLIER, PETER SYLVADA*
client
JAN COLLIER REPRESENTS

212

creative firm
RED CANOE
Deer Lodge, Tennessee
creative people
*DEB KOCH, CAROLINE KAVANAGH,
JAN COLLIER, JOE FLEMING*
client
JAN COLLIER REPRESENTS

creative firm
RED CANOE
Deer Lodge, Tennessee
creative people
*DEB KOCH, CAROLINE KAVANAGH,
JAN COLLIER, TRAVIS FOSTER*
client
JAN COLLIER REPRESENTS

creative firm
RED CANOE
Deer Lodge, Tennessee
creative people
*DEB KOCH, CAROLINE KAVANAGH,
JAN COLLIER, RICHARD BORGE*
client
JAN COLLIER REPRESENTS

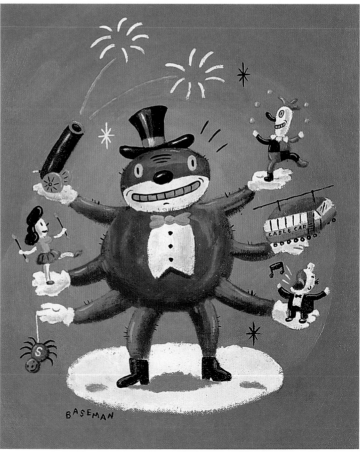

creative firm
RED CANOE
Deer Lodge, Tennessee
creative people
*DEB KOCH, CAROLINE KAVANAGH,
JAN COLLIER, GARY BASEMAN*
client
JAN COLLIER REPRESENTS

creative firm
RED CANOE
Deer Lodge, Tennessee
creative people
DEB KOCH, CAROLINE KAVANAGH,
JAN COLLIER, NICHOLAS WILTON
client
JAN COLLIER REPRESENTS

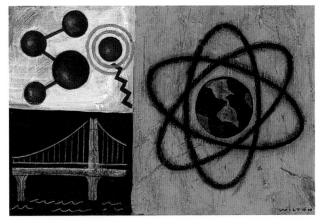

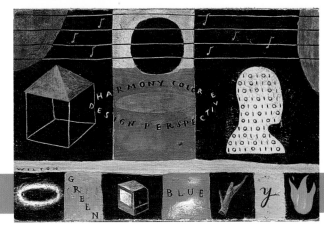

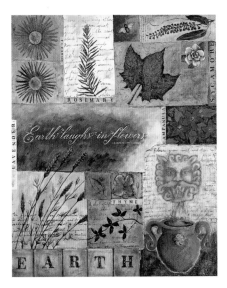

creative firm
RED CANOE
Deer Lodge, Tennessee
creative people
DEB KOCH, CAROLINE KAVANAGH,
JAN COLLIER, MARTI SOMERS
client
JAN COLLIER REPRESENTS

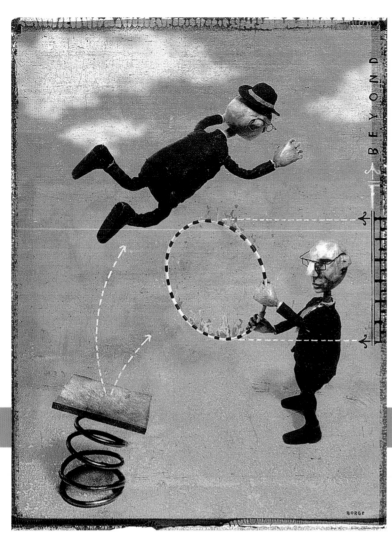

creative firm
RED CANOE
Deer Lodge, Tennessee
creative people
*DEB KOCH, CAROLINE KAVANAGH,
JAN COLLIER, RICH BORGE*
client
JAN COLLIER REPRESENTS

creative firm
RED CANOE
Deer Lodge, Tennessee
creative people
*DEB KOCH, CAROLINE KAVANAGH,
JAN COLLIER, NICHOLAS WILTON*
client
JAN COLLIER REPRESENTS

creative firm
RED CANOE
Deer Lodge, Tennessee
creative people
DEB KOCH, CAROLINE KAVANAGH,
JAN COLLIER, RICH BORGE
client
JAN COLLIER REPRESENTS

creative firm
RED CANOE
Deer Lodge, Tennessee
creative people
DEB KOCH, CAROLINE KAVANAGH,
JAN COLLIER, CHRISTIAN NORTHEAST
client
JAN COLLIER REPRESENTS

217

creative firm
P2 COMMUNICATIONS SVCS.
Falls Church, Virginia
creative people
BRYN FARRAR
client
CSC

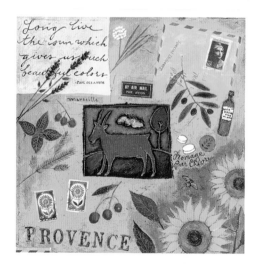

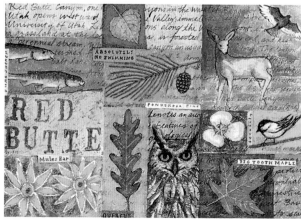

creative firm
RED CANOE
Deer Lodge, Tennessee
creative people
DEB KOCH, CAROLINE KAVANAGH,
JAN COLLIER, MARTI SOMERS
client
JAN COLLIER REPRESENTS

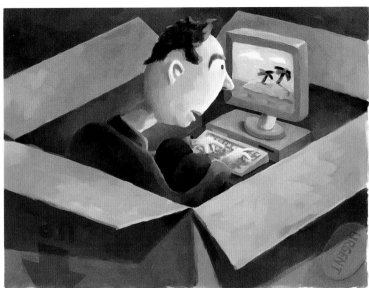

creative firm
RED CANOE
Deer Lodge, Tennessee
creative people
*DEB KOCH, CAROLINE KAVANAGH,
JAN COLLIER, MARTI SOMERS*
client
JAN COLLIER REPRESENTS

creative firm
RED CANOE
Deer Lodge, Tennessee
creative people
*DEB KOCH, CAROLINE KAVANAGH,
JAN COLLIER, TRAVIS FOSTER*
client
JAN COLLIER REPRESENTS

creative firm
P2 COMMUNICATIONS SVCS.
Falls Church, Virginia
creative people
BRYN FARRAR
client
CSC

creative firm
RED CANOE
Deer Lodge, Tennessee
creative people
DEB KOCH, CAROLINE KAVANAGH,
JAN COLLIER, TRAVIS FOSTER
client
JAN COLLIER REPRESENTS

creative firm
P2 COMMUNICATIONS SVCS.
Falls Church, Virginia
creative people
BRYN FARRAR
client
CSC

creative firm
RED CANOE
Deer Lodge, Tennessee
creative people
DEB KOCH, CAROLINE KAVANAGH,
JAN COLLIER, DAVID MILGRIM
client
JAN COLLIER REPRESENTS

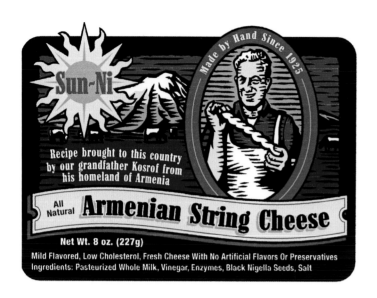

All Natural **Armenian String Cheese**

Net Wt. 8 oz. (227g)

Mild Flavored, Low Cholesterol, Fresh Cheese With No Artificial Flavors Or Preservatives
Ingredients: Pasteurized Whole Milk, Vinegar, Enzymes, Black Nigella Seeds, Salt

LABELS & TAGS

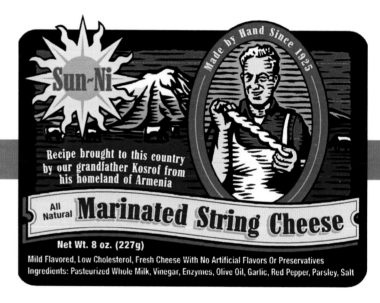

All Natural **Marinated String Cheese**

Net Wt. 8 oz. (227g)

Mild Flavored, Low Cholesterol, Fresh Cheese With No Artificial Flavors Or Preservatives
Ingredients: Pasteurized Whole Milk, Vinegar, Enzymes, Olive Oil, Garlic, Red Pepper, Parsley, Salt

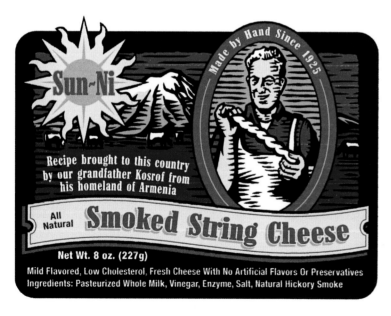

All Natural **Smoked String Cheese**

Net Wt. 8 oz. (227g)

Mild Flavored, Low Cholesterol, Fresh Cheese With No Artificial Flavors Or Preservatives
Ingredients: Pasteurized Whole Milk, Vinegar, Enzyme, Salt, Natural Hickory Smoke

creative firm
DEAN DESIGN/MARKETING GROUP, INC.
Lancaster, Pennsylvania
creative people
JEFF PHILLIPS
client
SUN-NI CHEESE

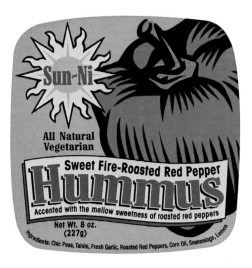

Sun~Ni

All Natural Vegetarian

Sweet Fire-Roasted Red Pepper

Hummus

Accented with the mellow sweetness of roasted red peppers

Net Wt. 8 oz.
(227g)

Ingredients: Chic Peas, Tahini, Fresh Garlic, Roasted Red Peppers, Corn Oil, Seasonings, Lemon

Sun~Ni

All Natural Vegetarian

Delightfully Dill

Hummus

A compelling combination made with imported dill herb

Net Wt. 8 oz.
(227g)

Ingredients: Chic Peas, Tahini, Fresh Garlic, Dill, Corn Oil, Seasonings, Lemon

Sun~Ni

All Natural Vegetarian

Jalapeño Pepper

Hummus

This hummus has heat! Deliciously refreshing, spicy and hot!

Net Wt. 8 oz.
(227g)

Ingredients: Chic Peas, Tahini, Fresh Garlic, Jalapeño Peppers, Corn Oil, Seasonings, Lemon

Sun~Ni

All Natural Vegetarian

Original

Hummus

A creamy concoction of chic peas, raw garlic and lemon

Net Wt. 8 oz.
(227g)

Ingredients: Chic Peas, Tahini, Fresh Garlic, Corn Oil, Seasonings, Lemon

Sun~Ni

All Natural Vegetarian

Sun Dried Tomato

Hummus

Real bits of California sun dried tomatoes spiked throughout

Net Wt. 8 oz.
(227g)

Ingredients: Chic Peas, Tahini, Fresh Garlic, Sun Dried Tomatoes, Corn Oil, Seasonings, Lemon

Sun~Ni

All Natural Vegetarian

Roasted Garlic

Hummus

Featuring additional chunks of fresh whole roasted garlic

Net Wt. 8 oz.
(227g)

Ingredients: Chic Peas, Tahini, Roasted & Fresh Garlic, Corn Oil, Seasonings, Lemon

creative firm
**DEAN DESIGN/
MARKETING GROUP, INC.**
Lancaster, Pennsylvania
creative people
JEFF PHILLIPS
client
SUN-NI CHEESE

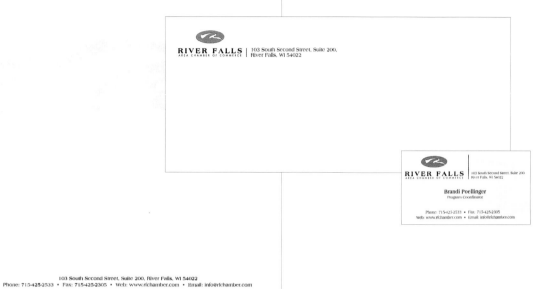

creative firm
RESCO PRINT GRAPHICS
Hudson, Wisconsin
creative people
SANDRA PLANK,
HATTIE THORNTON
client
RIVER FALLS AREA
CHAMBER OF COMMERCE

LETTERHEAD SETS

creative firm
HENDLER-JOHNSTON
Bloomington, Minnesota
creative people
CHRIS HENDLER
client
FLEXO IMPRESSIONS, INC.

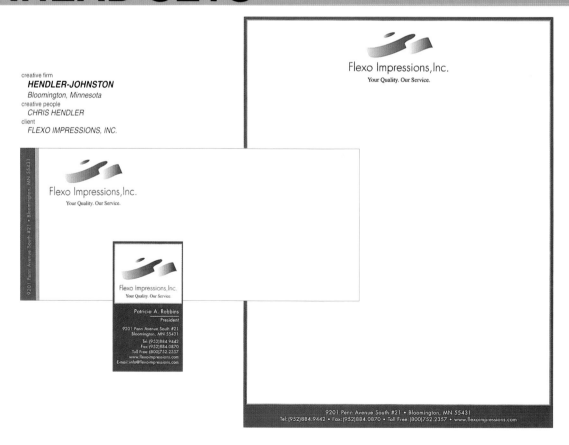

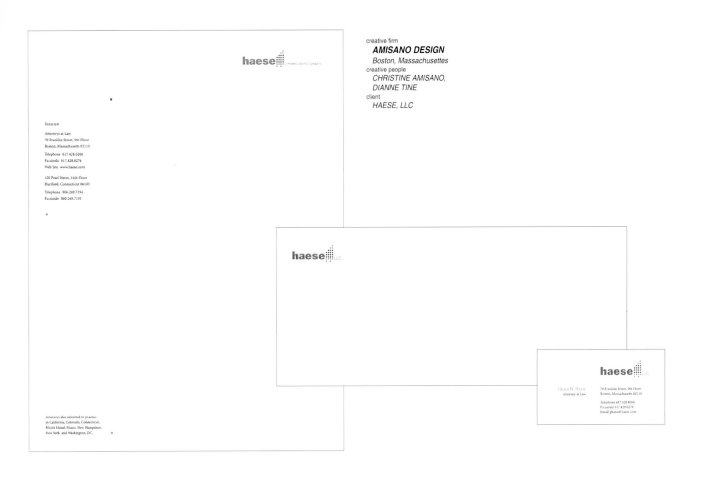

creative firm
AMISANO DESIGN
Boston, Massachusettes
creative people
CHRISTINE AMISANO,
DIANNE TINE
client
HAESE, LLC

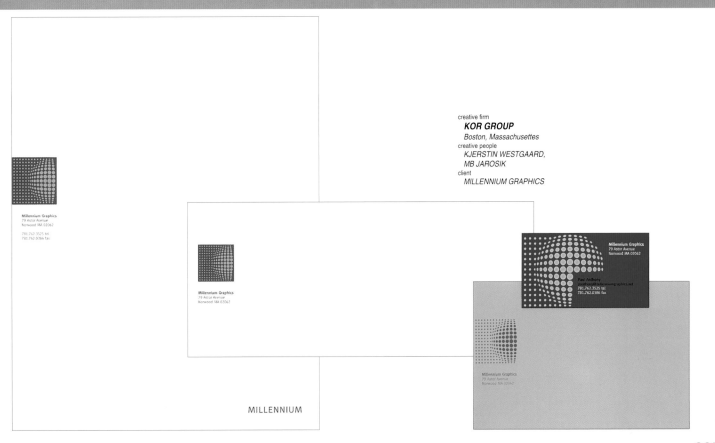

creative firm
KOR GROUP
Boston, Massachusettes
creative people
KJERSTIN WESTGAARD,
MB JAROSIK
client
MILLENNIUM GRAPHICS

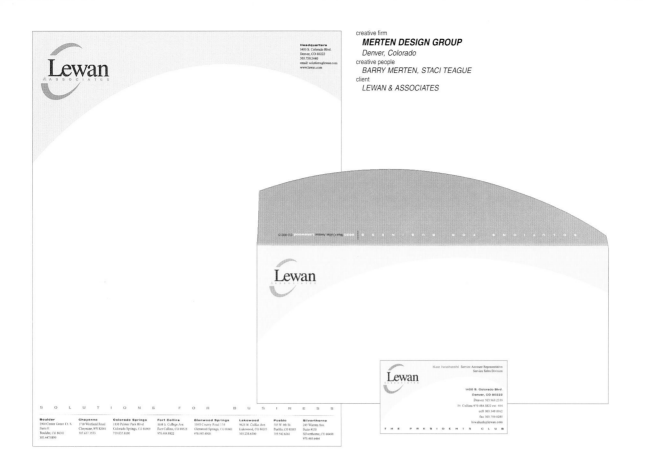

creative firm
MERTEN DESIGN GROUP
Denver, Colorado
creative people
BARRY MERTEN, STACI TEAGUE
client
LEWAN & ASSOCIATES

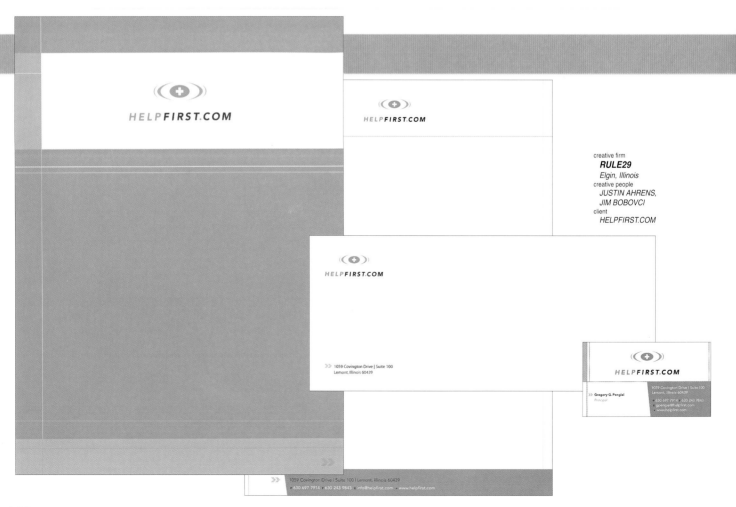

creative firm
RULE29
Elgin, Illinois
creative people
*JUSTIN AHRENS,
JIM BOBOVCI*
client
HELPFIRST.COM

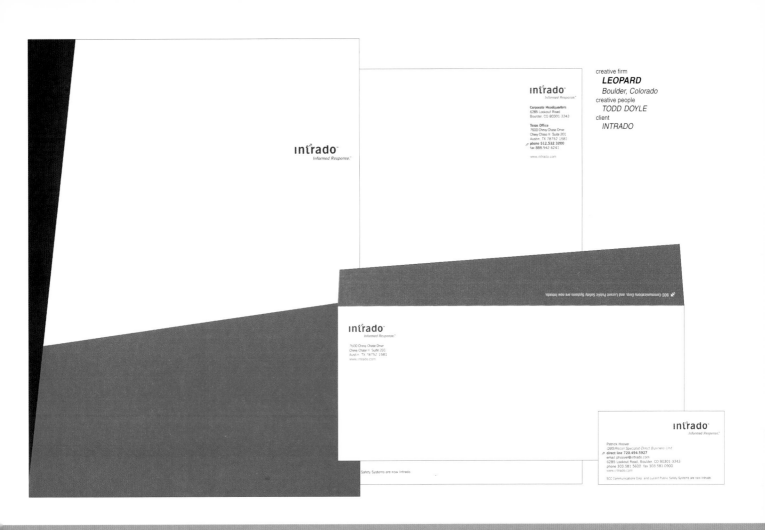

creative firm
LEOPARD
Boulder, Colorado
creative people
TODD DOYLE
client
INTRADO

creative firm
LAWRENCE & PONDER IDEAWORKS
Newport Beach, California
creative people
MARVIE BLAIR, GARY FREDRICKSON,
BIL DICKS, LOUIS LEOS
client
LAWRENCE & PONDER IDEAWORKS

creative firm
WELCH DESIGN GROUP, INC.
Madison, Wisconsin
creative people
*NANCY WELCH,
LISA HEITKE*
client
WELCH DESIGN GROUP, INC.

Welch Design Group, Inc.

Krista Ceniti

Welch Design Group, Inc.

608.258.1988
info@welchdesigngroup.com
Fax 608.258.1977

636 W. Washington Ave.
Madison, WI 53703

www.welchdesigngroup.com

633 W. Main St., Madison, WI 53703

636 W. Washington Ave., Madison, WI 53703 Voice 608.258.1988 Fax 608.258.1977 info@welchdesigngroup.com www.welchdesigngroup.com

GSO Graphics, Inc.
440 Ninth Avenue
New York, NY 10001
212.695.8300.T
212.631.0707.F
geographics.com

GSO

GSO

GSO Graphics, Inc.
440 Ninth Avenue
New York, NY 10001

Fast, accurate reproduction services for anyone who designs or constr

GSO Graphics, Inc.
440 Ninth Avenue
New York, NY 10001
212.695.8300.T
212.643.0606.F

Frank Ribaudo
Production Manager
fribaudo@geographics.com

GSO

creative firm
POULIN + MORRIS
New York, New York
creative people
*L. RICHARD POULIN,
DOUGLAS MORRIS*
client
GSO GRAPHICS INC.

creative firm
TODD CHILDERS GRAPHIC DESIGN
Bowling Green, Ohio
creative people
TODD CHILDERS
client
RHIZOMES.NET

creative firm
RED MONKEY DESIGN
San Carlos, California
creative people
KARIN LUBECK
client
COMMUNICATE

creative firm
COREY MCPHERSON NASH
Watertown, Massachusettes
creative people
DEBBIE SHMERIER
client
AVAKI

creative firm
ALTERPOP
San Francisco, California
client
ALTERPOP

creative firm
SKOORKA DESIGN
New York, New York
creative people
SUSAN SKOORKA
client
34TH STREET PARTNERSHIP

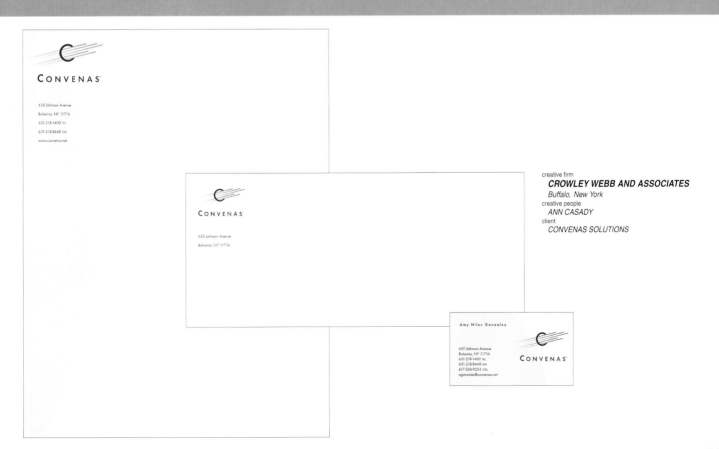

creative firm
CROWLEY WEBB AND ASSOCIATES
Buffalo, New York
creative people
ANN CASADY
client
CONVENAS SOLUTIONS

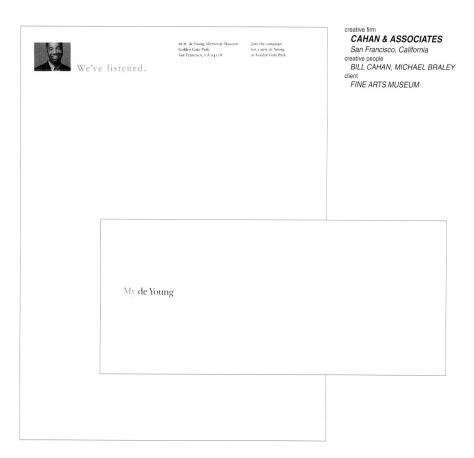

creative firm
CAHAN & ASSOCIATES
San Francisco, California
creative people
BILL CAHAN, MICHAEL BRALEY
client
FINE ARTS MUSEUM

creative firm
POULIN + MORRIS
New York, New York
creative people
*L. RICHARD POULIN,
AMY KWON*
client
POLSHEK PARTNERSHIP ARCHITECTS

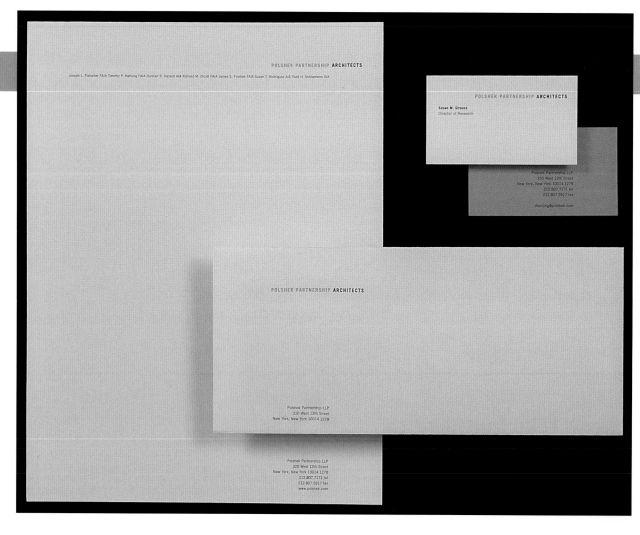

creative firm
GOUTHIER DESIGN INC.
Fort Lauderdale, Florida
creative people
JONATHAN GOUTHIER,
JO HALLMARK
client
THE ANCHOR CLUB

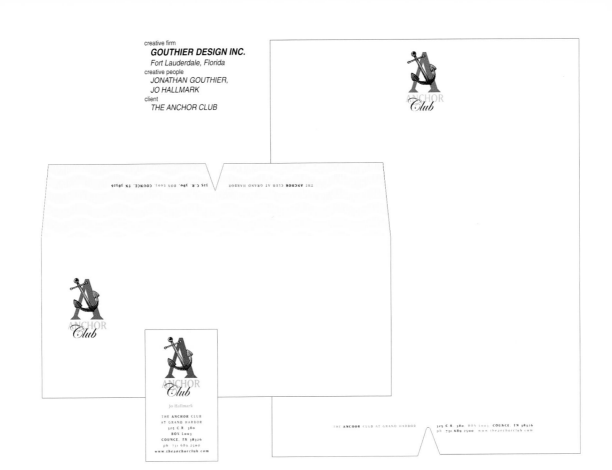

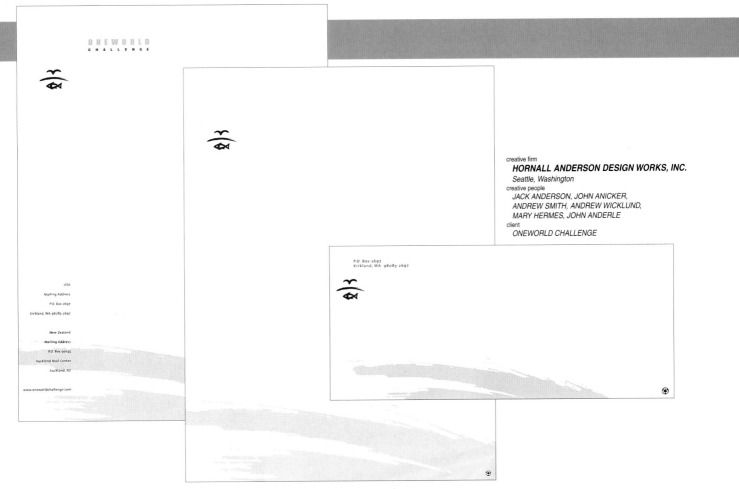

creative firm
HORNALL ANDERSON DESIGN WORKS, INC.
Seattle, Washington
creative people
JACK ANDERSON, JOHN ANICKER,
ANDREW SMITH, ANDREW WICKLUND,
MARY HERMES, JOHN ANDERLE
client
ONEWORLD CHALLENGE

creative firm
NESNADNY + SCHWARTZ
Cleveland, Ohio
creative people
MARK SCHWARTZ, GREG OZNOWICH,
JENNIFER CRAWFORD
client
CRAWFORD MUSEUM OF
TRANSPORTATION AND INDUSTRY

Frederick C. Crawford Museum of Transportation and Industry at Burke Lakefront Airport

10825 East Boulevard Cleveland Ohio 44106

Frederick C. Crawford Museum of Transportation and Industry at Burke Lakefront Airport

10825 East Boulevard Cleveland Ohio 44106

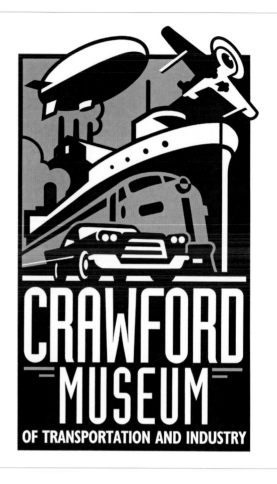

RYAN COMPANIES US, INC.
50 South Tenth Street, Suite 300
Minneapolis, MN 55403-2012

612-492-4000 *tel*
612-492-3000 *fax*

WWW.RYANCOMPANIES.COM

RYAN COMPANIES US, INC.
50 South Tenth Street, Suite 300
Minneapolis, MN 55403-2012

creative firm
TILKA DESIGN
Minneapolis, Minnesota
creative people
SARAH STEIL
client
RYAN COMPANY

creative firm
CROWLEY WEBB AND ASSOCIATES
Buffalo, New York
creative people
DAVE BUCK
client
RODERICK ENGLISH

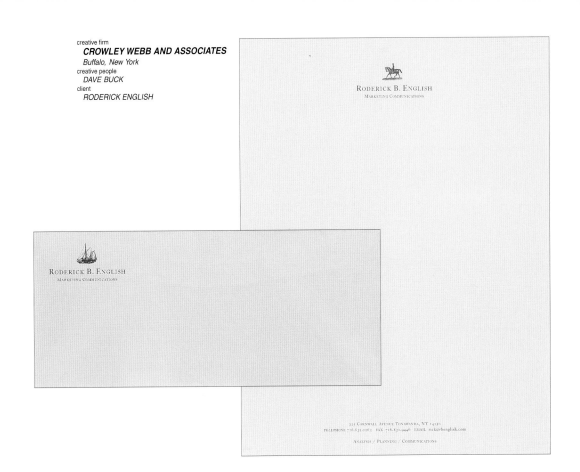

creative firm
FRITZ CREATIVE
Santa Barbara, California
creative people
KATHY FRITZ,
CLAUDINE JAENICHEN
client
CONDOR ENGINEERING

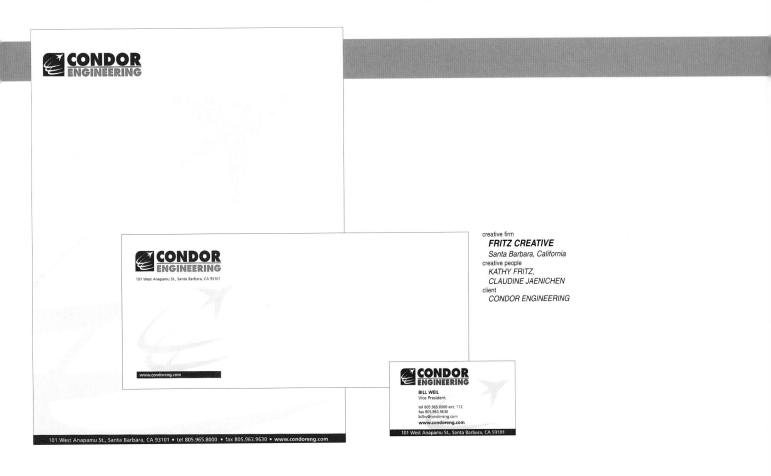

creative firm
DEKA DESIGN INC.
New York, New York
creative people
DMITRY KRASNY
client
SUMMERTECH INC.

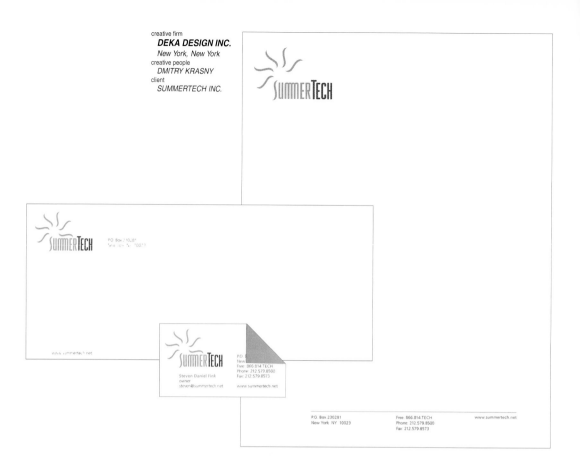

creative firm
PHINNEY BISCHOFF DESIGN HOUSE
Seattle, Washington
creative people
LORIE RANSON,
LESLIE PHINNEY
client
ESI

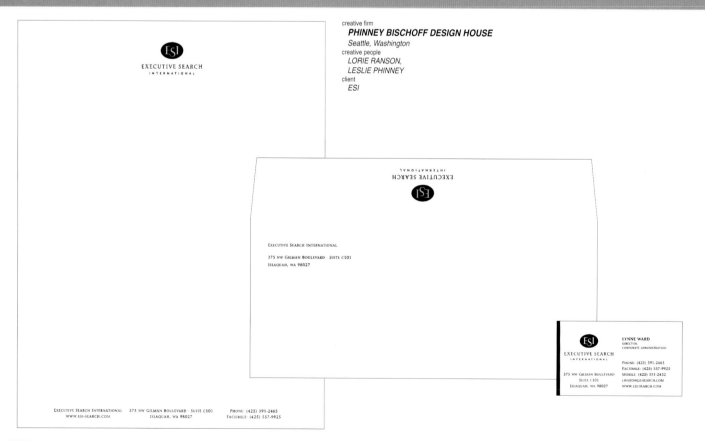

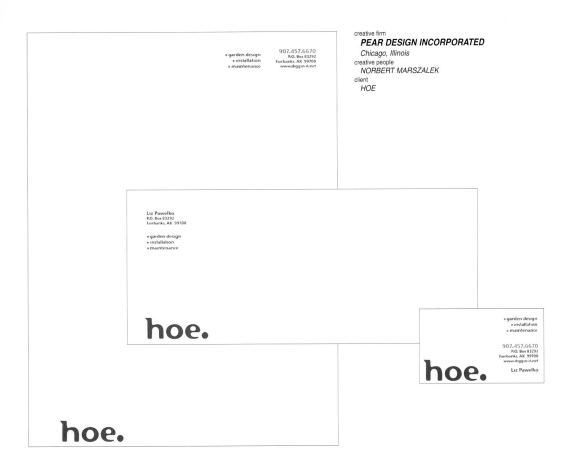

creative firm
PEAR DESIGN INCORPORATED
Chicago, Illinois
creative people
NORBERT MARSZALEK
client
HOE

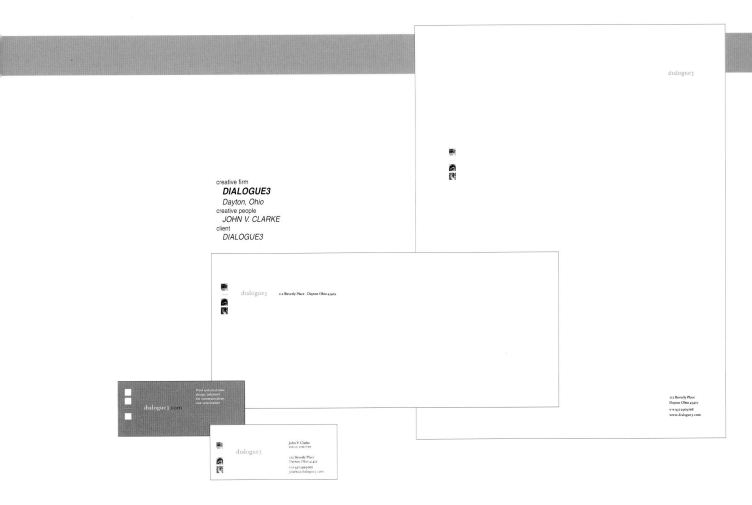

creative firm
DIALOGUE3
Dayton, Ohio
creative people
JOHN V. CLARKE
client
DIALOGUE3

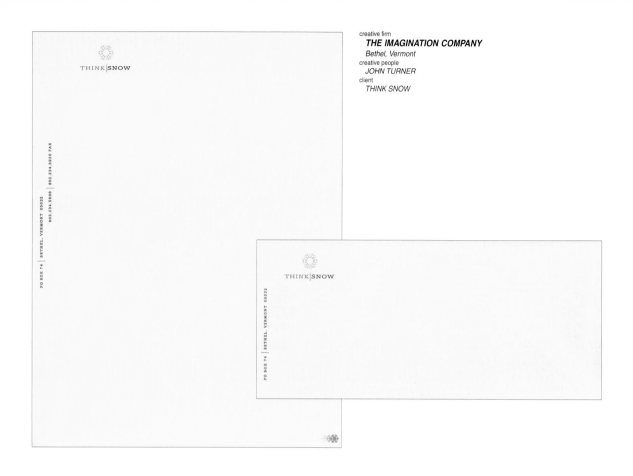

creative firm
THE IMAGINATION COMPANY
Bethel, Vermont
creative people
JOHN TURNER
client
THINK SNOW

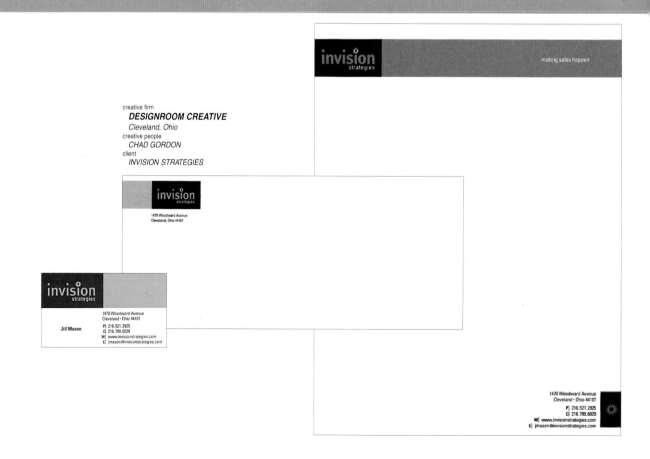

creative firm
DESIGNROOM CREATIVE
Cleveland, Ohio
creative people
CHAD GORDON
client
INVISION STRATEGIES

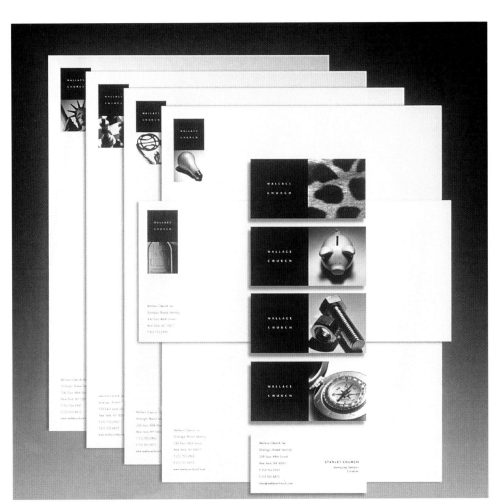

creative firm
WALLACE CHURCH, INC.
New York, New York
creative people
STAN CHURCH, NIN GLAISTER,
LAWRENCE HAGGERTY
client
WALLACE CHURCH, INC.

creative firm
HENDLER-JOHNSTON
Bloomington, Minnesota
creative people
CHRIS HENDLER,
KATHY R. ROTHSTEIN
client
EQUITY BANK

239

creative firm
ARTENERGY
Kentfield, California
creative people
SERGEY MARTINOV
client
H3R, INC.

creative firm
STRIEGEL & ASSOCIATES
Broken Arrow, Oklahoma
creative people
B. TAYLOR, JENNIFER TETLEY,
PEGGY STRIEGEL
client
JOHNSTON ENTERPRISES

creative firm
CAHAN & ASSOCIATES
San Francisco, California
creative people
BILL CAHAN, MICHAEL BRALEY
client
PORTAL PLAYER

Jason Kim
Principal Engineer
jason.kim@portalplayer.com

PortalPlayer, Inc.
3255 Scott Boulevard, Bldg. 1
Santa Clara, California 95054
408.855.0850 Telephone
408.855.0841 Facsimile

PortalPlayer, Inc. 12020 NE 115th Avenue, Kirkland, Washington 98034 Telephone 425.825.1672 Facsimile 425.825.1680 www.portalplayer.com

creative firm
LAURA COE DESIGN ASSOC.
San Diego, California
creative people
THOMAS RICHMAN
client
*PRINTING INDUSTRIES
ASSOCIATION OF SAN DIEGO*

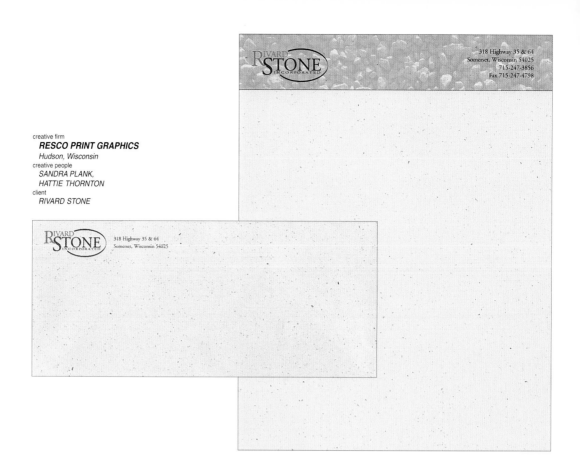

creative firm
RESCO PRINT GRAPHICS
Hudson, Wisconsin
creative people
SANDRA PLANK,
HATTIE THORNTON
client
RIVARD STONE

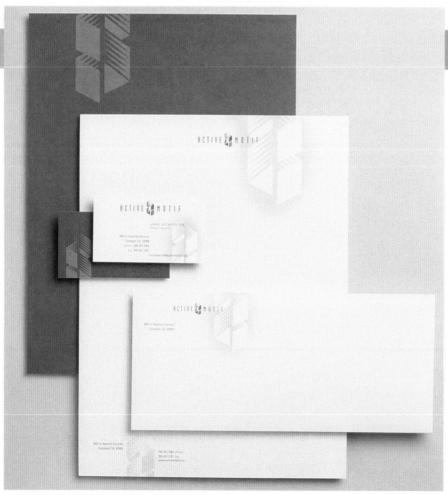

creative firm
LAURA COE DESIGN ASSOC.
San Diego, California
creative people
RYOICHI YOTSUMOTO
client
ACTIVE MOTIF

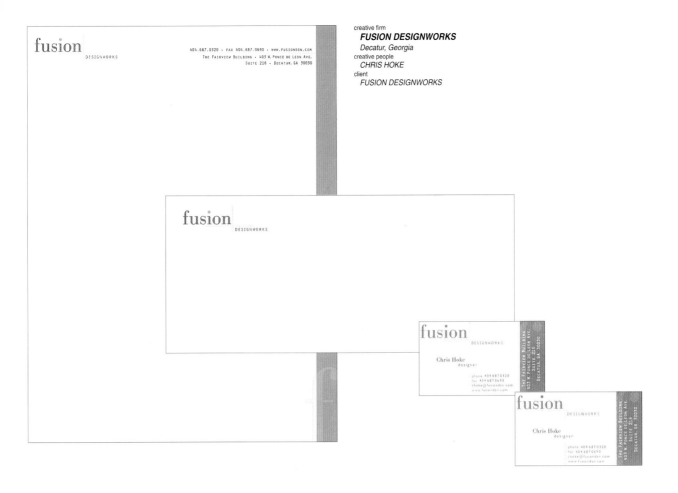

creative firm
FUSION DESIGNWORKS
Decatur, Georgia
creative people
CHRIS HOKE
client
FUSION DESIGNWORKS

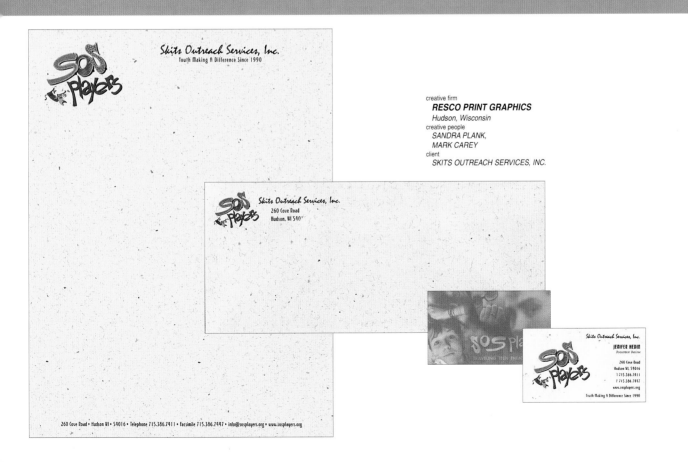

creative firm
RESCO PRINT GRAPHICS
Hudson, Wisconsin
creative people
SANDRA PLANK,
MARK CAREY
client
SKITS OUTREACH SERVICES, INC.

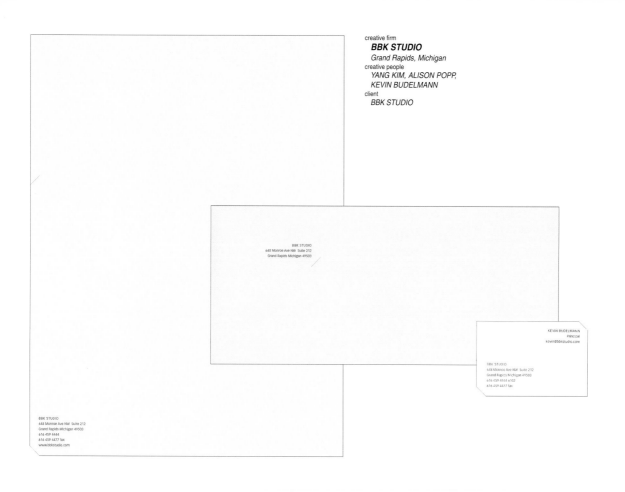

creative firm
BBK STUDIO
Grand Rapids, Michigan
creative people
YANG KIM, ALISON POPP,
KEVIN BUDELMANN
client
BBK STUDIO

BBK STUDIO
648 Monroe Ave NW Suite 212
Grand Rapids Michigan 49503

KEVIN BUDELMANN
Principal
kevin@bbkstudio.com

BBK STUDIO
648 Monroe Ave NW Suite 212
Grand Rapids Michigan 49503
616 459 4444 x102
616 459 4477 fax

BBK STUDIO
648 Monroe Ave NW Suite 212
Grand Rapids Michigan 49503
616 459 4444
616 459 4477 fax
www.bbkstudio.com

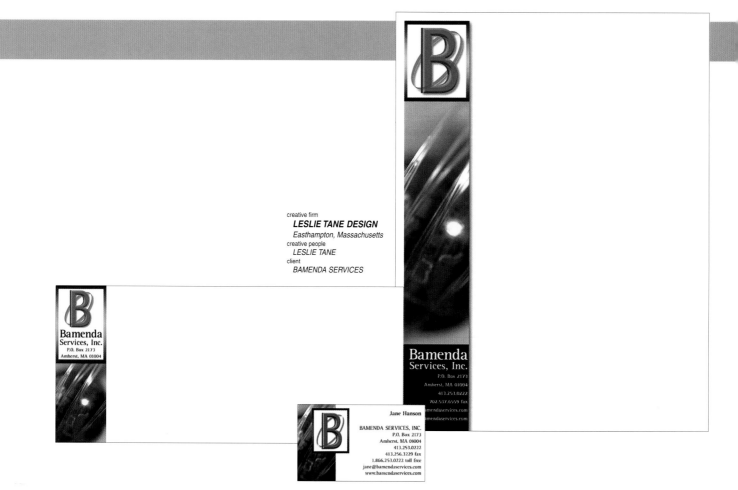

creative firm
LESLIE TANE DESIGN
Easthampton, Massachusetts
creative people
LESLIE TANE
client
BAMENDA SERVICES

Bamenda
Services, Inc.
P.O. Box 2173
Amherst, MA 01004

Bamenda
Services, Inc.
P.O. Box 2173
Amherst, MA 01004
413.253.0222
702.537.6559 fax
amendaservices.com
amendaservices.com

Jane Hanson

BAMENDA SERVICES, INC.
P.O. Box 2173
Amherst, MA 01004
413.253.0222
413.256.3229 fax
1.866.253.0222 toll free
jane@bamendaservices.com
www.bamendaservices.com

244

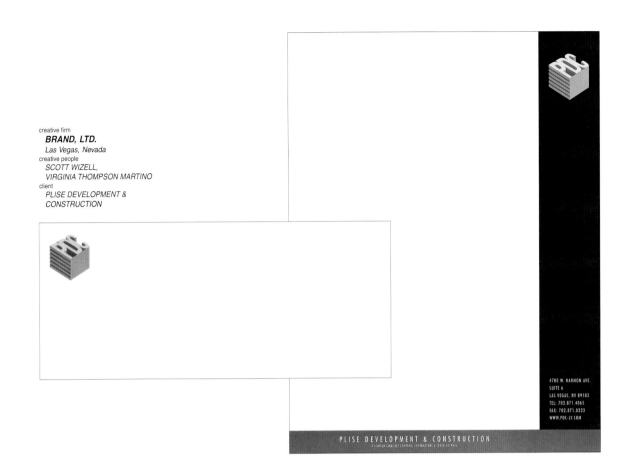

creative firm
BRAND, LTD.
Las Vegas, Nevada
creative people
SCOTT WIZELL,
VIRGINIA THOMPSON MARTINO
client
PLISE DEVELOPMENT &
CONSTRUCTION

4780 W. HARMON AVE.
SUITE 6
LAS VEGAS, NV 89103
TEL: 702.871.4065
FAX: 702.871.0333
WWW.PDC-LV.COM

PLISE DEVELOPMENT & CONSTRUCTION

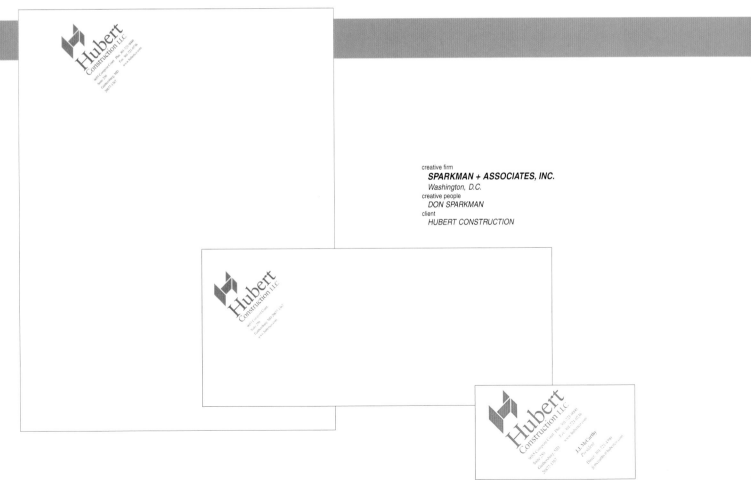

creative firm
SPARKMAN + ASSOCIATES, INC.
Washington, D.C.
creative people
DON SPARKMAN
client
HUBERT CONSTRUCTION

creative firm
SCHWENER DESIGN GROUP
Basalt, Colorado
creative people
DIANE SCHWENER,
JEN COLLIER
client
AMY C. CECIL, O.D.

Amy C. Cecil, O.D.
0100 Elk Run Drive
Suite 206
Basalt, Colorado 81621

Amy C. Cecil, O.D.

0100 Elk Run Drive

Suite 206

Basalt, CO 81621

phone 970.927.5107

fax 970.927.5108

Amy C. Cecil, O.D.
0100 Elk Run Drive
Suite 206
Basalt, CO 81621
phone 970.927.5107
fax 970.927.5108

Wirestone 157 Yesler Way, Suite 600, Seattle, WA 98104 phone 206.233.0300 fax 206.233.0788 www.wirestone.com

creative firm
DULA IMAGE GROUP
South Coast Metro, California
creative people
MICHAEL DULA,
MELISSA LUTHER
client
WIRESTONE

compete in the new economy

creative firm
ROSENBERGER DESIGN
San Rafael, California
creative people
SHAWN ROSENBERGER
client
COIT STAFFING

creative firm
ALEX MELLI DESIGN
Laguna Beach, California
creative people
ALEX MELLI, DUG BRADSHAW,
LIANNE FLINN
client
SUKTION PRODUCTION

247

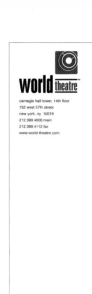

world theatre

carnegie hall tower, 14th floor
152 west 57th street
new york, ny 10019
212.399.4000 main
212.399.4112 fax
www.world-theatre.com

creative firm
CLARION
Atlanta, Georgia
creative people
HEATHER MIHALIC
client
WORLD THEATRE

world theatre

carnegie hall tower, 14th floor
152 west 57th street
new york, ny 10019
212.399.4000 main
212.399.4112 fax
www.world-theatre.com

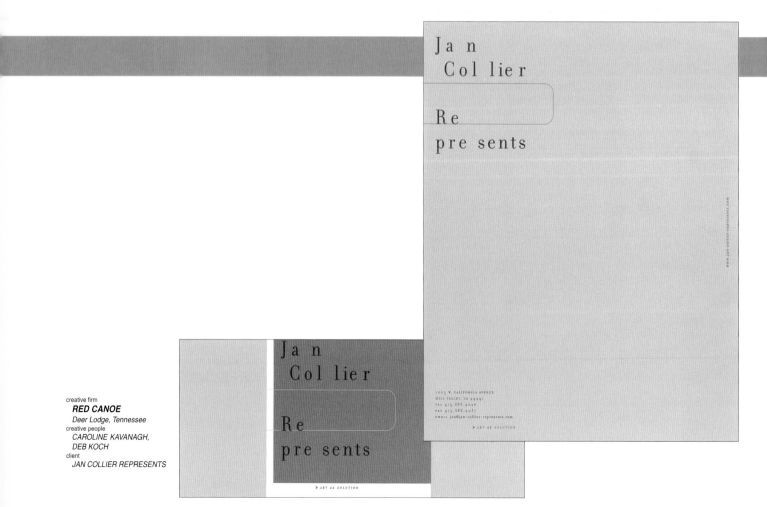

creative firm
RED CANOE
Deer Lodge, Tennessee
creative people
*CAROLINE KAVANAGH,
DEB KOCH*
client
JAN COLLIER REPRESENTS

creative firm
JIVA CREATIVE
Alameda, California
creative people
ERIC LEE
client
JIVA CREATIVE

creative firm
NASSAR DESIGN
Brookline, Massachusettes
creative people
NÉLIDA NASSAR
client
JULIANE HALIOWELL

creative firm
PHINNEY BISCHOFF DESIGN HOUSE
Seattle, Washington
creative people
DEAN HART,
LESLIE PHINNEY
client
LOCATE NETWORKS

creative firm
JIVA CREATIVE
Alameda, California
creative people
ERIC LEE
client
MARKETING CONCEPTS

paragraphs design
557 west polk street./floor 3
chicago illinois 60607

312.828.0200
312.828.9888 fax
paragraphs.com

annuals | branding | identity | interactive | marketing

annuals | branding | identity | interactive | marketing

to ›

paragraphs design
557 west polk street/floor 3
chicago illinois 60607
312.828.0200 x13
312.828.9888 fax
312.636.5264 cell

robin simon zvonek | president
robin@paragraphs.com

creative firm
PARAGRAPHS DESIGN
Chicago, Illinois
creative people
*JIM CHILCUTT,
ROBIN ZVONEK*
client
PARAGRAPHS DESIGN

THE PALM

THE PALM

creative firm
FUTUREBRAND
New York, New York
creative people
CAROL WOLF
client
PALM ISLAND DEVELOPERS

P. O. Box 17777
Dubai United Arab Emirates
www.thepalm.co.ae

Telephone +971 4 3991400
Fax (Marketing) +971 4 3991005
Fax (Engineering) +971 4 3998484
E-mail info@thepalm.co.ae

info@thepalm.co.ae

www.thepalm.co.ae

251

creative firm
**McELVENEY & PALOZZI
DESIGN GROUP**
Rochester, New York
creative people
*MATT NOWICKI,
PAUL REISINGER*
client
BADGER TECHNOLOGY

creative firm
X DESIGN COMPANY
Denver, Colorado
creative people
ALEX VALDERRAMA
client
ALDO LEOPARDI

creative firm
EMPHASIS SEVEN COMMUNICATIONS, INC.
Chicago, Illinois
creative people
RAMIZ GUSEYNOV
client
CORNELL FORGE COMPANY

creative firm
JONES DESIGN GROUP
Atlanta, Georgia
creative people
CAROLINE MCALPINE,
VICKY JONES
client
THE FOTOS GROUP

creative firm
TOMPERTDESIGN
Palo Alto, California
creative people
CLAUDIA HUBER TOMBERT,
MICHAEL TOMBERT
client
DRUCKWERKSTATT

creative firm
VMA
Dayton, Ohio
creative people
KENNETH BOTTS,
AL HIDALGO
client
GOLDCOAST SPECIALTY FOODS

creative firm
ADAM, FILIPPO & ASSOCIATES
Pittsburgh, Pennsylvania
creative people
LARRY GEIGER,
ROBERT ADAM
client
MID HEAVEN

creative firm
ORIGINAL IMPRESSIONS
Miami, Florida
creative people
MARIO ACUNA,
MARY RUIZ
client
MAKU ART USA CORP.

255

creative firm
PLANIT
Baltimore, Maryland
creative people
JOHN KLEMSTEIN
client
TRANSHIELD

creative firm
G1440, INC.
Baltimore, Maryland
creative people
GARY CARBAUGH
client
SWAMP DAWG, LLC

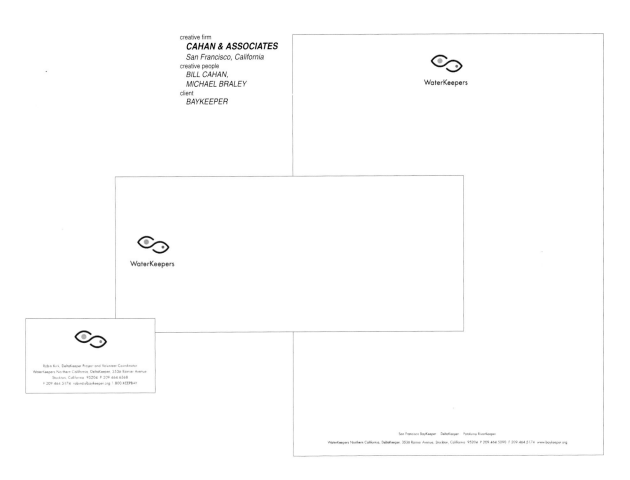

creative firm
CAHAN & ASSOCIATES
San Francisco, California
creative people
BILL CAHAN,
MICHAEL BRALEY
client
BAYKEEPER

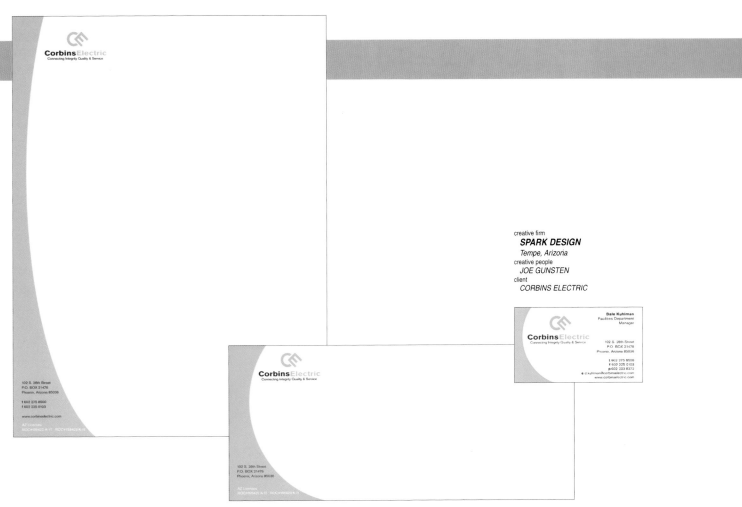

creative firm
SPARK DESIGN
Tempe, Arizona
creative people
JOE GUNSTEN
client
CORBINS ELECTRIC

257

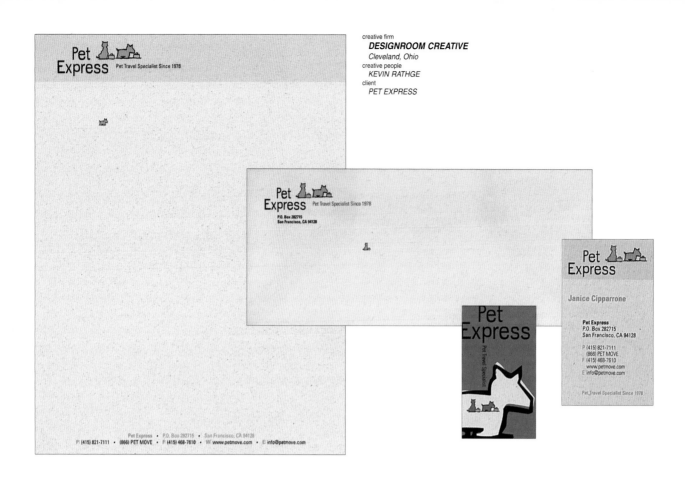

creative firm
DESIGNROOM CREATIVE
Cleveland, Ohio
creative people
KEVIN RATHGE
client
PET EXPRESS

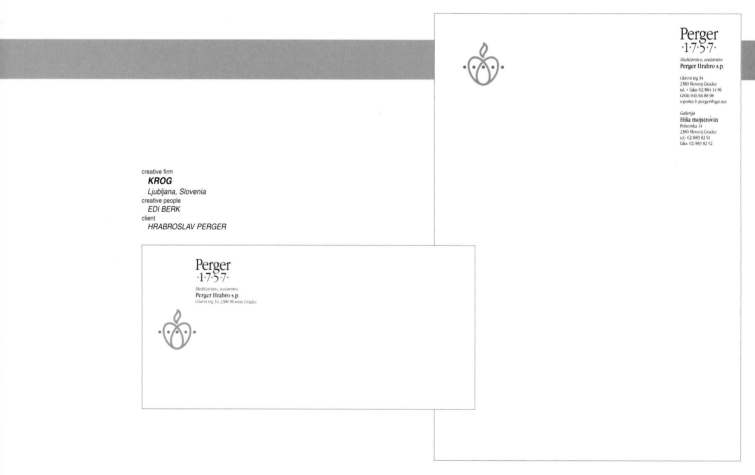

creative firm
KROG
Ljubljana, Slovenia
creative people
EDI BERK
client
HRABROSLAV PERGER

creative firm
POULIN + MORRIS
New York, New York
creative people
L. RICHARD POULIN
client
POLSHEK PARTNERSHIP

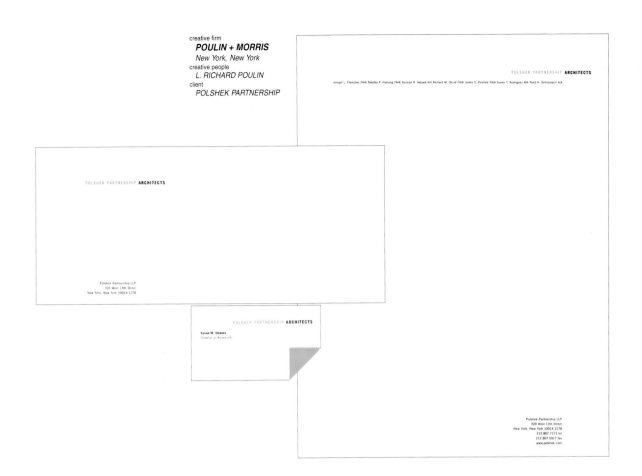

creative firm
GUTIERREZ DESIGN ASSOCIATES
Ann Arbor, Michigan
creative people
JEANNETTE GUTIERREZ
client
GUTIERREZ DESIGN ASSOCIATES

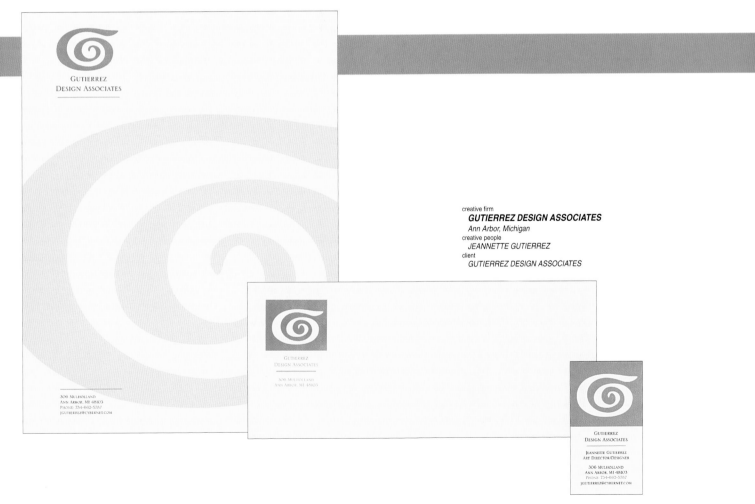

259

creative firm
KROG
Ljubljana, Slovenia
creative people
EDI BERK
client
LIONS KLUB LJUBLJANA ILIRIA

With compliments

LIONS KLUB LJUBLJANA ILIRIA

Topniška 14, 1000 Ljubljana, Slovenia
Pisarna tajništva: Ludvik Bokal
tel.: +386 (0) 41/766 661
fax: +386 (0) 1/236 23 13
e-mail: ludvik.bokal@siol.net
Redni sestanki kluba
so vsak prvi ponedeljek v mesecu ob 20. uri
v gostišču Pri Poku v Brezovici pri Ljubljani.

LIONS KLUB LJUBLJANA ILIRIA
Topniška 14, 1000 Ljubljana, Slovenia
Pisarna tajništva: Ludvik Bokal, *tel.:* +386 (0) 41/766 661, *fax:* +386 (0) 1/236 23 13, *e-mail:* ludvik.bokal@siol.net
Redni sestanki kluba so vsak prvi ponedeljek v mesecu ob 20. uri v gostišču Pri Poku v Brezovici pri Ljubljani.

creative firm
SUPON DESIGN GROUP
Washington, D.C.
creative people
JAKE LEFEBURE,
PUM LEFEBURE
client
VIRGINIA HOSPITAL CENTER—ARLINGTON

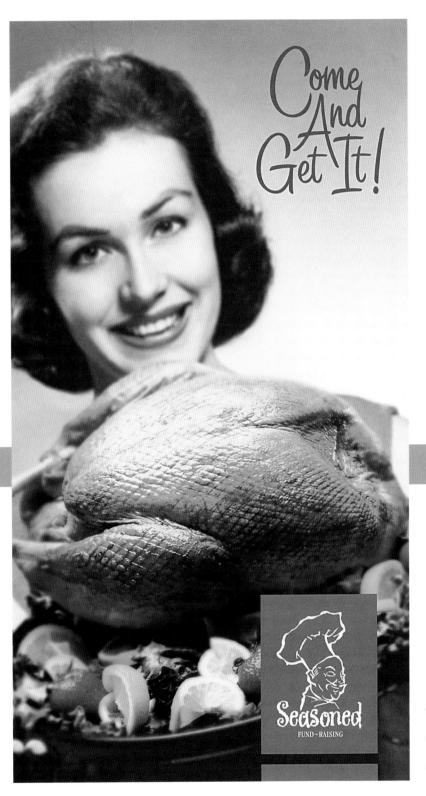

MENUS

creative firm
DESIGN SOLUTIONS
Napa, California
creative people
DEBORAH MITCHELL,
RICHARD MITCHELL
client
TREFETHEN VINEYARDS

MUSIC CDs

creative firm
X DESIGN COMPANY
Denver, Colorado
creative people
ALEX VALDERRAMA,
JEN DANLEN
client
ALDO LEOPARDI

creative firm
HAMAGAMI/CARROLL
Santa Monica, California
creative people
KRIS TIBOR
client
20TH CENTURY FOX

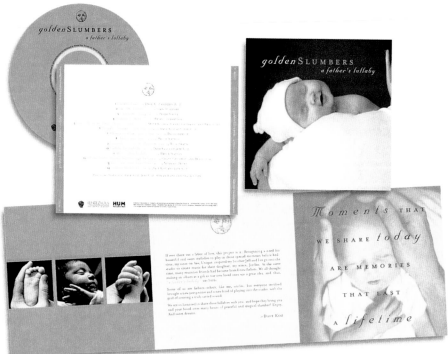

creative firm
TOP DESIGN STUDIO
Toluca Lake, California
creative people
REBEKAH BEATON,
PELEG TOP
client
WARNER BROTHERS RECORDS
RENDEZVOUS ENTERTAINMENT

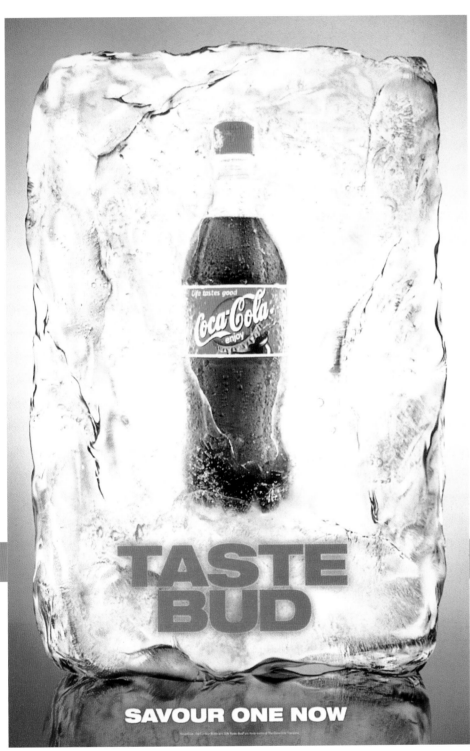

SAVOUR ONE NOW

creative firm
McCANN-ERICKSON SYDNEY
Sydney, Australia
creative people
PATRICK BARON,
JULIAN SCHREIBER
client
COCA-COLA

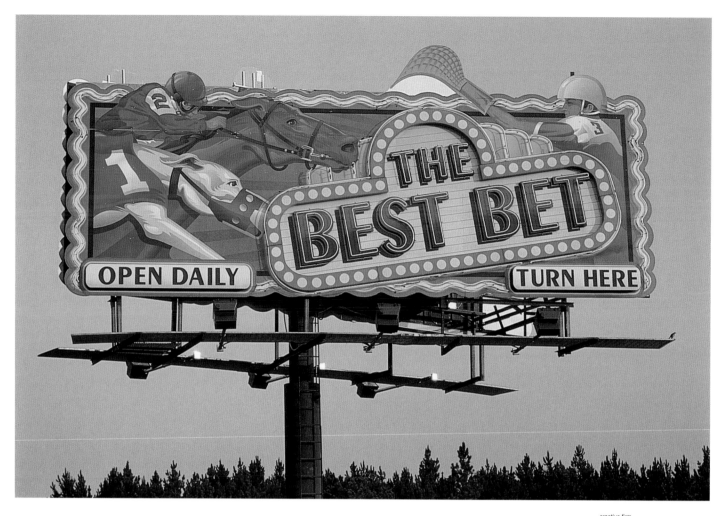

creative firm
GOLD & ASSOCIATES
Ponte Vedra Beach, Florida
creative people
KEITH GOLD,
JOSEPH VAVRA
client
THE KENNEL CLUBS/
ST. JOHNS GREYHOUND PARK

creative firm
GOLD & ASSOCIATES
Ponte Vedra Beach, Florida
creative people
KEITH GOLD, JOSEPH VAVRA
client
THE KENNEL CLUBS

YOU'RE ALMOST HOME.

Windham Mountain Exit 21

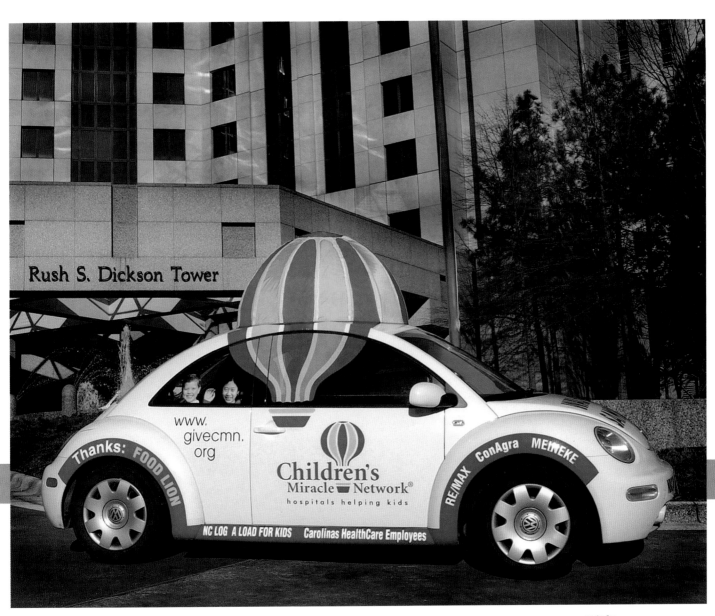

creative firm
**PERFORMANCE GRAPHICS
OF LAKE NORMAN INC.**
Cornelius, North Carolina
creative people
*MITZI MAYHEW,
ALEC McALISTER*
client
LIMEAIDE REFRESHING DELIVERY

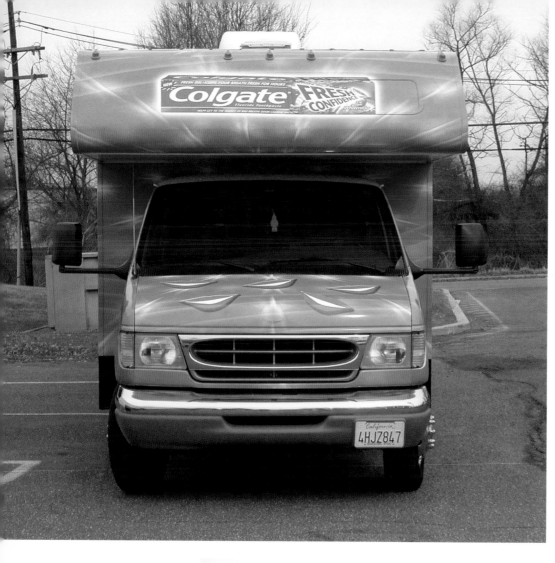

creative firm
COLGATE-PALMOLIVE
PROMOTION DESIGN STUDIO
New York, New York
creative people
LISA SILVERIO,
RANDI RODIN
client
COLGATE-PALMOLIVE

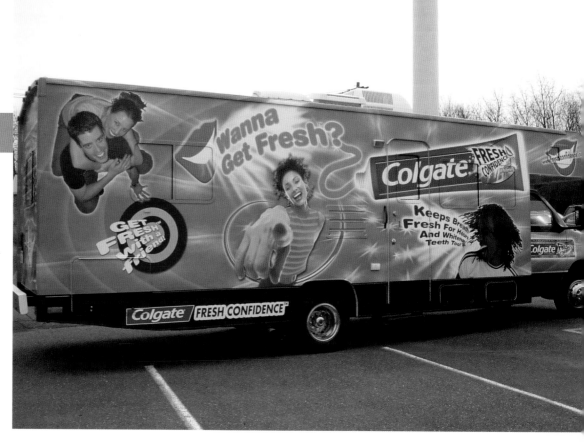

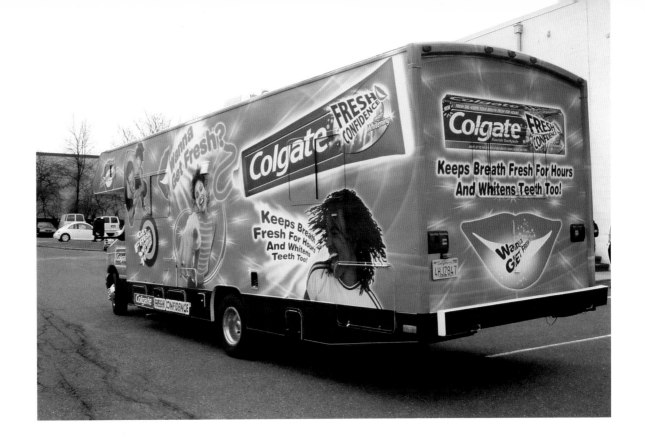

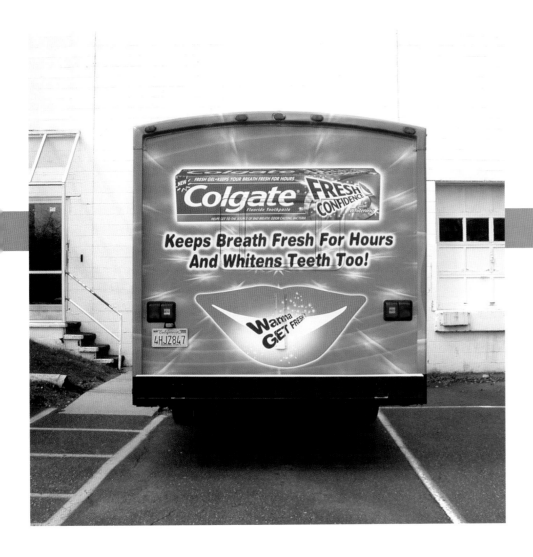

creative firm
WKSP ADVERTISING
Ramat Gan, Israel
creative people
DANIEL GOLDIN,
ORLY FRUM
client
SONOL
translation
CAN'T GET UP THE HILL?
THERE'S DIESEL.....AND THERE'S GOLDIESEL
THE ENGINE PROTECTOR. ONLY AT SONOL

creative firm
WKSP ADVERTISING
Ramat Gan, Israel
creative people
DANIEL GOLDIN,
ORLY FRUM
client
SONOL
translation
FILTERS BLOCKED?
THERE'S DIESEL.....AND THERE'S GOLDIESEL
THE ENGINE PROTECTOR. ONLY AT SONOL

המנוע עושה בעיות?

יש סולר ויש...

שומר הראש של המנוע. רק ב- *סונול*

creative firm
WKSP ADVERTISING
Ramat Gan, Israel
creative people
DANIEL GOLDIN,
ORLY FRUM
client
SONOL
translation
ENGINE TROUBLE?
THERE'S DIESEL.....AND THERE'S GOLDIESEL
THE ENGINE PROTECTOR. ONLY AT SONOL

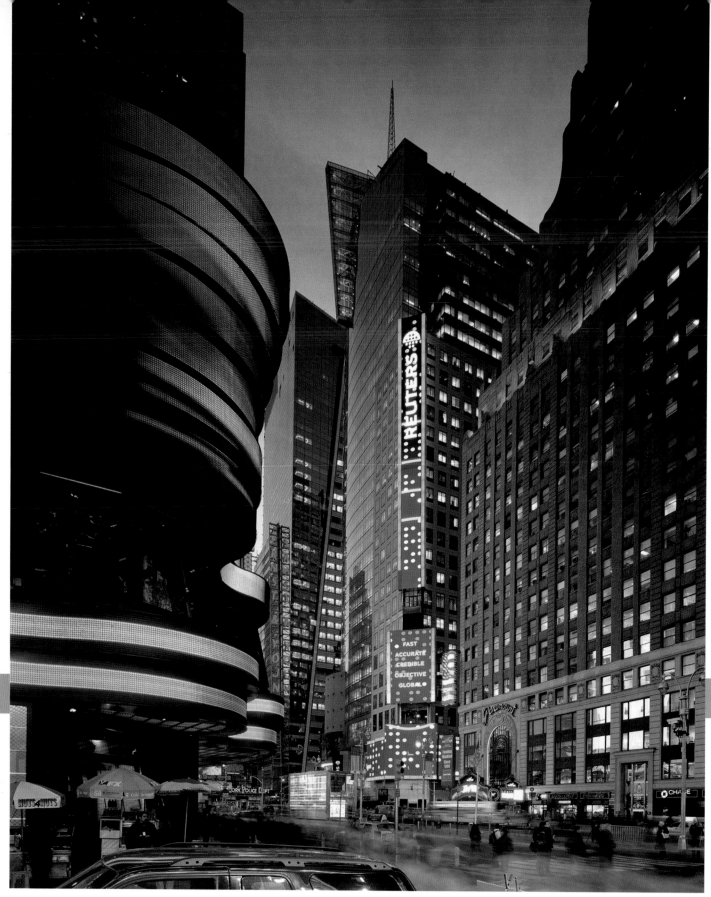

creative firm
ESI DESIGN
New York, New York
creative people
EDWIN SCHLOSSBERG, JOE MAYER, STACEY LISHERON, MARTHA GARVEY,
MATTHEW MOORE, GIDEON D'ARCANGELO, ANGELA GREENE, JOHN ZAIA,
MARK CORRAL, DEAN MARKOSIAN, NAOMI MIRSKY, RON McBAIN
client
REUTERS AND INSTINET

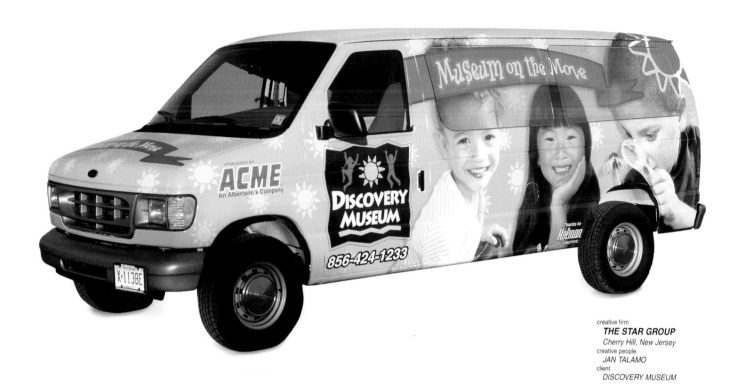

creative firm
THE STAR GROUP
Cherry Hill, New Jersey
creative people
JAN TALAMO
client
DISCOVERY MUSEUM

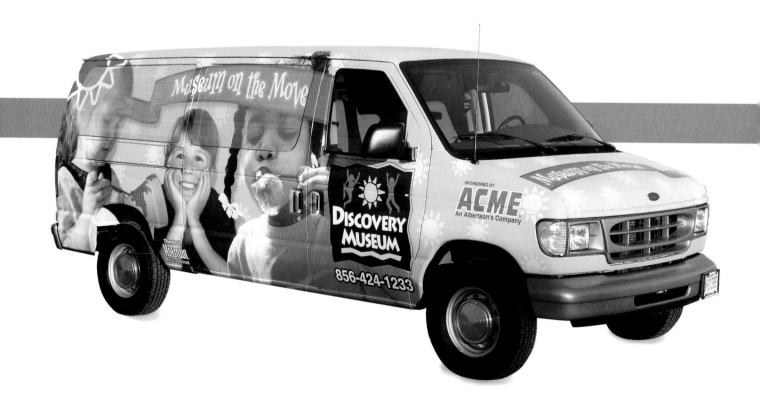

creative firm
ALBERT BOGNER DESIGN COMMUNICATIONS
 Lancaster, Pennsylvania
creative people
 KELLY ALBERT, KERRY BURKHART
client
 SNYDER'S OF HANOVER

creative firm
COMPASS DESIGN
 Minneapolis, Minnesota
creative people
 MITCH LINDGREN, BILL COLLINS,
 TOM ARTHUR MATT MCKEE
client
 BETTY CROCKER

PACKAGING

creative firm
SMITH DESIGN ASSOCIATES
 Charlestown, Indiana
creative people
 CHERYL SMITH
client
 KELLEY TECHNICAL COATINGS

creative firm
TD2, S.C.
Mexico City, Mexico
creative people
RAFAEL TREVINO MONTEAGUDO,
RAFAEL RODRIGO CORDOVA ORTIZ,
BRENDA CAMACHO SAENZ,
EDGAR MEDINA GRACIANO
client
BACHOCO

creative firm
TOM FOWLER, INC.
Norwalk, Connecticut
creative people
THOMAS G. FOWLER,
MARY ELLEN BUTKUS,
BRIEN O'REILLY
client
HONEYWELL CONSUMER
PRODUCTS GROUP

creative firm
SZYLINSKI ASSOCIATES INC.
New York, New York
creative people
ED SZYLINSKI
client
BAYER CONSUMER CARE DIVISION

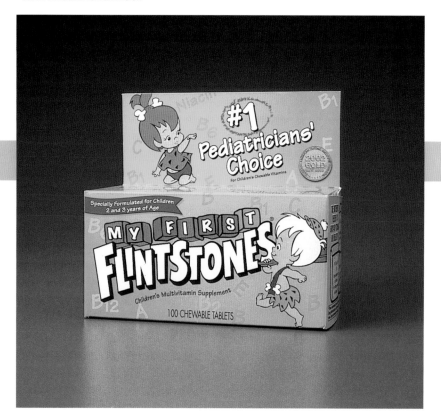

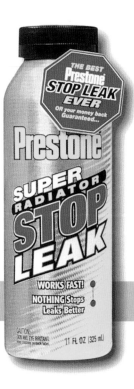

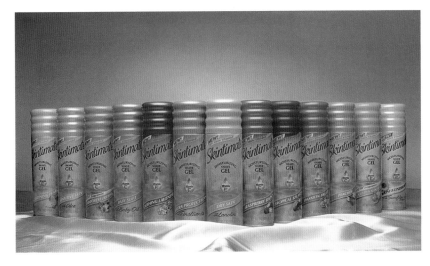

creative firm
THE WEBER GROUP, INC.
Racine, Wisconsin
creative people
*ANTHONY WEBER, SCOTT SCHREIBER,
NICK BINETTI, SHAD SMITH*
client
S.C. JOHNSON & SON, INC.

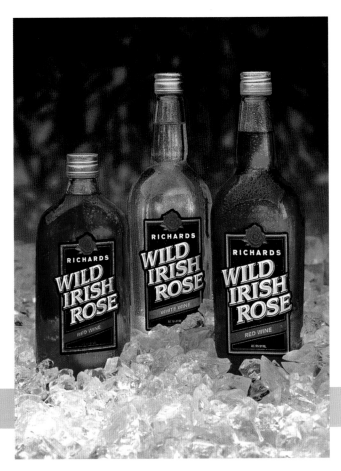

creative firm
THE IMAGINATION COMPANY
Bethel, Vermont
creative people
*KRISTEN SMITH, SHANE YOUNG,
MICHAEL CRONIN*
client
ROCK OF AGES

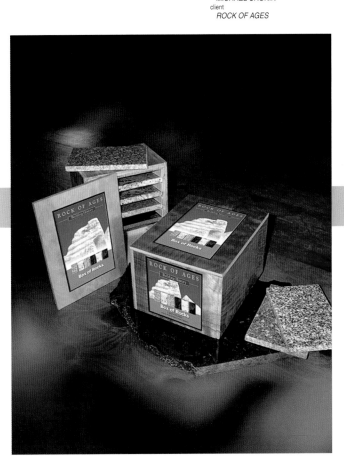

creative firm
McELVENEY & PALOZZI DESIGN GROUP, INC.
Rochester, New York
creative people
NICK WOYCIESJES

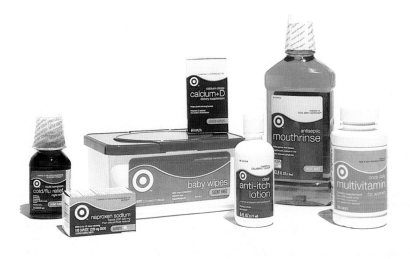

creative firm
DESIGN GUYS
Minneapolis, Minnesota
creative people
STEVE SIKORA, KATIE KIRK,
WENDY BONNSTETTER
client
TARGET STORES

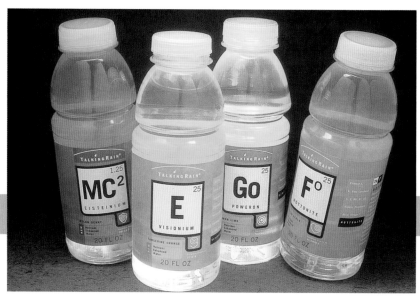

creative firm
HORNALL ANDERSON DESIGN WORKS, INC.
Seattle, Washington
creative people
JACK ANDERSON, JANA NISHI,
MARY CHIN HUTCHISON, BELINDA BOWLING
client
TALKING RAIN

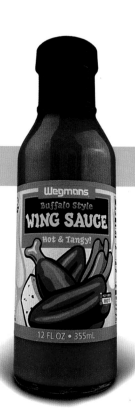

creative firm
FORWARD BRANDING & IDENTITY
Webster, New York
client
WEGMANS FOOD MARKETS

creative firm
**HORNALL ANDERSON
DESIGN WORKS, INC.**
Seattle, Washington
creative people
*JACK ANDERSON, LARRY ANDERSON,
GRETCHEN COOK, JAY HILBURN,
KAYE FARMER, ANDREW WICKLUND*
client
ROCKY MOUNTAIN CHOCOLATE FACTORY

creative firm
ZUNDA DESIGN GROUP
South Norwalk, Connecticut
creative people
*CHARLES ZUNDA,
PATRICK SULLIVAN*
client
MAXMILLIAN'S MIXERS

creative firm
THOMPSON DESIGN GROUP
San Francisco, California
creative people
DENNIS THOMPSON, PATRICK FRASER
client
NESTLÉ PURINA PETCARE COMPANY

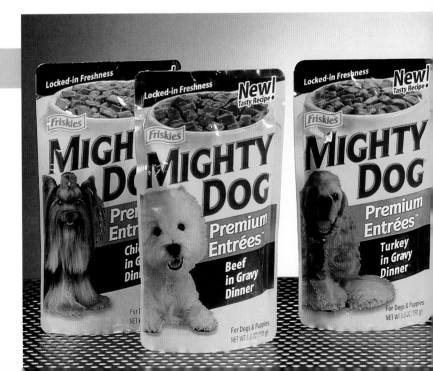

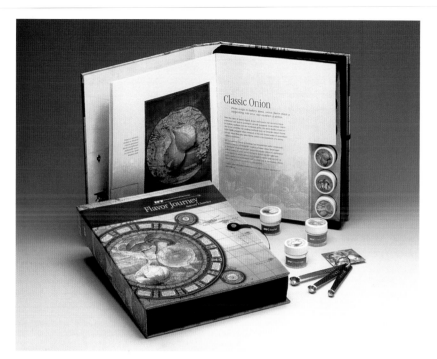

creative firm
AJF MARKETING
Piscataway, New Jersey
creative people
JUSTIN BRINDISI
client
*IFF INTERNATIONAL
FLAVORS & FRAGRANCES*

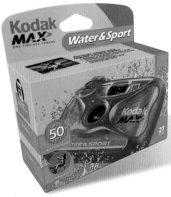
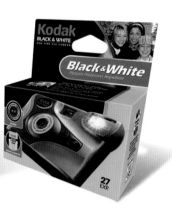

creative firm
FORWARD BRANDING & IDENTITY
Webster, New York
client
EASTMAN KODAK COMPANY

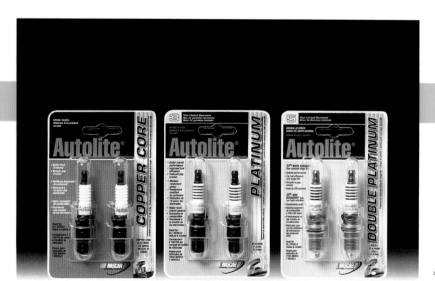

creative firm
TOM FOWLER, INC.
Norwalk, Connecticut
creative people
*MARY ELLEN BUTKUS,
THOMAS G. FOWLER,
BRIEN O'REILLY*
client
HONEYWELL CONSUMER PRODUCTS

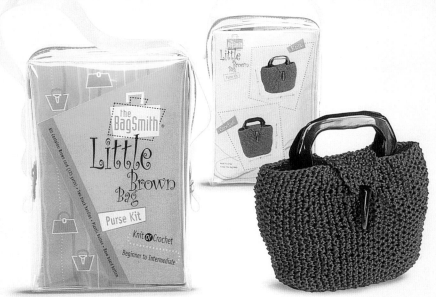

not to scale

creative firm
KAREN SKUNTA & COMPANY
Cleveland, Ohio
creative people
KAREN SKUNTA, CHRISTOPHER SUSTER,
BRITTYN DEWERTH
client
SMITH INTERNATIONAL ENTERPRISES

creative firm
THE LEYO GROUP, INC.
Chicago, Illinois
creative people
JAYCE SCHMIDT, HORST MICKLER,
ROBY AZUBEL, FERNANDA FINGUER,
GERARDO LASPIUR, BILL LEYO
client
BELLA NICO, INC.

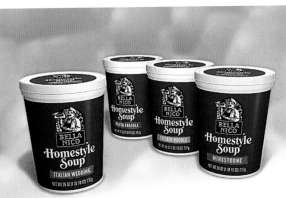

creative firm
COMPASS DESIGN
Minneapolis, Minnesota
creative people
MITCH LINDGREN, TOM ARTHUR,
BILL COLLINS, RICH MCGOWEN
client
GEDNEY

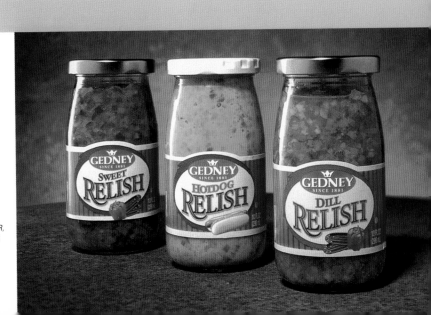

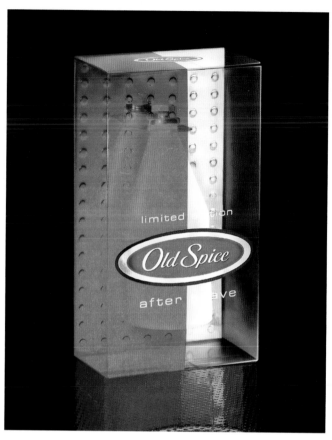

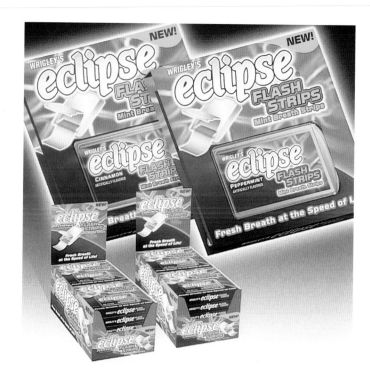

creative firm
CASSATA & ASSOCIATES
Schaumburg, Illinois
creative people
JAMES WOLFE
client
WM. WRIGLEY JR. CO.

creative firm
INTERBRAND HULEFELD
Cincinnati, Ohio
creative people
DENNIS DILL, BART LAUBE,
JEAN CAMPBELL
client
PROCTER & GAMBLE

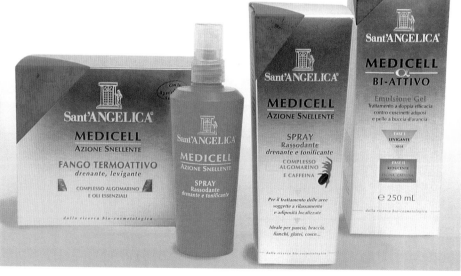

creative firm
POLAROLO IMMAGINE E COMUNICAZIONE
Torino, Italy
creative people
FELICE POLAROLO,
CRISTINA GARELLO
client
MEDESTEA

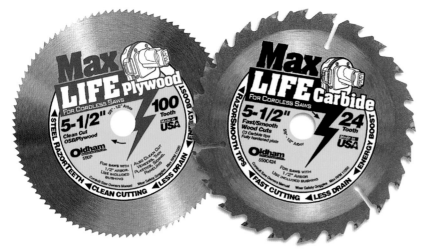

creative firm
BALL ADVERTISING & DESIGN, INC.
Statesville, North Carolina
creative people
LANE BALL, SHELLEY BALL
client
OLDHAM

creative firm
HORNALL ANDERSON DESIGN WORKS, INC.
Seattle, Washington
creative people
JACK ANDERSON, JOHN ANICKER,
ANDREW SMITH, ANDREW WICKLUND,
MARY HERMES, JOHN ANDERLE
client
ONEWORLD CHALLENGE

creative firm
DESIGN GUYS
Minneapolis, Minnesota
creative people
STEVEN SIKORA,
ANNE PETERSON
client
TARGET STORES

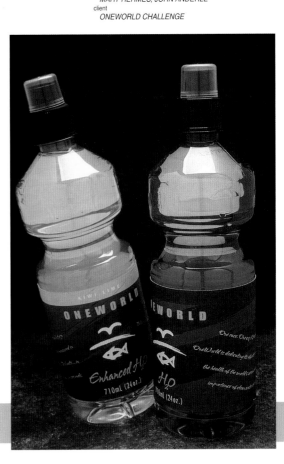

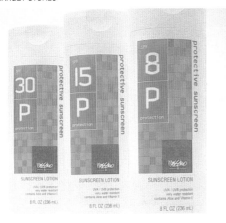

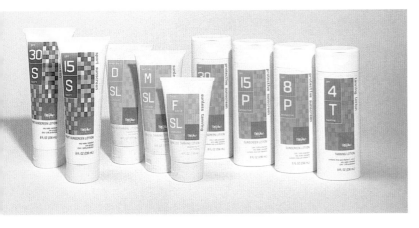

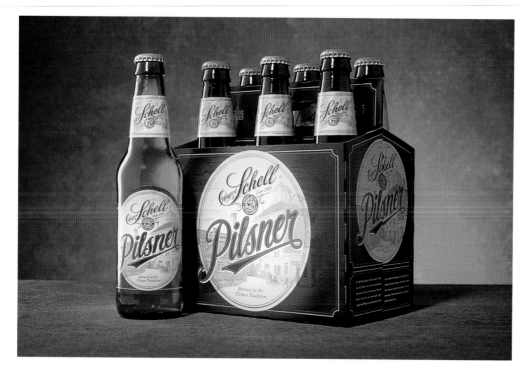

creative firm
COMPASS DESIGN
Minneapolis, Minnesota
creative people
MITCH LINDGREN, TOM ARTHUR,
BILL COLLINS, RICH MCGOWEN
client
AUGUST SCHELL BREWING CO.

creative firm
BAILEY DESIGN GROUP
Plymouth Meeting, Pennsylvania
creative people
CHRISTIAN WILLIAMSON,
STEVE PERRY, WENDY SLAVISH
client
WILLIAM GRANT AND SONS

creative firm
MARCIA HERRMANN DESIGN
Modesto, California
creative people
MARCIA HERRMANN
client
MARSHALL McCORMICK WINERY

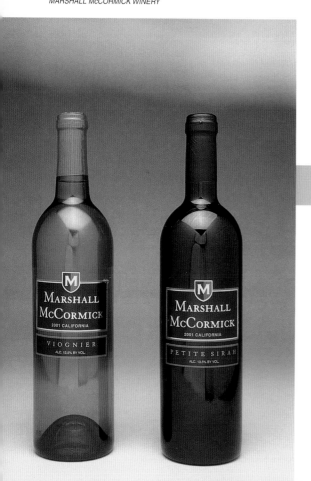

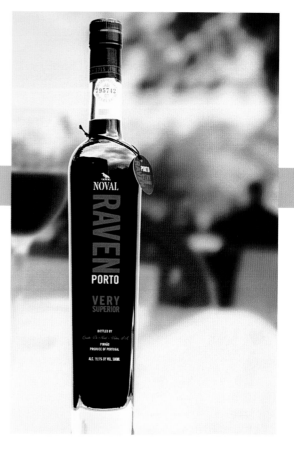

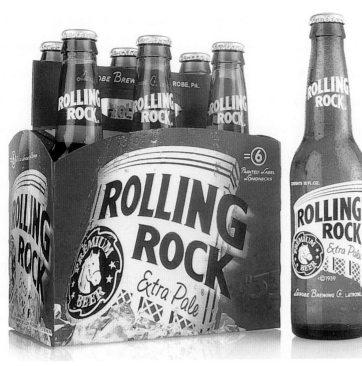

creative firm
HMS DESIGN, INC.
S.Norwalk, Connecticut
creative people
JOSH LAIRD
client
LABATT USA, INC.

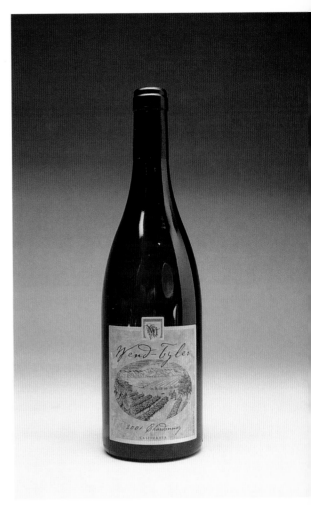

creative firm
MARCIA HERRMANN DESIGN
Modesto, California
creative people
MARCIA HERRMANN
client
WEND TYLER WINERY

creative firm
HORNALL ANDERSON DESIGN WORKS, INC.
Seattle, Washington
creative people
JACK ANDERSON, LARRY ANDERSON,
JAY HILBURN, KAYE FARMER, HENRY YIU,
MARY CHINN HUTCHISON, SONJA MAX,
DOROTHEE SOECHTING
client
KAZI BEVERAGE COMPANY

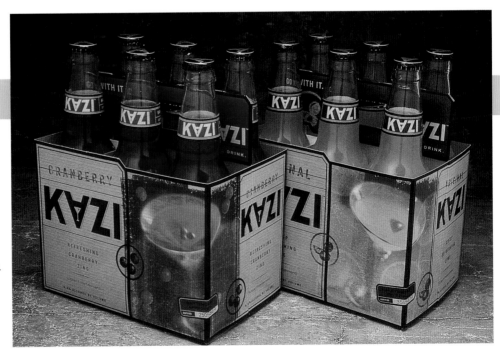

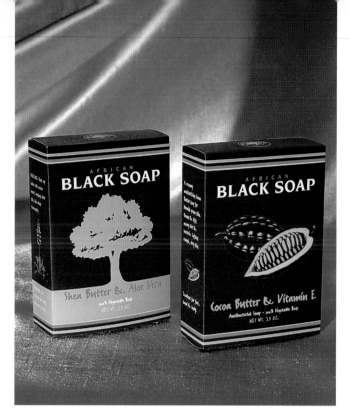

creative firm
MAINFRAME MEDIA & DESIGN LLC
Chester, New Jersey
creative people
LUCINDA WEI
client
BLACK SOAP

creative firm
WALLACE CHURCH, INC.
New York, New York
creative people
STAN CHURCH,
JOHN BRUNO
client
AHOLD

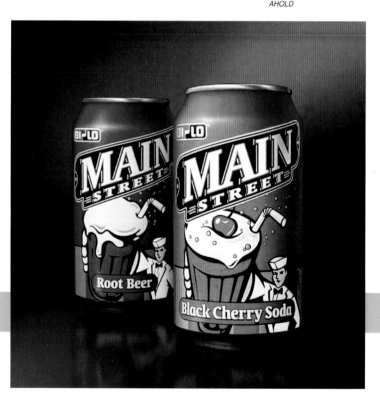

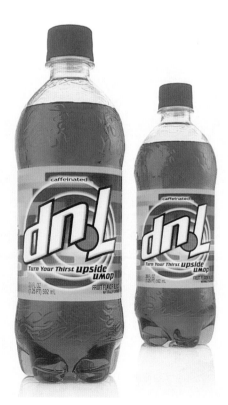

creative firm
HMS DESIGN, INC.
S.Norwalk, Connecticut
creative people
INGA EKGAUS
client
DPSU, INC.

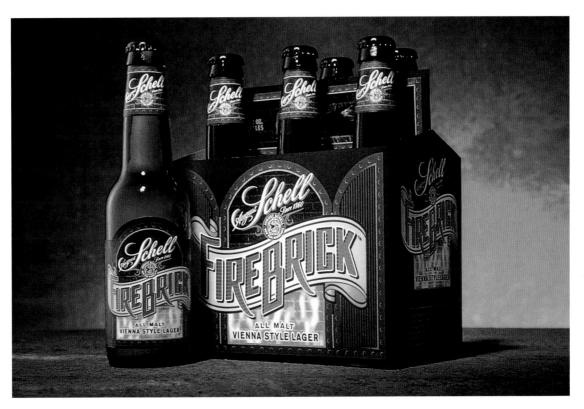

creative firm
COMPASS DESIGN
Minneapolis, Minnesota
creative people
MITCH LINDGREN
client
AUGUST SCHELL BREWING CO.

creative firm
BAILEY DESIGN GROUP
Plymouth Meeting, Pennsylvania
creative people
JERRY COVCORAN, WENDY SLAVISH,
STEVE PERRY
client
WILLIAM GRANT AND SONS

creative firm
McELVENEY & PALOZZI DESIGN GROUP
Rochester, New York
creative people
NICK WOYCIESJES
client
HERON HILL WINERY

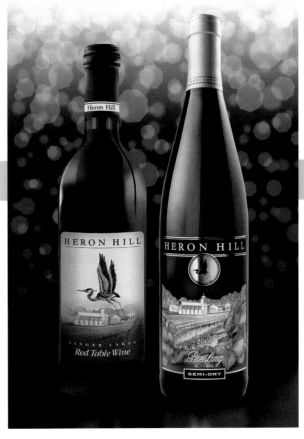

creative firm
KARACTERS DESIGN GROUP
Vancouver, Canada
creative people
MARIA KENNEDY,
MATTHEW CLARK
client
CLEARLY CANADIAN BEVERAGE CORP.

creative firm
WALLACE CHURCH, INC.
New York, New York
creative people
STAN CHURCH,
DAVID MINKLEY
client
AHOLD

creative firm
POLAROLO IMMAGINE
E COMUNICAZIONE
Torino, Italy
creative people
FELICE POLAROLO,
SONIA AMBROGGI,
STEFANIA RICCHIERI
client
MIRATO—ITALY

creative firm
KARACTERS DESIGN GROUP
Vancouver, Canada
creative people
MARIA KENNEDY, MICHELLE MELENCHUK,
MARSHA KUPSCH
client
C*ME COSMETICS

creative firm
**POLAROLO IMMAGINE
E COMUNICAZIONE**
Torino, Italy
creative people
FELICE POLAROLO,
SONIA AMBROGGI,
STEFANIA RICCHIERI
client
MIRATO—ITALY

creative firm
RGB DESIGN
Rio De Janeiro, Brazil
creative people
MARIA LUIZA GONCALVES VEIGA BRITO
client
DE MILLUS IND E COM. S.A.

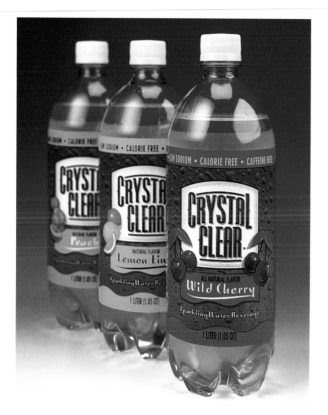

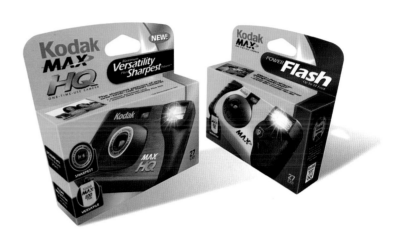

creative firm
**FORWARD BRANDING
& IDENTITY**
Webster, New York
client
EASTMAN KODAK COMPANY

creative firm
INTERBRAND HULEFELD
Cincinnati, Ohio
creative people
BART LAUBE, CHRISTIAN NEIDHARD
client
KROGER

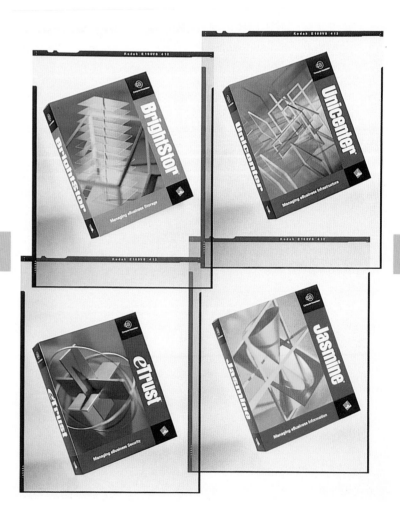

creative firm
**COMPUTER ASSOCIATES
INTERNATIONAL, INC.**
Islandia, New York
creative people
*LOREN MOSS MEYER,
DOMINIQUE MALATERRE*
client
COMPUTER ASSOCIATES

creative firm
AJF MARKETING
Piscataway, New Jersey
creative people
PAUL BORKOWSKI
client
IFF-INTERNATIONAL FLAVORS
& FRAGRANCES

creative firm
INGEAR
Buffalo Grove, Illinois
creative people
MATT HASSLER
client
SAM'S

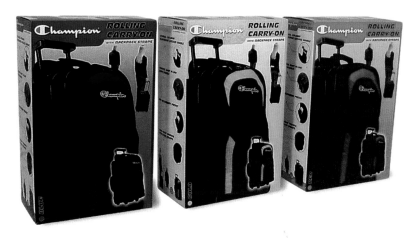

creative firm
AJF MARKETING
Piscataway, New Jersey
creative people
JUSTIN BRINDISI
client
IFF-INTERNATIONAL FLAVORS
& FRAGRANCES

291

creative firm
PHOENIX DESIGN WORKS
New York, New York
creative people
JAMES M. SKILES,
ROD OLLERENSHAW,
DARLENE PEPPER
client
FOX INTERACTIVE

creative firm
RASSMAN DESIGN
Denver, Colorado
creative people
LYN D'AMATO,
JOHN RASSMAN
client
SWIFT & COMPANY

creative firm
PHOENIX DESIGN WORKS
New York, New York
creative people
JAMES M. SKILES,
ROD OLLERENSHAW,
DARLENE PEPPER
client
FOX INTERACTIVE

creative firm
PHOENIX DESIGN WORKS
New York, New York
creative people
*JAMES M. SKILES,
ROD OLLERENSHAW,
DARLENE PEPPER*
client
FOX INTERACTIVE

creative firm
RASSMAN DESIGN
Denver, Colorado
creative people
*LYN D'AMATO,
JOHN RASSMAN*
client
SWIFT & COMPANY

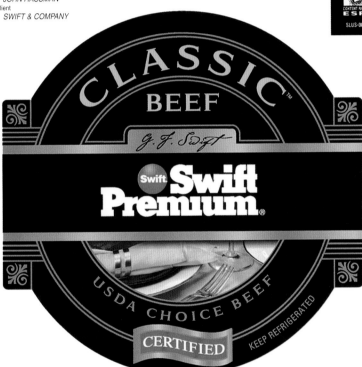

creative firm
PHOENIX DESIGN WORKS
New York, New York
creative people
*JAMES M. SKILES,
ROD OLLERENSHAW,
DARLENE PEPPER*
client
FOX INTERACTIVE

creative firm
CASSATA + ASSOCIATES
Schaumburg, Illinois
creative people
LESLEY WEXLER
client
KELLOGGS/KEEBLER

creative firm
FORWARD BRANDING & IDENTITY
Webster, New York
client
SORRENTO

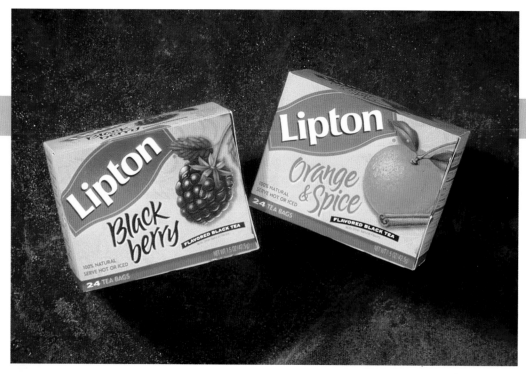

creative firm
**LIPSON ALPORT GLASS
& ASSOC.**
Northbrook, Illinois
creative people
MACK KRUKONIS,
WALTER PERLOWSKI
client
UNILEVER BEST FOODS

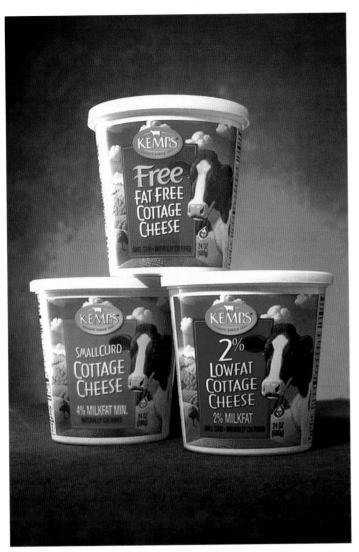

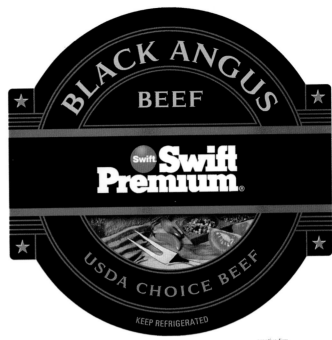

creative firm
RASSMAN DESIGN
Denver, Colorado
creative people
LYN D'AMATO,
JOHN RASSMAN
client
SWIFT & COMPANY

creative firm
COMPASS DESIGN
Minneapolis, Minnesota
creative people
MITCH LINDGREN, TOM ARTHUR,
RICH MCGOWEN
client
KEMPS

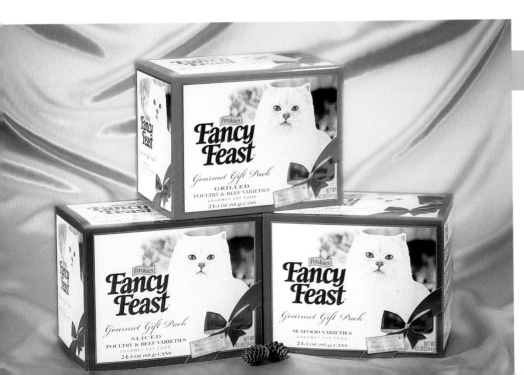

creative firm
THOMPSON DESIGN GROUP
San Francisco, California
creative people
DENNIS THOMPSON,
FELICIA UTOMO,
ELIZABETH BERTA
client
NESTLE PURINA PETCARE COMPANY

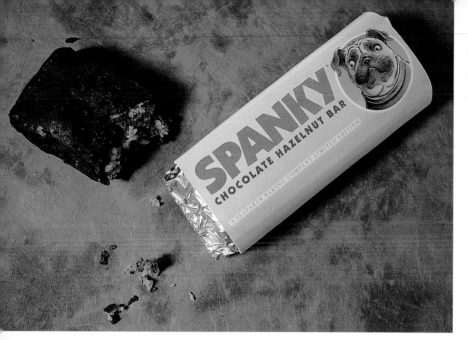

creative firm
SABINGRAFIK, INC.
Carlsbad, California
creative people
TRACY SABIN
client
SEAFARER BAKING COMPANY

creative firm
**McELVENEY & PALOZZI
DESIGN GROUP**
Rochester, New York
creative people
*JON WESTFALL,
MIKE JOHNSON*
client
SUN ORCHARD BRAND

creative firm
COMPASS DESIGN
Minneapolis, Minnesota
creative people
*MITCH LINDGREN, TOM ARTHUR
BILL COLLINS, RICH MCGOWEN*
client
NORTH AIRE MARKET

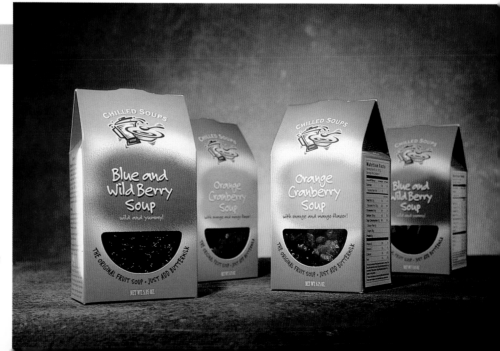

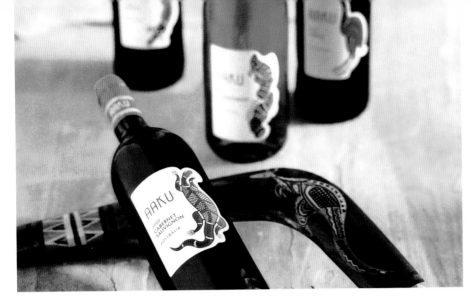

creative firm
BE.DESIGN
San Rafael, California
creative people
ERIC READ, CORALIE RUSSO,
LISA BRUSSELL, CORINNE BRIMM
client
COST PLUS WORLD MARKET

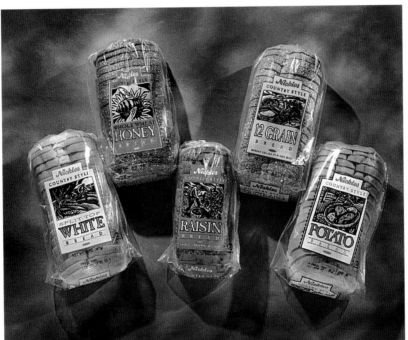

creative firm
INNIS MAGGIORE GROUP
Canton, Ohio
creative people
JEFF MONTER, CHERYL MOLNAR,
ERIC KITTELBERGER
client
NICKLES BAKERY

creative firm
BRADY COMMUNICATIONS
Pittsburgh, Pennsylvania
creative people
JIM BOLANDER, JIM LILLY,
PAUL SEMONIK
client
OLYMPIC

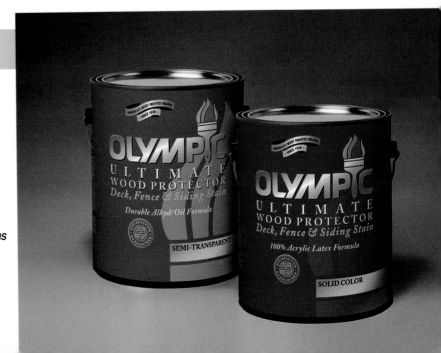

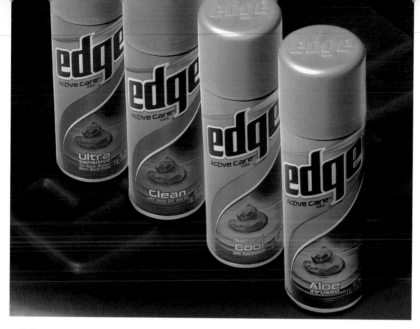

creative firm
THE WEBER GROUP, INC.
Racine, Wisconsin
creative people
ANTHONY WEBER,
SCOTT SCHREIBER
client
S.C. JOHNSON & SON, INC.

creative firm
EVENSON DESIGN GROUP
Culver City, California
creative people
KERA SCOTT,
STAN EVENSON
client
ROCAMOJO

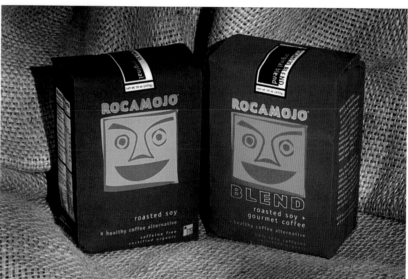

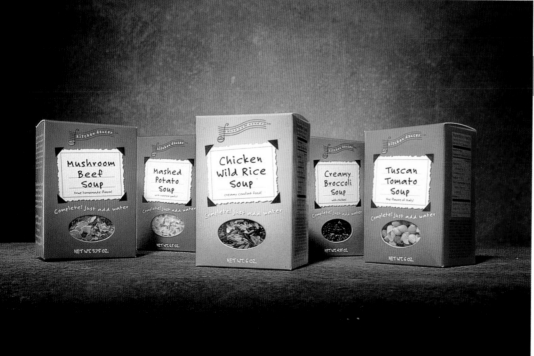

creative firm
COMPASS DESIGN
Minneapolis, Minnesota
creative people
MITCH LINDGREN, BILL COLLINS,
TOM ARTHUR, RICH MCGOWEN
client
NORTH AIRE MARKET

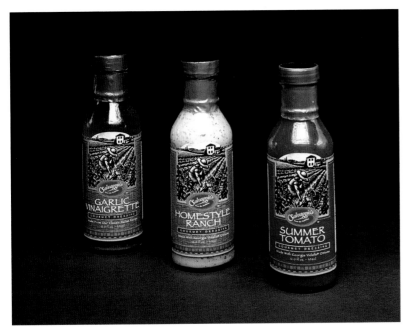

creative firm
GOLDFOREST
Miami, Florida
creative people
MICHAEL GOLD, LAUREN GOLD,
CAROLYN RODI, RAY GARCIA
client
NINO SALVAGGIO
INTERNATIONAL MARKETPLACE

creative firm
MAINFRAME MEDIA & DESIGN LLC
Chester, New Jersey
creative people
LUCINDA WEI
client
BLACK SOAP

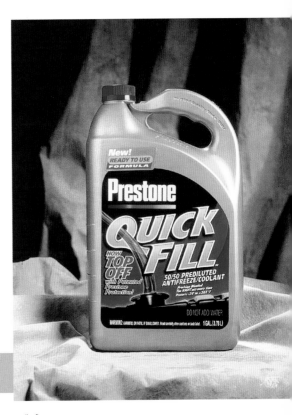

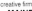

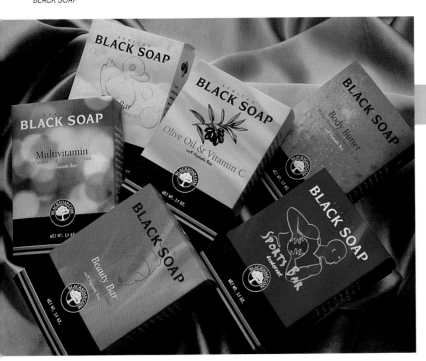

creative firm
TOM FOWLER, INC.
Norwalk, Connecticut
creative people
MARY ELLEN BUTKUS,
THOMAS G. FOWLER,
BRIEN O'REILLY
client
HONEYWELL CONSUMER PRODUCTS

299

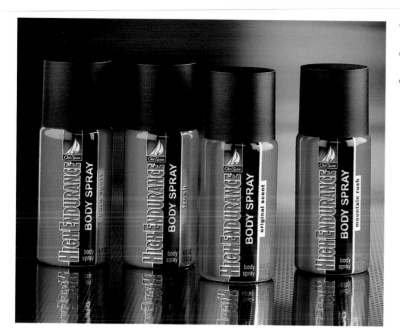

creative firm
INTERBRAND HULEFELD
Cincinnati, Ohio
creative people
*CHRISTIAN NEIDHARD,
JEAN CAMPBELL*
client
PROCTER & GAMBLE

creative firm
LEVERAGE MAR COM GROUP
Newtown, Connecticut
creative people
RICH BRZOZOWSKI
client
FAIRFIELD PROCESSING

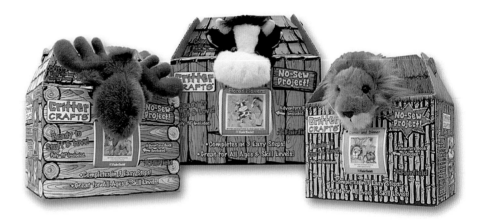

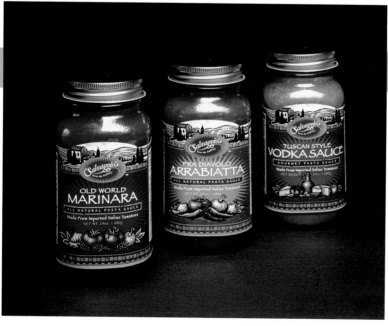

creative firm
GOLDFOREST
Miami, Florida
creative people
*MICHAEL GOLD, LAUREN GOLD,
CAROLYN RODI, RAY GARCIA*
client
*NINO SALVAGGIO
INTERNATIONAL MARKETPLACE*

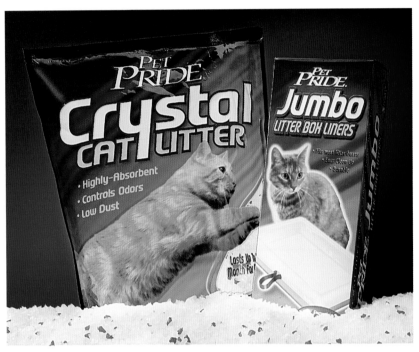

creative firm
INTERBRAND HULEFELD
Cincinnati, Ohio
creative people
BART LAUBE
client
KROGER

creative firm
FUTUREBRAND
creative people
PETER CHIEFFO,
JOE VIOLANTE
client
NESTLE

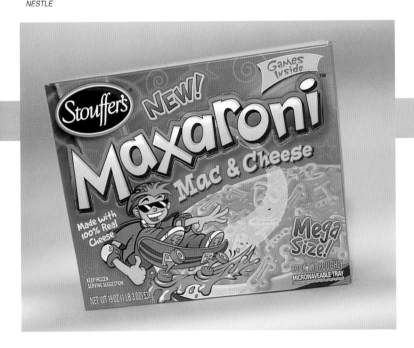

BARONET _02

creative firm
PAPRIKA
Montreal, Canada
creative people
*LOUIS GAGNON, LOUISE MAROIS,
FRANCOIS LECLERC*
client
BARONET

DESIGN CENTER / HIGH POINT, NC / 04.18-25.02
BARONET D523

POSTERS

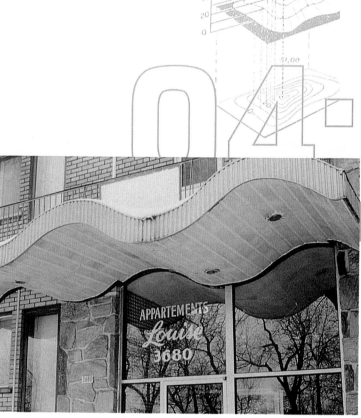

baronet D...

sprin02

design center 04.18-04.25 high point, nc

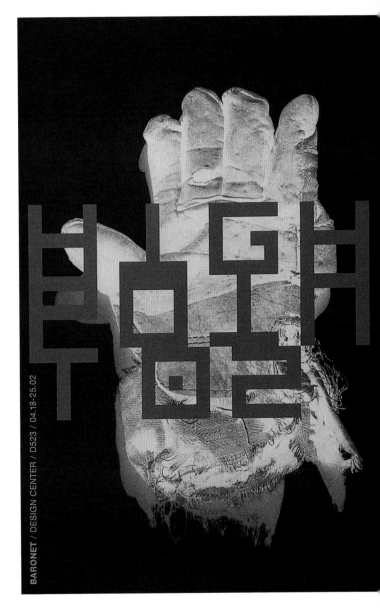

HIGH POINT 02

BARONET / DESIGN CENTER / D523 / 04.18-25.02

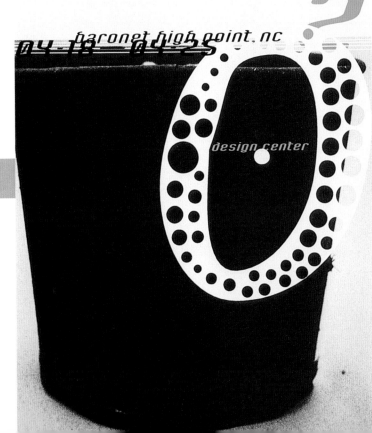

baronet high point, nc

04.18 04.25 ?

design center

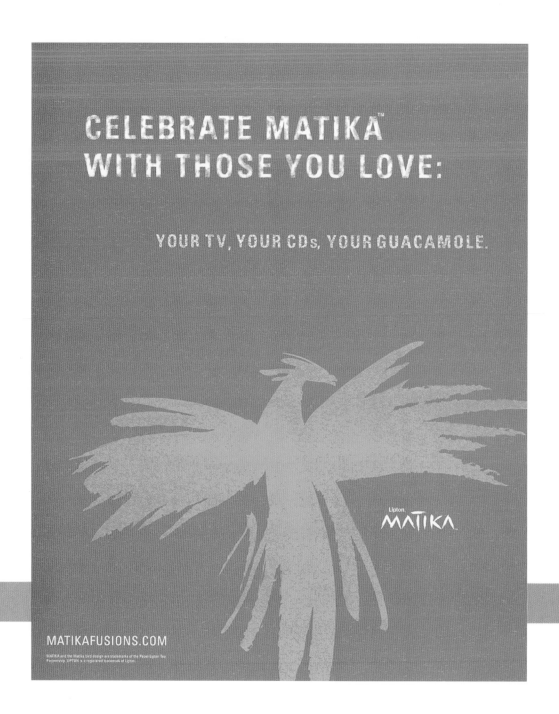

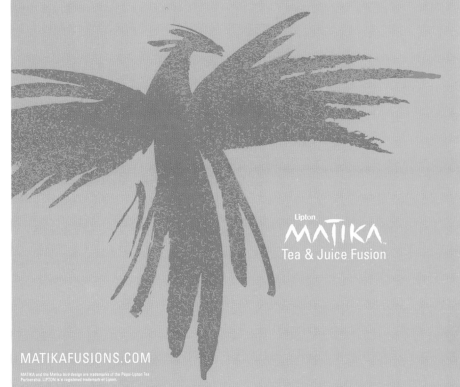

MATIKA™ IS A TIME FILLED WITH MYSTERY.

KIND OF LIKE YOUR DORM ROOM CLOSET, ONLY DIFFERENT.

Lipton.
MATIKA™
Tea & Juice Fusion

MATIKAFUSIONS.COM

MATIKA and the Matika bird design are trademarks of the Pepsi-Lipton Tea Partnership. LIPTON is a registered trademark of Lipton.

creative firm
J. WALTER THOMPSON
New York, New York
creative people
MIKE CAMPBELL, JON KREVOLIN,
MICKEY PAXTON, AVI HALPER,
STEVE KRAUSS
client
MATIKA

MATIKA™ IS MORE THAN A DRINK, IT'S A FEELING.

UNLESS YOU SPILL IT ON THE COUCH, THEN IT'S JUST A DRINK.

MATIKAFUSIONS.COM

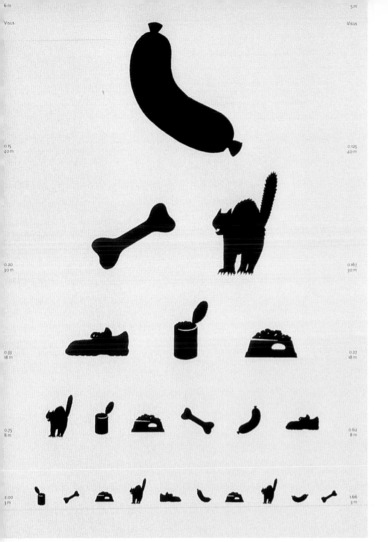

Sehtest für Hunde
Mit freundlicher Empfehlung: Partner Hund,
Europas größtes Hundemagazin.

Partner
HUND

"eye test for dogs"

creative firm
HEYE & PARTNER
Munich, Germany
creative people
ALEXANDER EMIL MÖLLER
client
MONA DAVIS MUSIC

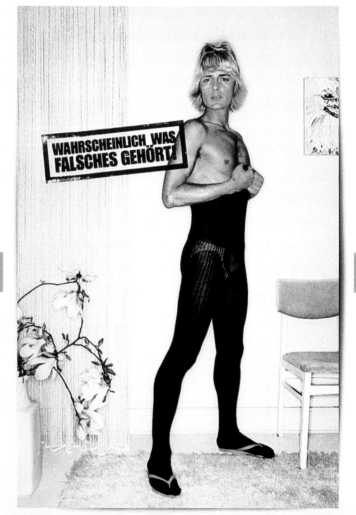

306

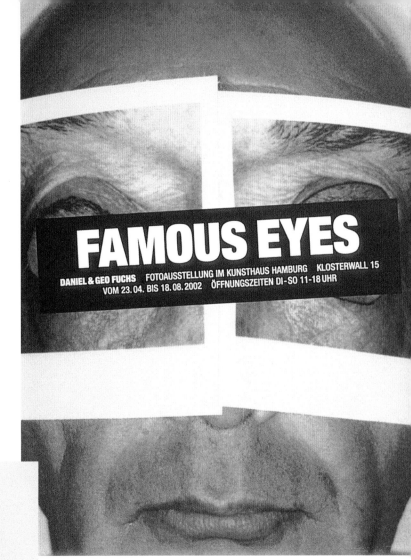

FAMOUS EYES

DANIEL & GEO FUCHS FOTOAUSSTELLUNG IM KUNSTHAUS HAMBURG KLOSTERWALL 15
VOM 23. 04. BIS 18. 08. 2002 ÖFFNUNGSZEITEN DI-SO 11-18 UHR

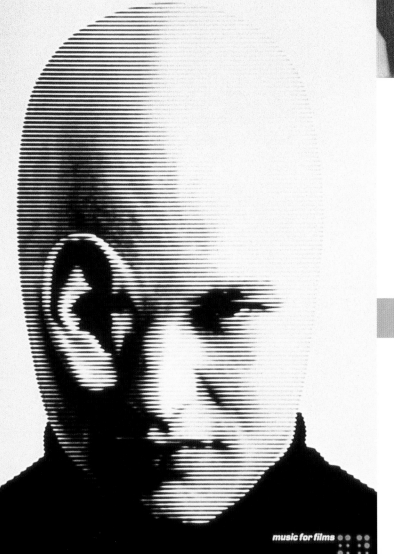

music for films
mona davis

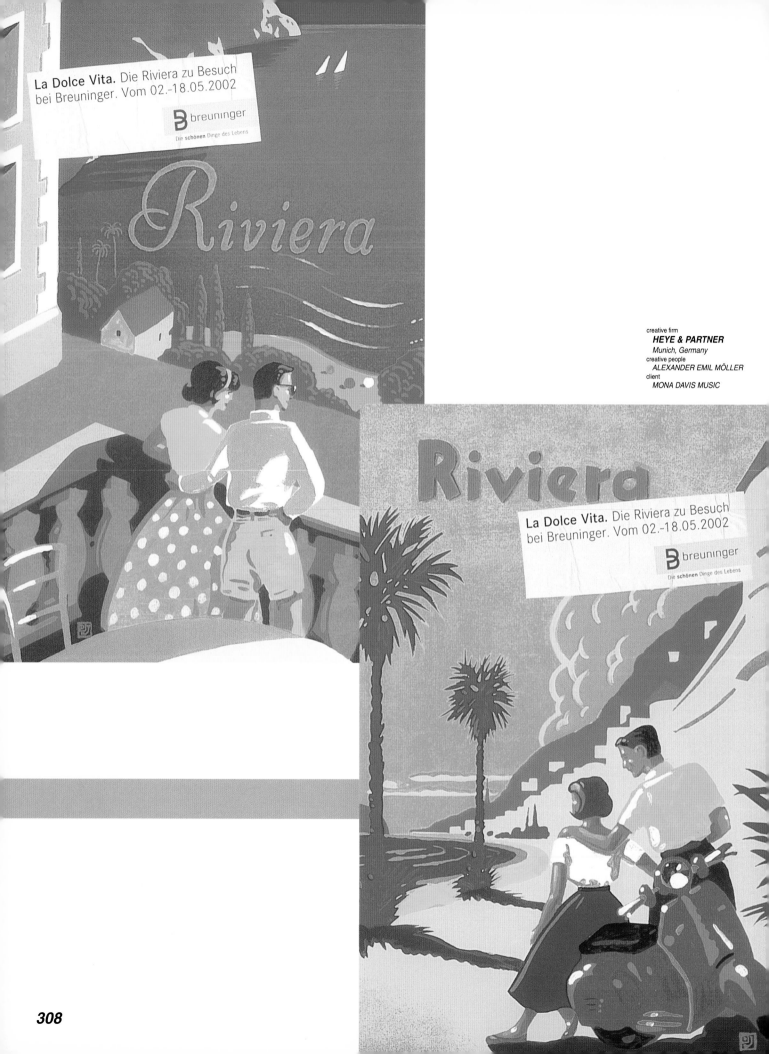

creative firm
HEYE & PARTNER
Munich, Germany
creative people
ALEXANDER EMIL MÖLLER
client
MONA DAVIS MUSIC

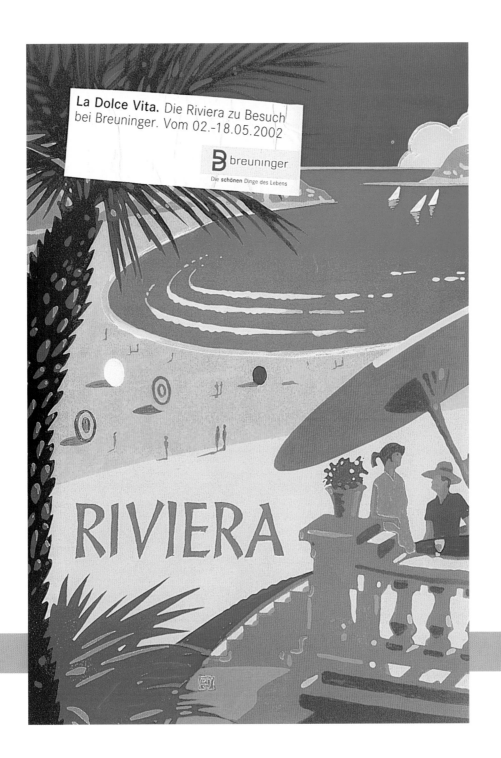

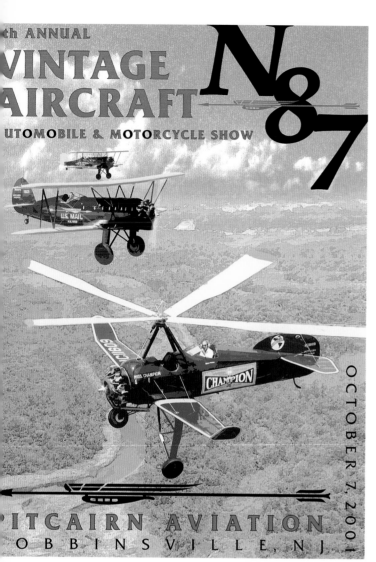

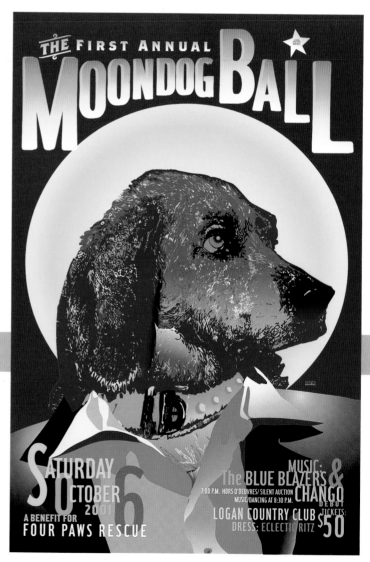

creative firm
ROBERT TALARCZYK DESIGN
Fair Haven, New Jersey
creative people
*ROBERT TALARCZYK, ALAN COPEN,
JIM KOEPNICK, HOWARD LEVY,
CHROMEWERKS, TOPRAN*
client
PITCARIN AVIATION

creative firm
**SLANTING RAIN
GRAPHIC DESIGN**
Logan, Utah
creative people
R.P. BISSLAND
client
FOUR PAWS DOG RESCUE

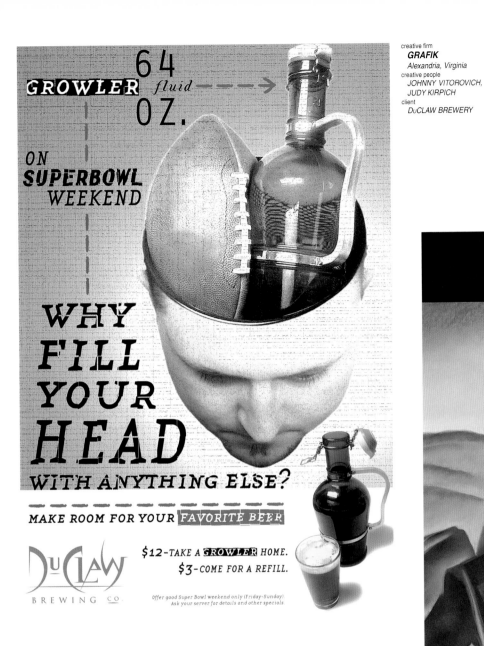

GROWLER 64 fluid —————→ OZ.

ON SUPERBOWL WEEKEND

WHY FILL YOUR HEAD WITH ANYTHING ELSE?

MAKE ROOM FOR YOUR FAVORITE BEER

DuClaw
BREWING CO.

$12-TAKE A GROWLER HOME.
$3-COME FOR A REFILL.

*Offer good Super Bowl weekend only (Friday-Sunday)
Ask your server for details and other specials*

creative firm
GRAFIK
Alexandria, Virginia
creative people
*JOHNNY VITOROVICH,
JUDY KIRPICH*
client
DuCLAW BREWERY

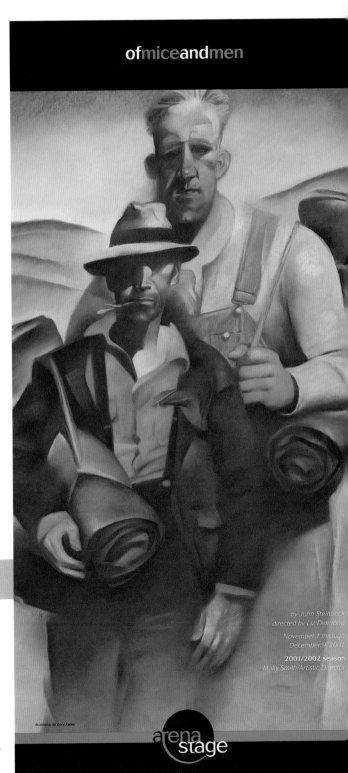

ofmiceandmen

by John Steinbeck
directed by Liz Diamond

November 1 through
December 9, 2001

2001/2002 season
Molly Smith/Artistic Director

Illustration by Gary Kelley

arena
stage

creative firm
MIRES
San Diego, California
creative people
*JENNIFER CADAM, SCOTT MIRES,
JODY HEWGILL, GARY KELLEY*
client
ARENA STAGE

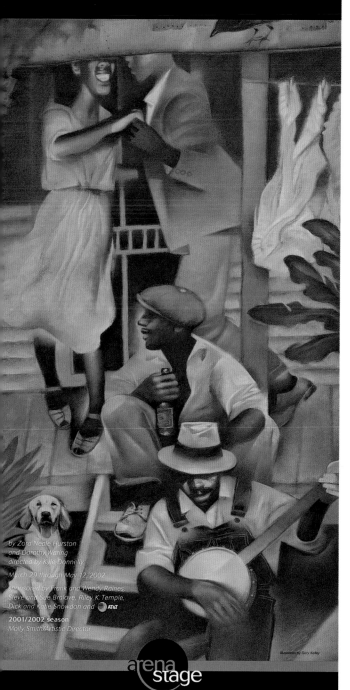

by Zora Neale Hurston
and Dorothy Waring
directed by Kyle Donnelly

March 29 through May 12, 2002

sponsored by Frank and Wendy Raines,
Steve and Sue Bralove, Riley K Temple,
Dick and Katie Snowdon and AT&T

2001/2002 season
Molly Smith/Artistic Director

arena stage

Illustration by Gary Kelley

creative firm
MIRES
San Diego, California
creative people
JENNIFER CADAM, SCOTT MIRES,
JODY HEWGILL, GARY KELLEY
client
ARENA STAGE

creative firm
**SLANTING RAIN
GRAPHIC DESIGN**
Logan, Utah
creative people
R.P. BISSLAND,
KEVIN KOBE
client
GIARDIA TRACK & DRINKING CLUB

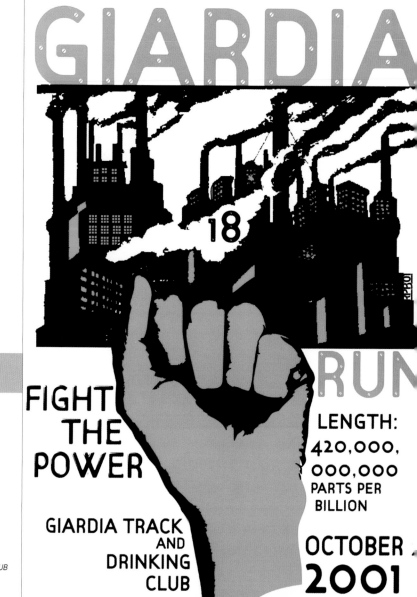

GIARDIA

18

RUN

FIGHT
THE
POWER

LENGTH:
420,000,
000,000
PARTS PER
BILLION

GIARDIA TRACK
AND
DRINKING
CLUB

OCTOBER
2001

LOAIRQUALITYAGAN, UTA

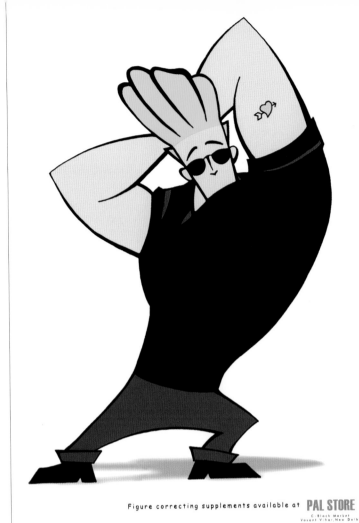

Figure correcting supplements available at **PAL STORE**
C-Block Market
Vasant Vihar, New Delhi

creative firm
TBWA-ANTHEM (INDIA)
New Delhi, India
creative people
*ARNAB CHATTERJEE,
KAPIL DHAWAN,
ABHINAV PRATIMAN,
ROHIT DEVGUN*
client
PAL SUPER STORE

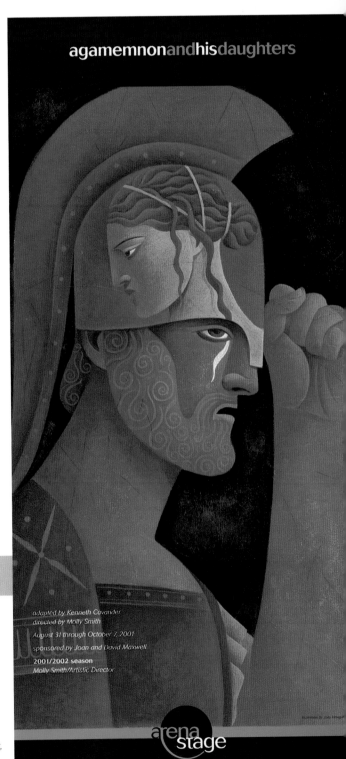

agamemnonandhisdaughters

adapted by Kenneth Cavander
directed by Molly Smith
August 31 through October 7, 2001
sponsored by Joan and David Maxwell
2001/2002 season
Molly Smith/Artistic Director

arena
stage

creative firm
MIRES
San Diego, California
creative people
*JENNIFER CADAM, SCOTT MIRES,
JODY HEWGILL, GARY KELLEY*
client
ARENA STAGE

WANT A REASON TO HOLD YOUR HEAD UP THIS HIGH?

When you give to the United Way, your money goes directly to those who need it most.
That should make you stand a little taller.

creative firm
CAMPBELL EWALD ADVERTISING
Warren, Michigan
creative people
BILL LUDWIG, JIM MILLIS,
NANCY WELLINGER
client
UNITED WAY

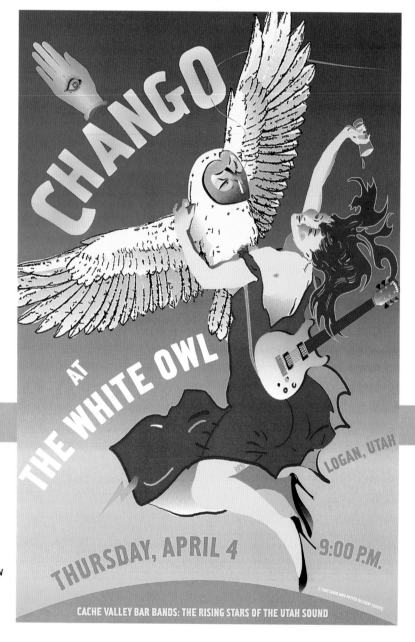

creative firm
**SLANTING RAIN
GRAPHIC DESIGN**
Logan, Utah
creative people
R.P. BISSLAND
client
CHANGO THE BAND

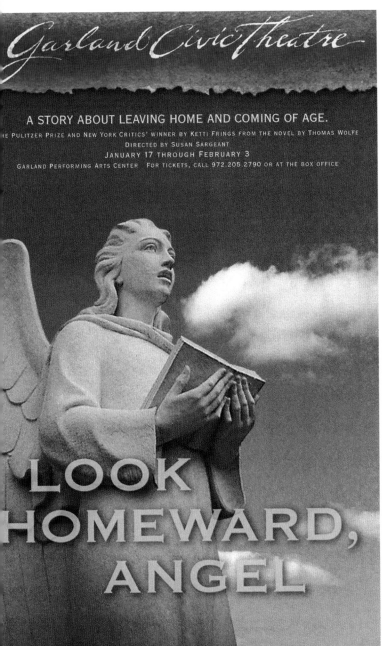

A STORY ABOUT LEAVING HOME AND COMING OF AGE.

THE PULITZER PRIZE AND NEW YORK CRITICS' WINNER BY KETTI FRINGS FROM THE NOVEL BY THOMAS WOLFE

DIRECTED BY SUSAN SARGEANT

JANUARY 17 THROUGH FEBRUARY 3

GARLAND PERFORMING ARTS CENTER FOR TICKETS, CALL 972.205.2790 OR AT THE BOX OFFICE

LOOK HOMEWARD, ANGEL

creative firm
FREDERICK/VANPELT
Garland, Texas
creative people
CHIP VANPELT,
J. FREDERICK
client
GARLAND CIVIC THEATRE

Give More. Get More.
1-800-462-5188

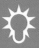

WANT TO SEE YOURSELF IN A BETTER LIGHT?

Give more to the United Way. It brightens the hopes of tens of thousands of area families. It'll give you a sunnier disposition, too. For more info, visit Socrates. To pledge, call 1-800-462-5188.

creative firm
CAMPBELL-EWALD ADVERTISING
Warren, Michigan
creative people
BILL LUDWIG, JIM MILLIS,
NANCY WELLINGER
client
UNITED WAY

TAKE A WALK AS WELL!

BE A GOOD SPORT. JOIN THE 5-KM WALK THAT RAISES
FUNDS AND SPIRITS.

METHODISTWALK002

VENUE: ANGLO-CHINESE JUNIOR COLLEGE
CAMPUS, DOVER CLOSE EAST
DATE: SATURDAY, 23 FEBRUARY 2002
TIME: AT 8.00 AM
GUEST OF HONOUR: REAR-ADM TEO CHEE HEAN,
EDUCATION MINISTER
AND 2ND MINISTER OF FINANCE

A Methodist Schools' Foundation fund-raising project
for the benefit of 14 Methodist schools.

creative firm
ZENDER FANG ASSOCIATES
Singapore
creative people
DOLLAH JAAFAR,
HATTY/HAN CHEWS STUDIO,
ESA SIDIN, SOPHIA TAN
client
METHODIST'S SCHOOL FOUNDATION

66 There's no such thing
as natural beauty.
It takes some effort to
look like this. 99

66 I would rather
have thirty
minutes of wonderful
than a lifetime of
nothing special. 99

66 My personal tragedy
will not interfere
with my ability to
do good hair. 99

66 The only thing
that separates
us from the animals
is our ability
to accessorize. 99

66 If you can't say
anything nice,
come sit by me. 99

Come To
Garland Civic Theatre's
8th Annual Fundraiser
And Hear Southern Belles
Tell It Like It Is.

Steel Magnolias

By Robert Harling
Directed by Mitch Carr
February 14 - March 3
Garland Performing Arts Center
For tickets, call 972.205.2790 or at the box office

creative firm
FREDERICK/VANPELT
Garland, Texas
creative people
CHIP VANPELT,
J. FREDERICK
client
GARLAND CIVIC THEATRE

316

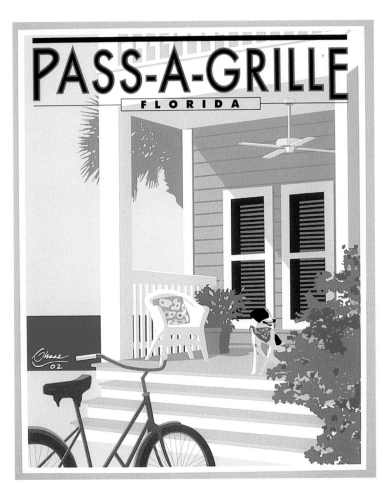

creative firm
CHASE CREATIVE
Galena, Illinois
creative people
GEORGE CHASE
client
PASS-A-GRILLE WOMEN'S CLUB

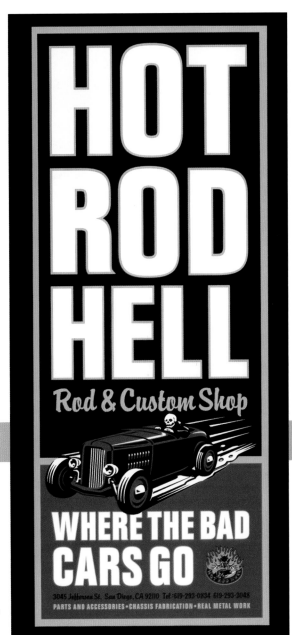

creative firm
MIRES DESIGN
San Diego, California
creative people
JOSE SERRANO, JEFF SAMARIPA,
TRACY SABIN
client
HOT ROD HELL

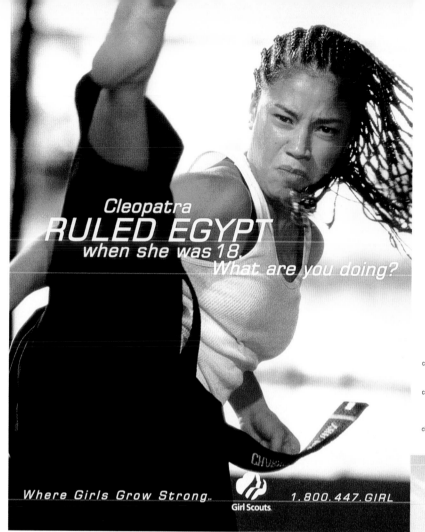

Cleopatra
RULED EGYPT
when she was 18.
What are you doing?

Where Girls Grow Strong. · Girl Scouts · 1.800.447.GIRL

creative firm
AMAZON ADVERTISING
San Francisco, California
creative people
*TRACI SHIRO, JENNIFER BRUNS,
LYNDA PEARSON, CURTIS MYERS,
ELIZABETH GRIVAS, DENNIS CURRY*
client
GIRL SCOUTS

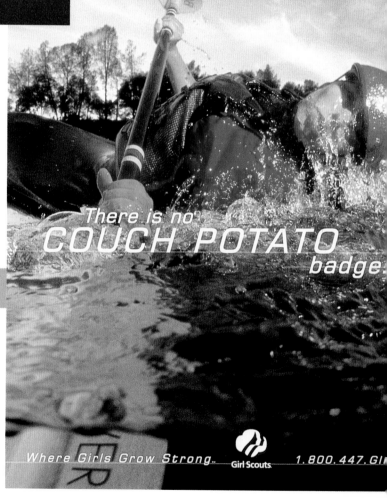

There is no
COUCH POTATO
badge.

Where Girls Grow Strong. · Girl Scouts · 1.800.447.GIRL

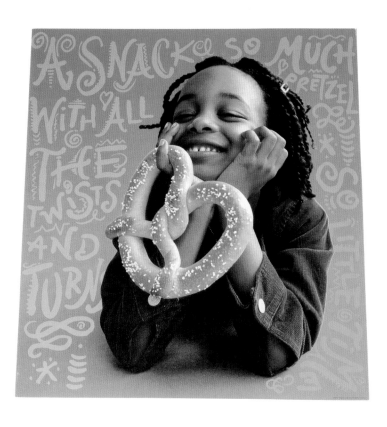

creative firm
GRAPHICULTURE
Minneapolis, Minnesota
creative people
*SHARON McKENDRY,
CHERYL WATSON*
client
TARGET

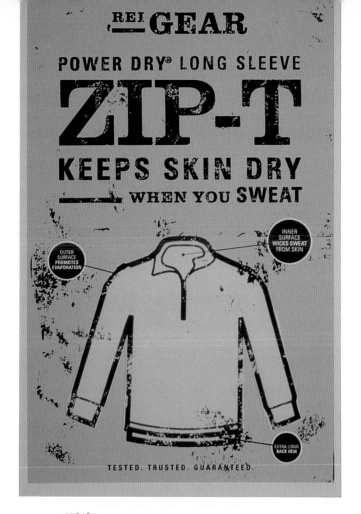

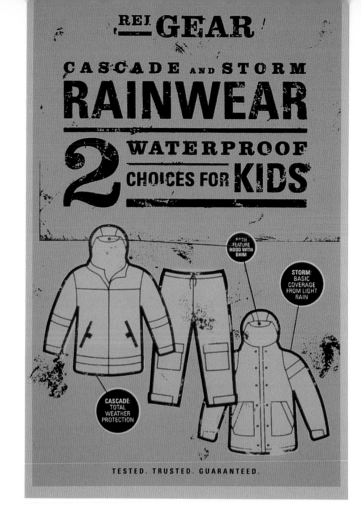

creative firm
LEMLEY DESIGN COMPANY
Seattle, Washington
creative people
*DAVID LEMLEY, YURI SHVETS,
MATTHEW LOYD, TOBI BROWN,
JENNY HILL*
client
RECREATIONAL EQUIPMENT, INC.

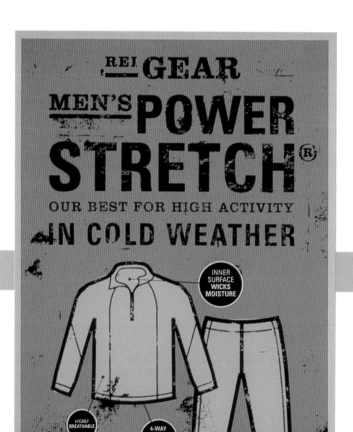

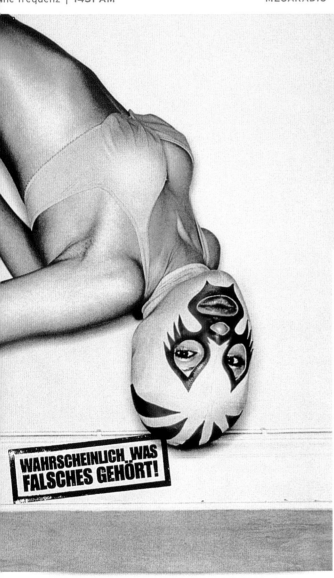

creative firm
GBK, HEYE
Munich, Germany
creative people
ALEXANDER BARTEL, MARTIN KIESSLING,
CHRISTINE BADER, PAUL WAGNER, HEINZ HELLE,
BILLY & HELLS
client
MEGARADIO

deine frequenz | 1431 AM

MEGARADIO

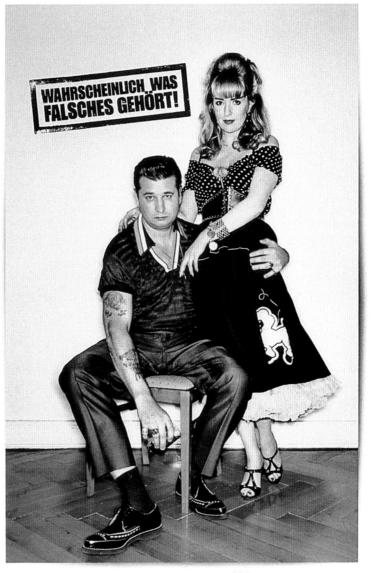

auch über kabel | satellit | G | www.megaradio.net

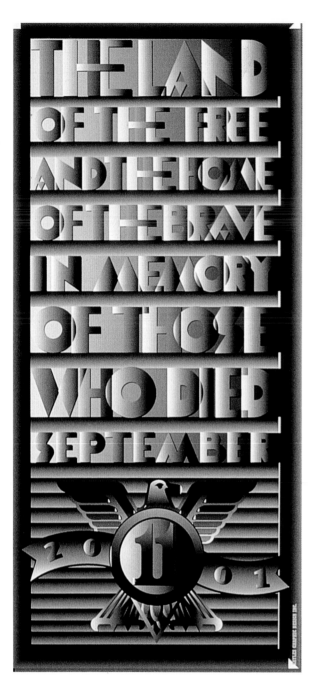

creative firm
SAYLES GRAPHIC DESIGN
Des Moines, Iowa
creative people
JOHN SAYLES,
SOM INTHALANGSY
client
ART FIGHTS BACK

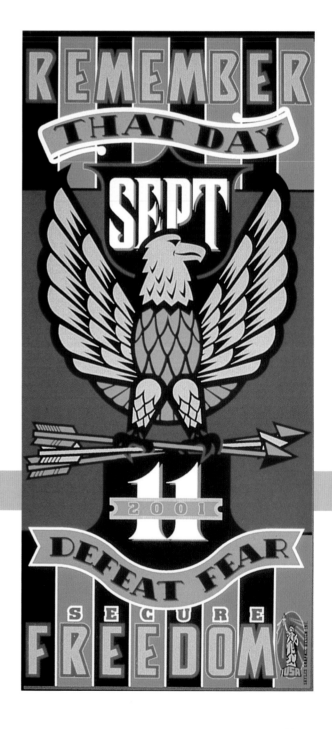

322

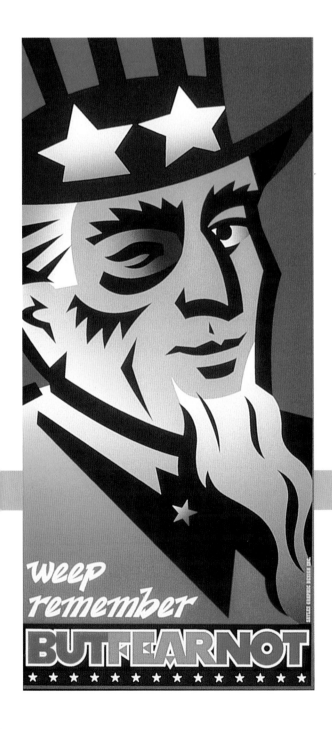

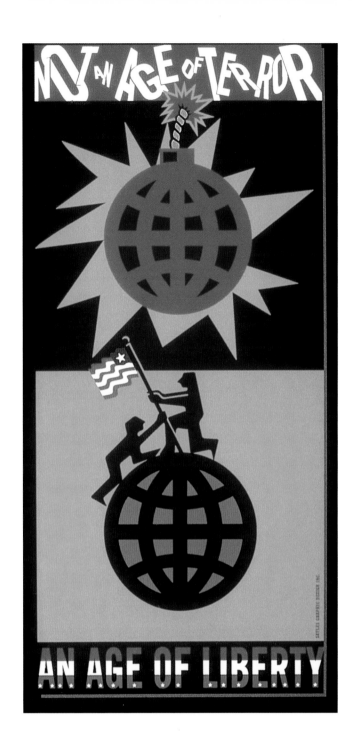

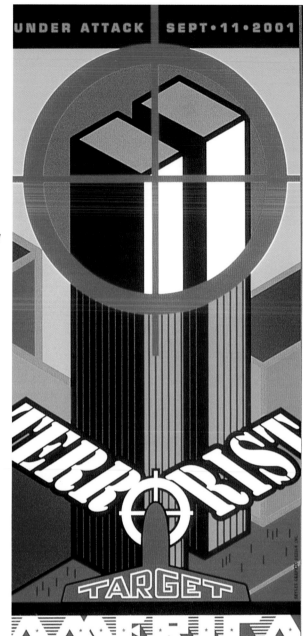

creative firm
SAYLES GRAPHIC DESIGN
Des Moines, Iowa
creative people
JOHN SAYLES,
SOM INTHALANGSY
client
ART FIGHTS BACK

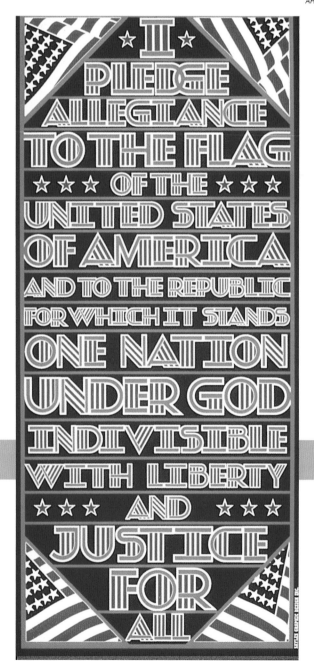

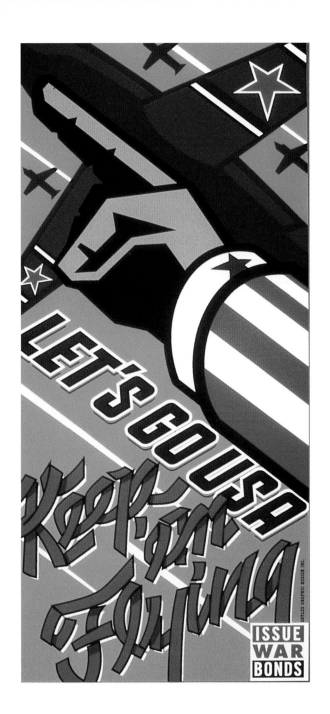

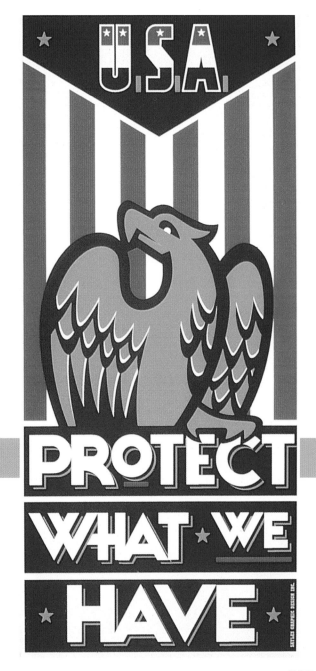

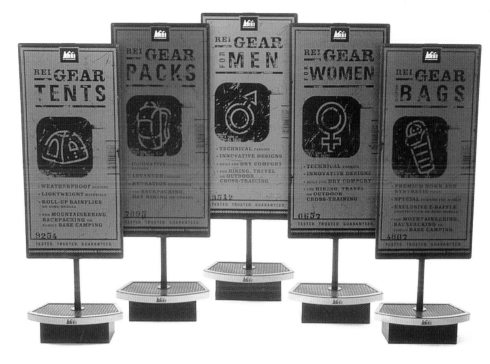

creative firm
LEMLEY DESIGN COMPANY
Seattle, Washington
creative people
DAVID LEMLEY, YURI SHVETS,
MATTHEW LOYD, JENNIFER HILL,
TOBI BROWN
client
REI

Give More. Get More.
1-800-462-5188

NEED A LIFT?

When you give to the United Way, over 90 percent of each dollar
goes directly to people in need of medical assistance, rehabilitation,
education and moral support. That ought to make you feel good.
For more info, visit Socrates. To pledge, call 1-800-462-5188.

creative firm
CAMPBELL EWALD ADVERTISING
Warren, Michigan
creative people
BILL LUDWIG, NANCY WELLINGER,
JIM MILLIS
client
UNITED WAY

M LIETUVOS VALSTYBEI – LIETUVOS KARALIAUS
MINDAUGO KARŪNAVIMUI–750

creative firm
VILNIUS ART ACADEY
Lithuania
creative people
AUSRA LISAUSKIENE

LIETUVOS VALSTYBEI–
LIETUVOS KARALIAUS
MINDAUGO
KARŪNAVIMUI–
750

NOTHING

EVER DOES WHAT YOU
WANT IT TO

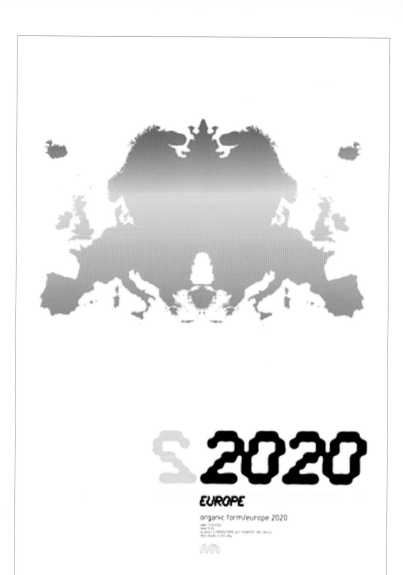

2020

EUROPE

organic form/europe 2020

creative firm
LIZA RAMALHO
client
*PAN EUROPEAN POSTER
DESIGN COMPETITION AND EXHIBITION*

creative firm
OMB DISENTO Y COMUNICACION VISUAL
Madrid, Spain
creative people
*OSCAR MARINÉ,
JOHN GIORNO*
client
SWATCH

creative firm
LIZA RAMALHO
client
AS BOAS RAPARIGAS

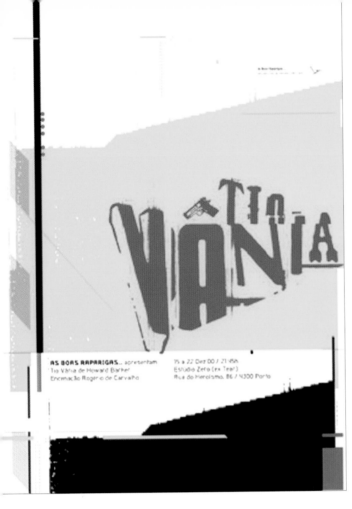

AS BOAS RAPARIGAS... apresentam
Tio Vânia de Howard Barker
Encenação Rogério de Carvalho

15 a 22 Dez 00 / 21:45h
Estúdio Zero (ex Teatr)
Rua do Heroísmo, 86 / 4300 Porto

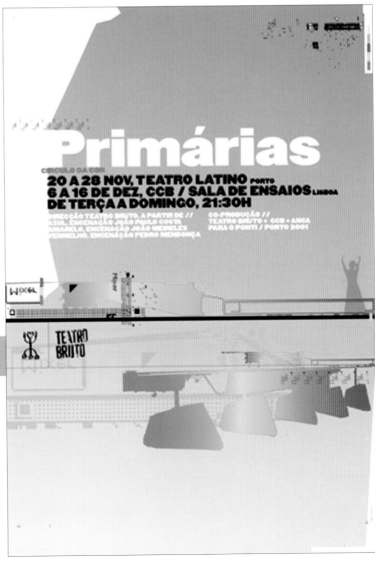

creative firm
LIZA RAMALHO
client
TEATRO BRUTO

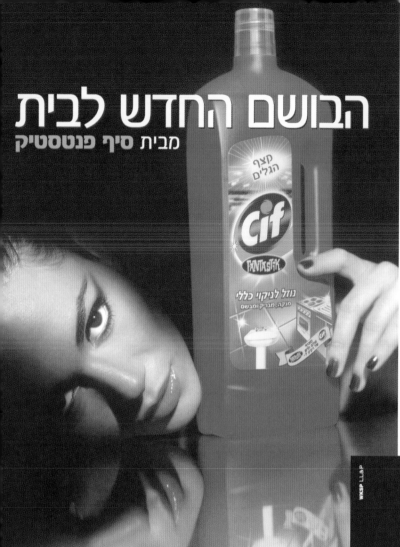

creative firm
WKSP ADVERTISING
Ramat Gan, Israel
creative people
*ALON ZAID, ORLY FRUM,
ORI LIVNY*
client
UNILEVER

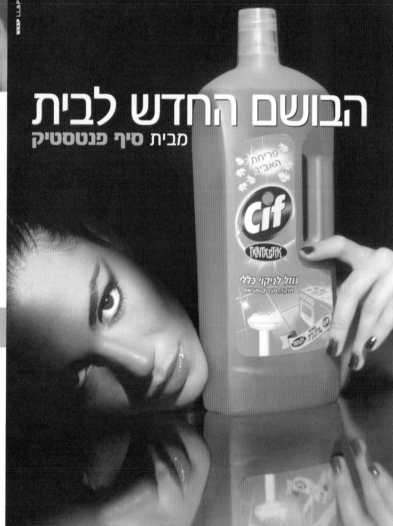

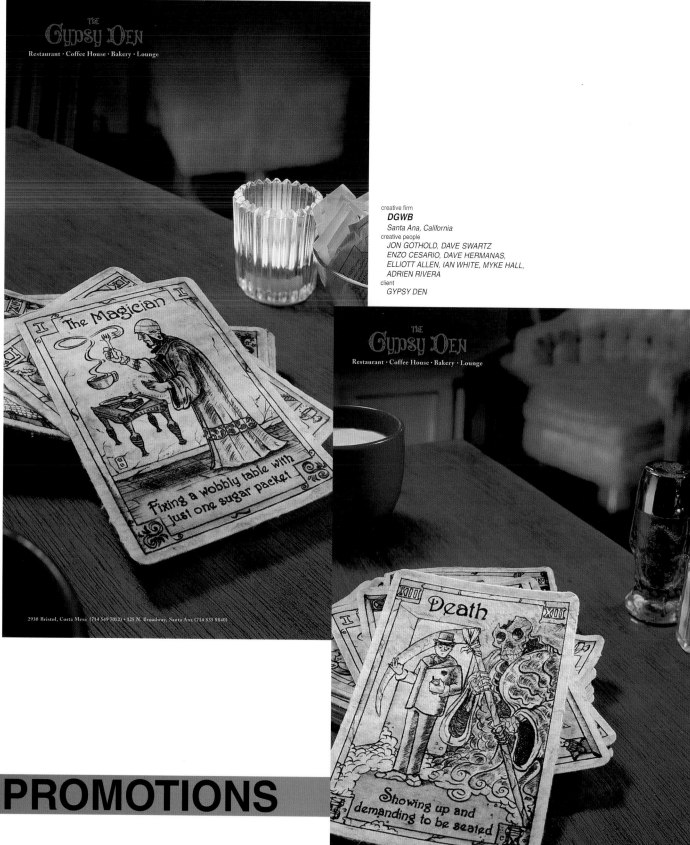

creative firm
DGWB
Santa Ana, California
creative people
*JON GOTHOLD, DAVE SWARTZ
ENZO CESARIO, DAVE HERMANAS,
ELLIOTT ALLEN, IAN WHITE, MYKE HALL,
ADRIEN RIVERA*
client
GYPSY DEN

PROMOTIONS

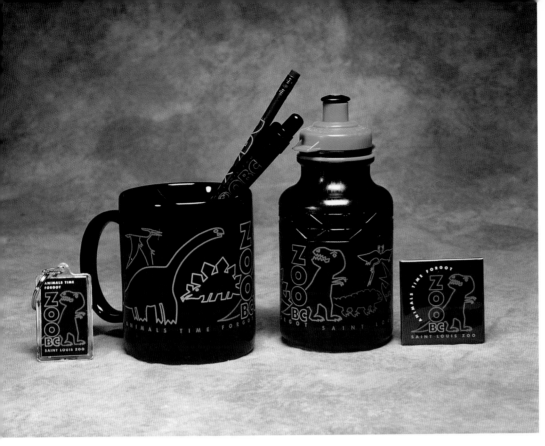

creative firm
CUBE ADVERTISING & DESIGN
St. Louis, Missouri
creative people
DAVID CHIOW
client
SAINT LOUIS ZOO

creative firm
BURROWS
Shenfield, Essex
creative people
*GARY CARLESS, BOB ASHWOOD,
CAROLINE RICE, ROYDON HEARNE*
client
FORD MOTOR COMPANY

BE SURE TO BRING
YOUR MOM'S CREDIT CARD.

[AND IF SHE'S HOT, BRING HER TOO.]

SERIOUS STUFF 4 SERIOUS BOARDERS.

creative firm
LAWRENCE & PONDER IDEAWORKS
Newport Beach, California
creative people
*LYNDA LAWRENCE, MATT McNELIS,
RICK UNDERWOOD, BIL DICKS,
GARY FREDERICKSON*
client
IWS BOARDSHOP

WE
GUARANTEE
YOU WON'T LOOK LIKE
YOU WENT SHOPPING
WITH MOMMY.

SERIOUS STUFF 4 SERIOUS BOARDERS

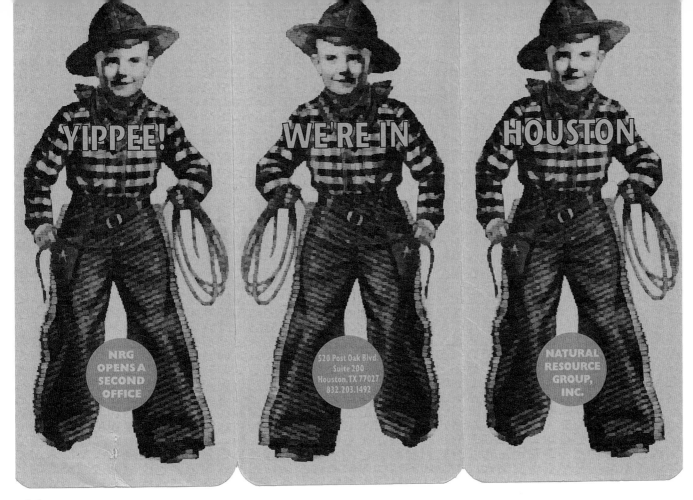

YIPPEE! WE'RE IN HOUSTON

NRG OPENS A SECOND OFFICE

520 Post Oak Blvd.
Suite 200
Houston, TX 77027
832.203.1492

NATURAL RESOURCE GROUP, INC.

creative firm
LYNN SCHULTE DESIGN
 Minneapolis, Minnesota
creative people
 LYNN SCHULTE
client
 NATURAL RESOURCE GROUP

creative firm
DAVID CARTER DESIGN ASSOC.
 Dallas, Texas
creative people
 EMILY HUCK, DONNA ALDRIDGE,
 ASHLEY BARRON MATTOCKS
client
 WATERCOLOR INN

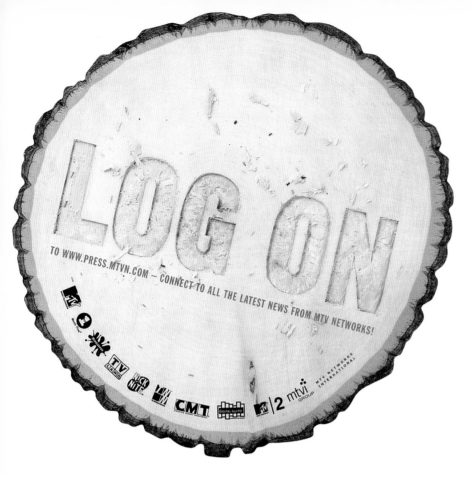

creative firm
MTV NETWORKS CREATIVE SERVICES
New York, New York
creative people
JOHN FARRAR, KEN SAJI,
CHERYL FAMILY
client
MTV NETWORKS

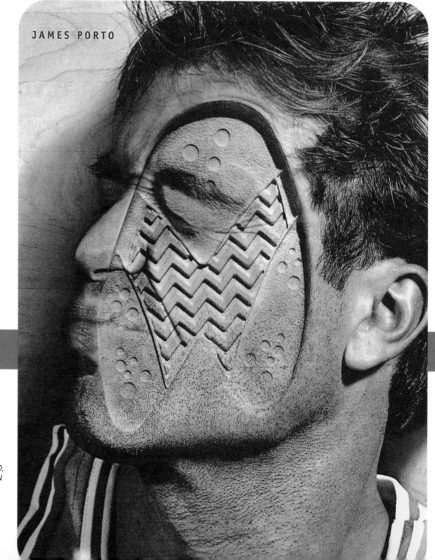

JAMES PORTO

creative firm
HUTTER DESIGN
New York, New York
creative people
LEA ANN HUTTER, JULIE GANG,
JIM HUIBREGTSE, JOHN MANNO,
JAMES PORTO, MICHAEL LUPPINO,
DAVID WEISS, MERVYN FRANKLYN
client
M REPRESENTS

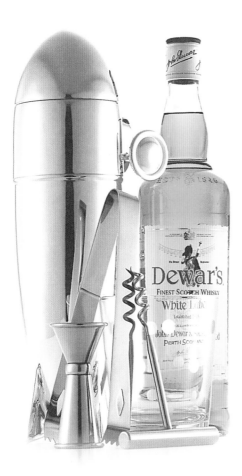

DAVID WEISS

(continued)
creative firm
HUTTER DESIGN
New York, New York
client
M REPRESENTS

JOHN MANNO

creative firm
ATOMZ INTERACTIVE
Singapore
creative people
PATRICK LEE,
VIVI CHANG
client
MCI WORLDCOM PTE LTD

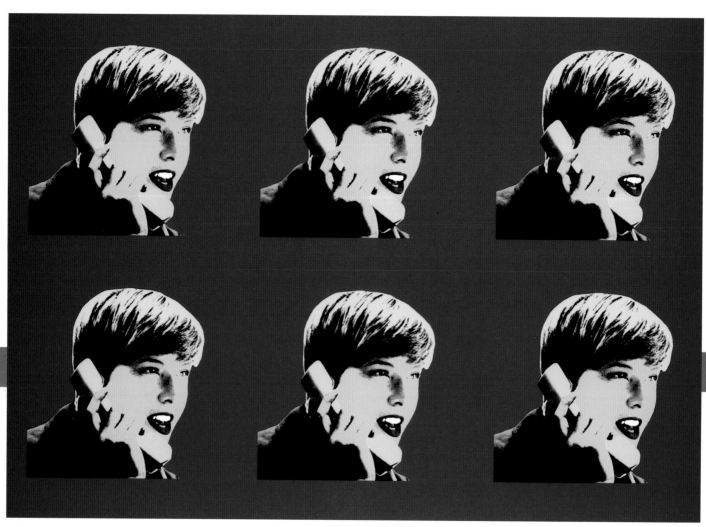

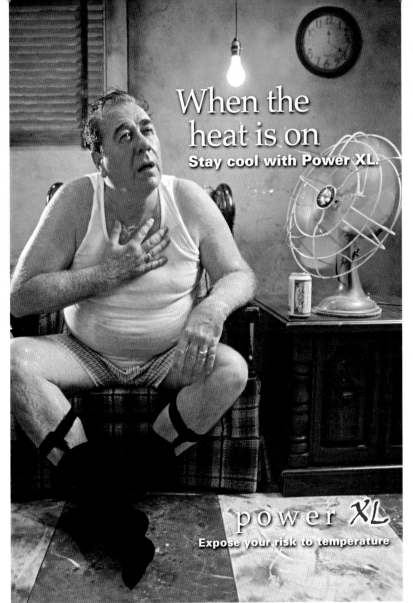

When the
heat is on
Stay cool with Power XL.

power *XL*
Expose your risk to temperature

creative firm
**GOODWICK/LIAZON
LEVERAGE MARCOM GROUP**
Newtown, Connecticut
creative people
*DAVID GOODWICK, HEATHER PATRICK,
MIKE PARTENIO*
client
TRIPLE POINT TECHNOLOGY

creative firm
DAVID CARTER DESIGN ASSOC.
Dallas, Texas
creative people
RACHEL GRAHAM
client
RENAISSANCE HOLLYWOOD HOTEL

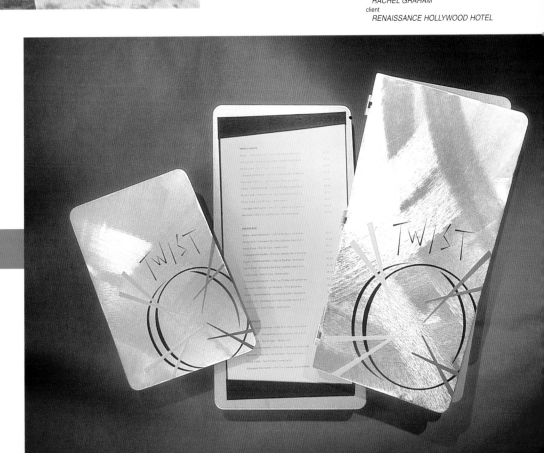

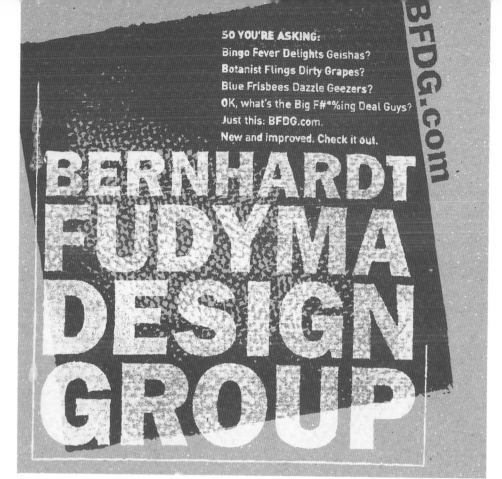

creative firm
BERNHARDT FUDYMA DESIGN GROUP
New York, New York
creative people
KRISTIN REUTTER, IGNACIO RODRIGUEZ,
DOUG HALL, ANGELA VALIE
client
BERNHARDT FUDYMA DESIGN GROUP

creative firm
CHAMPCOHEN DESIGN
Del Mar, California
creative people
JOHN CHAMP,
RANDY COHEN,
DIANE SHIELDS
client
ABBOTT ANIMAL HEALTH

No drooling
on the photos,
please.

(continued)
creative firm
CHAMPCOHEN DESIGN
Del Mar, California
client
ABBOTT ANIMAL HEALTH

Abbott
Crown Club
Work like a dog. Relax like a royal.

Rick Sealock
391 Regal Park N.E.
Calgary, Alberta
Canada
T2E 0S6

STAMP

TO:

FREE POSTCARDS INSIDE!

creative firm
BLACK LETTER DESIGN
Alberta, Canada
creative people
*KEN BESSIE,
RICK SEALOCK*
client
RICK SEALOCK

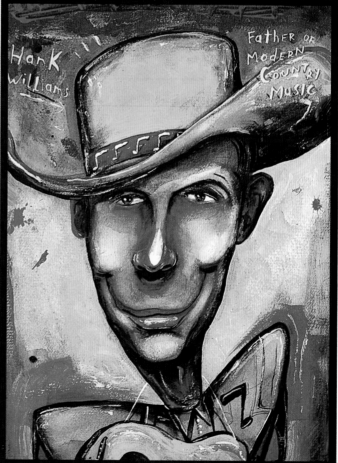

"The Father of Modern Country Music" portrait

Hank Williams

FATHER OF MODERN COUNTRY MUSIC

(continued)
creative firm
BLACK LETTER DESIGN
 Alberta, Canada
client
 RICK SEALOCK

creative firm
LYNN SCHULTE DESIGN
 Minneapolis, Minnesota
creative people
 LYNN SCHULTE
client
 NATURAL RESOURCE GROUP

creative firm
FUSZION COLLABORATIVE
Alexandria, Virginia
creative people
JOHN FOSTER
client
MGM

344

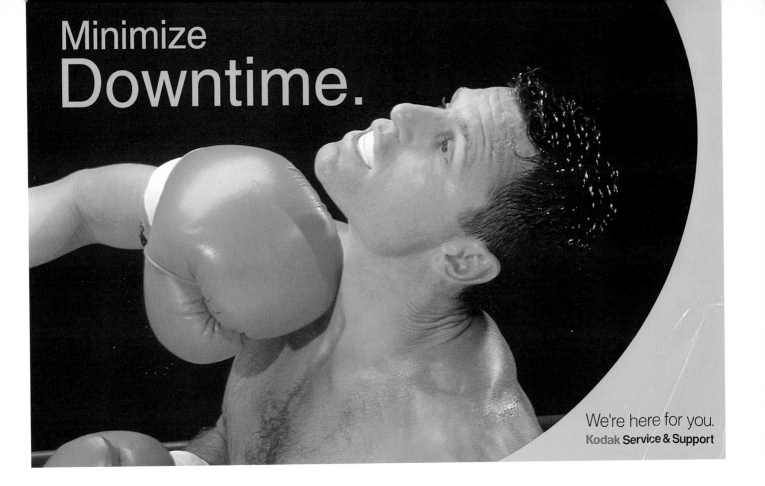

Minimize
Downtime.

We're here for you.
Kodak Service & Support

creative firm
FORWARD BRANDING & IDENTITY
Webster, New York
client
EASTMAN KODAK COMPANY

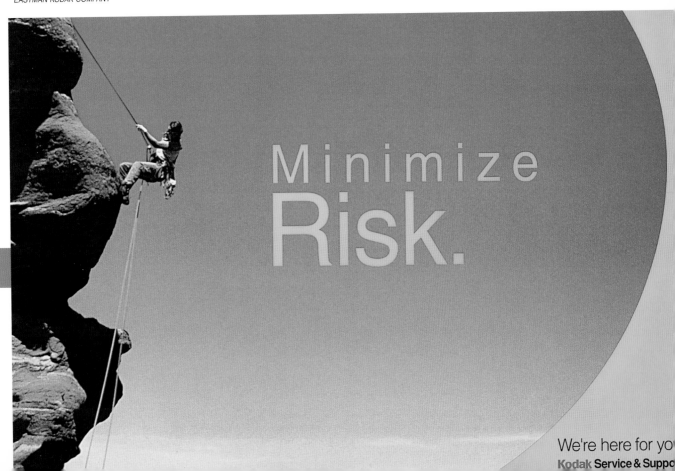

Minimize
Risk.

We're here for you
Kodak Service & Suppo

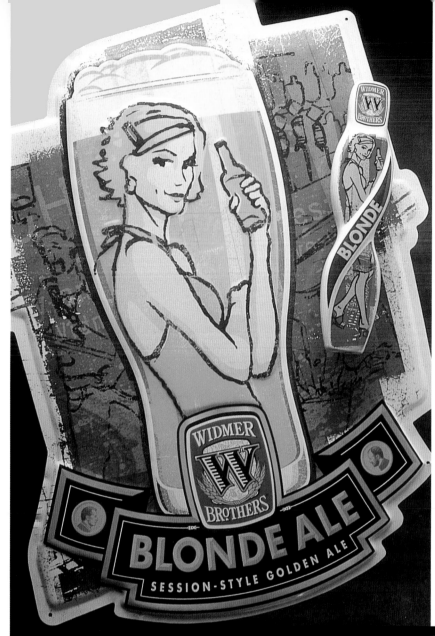

creative firm
HORNALL ANDERSON DESIGN WORKS, INC.
Seattle, Washington
creative people
LARRY ANDERSON, JACK ANDERSON,
JAY HILBURN, BRUCE STIGLER, HENRY YIU,
KAYE FARMER, DOROTHEE SOECHTING
client
WIDMER BROTHERS

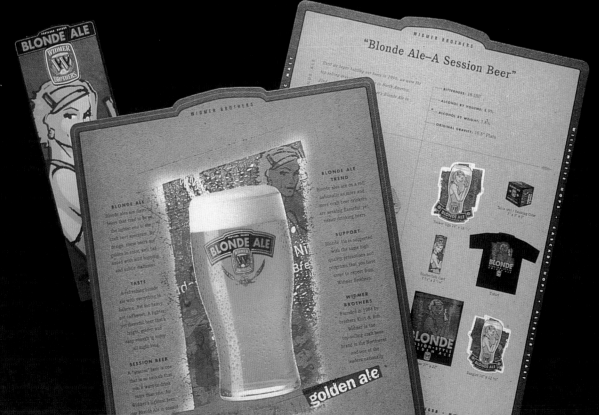

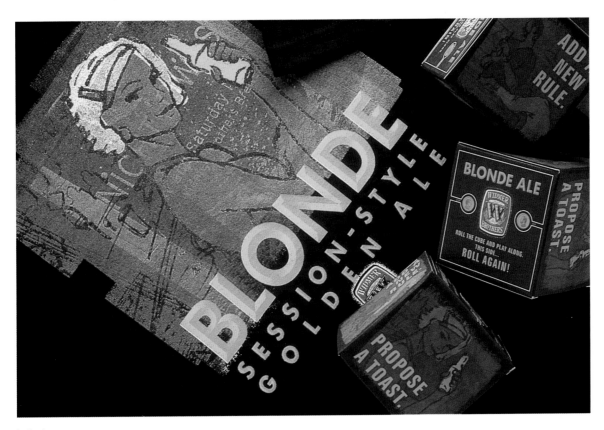

(continued)
creative firm
HORNALL ANDERSON DESIGN WORKS, INC.
Seattle, Washington
client
WIDMER BROTHERS

creative firm
AMP
Costa Mesa, California
creative people
LUIS CAMANO, CARLOS MUSQUEZ,
LUCAS RISE
client
COCA-COLA

creative firm
METHODOLOGIE
Seattle, Washington
creative people
*GABE GOLDMAN, MIAH NGUYEN,
SANNA MONTENEGRO, CLAUDIA MEYER-NEWMAN,
PAUL NASENBERRY*
client
Q PASS

BRAND PROMISE

Rest

MEMBERSHIP STARS

IDENTIFICATION EMBLEM

TROOP NUMBER

CURVED BAR

FIRST OR SECOND CLASS BADGE

Friendship

Balanced Diet

QPASS

2/3

BILL BRYANT
ONE OF THE THREE
FEARLESS LEADERS
OF QPASS

0 1 2 3 6 5 6 9

3/3 MARK McNEELY
ONE OF THE THREE
FEARLESS LEADERS
OF QPASS

(continued)
creative firm
METHODOLOGIE
Seattle, Washington
client
Q PASS

1/3 CHASE FRANKLIN
ONE OF THE THREE
FEARLESS LEADERS
OF QPASS

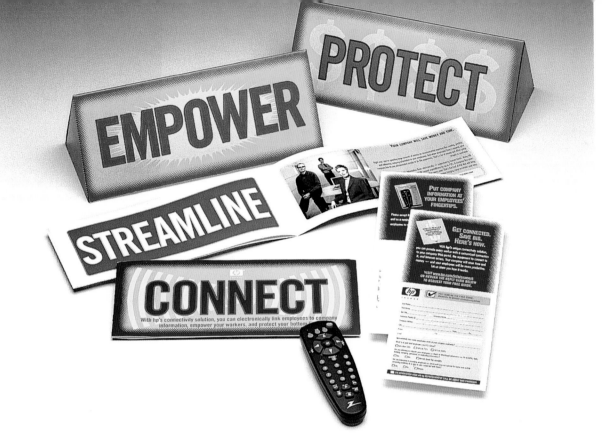

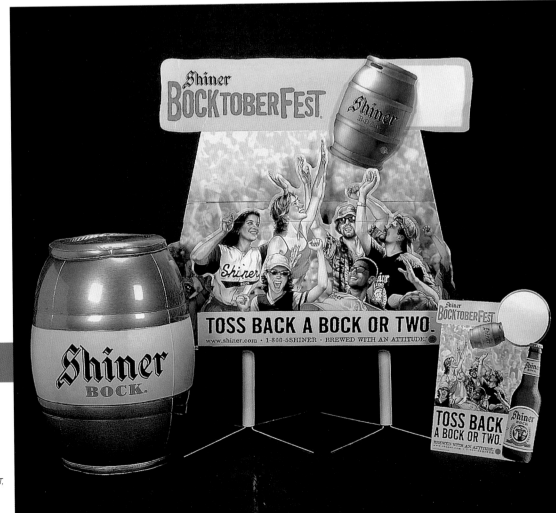

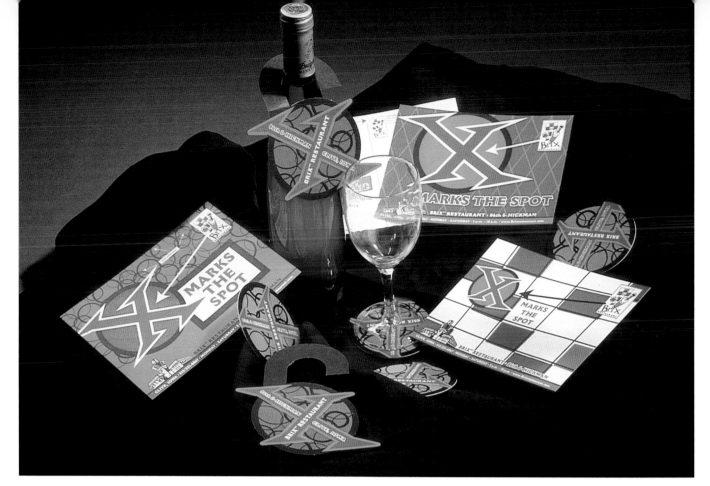

creative firm
SAYLES GRAPHIC DESIGN
Des Moines, Iowa
creative people
JOHN SAYLES,
SOM INTHALANGSY
client
BRIX RESTAURANT

creative firm
FUTUREBRAND
New York, New York
creative people
JOE VIOLANTE,
PETER CHIEFFO
client
LAF ENTERPRISES

352

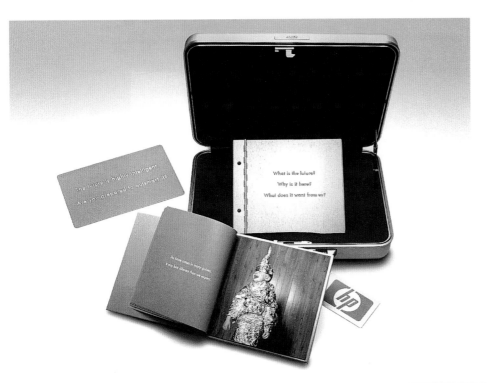

creative firm
PUBLICIS DIALOG
San Francisco, California
creative people
LOTUS CHILD,
TORIA EMERY
client
HEWLETT-PACKARD

What is the future?

Why is it here?

What does it want from us?

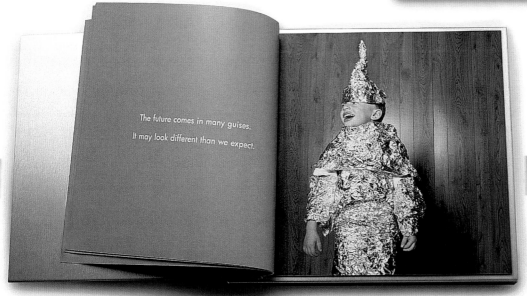

The future comes in many guises.
It may look different than we expect.

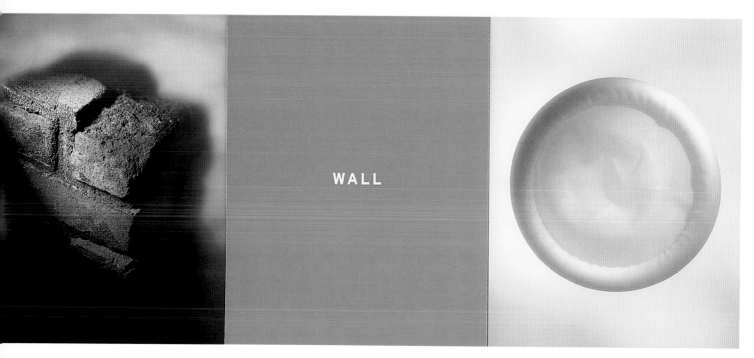

WALL

creative firm
HUTTER DESIGN
New York, New York
creative people
LEA ANN HUTTER,
JOHN MANNO
client
JOHN MANNO PHOTOGRAPHY

creative firm
GRAFIK
Alexandria, Virginia
creative people
JOHNNY VITIVARICH,
JUDY KIRPICH, RON HARMAN
client
GRAFIK

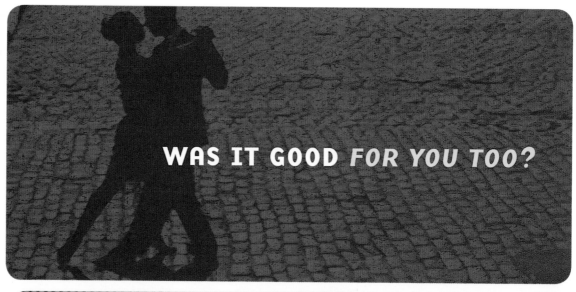

WAS IT GOOD *FOR YOU TOO?*

354

THAT WAS *FUN!*

_periphere

H

thien vous invite au lancement de la première collection periphere_ canapés et tables d'appoint_
luxe au goût du jour_ meubles haut de gamme pour ceux et celles à l'affut de moyens d'exprimer
avec passion et modernité leur désir d'individualisme et de sophistication_ le lundi 19 novembre 2001_
de 17h30 à 19h_ musée d'art contemporain de montréal_ 185, rue sainte-catherine ouest_
rsvp 514.733.0899 ou rsvp@periphere.com_

creative firm
PAPRIKA
Montreal, Canada
creative people
*LOUIS GAGNON, FRANÇOIS LECLERC,
RICHARD BERNARDIN*
client
PERIPHERE

SELF PROMOTIONS

creative firm
GRAFIK
Alexandria, Virginia
creative people
JUDY KIRPICH, JOHNNY VITOROVICH,
RODOLFO CASTRO
client
GRAFIK

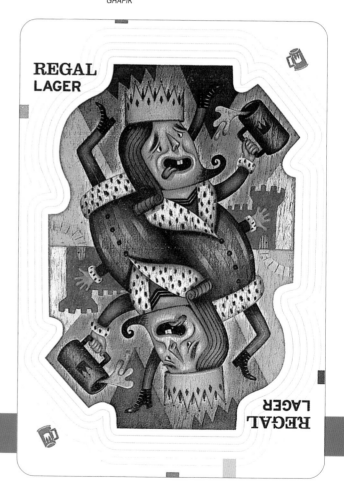

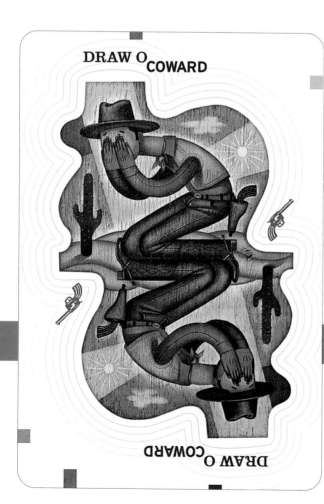

356

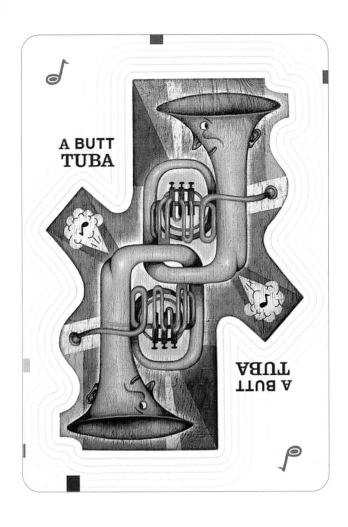

A BUTT
TUBA

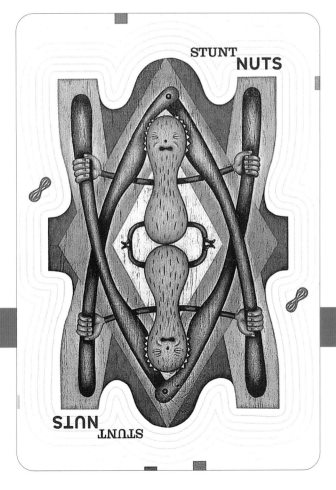

STUNT NUTS

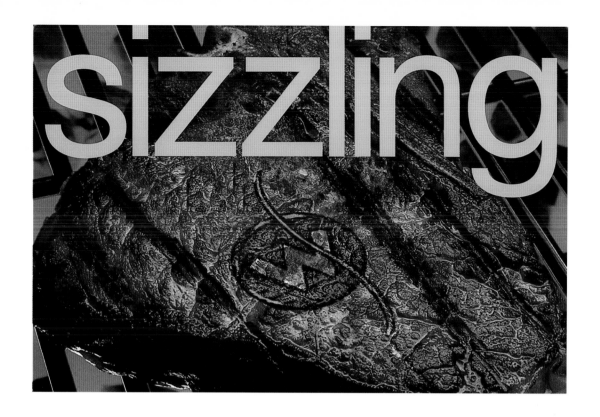

creative firm
THE WYANT SIMBOLI GROUP, INC.
Norwalk, Connecticut
creative people
*JULIA WYANT, JENNIFER DUARTE,
JASON JOHNSON, JENNIE CHEN,
TOD BRYANT*
client
THE WYANT SIMBOLI GROUP, INC.

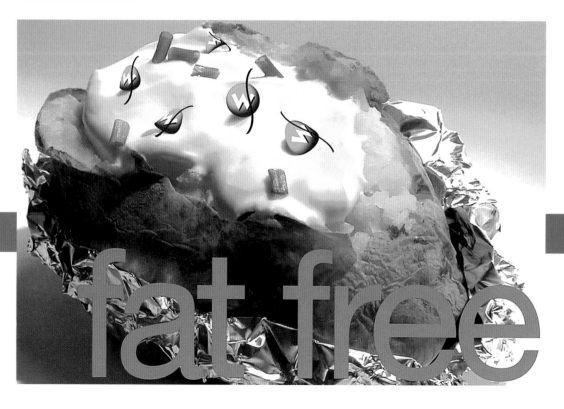

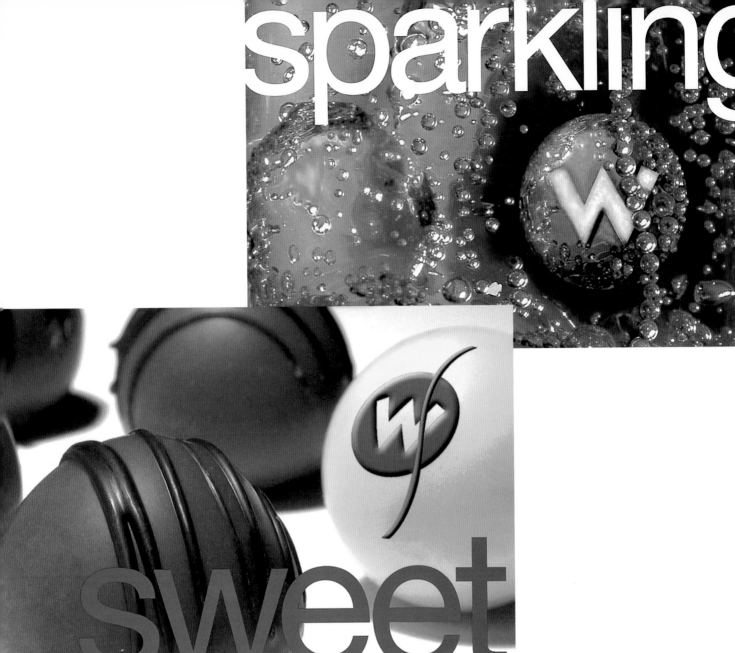

sweet

tasty

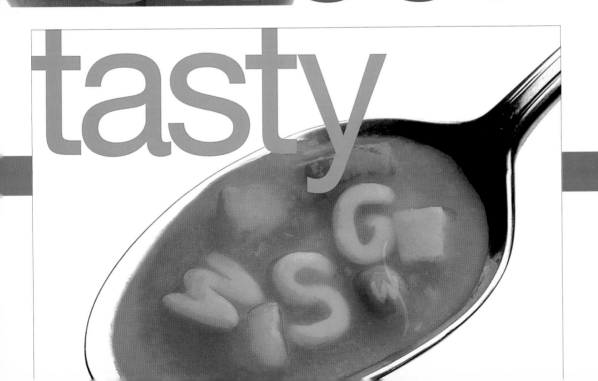

Stephanie Han Windham

Stephanie Han Windham

creative firm
JENSEN DESIGN ASSOC. INC.
Long Beach, California
creative people
DAVID JENSEN, VIRGINIA TEAGER,
CHARLES HARNISH, JOEL PENOS,
STEPHANIE WIDDHAM, JEROME CALLEJA,
ALYSSA IGAWA, KRISTEN BROWN,
SHIM SANTOS, KRIS ANGSLIVARD,
PATTY JENSEN, ANNO TAONO, ELMER JIMENEZ
client
JENSEN DESIGN ASSOC. INC.

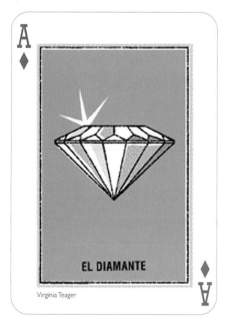

EL DIAMANTE

Virginia Teager

LA MAZA

Virginia Teager

EL CORAZON

Virginia Teager

Jerome Calleja

Charles Harnish III

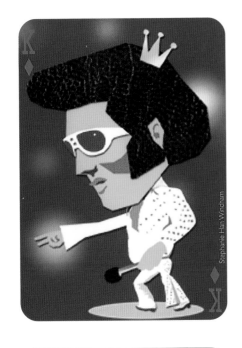

Stephanie Han Windham

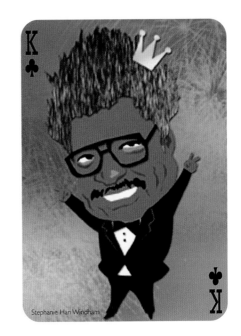

Stephanie Han Windham

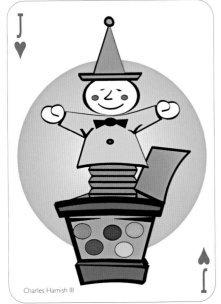

Charles Harnish III

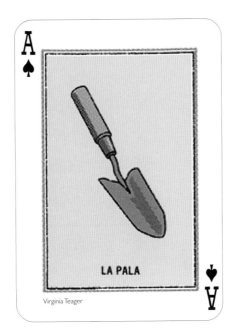

LA PALA

Virginia Teager

Charles Harnish III

Jerome Calleja

Charles Harnish III

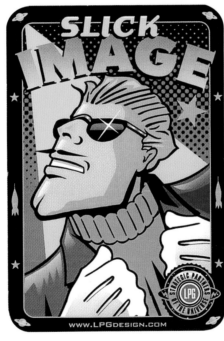

creative firm
LPG DESIGN
Wichita, Kansas
creative people
RICK GIMLIN
client
LPG DESIGN

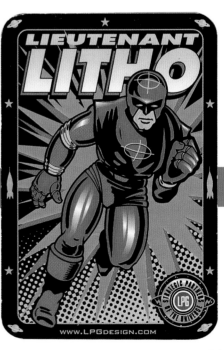

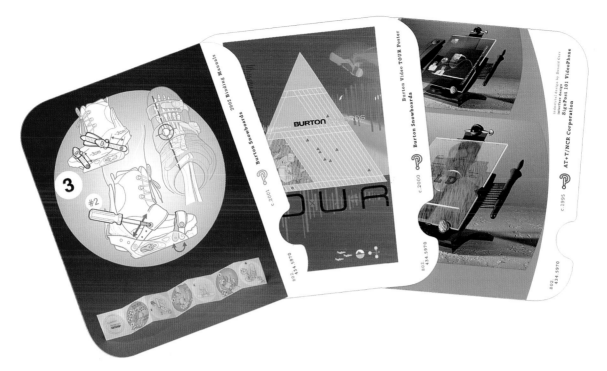

creative firm
INTERROBANG DESIGN COLLABORATIVE
Richmond, Vermont
creative people
MARK D. SYLVESTER,
LISA TAFT SYLVESTER
client
INTERROBANG DESIGN COLLABORATIVE

creative firm
DESIGN5
Fresno, California
creative people
RON NIKKEL
client
TODD & BETSY PIGOTT

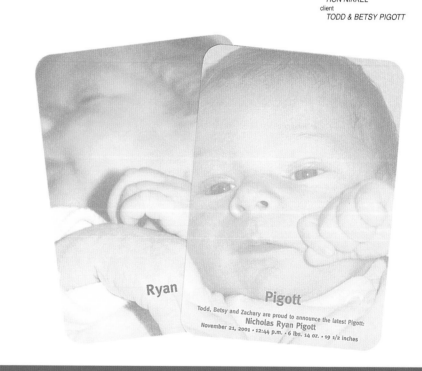

creative firm
STUDIO 405
Takoma Park, Maryland
creative people
JODI BLOOM, KRISTEN ARGENIO
client
STUDIO 405

Construyendo Valor de Marca con Diseño Inteligente Building Brand Equity through Smart Design

Construyendo Valor de Marca con Diseño Inteligente Building Brand Equity through Smart Design

Construyendo Valor de Marca con Diseño Inteligente Building Brand Equity through Smart Design

creative firm
TD2, S.C.
Mexico City, Mexico
creative people
RAFAEL TREVIÑO MONTEAGUDO,
RAFAEL RODRIGO CÓRDOVA ORTIZ
client
TD2, S.C.

Construyendo Valor de Marca con Diseño Inteligente Building Brand Equity through Smart Design

Construyendo Valor de Marca con Diseño Inteligente Building Brand Equity through Smart Design

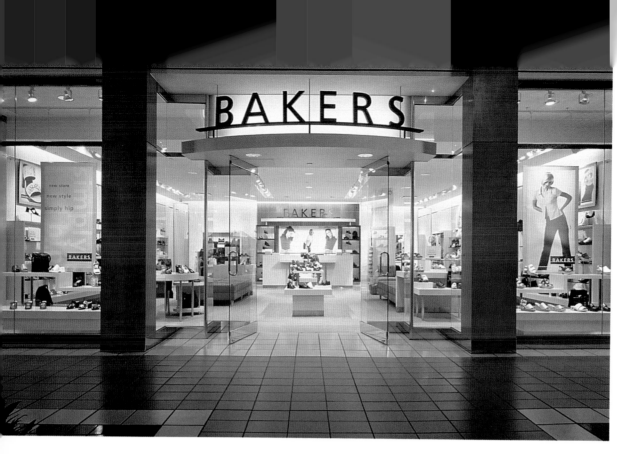

creative firm
FRCH DESIGN WORLDWIDE
New York, New York
creative people
*DERICK HUDSPITH,
ANDY BERGMAN*
client
*EDISON BROTHERS
(BAKERS)*

creative firm
AMBROSI AND ASSOC.
Chicago, Illinois
creative people
JOHN GARRISON
client
SEARS ROEBUCK & CO.

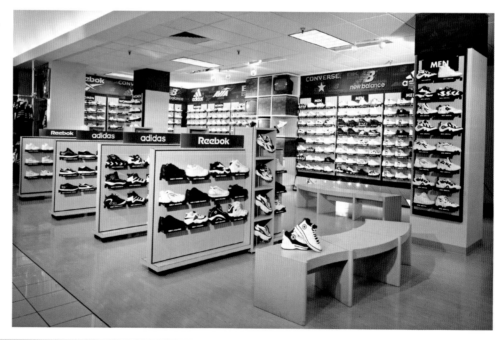

RETAIL GRAPHICS

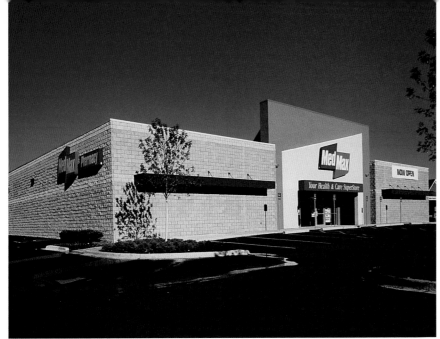

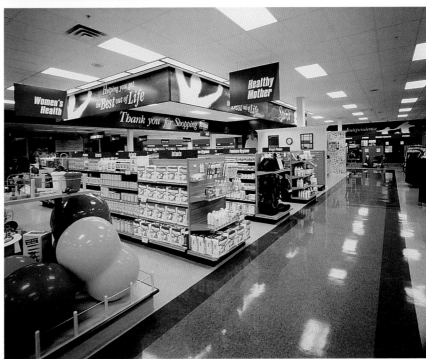

creative firm
JON GREENBERG & ASSOCIATES
Southfield, Michigan
creative people
TONY CAMILLETTI,
BRIAN EASTMAN
client
MEDMAX

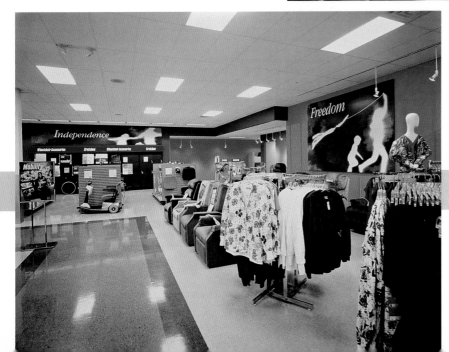

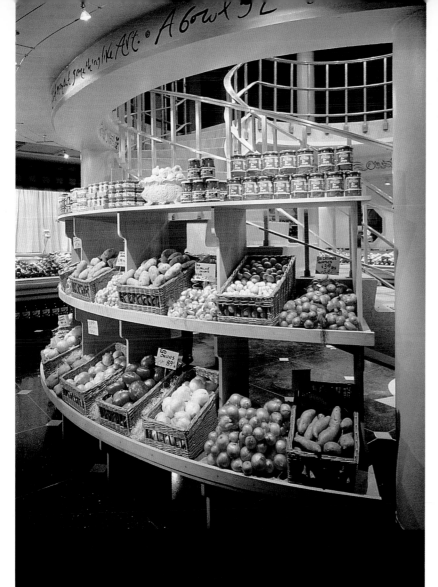

creative firm
KIKU OBATA + COMPANY
St. Louis, Missouri
creative people
*KIKU OBATA, PAM BLISS,
KEVIN FLYNN, AIA, THERESA HENREKIN,
LISA BOLLMANN, ALISSA ANDRES, SANDY KAISER*
client
STRAUB'S

creative firm
WALKERGROUP/CNI
New York, New York
creative people
*CHRISTINA WALKER,
ROSS CARN*
client
AT&T WIRELESS SERVICES

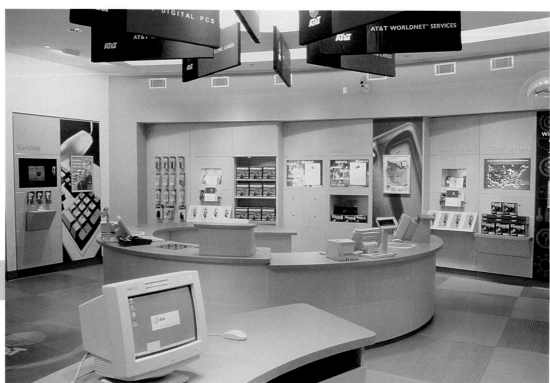

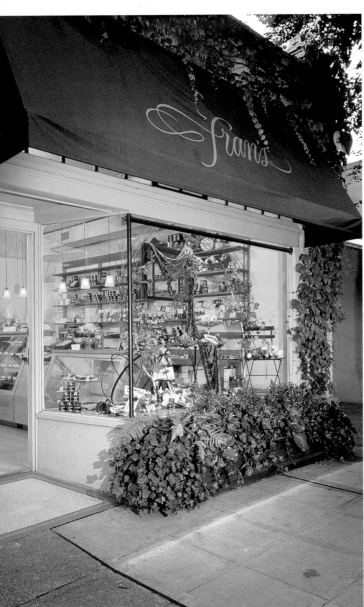

creative firm
WALSH & ASSOCIATES, INC.
Seattle, Washington
creative people
MIRIAM LISCO
client
FRAN'S CHOCOLATES LTD.

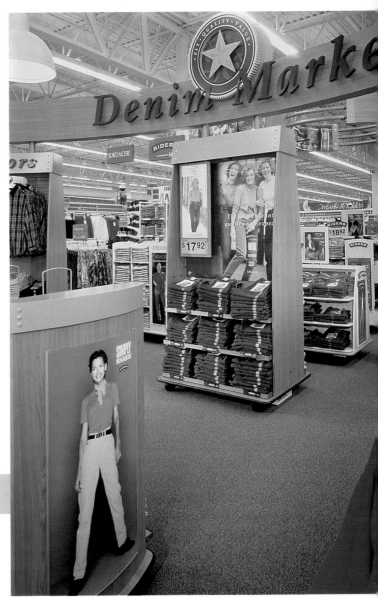

creative firm
CHUTE GERDEMAN, INC.
Columbus, Ohio
creative people
ADAM LIMBACH
client
WRANGLER

369

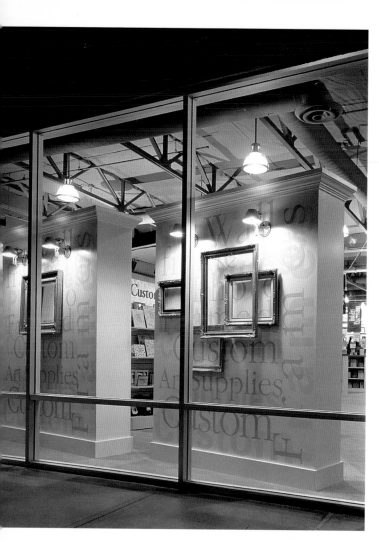

creative firm
KIKU OBATA + COMPANY
St. Louis, Missouri
creative people
*KIKU OBATA, KEVIN FLYNN, AIA,
DAVID HERCULES, JOE FLORESCA,
JEFF RIFKIN, LAURA McCANNA*
client
AARON BROTHERS ART & FRAMING

creative firm
RTKL ASSOCIATES INC.
Dallas, Texas
creative people
TOM BRINK
client
HINES

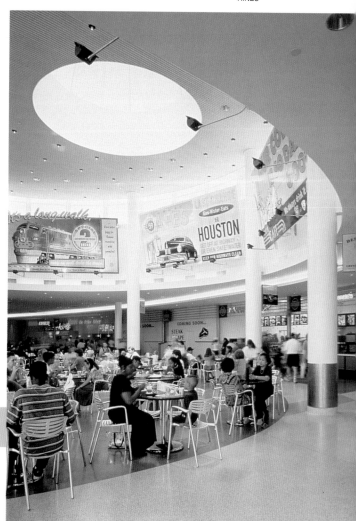

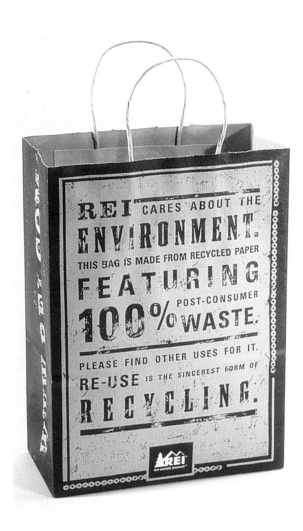

creative firm
LEMLEY DESIGN COMPANY
Seattle, Washington
creative people
*DAVID LEMLEY, YURI SHVETS,
MATTHEW LOYD, JENNIFER HILL,
TOBI BROWN*
client
REI

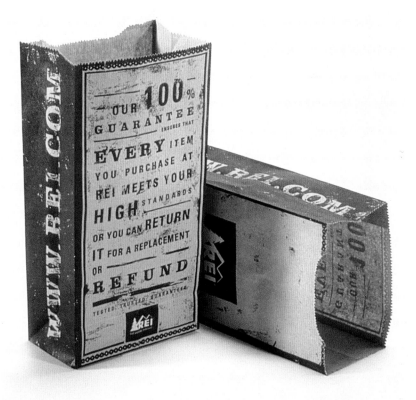

SHOPPING BAGS

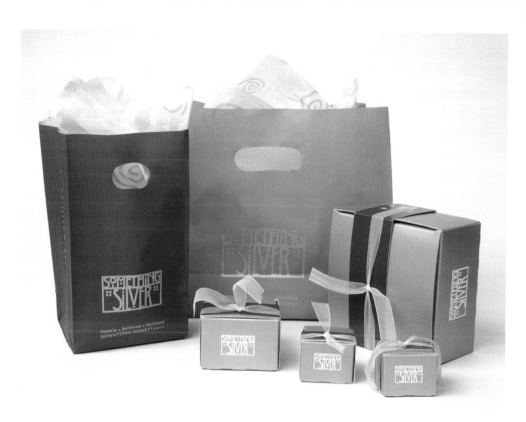

creative firm
MONSTER DESIGN
Redmond, Washington
creative people
THERESA VERANTH
client
SOMETHING SILVER

creative firm
HORNALL ANDERSON DESIGN WORKS, INC.
Seattle, Washington
creative people
JACK ANDERSON, JULIE LOCK
JANA WILSON ESSER
client
OKAMOTO CORPORATION

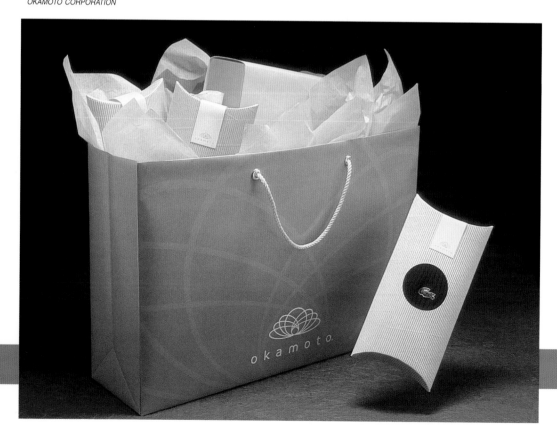

creative firm
HORNALL ANDERSON DESIGN WORKS, INC.
Seattle, Washington
creative people
*JACK ANDERSON, MARK POPICH,
ANDREW WICKLUND, ELMER DELA CRUZ,
GRETCHEN COOK, JOHN ANDERLE, SONJA MAX,
ANDREW SMITH*
client
SEATTLE SUPERSONICS

T-SHIRTS

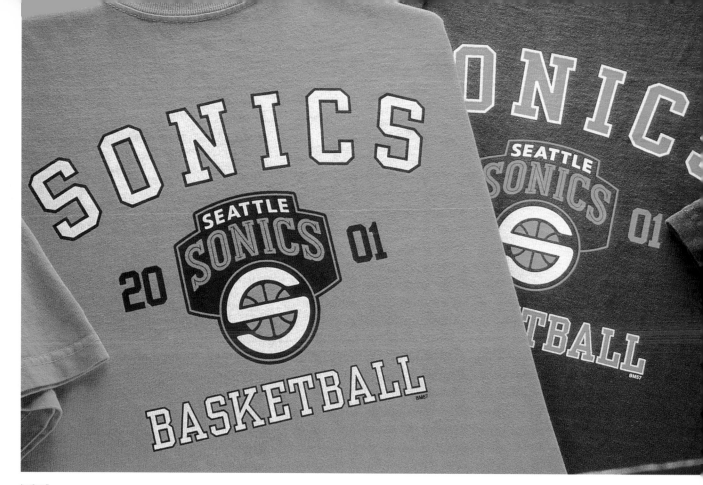

(continued)
creative firm
HORNALL ANDERSON DESIGN WORKS, INC.
Seattle, Washington
client
SEATTLE SUPERSONICS

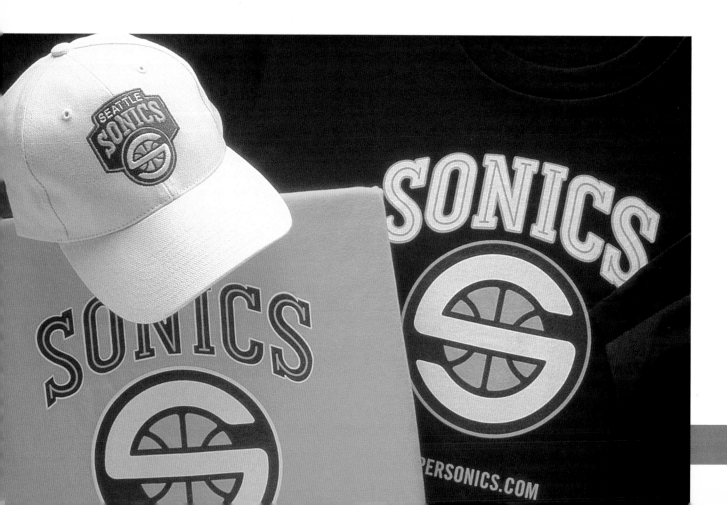

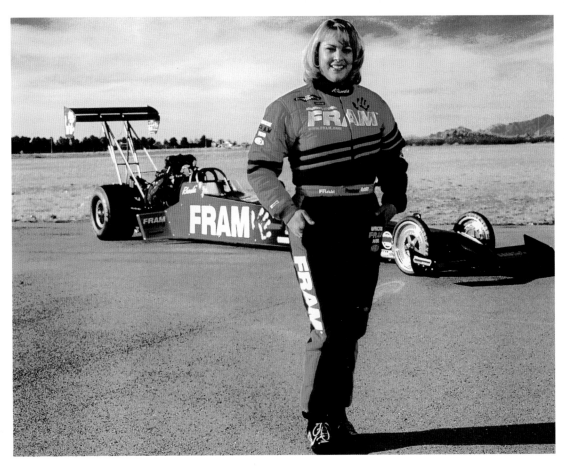

creative firm
TOM FOWLER, INC.
Norwalk, Connecticut
creative people
*THOMAS G. FOWLER,
MARY ELLEN BUTKUS,
BRIEN O'REILLY*
client
HONEYWELL CONSUMER PRODUCTS GROUP

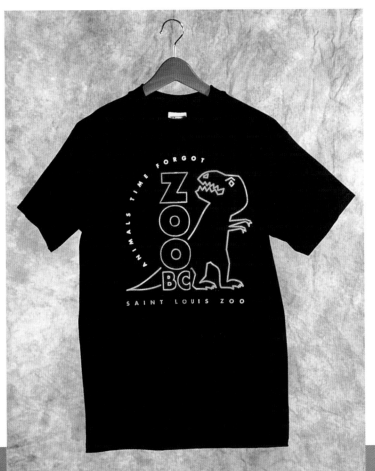

creative firm
CUBE ADVERTISING & DESIGN
St. Louis, Missouri
creative people
DAVID CHIOW
client
SAINT LOUIS ZOO

creative firm
PINKHAUS
Miami, Florida
creative people
RAFAEL ROSA, NATHALIE BRESZTYENSZKY,
JILL GREENBERG, PLUMB DESIGN
client
BACARDI USA, INC.

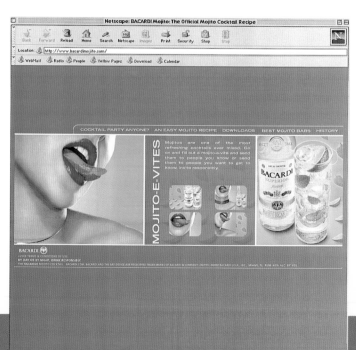

WEB PAGES

Organizing for Success

The key to success in the global marketplace is anticipating change and capitalizing on it. In 2001, Eaton faced sharp declines in nearly all of our markets. While we could not control the economy, we could—and did—take decisive actions to help ensure the continued competitiveness of our organization. We lowered our structural costs and resized the company to operate more effectively and efficiently. We shed businesses and product lines that no longer fit our strategic objectives. We closed plants and consolidated facilities and functions. And we reduced the size of our workforce in order to compete at lower levels of economic activity. We expect these restructuring actions to deliver $100 million of savings in 2002. Additional restructuring actions undertaken in early 2002 in the Truck, Fluid Power and Industrial & Commercial Controls segments are expected to yield an additional $30 million of savings, for a total of $130 million of savings during the year. In 2001, we also acquired new businesses to help us reach or exceed our target of growing earnings per share by 10 percent through the cycle. All of this would have been impossible to accomplish without the

creative firm
NESNADNY + SCHWARTZ
Cleveland, Ohio
creative people
*CINDY LOWREY,
JOHN-PAUL WALTON*
client
THE EATON CORPORATION

Accelerate
Eaton gets real growth and real profits from real products.

Growth Opportunities

High-performance products come out of Eaton facilities every day—products that contribute to our customers' success. And as they succeed, so do we. Our Aerospace business won nearly $2 billion in future commercial and military contracts during the year with fluid power system awards on Lockheed Martin's Joint Strike Fighter, the U.S. Army's new RAH-66 Comanche helicopter, Gulfstream's new GIV aircraft, and the world's largest lighter-than-air cargo airship from CargoLifter AG. In addition, Airbus selected Eaton to provide the hydraulic power generation system for the world's largest commercial airliner, the A380. We also secured a contract with General Electric to develop the gas turbine engine lubrication system to power the Army's M2 main battle tank and Crusader armored vehicle. New supercharger contracts with Mercedes-Benz and our $500 million multi-year variable valve actuation technology contract with General Motors reinforce our Automotive segment's strategic focus on improving safety, performance, fuel economy and the environment. Our Truck segment accelerated its global reach with the $250 million DaimlerChrysler AG

Measure

Financial Highlights

	Excluding unusual items		As reported	
	2001	2000	2001	2000
(Millions except for per share data)				
Continuing Operations				
Net sales	$7,299	$8,309	$7,299	$8,309
Income before income taxes	346	582	278	552
Income after income taxes	233	383	169	363
Income from continuing operations per Common Share assuming dilution	$3.30	$5.28	$2.39	$5.00

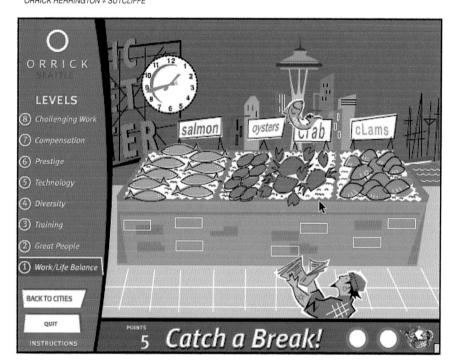

creative firm
GREENFIELD/BELSER LTD.
Washington, D.C.
creative people
*BURKEY BELSER, JILL SASSER,
JASON HENDRICKS, ROBYN McKENZIE,
LISA HENDERLING, DANIELLE CANTOR*
client
ORRICK HERRINGTON + SUTCLIFFE

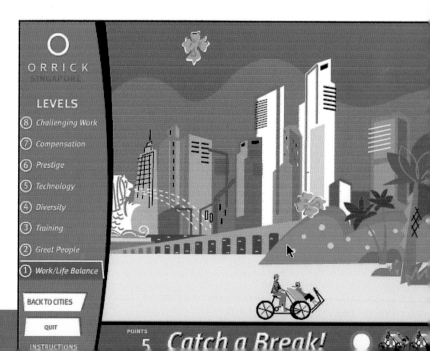

above and beyond

2001 FINANCIAL HIGHLIGHTS ✱ 2001 FINANCIAL REVIEW
VISION, VALUES, OBJECTIVES SHAREHOLDER INFORMATION
WHAT YOU SHOULD EXPECT 2001 DOWNLOADS
LETTER TO SHAREHOLDERS INVESTOR RELATIONS

2001 Financial Review

Ten Year Summaries ⇕

✱ TEN YEAR SUMMARY—FINANCIAL HIGHLIGHTS TEN YEAR SUMMARY—GAAP CONSOLIDATED OPERATING RESULTS

Ten Year Summary—Financial Highlights
(NOT COVERED BY REPORT OF INDEPENDENT ACCOUNTANTS)

(MILLIONS—EXCEPT RATIOS, PER SHARE AMOUNTS AND NUMBER OF PEOPLE EMPLOYED)

2001-1997 1996-1992

	2001	2000	1999	1998	1997
Insurance Companies Selected Financial Information and Operating Statistics–Statutory Basis					
Policyholders' surplus[1]	$ 2,647.7	$ 2,177.0	$ 2,258.9	$ 2,029.9	$ 1,722.9
Ratios:					
Net premiums written to policyholders' surplus	2.7	2.8	2.7	2.6	2.7
Loss and loss adjustment expense reserves to policyholders' surplus	1.2	1.3	1.0	1.0	1.1
Loss and loss adjustment expense	73.6	83.2	75.0	68.5	71.1
Underwriting expense	21.1	21.0	22.1	22.4	20.7
Statutory combined ratio	94.7	104.2	97.1	90.9	91.8
Selected Consolidated Financial Information–GAAP Basis					
Total revenues	$ 7,488.2	$ 6,771.0	$ 6,124.2	$ 5,292.4	$ 4,608.2
Total assets	11,122.4	10,051.6	9,704.7	8,463.1	7,559.6

above and beyond

2001 FINANCIAL HIGHLIGHTS 2001 FINANCIAL REVIEW
VISION, VALUES, OBJECTIVES SHAREHOLDER INFORMATION
✱ WHAT YOU SHOULD EXPECT 2001 DOWNLOADS
LETTER TO SHAREHOLDERS INVESTOR RELATIONS

High Expectations | Day and Night | On the Bright Side - Expanding Horizons

Answers | Recommended Links

You're a Progressive customer.
It's 1 a.m. You're going out of town in the morning and you want to pay your bill before you go. [more]

Do you remember when you first started using the Internet?
Progressive does. In 1995, the Company stepped into the future with the launch of progressive.com [more]

creative firm
NESNADNY + SCHWARTZ
Cleveland, Ohio
creative people
CINDY LOWREY,
JOHN-PAUL WALTON
client
THE PROGRESSIVE CORPORATION

above and beyond

2001 FINANCIAL HIGHLIGHTS 2001 FINANCIAL REVIEW
VISION, VALUES, OBJECTIVES SHAREHOLDER INFORMATION
WHAT YOU SHOULD EXPECT 2001 DOWNLOADS
LETTER TO SHAREHOLDERS INVESTOR RELATIONS

above and beyond

Since the Progressive insurance organization began business in 1937, we have been innovators—growing into new markets and pioneering new ways to meet consumers' needs. In 1956, Progressive Casualty Insurance Company was founded to be among the first specialty underwriters of nonstandard auto insurance. Today, The Progressive Corporation provides all drivers throughout the United States with competitive rates and 24-hour, in-person and online services, through its 73 subsidiaries and two affiliates.

Our commitment to creating a Virtually Perfect customer experience led us to choose service as the theme for this year's annual report. Progressive combines online access to policy information with 24/7 personalized assistance for buying, policyholder service and claims. For examples of Progressive's commitment to service, please visit personal.progressive.com.

Artist Robert ParkeHarrison was commissioned to respond visually to service. ParkeHarrison is the inventor, painter, set designer, producer and model of his photographic situations. ParkeHarrison's work will become part of Progressive's growing collection of contemporary art. For a brief history of Progressive's art collection, stop by art.progressive.com.

[**Continue** to *2001 Financial Highlights*]

T-Online Vision

» t-sports - subcategorypage

creative firm
SAPIENT GmBH
Munich, Germany
creative people
ANITA KOREIS, ELEANOR REAGH,
JAMES FIDUCCIA, RICHARD SCHATZBERGER,
TRACY TAVIS, TYSON GUSHIKEN
client
T-ONLINE INTERNATIONAL AG

T-Online Vision

» t-finance

T-Online Vision

» t-news - categorypage

INDEX